PICASSO

AN INTIMATE PORTRAIT

First published in French by Éditions Albin Michel, Paris, 2013
First published in English in 2018 by order of the Tate Trustees
by Tate Publishing, a division of Tate Enterprises Ltd,
Millbank, London SW1P 4RG
www.tate.org.uk/publishing

First edition in French © Éditions Albin Michel, 2013
English edition © Tate Enterprises Ltd 2018

A catalogue record for this book is available from the British Library

ISBN: 978-1-84976-589-3

Measurements of artworks are given in centimetres (height before width before depth)

Editorial management: Isabelle Pailler (Arte) and Nicolas de Cointet (Albin Michel),
with the assistance of Mihaela Cojocariu
Documentary and artistic research: Elisabeth Marx
Translated from the French by Mark Harvey
Translation consultant: Matthew Drushel
Artistic director: Perruk
Layout: Coline Chair
Production: Alix Willaert
Photogravure: IGS-CP, 16340 L'Isle d'Espagnac
Printed and bound in France by Pollina s.a., 85400 Luçon - 82155B

OLIVIER WIDMAIER PICASSO

PICASSO
AN INTIMATE PORTRAIT

TATE PUBLISHING

CONTENTS

FOREWORD 6

1. **PICASSO AND WOMEN** 11

2. **PICASSO AND POLITICS** 125

3. **PICASSO AND THE FAMILY** 157

4. **PICASSO AND MONEY** 221

5. **PICASSO AND DEATH** 267

6. **PICASSO AND ETERNITY** 289

CONCLUSION: **'MISCHIEVOUS DEVIL!'** 306

APPENDICES 308

NOTES 309

CHRONOLOGY 310

BIBLIOGRAPHY 314

FOREWORD

I never knew Pablo Picasso; my grandfather only began to come to life for me the day he died, on 8 April 1973.

Before that, he had no existence, either in my dreams or in reality. He only existed on walls, omnipresent but at the same time quite abstract; someone that people talked to me about occasionally, but whom I never saw.

All my schoolfriends had grandfathers that they often went to visit on Sundays. I didn't. The oddest part was that I didn't really miss that. They had family photos. I had family portraits: my mother as a child, my grandmother looking pensive... and painted objects for which the term 'still life' was used, though I didn't understand how a coffee pot or a piece of bread could be alive or dead.

But on 8 April 1973, all that changed. All this 'still life' was reanimated.

It was a Sunday afternoon, and after lunch we were watching a film on television as usual – my mother Maya, my sister Diana, who was still a baby, and myself, aged about ten. My father Pierre had gone out with Richard, my younger brother.

At the end of the film, a special newsflash was announced. I knew what that meant: some sort of disaster, a terrorist attack, the death of some famous person. There was no picture, but an unemotional voice broadcast: 'The painter Pablo Picasso passed away this morning at his home on the Côte d'Azur. He was ninety-two. He was generally held to be the artist who invented twentieth-century art.'

Then the normal programme resumed. But in our sitting room, it was as if the sound had been switched off. For my part, I felt no reaction at all – just a confused feeling that the newsreader had been talking about someone I was supposed to know well, though I didn't know him at all; a sensation of being hot and cold. I was intimately involved, and at the same time completely out of place.

I looked at my mother. Without a word, she got up from her armchair and walked quietly, mechanically, to the telephone in the next room. She dialled the number of her brother Paul at Boisgeloup, a property that I knew well, in Gisors, near Paris. I heard her say, 'Hello Paul, Maya here. Tell me, have you had any news of Father?' He answered, as she told me later, that he had rung up the

'Yo Picasso': Self-Portrait, *Paris, spring 1901, oil paint on canvas, 73.5×60.5, private collection.*

6

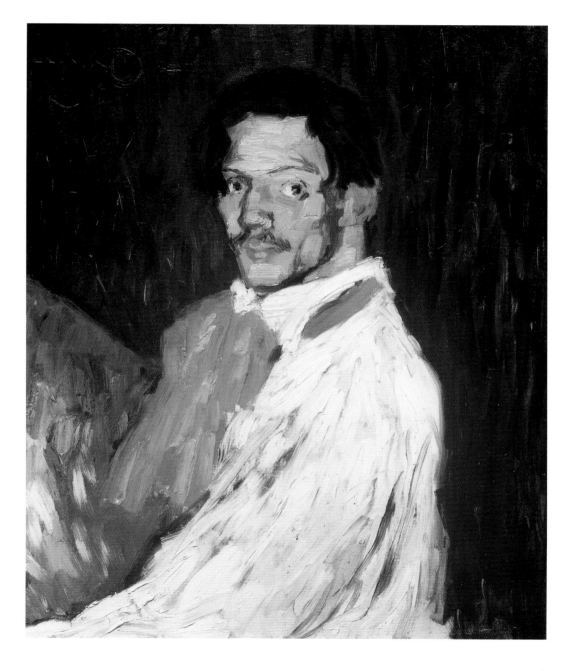

day before, and that their father had seemed very tired. Nothing more than that.

Paul, clearly, did not know yet. My mother did not dare to tell him about the television newsflash. They exchanged a few more words, and she hung up. A few days later, I heard that he had been told the news in a brief phone call from the Côte d'Azur. Paul returned to Paris and met the concierge of his block of flats at the foot of the stairs: 'Oh sir, your poor father!' Then he left for Orly airport to take the plane and travel to Mougins.

8 April 1973. Nothing would ever be the same again.

After the front-page splashes of the daily papers announcing the death of the 'Grand Master' and recalling his exceptional artistic career, after the official tributes lamenting such a loss, came the phase of the 'Picasso mystery'. The subsequent year was peppered with what the press called 'necessary' legal procedures. And then, in 1977 *L'Express* ran a front-page headline: '1,251,673,200 New Francs: the inheritance of the century' – and we were still far from the true amount – with a black-and-white photo of Pablo Picasso, revealing to every single person in my school that I now belonged to a different world.

In the end, the skill of the lawyers, the collaboration of the State and most certainly the goodwill of the heirs, succeeded – with surprising speed for a matter of such importance from both the artistic and financial points of view – in settling the whole affair. After that, the moral aspect remained to be managed, by all of us together. The Picasso Succession made way for the Picasso Joint Ownership.[1]

My memories of this period are of the interminable lists that my mother told me about: calculations, decisions, selections. My grandfather, mischievous and inventive man that he was, had generated a gigantic database. Every work recorded had been given a number or numbers – and an estimated value. At school, I had become an object of curiosity – as if I had won a medal or a prize. Picasso's grandson! I was now for ever 'different'.

But life went on. The Succession was sorted out, and Joint Ownership was established. The Picasso Museum in Paris was officially opened in 1985 by François Mitterrand: Picasso's oeuvre became an official monument, and Pablo an institutional figure.

Until, in the mid-1980s, after the time of official celebrations and scholarly interpretations, essays and exhibitions, came the time of criticism – the time of the inquisition: the work was no longer self-sufficient; it was now neglected in favour of confronting the genius of 'the ordinary'. The man who deconstructed art must by definition also have destroyed people. The majority in our family chose to remain detached. It was pointless to add to the scandal by launching interminable legal actions. I completed my law studies and became a television producer, and at the end of 1994, when I decided to produce

the first CD-ROM devoted to Pablo Picasso, I restricted myself to his creative genius, in contrast to the savagery of articles, books and films that had been released previously. On its launch in September 1996, it was the exhaustive catalogue of an exceptional body of work – the ideal museum, set out on more than two thousand interactive pages. We had decided to focus entirely on the oeuvre, which itself would establish the link between the biographical references and the events of each epoch covered.

For this present book, the task I set myself was to add one more stone to the already impressive edifice of knowledge of Picasso; to discover a day-to-day reality that intrigued me. In addition to consulting a great deal of written work, I was privileged to be able to meet many people who had known him, some of whom had never spoken of what they knew, or at least had never talked to a member of the family. I travelled back in time with them, these people who had shared moments of happiness or doubt with him; people in whom my grandfather had confided, who had been present in his day-to-day life, or even at his death, or at other still little-known events.
So the pages that follow draw the portrait of a man, with all his strengths and weaknesses; with his encounters and conquests, his companions, his children, his friends, his family; his doubts, fears and regrets, but also his certainties and commitments, his unique audacity, his

fidelity, his betrayals, his joys and sometimes his quarrels and anger; with that candid and perpetual calling into question of his work that never ceased.
In the end, that is why I decided to write this book: to go on a journey of discovery of my grandfather, of whom I knew so little. And who was such a colossal figure that, forty-five years after his death, not a day goes by without some mention either of his life or his work.

'The first thing I did in the world was to draw, as all kids do of course, but many of them don't keep it up.'

Chapter 1

PICASSO AND WOMEN

'I don't seek, I find!'[2]
Pablo Picasso

If legend is to be believed, Pablo Picasso was one of the most seductive men of the twentieth century. Yet he possessed few of the traditional attributes of the type. He was not very tall, about 5 feet 5 inches, sturdily built and powerful. When asked if there was anything missing from his life, he used to say: 'Yes, about two inches!' He made up for it in other ways.

It is true that for a while he was always very elegantly dressed, especially from 1915 when more money was coming in, and for at least the next twenty years – his 'duchess period', as his old friends used to joke. Early in the 1930s, the photographer Cecil Beaton, who was expecting to photograph an uncivilised bohemian in a chaotic studio, was confronted with Pablo, wearing a silk tie and a sumptuous navy blue suit, in his immaculate Regency-style apartment in the rue La Boétie. This bespoke-tailored chic, worthy of London's famous Savile Row, was the sign that he had made his fortune and arrived in a new world. Once he had got over this ostentatious elegance, he retained his personal style (the famous sailor's jersey and shorts of the post-war period) and a certain pride in his appearance (collections of materials, such as velvet or tweed, colours and prints) until the end of his life.

He listened a lot and did not necessarily talk himself. However, as soon as he spoke, his enthusiasm and charisma triumphed, arousing the interest of women in particular. A piercing gaze, a few direct, trenchant words, and he could obtain the desired favour.

He had more and more affairs as time went by. The big lock of brown hair across his determined brow had disappeared by the early 1940s. It was then a Picasso haloed with sparse grey hairs who aroused feminine fantasies and, without any doubt, masculine jealousy – even if some husbands literally offered their wives, often in vain, for the 'affection' of the master. His gaze remained dark, piercing, attentive, disturbing in its intensity, hypnotic. He backed it up with words – with a certain shyness to start with – and, more by instinct, his features, the arrow that hit the bull's-eye.

Pablo's love-life was the *sine qua non* of all his work. Even when his hand was guided by politics alone, as in *Guernica*, it was always a woman or the feminine influences of the moment, even if these were in competition, that gave human form to the figures in the work.

Women were to Picasso what paint is to the brush. Inseparable. Essential. Fated. He gave his century the most extraordinary

portraits of women, moving from the most absolute classicism to the most polemical deconstruction and back again, obeying only his instinct – and his love. Love that was paramount, ever-present, even if its object was different every time. Picasso loved, loved like a madman, in a frantic search for the woman who would nourish his art, his life, his dream of eternity. Each new companion was taken through a process of initiation, an emotional and artistic test, to charm her, reassure her, constrain her, draw a source of inspiration and creation from her before he abandoned her, inevitably, to start the same game with another, and another. Few could resist. My grandfather was aware of his aura. He had the eye of the Minotaur, simultaneously strong and tender, seductive and implacable, commanding and tamed, capable of the best or the worst.

His women thus gained eternity. What a potent weapon, the painter's capacity to sublimate on his canvas the gaze of a woman, for ever.

Whether I am visiting an exhibition or reading an art book about my grandfather, I cannot imagine that such and such a work could have been conceived without love – without other people. The things that set him apart were his raw, living materials: love and humanity. After all, he even declared, in his one and only television interview in the 1960s, that the essential thing was to love, and that if there were no people left to love, he would have loved anything, even a doorknob!

His passion was other people. Without them, his work would be empty, devoid of lines, of pencil, of paint – and of meaning. My grandfather had an immense need for affection and he angled from day to day for certain proof, proof of love. If he saw the world through his painting, then he saw his painting through other people.

ANGELES MENDEZ GIL

Surrounded by his mother, his sisters and his aunts in the Malaga of his childhood, he had been a little king in a realm of devoted women. Attention and affection were self-evident. Even his lack of interest at school did not call down the wrath of either of his parents. His mother, Doña María, idolised him; his father, Don José, understood the inexplicable.

Pablo had shown an early talent for drawing, and with unconditional support from his father, who taught at the art school, and his uncle, he had no need to be ashamed of his childish errors because he held absolution for his faults in the genius of his hand. After observing all those around him, after capturing to perfection the pigeons and the bulls at the corridas where his father took him, it was at the age of thirteen, in 1894, that he suffered his first amorous upset – his first wound.

My grandfather was born on 25 October 1881 in Malaga, in the province of Andalusia, in southern Spain. In 1891, the family settled in La Coruña, a rainy, windswept seaside

town, in the north of Spain. There Pablo fell in love with a schoolgirl in his class, Angeles Mendez Gil, the daughter of a very middle-class family. He intertwined his initials with hers in the drawings that he gave her, just as he would do much later with my grandmother, Marie-Thérèse, in the late 1920s. In this way he conducted a secret affair under the very noses of their respective families. But the family of Angeles found out, and disapproved so strongly of this idyll with a boy of such low-class antecedents that the girl was sent away to another town. That was the end of their brief love affair. The adolescent Pablo was heartbroken, his pride deeply wounded. In the end, the Ruiz Blasco y Picasso family settled in Barcelona – a Mediterranean paradise after the hellish Atlantic coast. There, Pablo had his first adventures before he was fifteen. As soon as he arrived at the School of Fine Arts (known to its pupils as La Lonja, or Llotja in Catalan), he made the acquaintance of a comrade, Manuel Pallarés, who became his lifelong friend (Pablo would die in 1973, Pallarés in 1974).

Five years his senior, Pallarés led Pablo astray, doing the rounds of the bars and brothels, immersing him at an early age in the coarse realities of life. Pablo veered from wild romanticism to the crudest sensuality. These early experiences – whether chance encounters or modestly paid for – would remain with him in the form of a lifelong fascination with physical love, the symbol of life and youth, which his erotic work would retrace in all its energy – and frequency.

In 1897, he went away to Madrid to train at the Royal Academy of San Fernando. It was not long before his absence from classes and his nocturnal escapades led his benefactor, his uncle Don Salvador, to cut off his allowance. His father, however, continued to send him a small sum to pay for his room. Pablo entered his period of survival.

To crown it all, he fell ill: scarlet fever, or the consequences of his riotous living. His pockets empty, with rings under his eyes, he returned to his family in Barcelona, then set off again with his alter ego for the village of Horta de Ebro (now renamed Horta de Sant Joan), where the Pallarés family came from. Pablo intended to convalesce there and get his strength back. As for Pallarés, his real reason for seeking refuge there was to avoid being conscripted by the army (Spain was then at war with the United States).

At that time, Horta was a large village with more than two thousand inhabitants. Access was by road, and then along footpaths. For Pablo, who had never known anything but the urban world, it was fascinating to discover this peaceful rural life, surrounded by fields of almond and olive trees, modest pastures and arid landscapes. Here he met a people accustomed to hard work, sacrifice, mutual support. Here he laid the foundations for his relationships with people and things. Whatever success and fortune might be his later on, he would remain faithful to this simplicity and would never forget how it had contributed to the happiness of the inhabitants of Horta through the centuries.

The two friends stayed there nearly eight months, travelling all through the surrounding mountains and hills. They had also come to paint. Pablo and Manuel lived simply, sleeping under the stars or in some cave or other, and every two or three days receiving provisions brought to them by Salvador, Manuel's little brother. Pablo's father also had stretched canvases and paints sent to his son.

According to the American biographer Arianna Stassinopoulos-Huffington – and her alone – in reference to an interview with Françoise Gilot in the mid-1980s, there was a third person, 'a young gypsy boy' as she described him, accompanying Pablo and Manuel. 'The gypsy was two years younger than Pablo and he too was a painter: all three of them spent much of the day painting... Together, they [Pablo and the gypsy] observed the daily miracle of the dawn and went on long walks ... Soon their friendship became intense.' She adds: 'Picasso was in love: in love with the gypsy and with the world.'[3] These are allusions to a homosexuality which is not corroborated by anyone, not even Françoise Gilot.

From the other travellers whose company he kept, unbeknownst to his family, he learnt to smoke a cigarette in one nostril, and the rudiments of flamenco dancing. 'I can't begin to tell you all the tricks those gypsies taught me,' he added mysteriously. In addition to these innocent diversions, there is a portrait of a young gypsy seated, painted at Horta in that year (1898) in the purest academic style of the period, nude like all the models at the art school. This work undoubtedly belongs to the tradition of the pupils of the San Fernando academy.

Another biographer, John Richardson, also recounts the brief presence at the Bateau-Lavoir[4] of a young gypsy painter, Fabián de Castro: 'Fabián is probably the gypsy painter with whom Picasso has been accused of having an affair.' He slept on the floor in the same room as Pablo but, Richardson adds, 'There is no reason to conclude that this encounter led to sexual relations.'[5]

In the whole of Picasso's erotic output, indeed, nothing can be found that implies any interest in male homosexuality. Like many strict heterosexuals, on the other hand, he enjoyed the spectacle of lesbian frolics that was frequently offered by the young residents in the brothels of his youth, and which he reproduced in many sketches of this period.

Picasso was heterosexual, that is a fact. And indeed that was the tragedy for many a woman! The archetype of the handsome, saturnine man, well built and indisputably Latin: no woman could be indifferent to him. He did not merely stare at a woman, or stop at her outer appearance alone: he penetrated her, violated her with his eyes, and provoked an arousal that he was well able to turn to account, consciously or not. He also had homosexual friends whom he would certainly have defended, in that less tolerant period, but if he was homosexual himself, it was on the side of his character that was... lesbian.

GERMAINE

(1881–1948)

On his first visit to Paris in October 1900, with his friend and room-mate from Barcelona, Carles Casagemas, Pablo visited the Universal Exhibition and stayed with one of their acquaintances, the Catalan painter Isidre Nonell (whom he had met at the Els Quatre Gats café in Barcelona), at 49, Rue Gabrielle in Montmartre. Soon afterwards, they moved into the Bateau-Lavoir at 13, Rue Ravignan, where they found a whole community of Catalan emigrants like themselves, including Casas, Utrillo, Fontbona, Isern, Pidelaserra and Junyent.

They made the acquaintance of two young women, Odette and Germaine. The latter became friends with his comrade Casagemas. Laundress and model to the painters of Montmartre, Germaine kept company with this community of young people, but, although she was married, she was not at all uninhibited. Casagemas had great hopes of this relationship, which was too platonic for his taste.
Things quickly turned sour between them, however. Germaine did not want their association to be seen as anything more than simple friendship. On his side, Casagemas, who furthermore suffered from congenital impotence, fantasised about a relationship where there was none. The reality depressed him a little more each day. One evening – in front of Odette,

Pallarés and the Catalan sculptor Manolo – Casagemas pulled a revolver out of his pocket and shot at Germaine. 'So much for you!' he said. The bullet missed its mark, but the detonation stunned Germaine who collapsed on the floor. Thinking that he had killed the woman he loved, Casagemas turned the gun on himself and, crying 'So much for me!', put a bullet into his temple.[6]

Germaine was a head-turner. When Picasso returned to Paris in June 1901 and took accommodation at 130c, Boulevard de Clichy, in the Spanish colony, his friend Manolo had become the young woman's recognised lover, but Picasso quickly took his place. 'He announced the news in a comic strip addressed to Miquel Utrillo in Barcelona, in which he depicts the jealousy of Manolo and draws himself in bed with Germaine, in the face of Odette's anger,' Pierre Daix relates.

Pablo seemed very proud of this conquest. Was it a way of drawing closer to his friend, or his friend's soul, by sharing his attraction to the same woman? And by succeeding where Casagemas had been met with rejection?
This period at the Bateau-Lavoir was a time of change and searching, in morals as in painting. Insouciance was the rule, here on the fringes of the prevalent puritanism. My grandfather and his friends were taking part in an artistic movement whose worldwide repercussions they could scarcely have foreseen, and which prefigured many

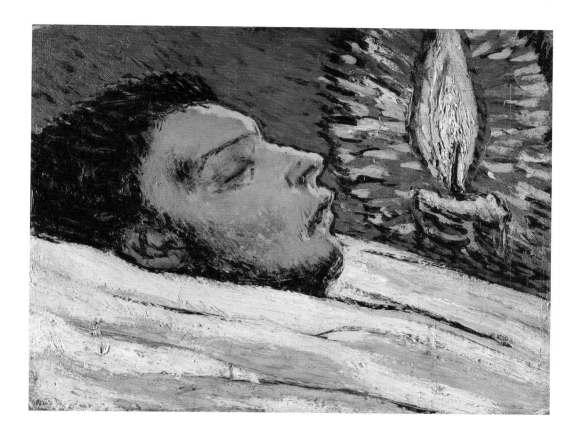

subsequent liberation movements. Years before any real moral emancipation, they gave free rein to their desires.

In them, the emotional instinct, which was necessarily curious and flighty, nourished the creative urge, marked by freedom, and defying academicism. Pablo had repeated adventures and drew them like so many victories. Many of his models are portrayed, then, for the space of a pose or a brief affair, such as Jeanne, or a certain Blanche who is remembered as a short but intense liaison. He would later say of these ephemeral women: 'At first, the only thing you think about is painting them. Then, afterwards, you go on to something else!' And he did indeed go on to something else, and then on to the next one.

MADELEINE

Still under the influence of his emotional wanderings, Pablo saw Germaine again several times on his trips to Paris, in 1902 and 1904, but at the same time he was going out with another model, Madeleine, whom he had met at the famous Montmartre nightclub Le Lapin Agile. He even considered forcing the pace and having a child by her, in 1904.

We know little about this affair. According to Pierre Daix, 'our ignorance is doubtless due to the fact that when it was going on, only Max Jacob could have known about it, and he always kept his lips sealed about his friend's [Pablo's] adventures, which must have tormented him with jealousy. ... Fearing no doubt to annoy Fernande [Olivier], who claimed to be "Madame Picasso" and

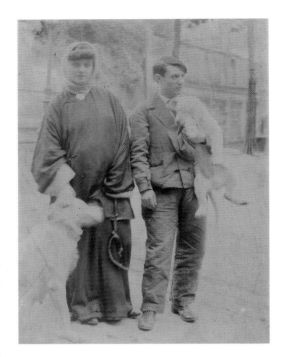

also his first mistress, Pablo did not reveal the existence of Madeleine until after the death of Fernande, in order to avoid any comments on her part. It is likely that his friends in the Spanish colony knew about it, but they too were adept at keeping secrets.'[7] On the romantic front, my grandfather learnt early on that discretion was his best friend. Not that he had decided to have more and more adventures and to dupe his conquests. But in spite of explicit separations, he always maintained a connection, even if it was only artistic. As each new relationship began, another was still in progress.

FERNANDE OLIVIER

(1881–1966)

Born on 6 June 1881, the same year as Pablo, Fernande Olivier was really named Amélie Lang. In 1899, she had married a brutal man called Percheron, an office clerk. It was a forced and unhappy marriage. Exasperated by her violent husband, she soon left him to live with Laurent Debienne, a Montmartre sculptor. She made a living posing for various painters.

Fernande was a well-known, even picturesque figure at that time, in what is still the village of 'La Butte'. She met Pablo in the summer of 1904. She too was living at the Bateau-Lavoir and one evening, during a violent thunderstorm, she ran into him in the little front porch. Then took refuge in his studio. She was uncomplicated and spontaneous. Their relationship began that first evening,

but Fernande was also having an affair with the Spanish painter Joachim Sunyer, and Pablo was still going out with Madeleine – not to mention engaged in a brief fling with Alice Princet, who would later become the wife of the painter Derain.

It is difficult to keep track of these amorous entanglements, but they testify to a real *joie de vivre*, despite the indescribable poverty that was the daily lot of their community of artists.

The Bateau-Lavoir was an old 'dilapidated building, mostly built of wood, zinc and dirty glass with stove-pipes sticking up randomly'.[8] It had a single lavatory, with just one cold-water tap to supply thirty studios. But it was always possible to get a drink of water at the fountain in the Place Ravignan. An appalling smell hung over this shambles, compounded of mould, cats' piss and paint. In winter, it was freezing; in summer, a furnace. A little like Madrid.

Pablo lived in utter destitution, his only furniture a ramshackle bedstead and an old trunk that served as an armchair. He

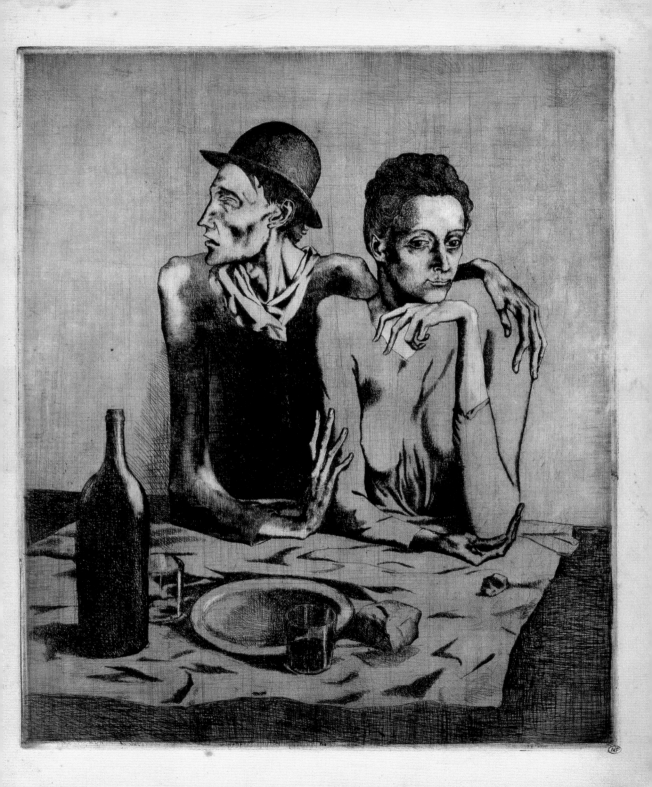

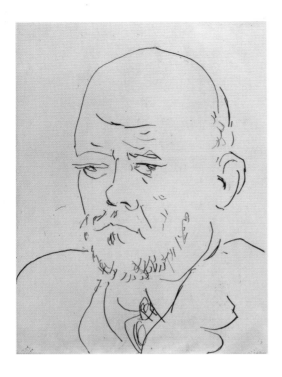

never forgot those years of privation: even when he was the possessor of a fortune of which he himself could not tell the value, he remained a simple, thrifty man, though always generous, with discrimination. Fernande came to live with him from early 1905. She relates with nostalgia, in her book of memoirs, those times of happiness, awful though they were in material terms. 'Does Picasso still remember a young friend whom he often used as a model and who at one time couldn't go out for months because she had no shoes? Does he remember the winter days when she had to stay in bed because there was no money for coal to heat the freezing studio?... And the days of enforced fasting? And the piles of books bought from a second-hand bookseller in the Rue des Martyrs? Nourishment that was vital to me because Picasso, in a kind of morbid jealousy, kept me shut away. But with tea, books, a divan and little housework to do, I was happy, very happy.'[9]
It is difficult not to see this possessive jealousy with which Pablo burdened

Fernande as foreshadowing the similar jealousy that he would display later on towards my grandmother, Marie-Thérèse. And how can it fail to call to mind the proposal that Pablo made to Françoise Gilot that she should live in concealment in the little flat over the studio in the Rue des Grands-Augustins, a dove cloistered in a love-nest? Was it a sublimated collector's instinct in his make-up? Or the anxiety of the adolescent whose little Angeles had been taken away from him, an experience of injustice that he had no wish to go through again? Or even a confusion between the image captured on the canvas and the woman captive in real life?
Fernande and Pablo's material situation improved after November 1905, when the American collector Leo Stein and his sister Gertrude began to take an interest in his works, and then again in May 1906 when the celebrated dealer Ambroise Vollard, who had bought nothing from Pablo since 1901 (their first exhibition had won critical acclaim, but Vollard had had no liking for the following years of the painter's 'blue' period), purchased some twenty canvases, all of them important works. This unexpected windfall gave the lovers the chance to make a short trip to Spain. First to Barcelona, to see Catalan friends who had remained in the country, then to Gósol, where Pablo, in his element, painted furiously.
In this very isolated Catalan village, which was reached at that time on mule-back, he relived his retreat to Horta de Ebro

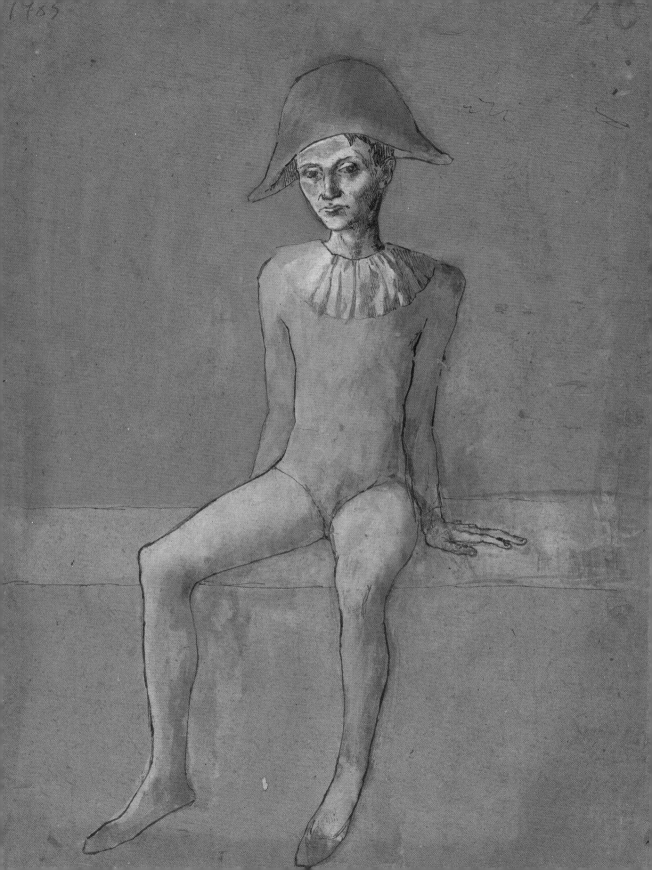

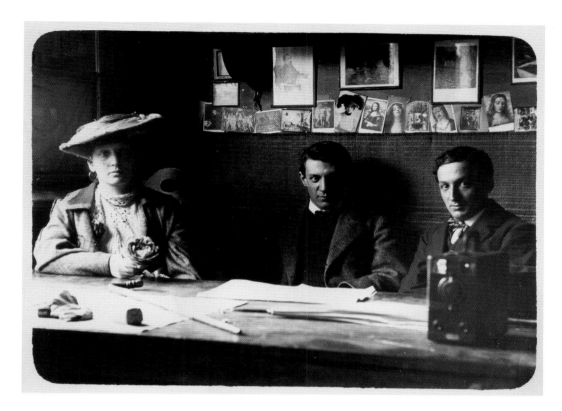

years before. Indeed, throughout his life, my grandfather liked to return with his companions to the haunts of his youth: to Barcelona with Olga, and later with Marie-Thérèse (that was in fact his last journey to Spain), to Montmartre and the Rue La Boétie with Françoise. He was trying to get them to admit that he was the child of his past, that they had to accept it, and also tolerate in him a 'free zone' to which they did not have access.

Pablo now devoted himself almost entirely to his work and, certainly influenced by the fauvism that had caused a scandal at the Salon des Indépendants in 1905, with the exhibition of canvases by Cézanne, Derain, Matisse and Braque, he was once more making liberal use of colour.

He drew a lot of nudes: it was the beginning of his representation of desire. Thus, in the spring of 1906, he painted *Nude Combing her Hair*, and, in autumn 1907, a *Draped Nude*. Then, after discovering sculpture and tribal art, which caused real trauma in him, he suddenly introduced hatching and cloisonné surfaces into his work.

Meanwhile, Fernande was taking an interest in a young Dutch painter, Kees Van Dongen, who had just come to live in La Butte. She posed nude for him, making Pablo beside himself with jealousy. Convinced that she had been unfaithful to him, he announced that they were breaking off their relationship. Gertrude Stein, informed by Fernande, doubted whether this theatrical separation was really sincere. She was quite right: three months later, the couple started living together again. Fernande was actually hoisting every possible signal to attract Pablo's attention, but he was completely absorbed in his work

Fernande with a White Mantilla, spring-summer 1906, Gósol, charcoal, 63.1×47.4, Musée national Picasso-Paris.
Fernande, Pablo and Jacint Reventos at El Guayala, Barcelona, 1906.

Les Demoiselles d'Avignon: it would make him the creator that the new century had been waiting for.

The picture, however, would not be exhibited until nine years later. Only a few privileged people saw the work in his studio. Most of them, unimpressed, sniggered at it, even Leo Stein, Derain, Apollinaire and Braque, to whom we owe the famous remark: 'In spite of your explanations, your painting is like forcing us to eat tow and drink paraffin so as to spit fire!' Fernande does not even mention this great painting in her memoirs. Gertrude Stein was almost the only one to be enraptured and to preserve the memory of this historic moment.

It was the opportunity for a German art dealer called Daniel-Henry Kahnweiler to experience the epiphany of his young career. At his first meeting with this Picasso, whom he had been told about by a German colleague, he discovered, simultaneously, the artist and the masterpiece of modern art. He would become Pablo's accredited dealer. He began by buying several important canvases. The lifestyle of Pablo and his companion improved. At the same time, Pablo was starting a stimulating series of exchanges with Braque, in a dialogue which would continue at least until 1914, on the subject of what would come to be known as cubism.

Fernande had two essential qualities: she liked his artist friends and she was good at organising a home to receive them. Despite Pablo's consuming passion for his work,

– with the risk that their relationship might inexorably die away. Work before everything else: that was the artist's credo. Nothing and nobody could distract him from his work any more.

'I experienced my deepest artistic emotions when the sublime beauty of sculptures executed by anonymous artists in Africa was suddenly revealed to me.'

While Fernande was away, Pablo was at last drawing together the threads of the studies that he had been conducting since the autumn of 1906. He was inspired by Gauguin and his Tahitian women with their massive shapes, and by his visits to the Musée de l'Homme, a haven of African art. A long series of preparatory sketches led to the completion, in June 1907, of a canvas that was to become emblematic of modern art,

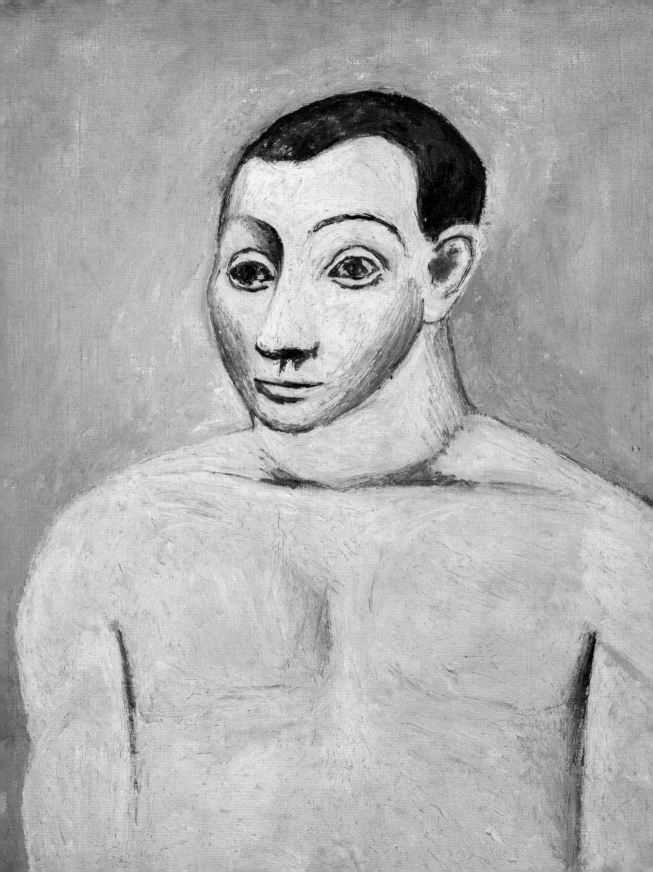

Three Figures Under a Tree, c.1907, oil paint on canvas, 99×99, Musée Granet, Aix-en-Provence.

Bruno Ely, director of the Musée Granet and also the organiser of the Picasso–Cézanne *exhibition in 2009, recalled that 'the work of Cézanne accompanied Picasso all his life. From his earliest years, from his initial expressionism to his rose period, from* Les Demoiselles d'Avignon, *who might never have existed without the* Grandes Baigneuses *[...] up to his purchase of the Château de Vauvenargues in Cézanne country'. Pablo did not know at the time that his work would join that of Cézanne in Provence a century later.*

Guillaume Apollinaire in Pablo's studio at 11, boulevard de Clichy, 1910.

which took up more and more time and space, and despite his detestation of habit, she was happy to welcome good friends with him. The poets Guillaume Apollinaire, André Salmon, Max Jacob of course and many other painters were regulars in the rue Ravignan. But this bohemia, which Pablo would often lament, was gradually turning into a kind of Parisian society that mingled artists, intellectuals, painters and writers with too much formality. Picasso was already feeling stifled.

In the summer of 1908, he rented a little house about forty kilometres from Paris, in La Rue-des-Bois, near Creil, and moved in with Fernande, his large dog and a cat which was on the point of giving birth. This was a temporary isolation in the country which would be repeated frequently: Fontainebleau with Olga, the Château de Boisgeloup in the Eure or Le Tremblay-sur-Mauldre with Marie-Thérèse, Ménerbes with Françoise.

Pablo returned to Paris for the Autumn Salon (it had been created in 1903, and he had been giving it his attention since 1905). There he discovered the works that Braque had executed over the summer in L'Estaque, near Marseilles, described by the critic Louis Vauxcelles as 'distorted metallic figurines, shamefully simplified'. Braque, he said, 'despises form and reduces everything – landscapes, places, houses and people – to cubes'. Cubism was born. But the foundation on which it was built was *Les Demoiselles d'Avignon*, still kept secret.

In November 1908, Pablo made the acquaintance of the famous Henri Rousseau, in whose honour he held a memorable banquet to mark the purchase, organised through old Soulié,[10] of the canvas *Portrait of a Woman*. He would keep this portrait at hand all his life.[11]

A banquet like this was probably the event that was most emblematic of the Bateau-Lavoir, with its artists and their carefree spontaneity. To my mind, this story testifies to all the friendship that my grandfather demonstrated towards someone who had sincerely moved him. The feast was held in Pablo's studio in the Bateau-Lavoir, where Fernande brought all her housewifely talents to bear to receive the whole 'Picasso gang'.

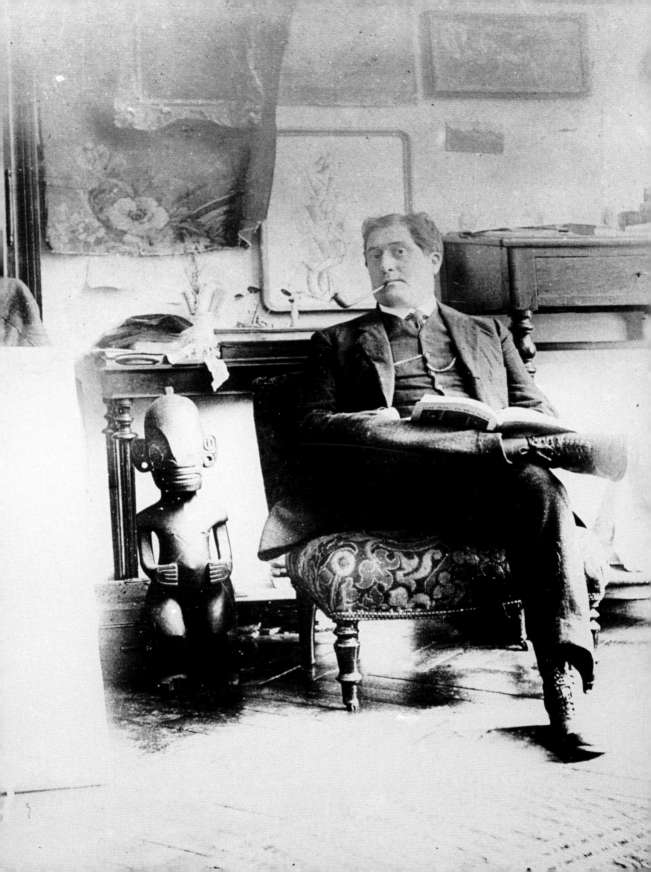

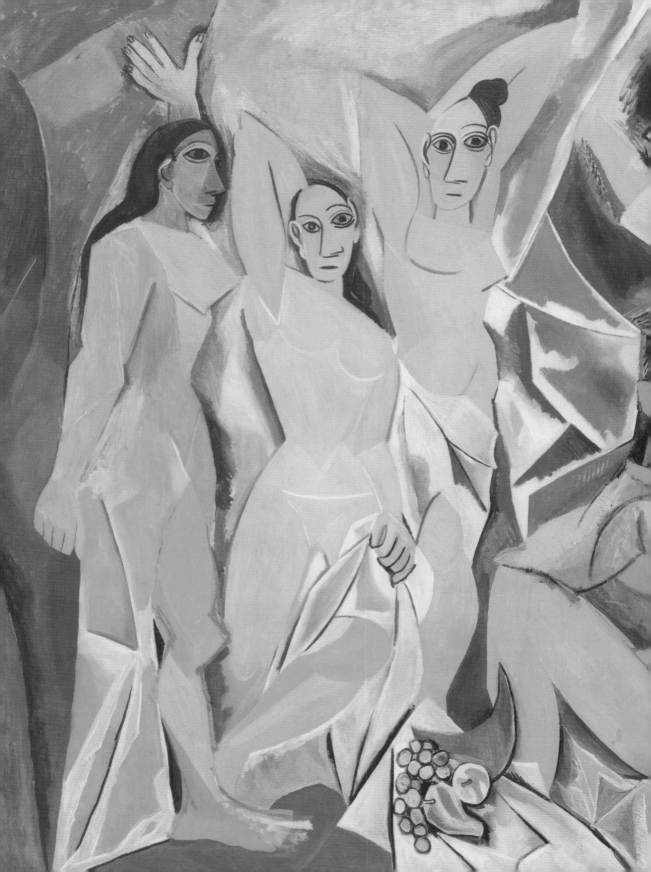

Les Demoiselles d'Avignon, *1907, oil paint on canvas, 244×234, Museum of Modern Art, New York. MoMA received this work in a donation in 1937. The present director Glenn Lowry has noted: 'It is undoubtedly the most precious work in the museum's entire collection, which includes 1,300 works by Picasso, and is one of the most important paintings of the twentieth century.'*

During the summer of 1909, Pablo took Fernande to Spain again. After a short stay in Barcelona to see his family, they spent their holiday at the famous Horta de Ebro. The Catalan landscapes inspired him to paint new cubist works – in the 'Cézanne cubism' style in which the subject and the background are all treated in the same way and in the same plane, as so many facets, prisms and cubes. The colours closely resemble those of Cézanne's landscapes and still lifes – *the* emotional reference for Pablo. At Horta, he once again met some of the friends he had made on his first visit, including, of course, Manuel Pallarés. Then Fernande fell ill. Pablo suddenly turned nasty, the first symptom of his phobia of sickness and death. He flew into a rage on principle against sickness and could not control his revulsion. Death had taken his little sister Conchita from him: had the child that he then was grasped the whole tragedy? To him, illness was death. This obstinate refusal soon became a chronic fear, for no logical reason. Why did Fernande have to fall ill here, in Horta, in this Eden of fulfilment and happiness? Was it an evil omen? To this man, steeped in superstition, everything took on a disproportionate, irrational dimension. Worse still, that summer Pablo was worrying about rumours of a riot in Barcelona. He would have liked to be there. News spread slowly in those days. Another vital aspect of his character was taking shape: an interest in politics.

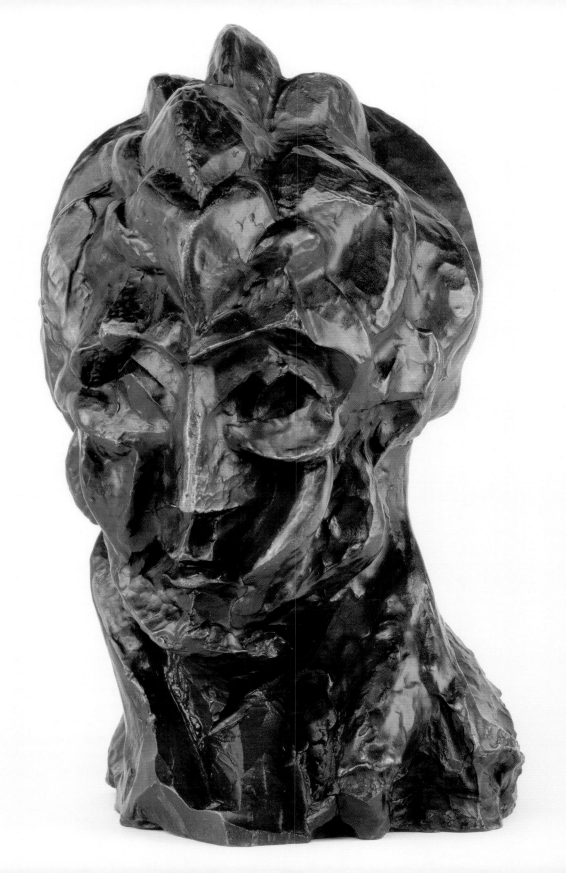

Pablo and Fernande came back to Paris in September and moved from the Bateau-Lavoir to a comfortable new flat at 11, Boulevard de Clichy. Bohemia had lost its cultural setting, the lovers were becoming middle-class: 'We took our meals,' Fernande relates, 'in a dining room with old mahogany furniture, served by a maid with a white apron. We slept in a bedroom made for repose, in a low bed with a heavy, square, brass bedstead.'[12]

Fernande soon metamorphosed back into a petit-bourgeoise Parisienne, marvelling at the comforts of everyday life that were hers at last. But Pablo ordered that his studio was not to be tidied without his permission. His need for self-reassurance, through this 'settled' life, was in opposition to his continual need to create which in turn forced him to transgress the rules of his new status. While Fernande dreamed of children and order, her companion was methodically deconstructing classical art and persisted in inventing modern art.

Fernande sometimes found it difficult to understand his unremitting application, and had reservations about his painting. The lovers, now too well settled, were gradually drifting apart. The years 1910 and 1911 were marked by growing mutual incomprehension. Pablo only tore himself away from his canvases unwillingly, except to meet those individuals who were now stirring up their artistic epoch at the Café de l'Ermitage on Boulevard Rochechouart.

It was there, in autumn 1909, that he met the Polish painter Marcoussis and, with very much greater interest, his companion, Eva Gouel. It was love at first sight. Their fate was sealed as their eyes met. His new conquest began to appear in his work, gradually taking the place of his official love.

Nevertheless, Fernande and Pablo spent the summer of 1910 together at Céret, in the south of France, where they renewed acquaintance with the accents of Spain in the landscapes and people of the region. Pablo acquired a taste for the charms of the neighbouring Pyrenees, and for meeting other artists on holiday. The idyll with Fernande had had its day, but was still 'official'. She even permitted herself a few affairs, coming to the bitter realisation that Pablo no longer in the least displayed the same enthusiasm for her. In his eyes, since the autumn, the only woman who counted was Eva. The subsequent year only confirmed this state of affairs.

In 1912, Pablo rented a studio in the Bateau-Lavoir again, on the pretext of enormous amounts of work and a need for space. The truth was that he made it the setting for his

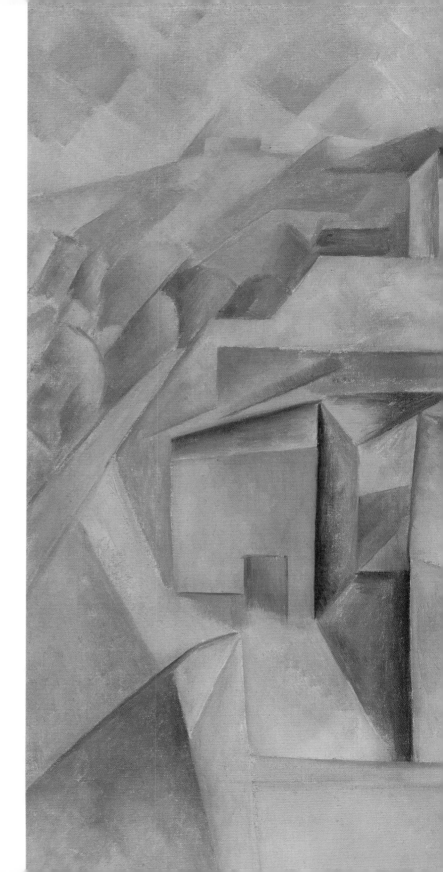

Houses on a Hill, *1909, oil paint on canvas, 65×81, Museum Berggruen, Berlin. Picasso's cubism covers two periods: analytical cubism and synthetic cubism. In the first phase, the artist endeavours to show every possible point of view, freeing himself from perspective by decomposing three-dimensional space to obtain an almost abstract representation of the subject.*

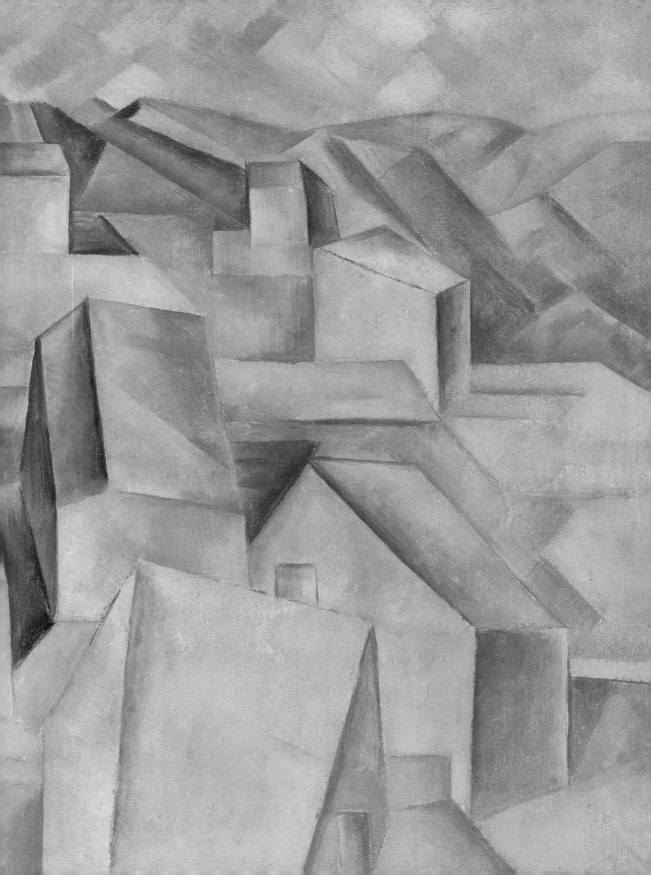

secret liaison with Eva. Fernande guessed what was happening and pre-empted him: she created a fuss and left Pablo for another man. 'We know about it through a note from Picasso to Braque,' Pierre Daix relates. 'Fernande had gone off with Umbaldo Oppi. The dog Frika was adopted by Germaine Pichot. Kahnweiler was given the job of recovering the artworks and materials from the Boulevard de Clichy, from where Picasso moved at the end of September to go and live with Eva at 228, Boulevard Raspail.'[13]

In this month of June 1912, things took a decisive turn. Marcoussis, abandoned by Eva, published a satirical drawing in *La Vie parisienne* – representing Pablo dragging Eva away with a ball and chain on her ankle, while he himself jumped for joy – to put a definitive end to their romance.

Eva and Pablo were already far away, in Céret. Germaine and Ramon Pichot went there with Fernande, to try and persuade Pablo to leave Eva. But the passionate lovers left Céret in time and went to stay in Sorgues.

Thus Pablo rediscovered the artist's life that so inspired him. He was now experiencing a spontaneous passion free of pretence or tedious rules – and with no need to worry about everyday matters any more. Eva understood him; she stimulated him in his work just at the time when he was exploring what would in due course be termed 'synthetic cubism'. He shared his energy with his mistress.

In Sorgues, the 'refugees' were joined by Braque and Marcelle, the woman the latter had just married. The barometer of life showed set fair. The two artists resumed their dialogue, especially on the topic of African art. The two couples visited Marseilles and its surroundings.

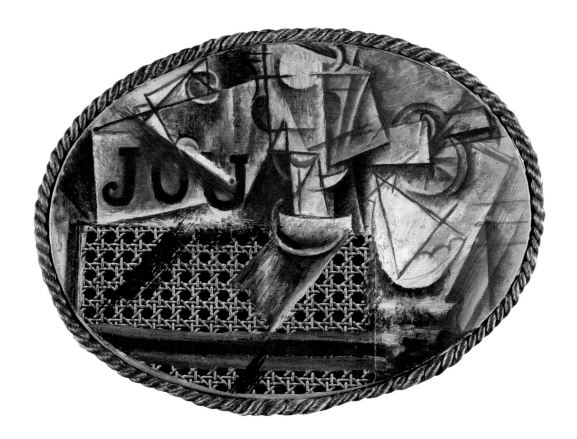

It was a new page in Pablo's life. His existence became a sequence of swings to and fro between conformism and bohemianism, academicism and freedom, mastery and daring – with genuine jubilation at each mutation, each 'period'; and an almost instant rejection of any attempt at confinement.

Fernande ceased to be a part of his love-life for good. He would have no further news of her until the early 1930s, when her memoirs were published.

However, he never forgot how she had helped him when times were hard, and he was to help her in his turn when she found herself almost destitute, in the 1950s.

Out of friendship and courtesy, he refrained from revealing his affair with Madeleine until after Fernande's death, on 26 January 1966.

Violinist, *summer 1912, drawing, 30.7×19.5, Musée national Picasso-Paris.*

Man with a Mandolin, *autumn 1911, oil paint on canvas, 162×71, Musée national Picasso-Paris.*

Still Life with Chair-Caning, *spring 1912, oil paint on canvas, 29×37, Musée national Picasso-Paris.*

In the second, 'synthetic' phase of Picasso's cubism, the artist introduces letters and figures, thus freeing himself from visual imitation to suggest a new interpretation of forms and space. Apollinaire, recalling his conversations with Pablo, writes of cubism: 'It is the art of painting new assemblages composed of elements drawn not from the reality of vision, but from the reality of knowledge.'

EVA GOUEL

(1885-1915)

Eva Gouel's real name was Marcelle Humbert. She seems to have met my grandfather at the end of 1909 in the Café de l'Ermitage, where he often used to go to talk to his 'futurist' friends after he started to live in the Boulevard de Clichy with Fernande.

According to Pierre Daix, 'she was the antithesis of Fernande, physically and in her way of life. Small and slim, undoubtedly intelligent, she disliked both bohemianism and financial extravagance and she brought Picasso regular habits, a talent for cookery and the peace of mind that he needed.'[14]

The 'Eva period' was very happy. Pablo was madly in love and joyfully expressed his happiness. Symbolically, she is everywhere. Her initials, her name, her nickname 'Ma Jolie', the title of a fashionable hit tune: all the joy of his love is apparent in his works, which regain colour until his first collages make their appearance. In the autumn of 1912, the lovers were living together on the Boulevard Raspail, in Montparnasse: Pablo had left Montmartre and gone to live in the district of his new love.

During the following summer, Braque executed his first collages, incorporating pieces of wallpaper into his canvases. Pablo enthusiastically followed suit. He added different materials (wood, glue, rope or sand), writing to his friend: 'I'm using your latest papery and dusty techniques'. The two of them had just opened the door to the collages and all the constructions and accumulations that are such a feature of artistic practice today.

In December 1912, Pablo indulged his taste for 'pilgrimages' and went back to Céret with Eva, and then to Barcelona, to show her his native town and introduce her proudly to his Catalan friends. It was a reprise of the ritual.

Back in Paris, the couple resumed their day-to-day existence of unclouded happiness. Then, in the spring of 1913, they went back to Céret. Juan Gris, a friend as well as a competitor of Pablo's (and furthermore, also represented by Kahnweiler), came to visit them, as did Max Jacob. Everything was perfect in Pablo's little world.

1913: the terrible year. Don José, his father, passed away at the end of May. Death crossed Pablo's path and took away his only master, the only one he really wanted to outdo. This death made its own contribution to Pablo's pessimism and strengthened his fatalistic bent.

Pablo had only just got back from the funeral in Barcelona when he suffered an

attack of fever (or more probably dysentery) which was very nearly fatal and kept him confined to bed for a month. Then the first symptoms of Eva's illness appeared.
Not to mention the premonitory signs of a generalised conflict in Europe.

Eva was always at the core of Pablo's work: *Female Nude 'I Love Eva'* (autumn 1912), *Woman in a Chemise in an Armchair* (late 1913 to 1914), *Painter and his Model* and *Portrait of a Young Woman* in the summer of 1914, after a stay, which was still peaceful, in Avignon. In Paris, by Eva's side, Pablo embarked on a new social life and began to become something of a celebrity.
Then war broke out. Braque and Derain left for the front; Apollinaire set off for battle full of enthusiasm, jubilant at being passed 'fit for service'. Fortunately, they still had their friend Max Jacob, the poet, who

had become Pablo's godson following his conversion to Catholicism. Spain, in this war, was neutral. So Pablo stayed behind with the wives of his friends who had gone off to fight – and, fortunately, with Eva. He was bitter about this neutrality – but this was only the beginning of his misfortunes.
Eva had been complaining of pain for several weeks. The sickness was gaining ground. She was diagnosed with cancer of the throat. Her health deteriorated steadily throughout the spring of 1915, and even more during the summer. As if to put the finishing touch to this grim picture, Braque was seriously wounded in the head that same spring.

Max Jacob and Pablo on the Boulevard Montparnasse in front of the Rotonde café, 1916.
Self-portrait with Man Leaning on a Table *in the studio at the Rue Schoelcher, 1916.*

Pablo was overcome with grief. And so alone. He raced from one hospital to another in an attempt to save the woman he loved. All the beds were occupied by war wounded. Eva spent the last few weeks of her life in a clinic in Auteuil, where she passed away on 14 December 1915.

Most of the biographies devoted to my grandfather describe Eva as 'the great love of his life'; she was certainly the cause of his deepest despair. The unsettled Pablo had talked of establishing a household with her, of marrying her and having children. Her illness overturned this dream of eternity, and Pablo would have great difficulty getting over it.

At the same time, the transience of this love would contribute to its sublimation: Pablo had not exhausted the inspiration that Eva had brought him, and their emotional and artistic story was fated to remain an unfinished masterpiece.

Pablo, in desperation, tried to forget her through fresh conquests, passing affairs in which, in his bewilderment, he even went so far as to propose marriage, without conviction and without success. These successive liaisons involved Gaby Lapeyre (later Madame de Lespinasse); Irène Lagut, his neighbour and devoted confidante in the Rue Schoelcher, where he had set up home with Eva in 1912; Elvira Paladini (familiarly known as You-You); and a certain Emilienne Pâquerette, a fashionable model, who found in Pablo the ideal man to set off her image of a woman in the public eye. He managed to juggle these four affairs, more or less simultaneously, all through 1916 and into early 1917.

In October 1916, he moved from the Rue Schoelcher and went to Montrouge, fleeing the memory of Eva, which obsessed him. He was then a sedulous regular at La Rotonde, the fashionable bar since intellectuals and artists had migrated from Montmartre to Montparnasse. There he made new friends, such as Marie Vassiliev and especially Jean Cocteau, a frenetic young society poet whom he met at the end of 1915, and who opened up new horizons to Pablo's life and work. The future author of *La Machine infernale* was ideally placed to give him the entrée to high society. Cocteau, enthusiastic about his new friend and so demonstrative that he hoped – in vain – to be painted as Harlequin, introduced Pablo to Eugenia Errazuriz.

Born in 1860, Chilean in origin, Madame Errazuriz was a celebrated figure in Parisian society and a patron of cultural life, in which Sergei Diaghilev, the 'creator' of the Ballets Russes, was one of the key figures. She acted as a guide to Pablo, whose mother tongue she spoke, and introduced him into refined, cosmopolitan circles. Thus Pablo made the acquaintance of Count Etienne de Beaumont, who, together with his wife, was a leading figure at the most notable festivities in Paris. In October 1916, the couple invited him to the memorable 'Soirée Babel', which they had organised.

A new life was beginning – Pablo's 'duchess period', as his comrade Max Jacob called it.

OLGA KHOKHLOVA

(1891-1955)

Early in 1917, Cocteau persuaded Pablo to work on the scenery of *Parade*, a ballet in one act, of which he was the author. For this project, he wanted to assemble all the artists who were the most prominent at the time: the composer Erik Satie, the choreographer Leonid Massine, Sergei Diaghilev's Ballets Russes, Pablo Picasso for the scenery and costumes, and himself, of course.

It was the electric shock treatment that Pablo had been waiting for, having sunk for several months into a life that seemed to him devoid of interest, either emotionally or artistically. He went to Rome to join Diaghilev and his dancers. Among the company, he met a young dancer, twenty-six years old, Olga Khokhlova. According to Michael C. Fitzgerald, 'she was not a neophyte in the world of theatre. After joining the Ballets Russes in 1911, at the age of twenty, she took part in the first shows put on by Diaghilev under his own name. The daughter of Stéphane Khokhlova, a colonel in the Imperial Army, and Lydia Vinchenko, she had already worked at St Petersburg in the school of a highly respected ballet teacher, Yevgenia Pavlovna Sokolova, but in 1911, it was her first professional engagement.'[15]

As one biographer has followed another, reservations have accumulated about Olga, drawing a caricatured portrait of the young woman. No one in Pablo's amorous career has excited as much controversy as she has. There are very few direct testimonies about her, and those that exist describe either a cold character, without much further comment, or else an explosive personality. She was certainly a product of her education, hemmed in with rules and constraints. The violence of their separation, in 1935, intensified by the 'official' aspect of the divorce proceedings, has tarnished her image in retrospect, so that it tends to be forgotten that their relationship was happy to begin with.

Was it her reserve and her good manners that attracted Pablo? Was it her Russian origin, a paradoxical blend of Bolshevik revolution, exciting as that was, and Tsarist empire in dramatic collapse? Olga is a mystery, in herself and in what she represents. It matters little that she was not the dancer she had hoped to be: she had other aspirations, which she could only attain through Pablo. For his part, he had artistic aims that she would help him to achieve. Through their apparent contradictions, they complemented each other.

Overleaf: Picasso during the execution of the curtain for the ballet Parade, *Rome, 1917.*

Curtain for the ballet Parade, *1917, distemper and oil paint, 10.5×16.4 m, Musée national d'art moderne, Centre Georges Pompidou, Paris.*

Pablo followed the company to Paris, Madrid and lastly Barcelona, where he introduced his new conquest to his mother, who strongly advised Olga not to marry her son. 'I do not believe that any woman could be happy with him,' she is said to have told her. And Abuelita (Picasso's 'little grandmother') echoed Doña María's words to her darling son, telling him that he should not on any account marry that woman.[16] Meanwhile, Diaghilev was insisting to Pablo: 'A Russian woman – you must marry her!' Pressure from all directions.

All this time, Pablo was practising his usual subtle game of seduction on Olga, with painting as his ultimate weapon. In Barcelona, the Russian Olga adopted a Spanish look and wore a mantilla. Her portrait, in pointillist technique, seems like a proposal of marriage. Executed to integrate Olga into the Spanish family, the portrait satisfied the sitter and Doña María, who kept the work in Barcelona.

The 'Olga period' is marked by a return to neoclassical style. In Rome, Pablo had been dazzled by the historic city, the monumental architecture and the statuary. The majesty of the setting and the simplicity of Latin life harmonised to perfection in his eyes. He was also fascinated by the ruins of Pompeii. Traumatised by the death of Eva, weary of dead-end affairs, he was regaining a taste for a life of peace, bringing rest for heart and soul. He was surrounded by talented people, and the fine weather and prevailing good humour were favourable to inspiration. His creative work with Diaghilev and the campaign to seduce Olga stimulated his enjoyment of life. It was a renaissance; a new life!

Did his return to the family in Barcelona not mark the close of his life as a young man? Was it not time to start a family? Olga was hungry for a bourgeois, high-society life, such as she had been educated for. When the company left Barcelona, she chose to stay with Pablo, giving up her career for a more promising woman's life (though she would actually take part in a few more performances, the last one in 1922). At the end of November 1917, the couple settled in Montrouge, in Pablo's studio. Olga took the household in hand. Henceforth, order and civilisation reigned. No more bohemia, the fertile muse, from now on held to be *non grata*. Furthermore, the revolution had just broken out in Russia. Olga realised that she would never see her native land again: she too was now an émigré.

The world of the 1920s had changed for good in the wake of the First World War, the Bolshevik Revolution, artistic revolutions and, in parallel, the upheaval in French morals and society. Olga dreamed of a world that no longer existed. In her eyes, Pablo was a man who rivalled Cocteau and Diaghilev in elegance, and he was paying court to her. It was an image that matched her code of good manners. She knew nothing of all the rest, in particular the mechanics of his creative genius and his inner sufferings.

It must be admitted that Pablo was curious to get to know high society, and he seemed prepared to make the same sacrifices as many other men to win a high-class young

woman. In any case, he made the attempt. Right from the start of their entirely proper relationship, he undertook to portray Olga with all the respect that she demanded: first and foremost, she wanted to recognise herself. The portraits show her as thoughtful, almost absent, with notably regular features. Picasso had cleaned up his life; he had almost cleaned up his art.

Pablo and Olga were married on 12 July 1918, against the backdrop of the last deadly convulsions of a world war, at the Russian church in the Rue Daru. The witnesses were Jean Cocteau, Max Jacob and Guillaume Apollinaire.

The euphoria of the wedding, however, did not last long. Even during the first few days of the honeymoon in Biarritz, in the house of his dear friend, Madame Errazuriz, Pablo did not display the enthusiasm to be expected of a young husband. Had he committed the error of not being alone with Olga, just the two of them? During this supposedly nuptial stay, Eugenia introduced him to his future dealers: Georges Wildenstein and Paul Rosenberg (brother of Léonce, another dealer, with whom Pablo had already worked). But he was bored. He wrote to his friends in a confused way, he sketched, he decorated a bedroom in the house – nothing very exhilarating. In a letter to Apollinaire, he made the admission: 'I'm not very unhappy.'

Back in Paris, Olga and Pablo looked for a new flat. Olga wanted to entertain, and the accommodation in Montrouge, although now clean and tidy, was no longer suitable – not sufficiently respectable. Paul Rosenberg found the ideal location at 23, Rue La Boétie in the 8th arrondissement of Paris, just next door to his luxurious gallery. This area, the Champs-Élysées district, was already prestigious, with its shops selling furs, its art galleries and its town houses. After Montmartre and Montparnasse, Pablo found himself surrounded by creative people with established reputations and money in the bank.

The flat underwent major conversion work, which took so long that Olga persuaded Pablo to take up residence in the interim in the Lutetia hotel, Boulevard Raspail, 8th arrondissement – still close to Montparnasse and Saint-Germain-des-Prés, on the left bank of the Seine, but also adjoining the wealthy private town houses of the 7th arrondissement. In this way, she managed to distance him a little from his artist friends. 'Pablo's taken to the posh districts,' they would say, resentfully.

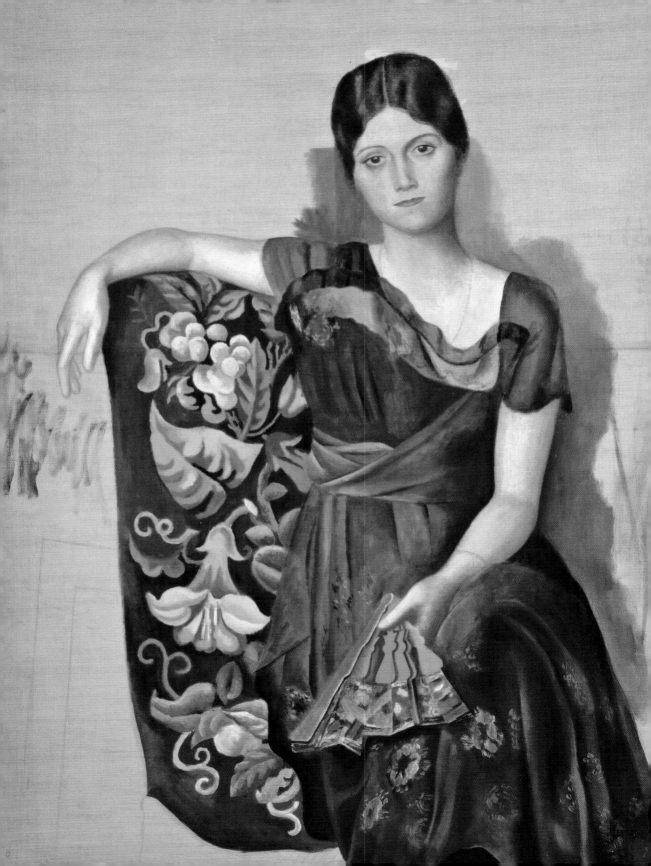

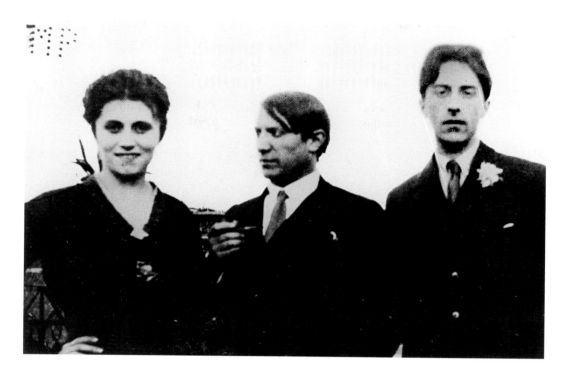

Once they actually moved into their own place, however, Pablo decided to rent the apartment on the fourth floor, just above, and make it into his studio. In this way, he could divide his time between the immaculate reception rooms, richly decorated by Olga (the same that had taken Cecil Beaton, the photographer, by surprise), and the studio, where he could organise, or rather disorganise, his 'bohemia' as he liked – and, for a while, reconcile their respective aspirations. Nevertheless, little by little, high-society life gained ground. Dinners were succeeded by soirées and galas, while Pablo tried to get on with his work.

At the beginning of 1919, he went to London with Olga. They stayed there nearly three months, so that Pablo could work on the backdrop for a new ballet, *The Three-Cornered Hat*, with Diaghilev and Massine. They were continually invited everywhere. Pablo was not impervious to all the praise and the siren songs of fame. And Olga accompanied his triumph with elegance.

In August, they went down to the fashionable resort of Saint-Raphaël, on the Côte d'Azur. In February 1920, Pablo created the scenery and costumes for *Pulcinella*, presented by Diaghilev the following May at the Paris Opera. He was now exhibiting his canvases at Paul Rosenberg's gallery, earning a more than comfortable income. Daniel-Henry Kahnweiler, back in Paris after the war (France had seized his collections during the conflict as 'enemy property'), opened a new gallery in the Rue d'Astorg and immediately invited him to exhibit his work there. Pablo seized this opportunity to put his two dealers in competition with each other. This manoeuvre would ensure that his fame and income grew constantly. Rosenberg had the advantage because, with his associate Wildenstein, he could promote Pablo's work in the United States, whence his subsequent universal success.

Portrait of Olga in an Armchair, *autumn 1917, oil paint on canvas, 130×88.8, Musée national Picasso-Paris.*
Olga, Pablo and Jean Cocteau in Rome, 1917.

The couple returned to Saint-Raphaël the following summer. And then Olga found that she was pregnant. At last! This happy event gave the couple a new lease of life. Pablo regained his vigour and creativity – and also his affection for his wife. The birth of a son, Paul, on 4 February 1921, constituted a new milestone for him, now a father in his fortieth year. Olga's pensive face in his canvases became that of a mother absorbed in her child. All the force of Picasso's artistic quest was channelled into tenderness. Numerous *Mother and Child* works came into being, especially in July 1921, when the couple settled in Fontainebleau with their baby. In the figure of Olga, he suggests an unsuspected dimension, deformed but sublimated. While her features are transmuted, it is the intensity of their emotions that he lays down on the canvas. The influence of his travels, especially to Rome, of solidly built dancing girls, of the bathers that he had seen at the seaside and who reminded him of those in the bathing

huts at La Coruña in his childhood, added to Olga's pregnancy, inspired him to depict statuesque figures. It was his 'giantess period'. He was also disturbed by the works of Renoir's last years, of which he saw many at Rosenberg's: generously proportioned aberrations explored by the impressionist painter, which Pablo indirectly adopted, too. Renoir's women conserve their colours; those of Pablo are austere and pensive. In this way, he establishes a link between classicism and modernism. He was entering an artistic dimension that sounded the death knell of his cubist period and, at the same time, the bohemian period of his life.

In July 1922, while staying in Dinard with Olga, his work developed towards a more strongly defined 'representation of movements'. 'These deformed figures playing with a ball or a skipping rope inhabit the joyful, free atmosphere of a beach.'[17] The psychological aspect of the portraits was enhanced, and he found a greater diversity of sources of inspiration. The face of Olga faded away.

When the couple returned to Paris at the end of the summer, Pablo created the scenery for the free adaptation of *Antigone* by Cocteau, performed at the Théâtre de l'Atelier. On her part, Olga continued to organise their social life, involving her husband more and more. Pablo was not impervious to the charm of these soirées, all through the Roaring Twenties, which saw the beginnings of the reconstruction of Europe and the simultaneous rise of

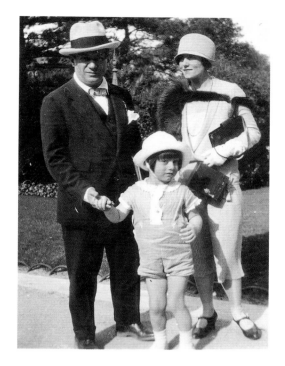

different kinds of fascism. And among the habitués of these amazing parties were future clients. The soirées continued, though doubtless losing their attraction.

At one of these social functions, Pablo met Gerald Murphy and his wife Sara, rich Americans from Boston. He was a painter, she a dazzling socialite. Picasso found her very beautiful and particularly good company. He met the couple again at Cap d'Antibes in the summer of 1923, at the Hôtel du Cap, open at that time in the summer – where Doña María, on her first visit to France, had the opportunity to see how respectable her son had become. Pablo's eccentricity appealed to the lovely Mrs Murphy. The pair were also living in Monte Carlo, and beautiful photographs immortalise an elegant couple and their little boy.

That summer, Pablo worked on different studies for *Women Bathing*, painted *The Pipes of Pan* and once more portrayed Olga, pensive, distant... What, we may wonder, was she thinking about? Could it be what she had dreamed of and never had, or what she still hoped might come her way?

At the same time, Pablo was persevering with his work on photography. For several years, he had taken an interest in this technique, analysing the way a print reproduced reality, with the variations in shades of grey and the impression of depth that it recreated. Images of Olga, their son Paul, Diaghilev and, a few years earlier, Apollinaire, are thus fixed in silver salts, and then reproduced, from their photographs, in paintings or drawings.

In the course of 1924, Pablo worked on Leonid Massine's ballet *Mercure*, then on Serge de Diaghilev's *Train bleu*: altogether, since 1916, he had taken part in eight theatrical or dance productions. *Mercure* caused a scandal again, as *Parade* had done. Pablo, even after 'settling down', was an inveterate subversive, to the delight of the most radical intellectual movements – first and foremost, from 1920, the dadaists. These anarchists of the creative act, and even simply their name, appealed to Pablo, reminding him of his own dissenting youth in Barcelona. The dada group, led by the poet Tristan Tzara, numbered eminent activists in its ranks, such as Paul Eluard, Louis Aragon and André Breton, and the painters Francis Picabia and Max Ernst. However, despite their admiration for Picasso's paper collages, they believed, mistakenly, that he was practising 'commercial' cubism. The misunderstanding probably arose because of the time-lag with which Kahnweiler presented the works to purchasers. The public was behind the times.

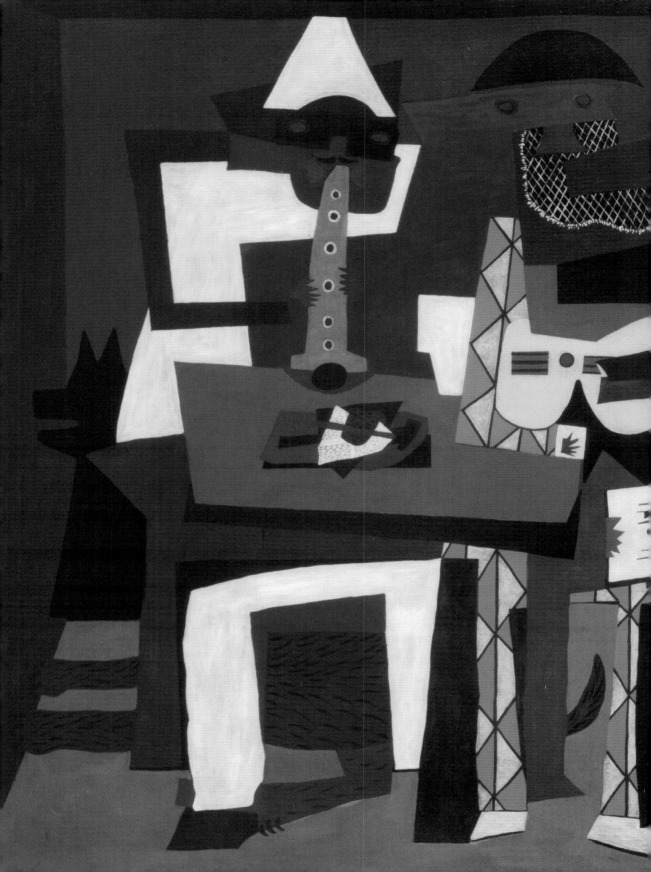

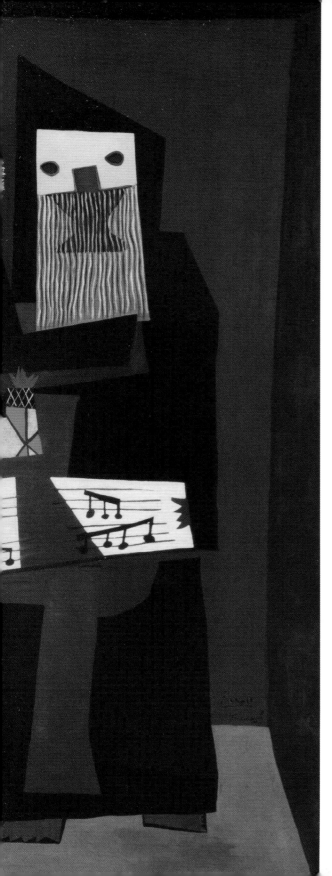

On the other hand, the ballet *Mercure*
provoked lively protests from the surrealists,
who had recently split from dada under the
leadership of Breton – this time, against the
soirée held by the Comte de Beaumont in
aid of Russian refugees who were enemies
of the Bolshevik Revolution, rather than
against Picasso's scenery, which accorded
with their own artistic conceptions. Indeed,
in June 1924, the surrealists *en bloc* paid
tribute to him to dissociate him from the
Mercure scandal: was Picasso not himself
the forerunner, the man who had been
the first, with his cubism and collages,
to liberate himself from the mechanical
processes of academicism?

In the course of the summer, at Juan-les-
Pins, Pablo enjoyed himself again painting
little Paul, who was now known as Paulo,
wearing different costumes – tempted for
the last time by classicism. But the surrealist
wave had conquered Pablo. In the view of
André Breton, 'the most cherished aim of the
surrealists, now and in the future, must be the
artificial reproduction of the ideal moment in
which a man is prey to a particular emotion'.
Pablo, who shared this point of view, put
it into practice in the new approach to his
work. The appearance of objects and people
is expunged. He came back to the thinking
of his late lamented friend, Apollinaire – the
inventor of the word 'surrealist' in relation to
the ballet *Parade*.

In 1925, Olga, Paulo and Pablo set off again
for the Côte d'Azur, in a ritual that had lost
its charm. Even Olga seemed to be forcing

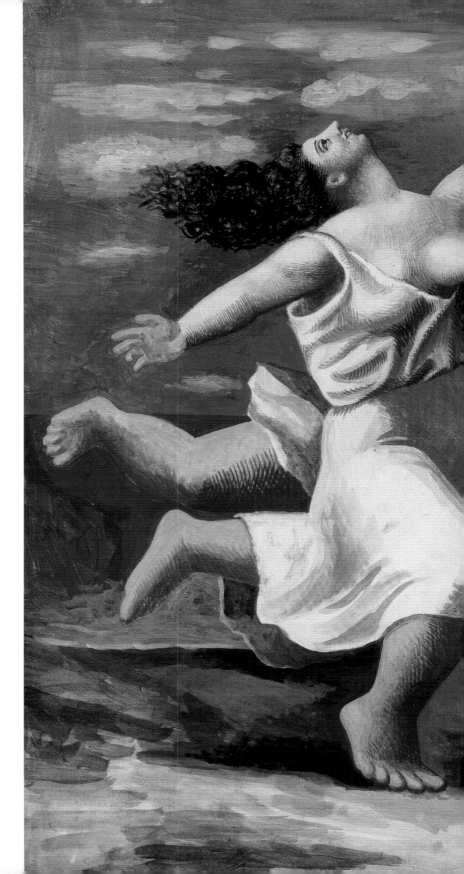

Two Women Running on the
Beach (The Race), *summer 1922,*
Dinard, gouache on plywood,
32.5×41.5, Musée national
Picasso-Paris.

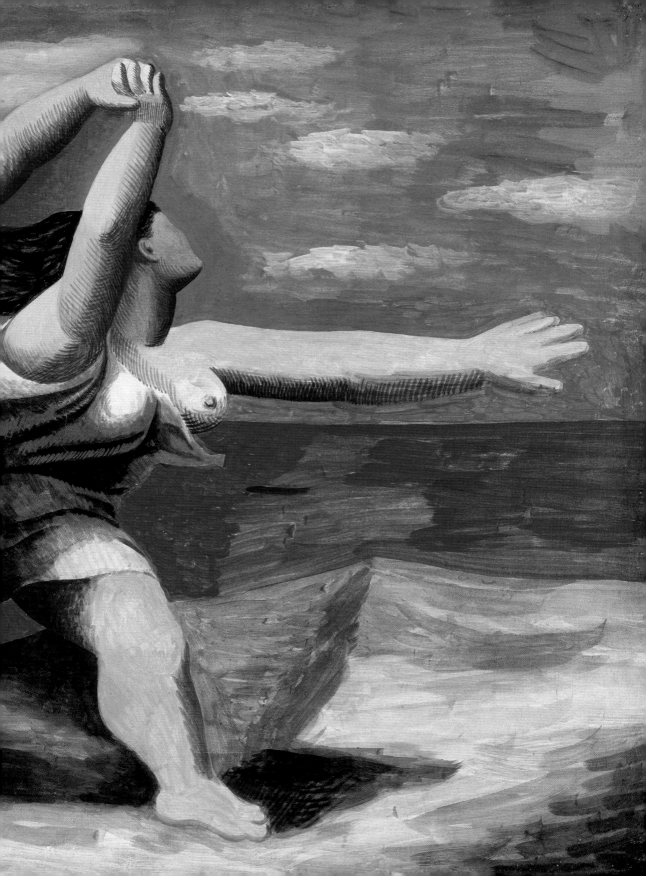

herself. The soirées resumed, as if inexorably, most often in Monte Carlo. Pablo's interior conflict was worsening. He had considered the matter from every angle and come to the conviction that he was wasting his time while an artistic and intellectual revolution was underway, elsewhere, without him. Life with Olga was deteriorating. She was well aware that she was losing her husband. There were no more smiling family photographs. She wished that Pablo would take an interest in her again. But was it too late? Quarrels had become a daily occurrence. Instead of seeking the reasons for their dissensions, Olga simply rejected them. They were beyond her comprehension. In the autumn of 1925, in spite of an earlier decision never to take part in group exhibitions, Pablo agreed to exhibit in the first surrealist show at the Galerie Pierre in Paris. The couturier and collector Jacques Doucet lent his *Demoiselles d'Avignon*, which he had purchased in 1916[18] – now considered the mothers of all modern art, although they had been painted in 1907. At the exhibition Picasso met numerous new artists; he had once more become a 'contemporary'. A brilliant stroke, he finished *The Three Dancers*, today in the Tate Modern in London, a very large canvas, which marks the definitive breakaway from his neoclassical period. There followed *The Kiss*, a scandalous and extremist erotic work, indecipherable and yet quite unequivocal, which he would keep all his life.

At this point he made a complete break with his years of socialising, not because he had not appreciated them in the past, but because he felt weakened, almost castrated by them.

In January 1925, a young man, Christian Zervos, created an independent review of modern art, *Les Cahiers d'Art*, devoting his first studies to Pablo. He proposed to compile a critical catalogue of the latter's oeuvre. This was the start of an ongoing dialogue between them, with an almost weekly session taking photographs of past pieces and works in progress. Zervos went on taking photographs unremittingly until his death in 1970. The fruit of these painstaking labours was thirty-three volumes of capital importance, without precedent in the history of art. And yet it does not include the whole of Picasso's output!

For the summer of 1926, Pablo, Olga and Paulo went to stay in Juan-les-Pins with a cook and a housekeeper. They rented a villa there, La Haie Blanche. The couple, despite their disintegrating relationship, still answered the call of Riviera high society. The following October, the little Picasso family went to Barcelona again. But these few weeks of Catalan seclusion convinced Pablo that a change in his life had become essential. In the seething political context of the time, with the Spanish military dictatorship, European fascism smouldering and communism spreading, Pablo was no longer a revolutionary, but a sleepy, forty-five-year-old bourgeois.

The Pipes of Pan, *summer 1923, oil paint on canvas, 20.5×17.4, Musée national Picasso-Paris.*

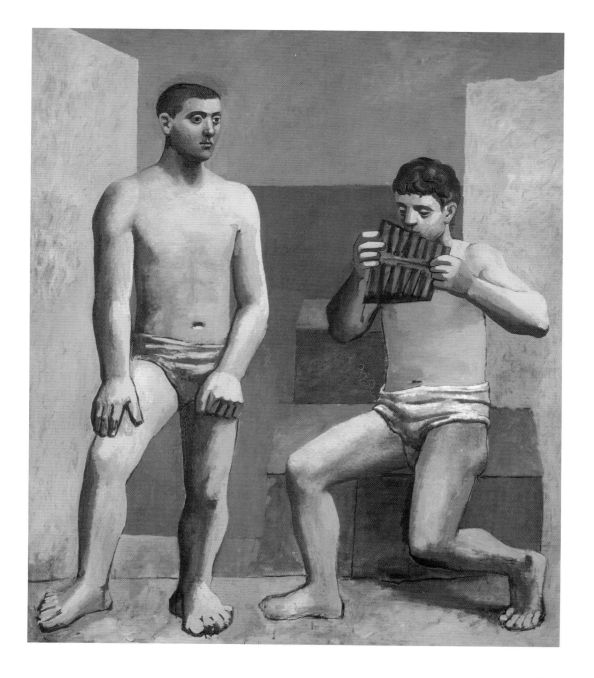

Marie-Thérèse on the beach at Dinard, August 1928.
Face of Marie-Thérèse in Profile, 1931, oil paint on canvas and charcoal, 111×81, private collection. This work was used for the cover of the catalogue of the Picasso Black & White *exhibition at the Guggenheim Museum, New York, in the autumn of 2012.*

MARIE-THÉRÈSE WALTER

(1909–1977)

On Saturday 8 January 1927, in the late afternoon, Pablo noticed a girl through the shop window of the Galeries Lafayette. He watched her, waited until she came out, then accosted her with a big smile. 'Mademoiselle, you have an interesting face. I would like to paint your portrait.' He added, 'I'm sure we shall do great things together. I'm Picasso,' pointing, by way of introduction, at a large book about himself in Chinese or Japanese. 'I would like to see you again. I'll meet you at 11 o'clock on Monday in Saint-Lazare metro station.'[19] Marie-Thérèse Walter, my future grandmother, had just met the man of her life.

And Picasso had just been reborn. She had not the slightest idea who this Picasso might be, but she noticed his superb red and black tie – which she would afterwards keep all her life: 'In the old days, young women didn't read the papers. Picasso meant nothing to me. It was his tie that interested me. Besides, I found him charming'. Marie-Thérèse would also treasure a little calendar of 1927 in a red leather Hermès case, together with some locks of Pablo's hair and a self-portrait that he had drawn on a small sheet of paper, which confirms the highly symbolic value that he attached to the year 1927.

Marie-Thérèse kept the appointment. The peculiar 'gentleman' was there all right. 'I turned up just like that, by chance, because he had a lovely smile,' Marie-Thérèse would relate half a century later. 'He took me to a café, then to lunch, and then to his studio; he looked at me, he looked at my profile, he looked at my face, and then I left. He told me: "Come back tomorrow." And

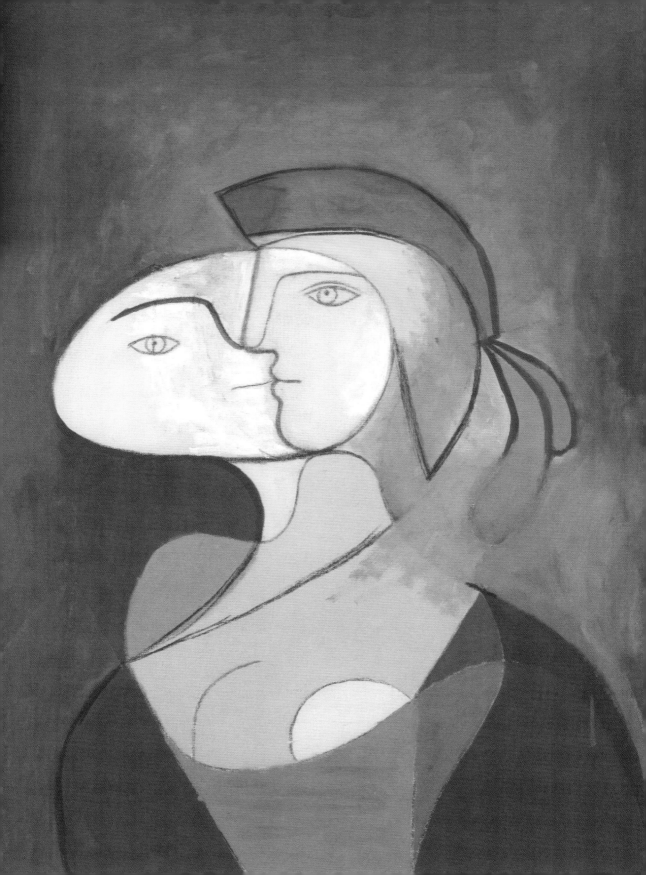

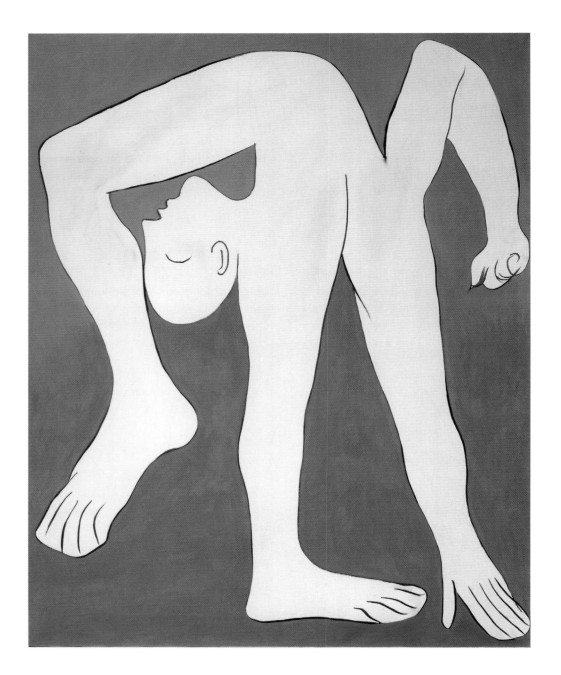

after that, it was always tomorrow; I told my mother I was going to work.' They started a conversation which was renewed every day. My future grandfather prudently went to fetch Marie-Thérèse from Maisons-Alfort. He quickly won the approval of Marguerite, Marie-Thérèse's mother, who was reassured by this gentleman's courteous manners. She simply went to pose in the studio in the Rue La Boétie, the 'no man's land' where no one ever went. Even Olga did not go up there. As Marie-Thérèse would repeat: 'I didn't take the liberty of poking about, but there was such a mess'. Pablo started by painting her portrait in the classical manner. He told her that she had 'saved his life', which Marie-Thérèse scarcely understood. She had not yet come of age, and Pablo had to do his best to conceal this liaison, which in legal terms was the criminal offence of 'abducting a minor'. So, despite their burgeoning passion, they waited for her eighteenth birthday (the first stage in coming of age) to consummate their liaison. Pablo went back to his conjugal home in the Rue La Boétie every evening. Olga asked no questions, and, although her husband's absences were increasingly frequent and he returned late, she contented herself with his announcement, 'I'm going out!' or a simple 'Good night!' As long as he came back, honour was satisfied.

These interludes of happiness enabled my grandfather to bear the confinement of his life as a husband. He and Olga postponed explanations – pointless though this was. Olga sank into bitterness, Pablo into indifference.

Meanwhile he drew his sweet, tender Marie-Thérèse frenziedly. Superb drawings, though still anonymous, like those that illustrate *The Unknown Masterpiece,*[20] the fruit of his love which Olga, however, must never discover. Was it out of respect for his wife? Divorce did not exist in Spain: being Spanish in nationality, Pablo had no hope in that direction. Perhaps it might be possible to come to an arrangement.

Pablo tenderly intertwined his initials with those of Marie-Thérèse, just as he had done, as an adolescent, with those of young Angeles, and then those of Eva. This game with letters which often ended up in the shape of a guitar, amused him immensely. He regained the spontaneity of happy-go-lucky youth; he became a young lover again. Life with Pablo 'was absolutely exhilarating', my grandmother recalled. 'Covered with love, kisses, jealousy and admiration',[21] Marie-Thérèse was different from other young women because she was innocent and also because she had no connection with artistic circles. She was so young, compared with the experienced Pablo.

My grandmother was free of social ambition; it did not even occur to her. Slim and athletic, which was exceptional at that time, she rowed (a skiff), cycled and played ball (the well-known, heavy medicine ball, which was to inspire my grandfather so much); later, she would ride regularly, and then go climbing in Chamonix. She was fresh and spontaneous; not shy, but reserved; well brought up, but

The Acrobat, 18 January 1930, oil paint on canvas, 160×130, Musée national Picasso-Paris.

not 'educated' like the young women who, in those days, used to be trained in their social duties. And to crown it all, she was completely free of self-interest. She was the embodiment of a purity which Pablo had sensed immediately. Pablo, finally, was himself. He no longer cheated.

So, in perfect serenity, my grandfather discreetly constructed the nest he had so long dreamed of. 'My life with him was always secret,' Marie-Thérèse relates. 'Calm and peaceful. We said nothing to anyone. We were happy like that, and we did not ask anything more.'[22] The artist could devote himself to his art, with no financial worries, and with a model for himself alone. The lovers were cut off from the world in an ivory tower, where Pablo, to tell the truth, controlled everything. He isolated his carefree muse, who would pay the price, but he recreated his famous lost paradise.

The experts agree that this 'Marie-Thérèse period' generated drawings and engravings of exceptional force, both in their subjects and in the emotions that inspired them. What he records on paper or canvas is not the character of Marie-Thérèse, which would tend to suggest soothing repose. The first things she brought to Pablo were a face and curves. As she admits quite frankly, the ritual was unchanging between the man, the woman, the model and the artist: 'First he violated the woman, as Renoir put it, and then we worked.'[23] An accommodating lover, she gave her malleability to the work, happily metamorphosing into a child, a modest young girl, a woman convulsed and abandoned to the ardours of a god now human, now bestial.

Won over by the inspiration that she aroused, Marie-Thérèse nevertheless remained detached from it. She had never heard the word 'cubism'. She admitted it quite spontaneously even at the end of her life. The world of the artists of Montmartre or Montparnasse, the cubists, the surrealists, this little world of the privileged, of intellectuals or rich socialites was something in which Marie-Thérèse had no part. She had boundless admiration for Pablo. She knew nothing of Picasso.

As Marie-Thérèse quietly emerged from secrecy, between 1927 and 1931, Olga, the serene wife of the early portraits, was transformed into a Dido screaming with fury. In this way, she provided another sort of inspiration for Pablo, in a brief sequence of works in which he translates the violence of their confrontations. However, although these disputes may have stimulated him on the artistic level, they no longer concerned him emotionally. His passion was now elsewhere. Summer 1927, Dinard. Olga and Paulo play near the family beach hut, not far from another hut rented by Marie-Thérèse, who is staying in a family guest-house. All Pablo has to do is take a nonchalant stroll along the beach to move from one world to the other. They will all come back again the next two summers!

In 1928, in connection with a projected monument to pay tribute to his friend Apollinaire, who had died ten years

previously, Pablo at last came back to sculpture, which he had given up in 1914. He took advantage of the offer of the sculptor Julio González, whom he had met at the Quatre Gats in Barcelona, of advice and a studio in Montparnasse. These four little projects for 'a statue made of emptiness, of nothing', as Apollinaire himself had suggested, awakened in Pablo the desire to work with solid matter. His experiments in monumental painting after his trip to Italy found nourishment, in Marie-Thérèse's sturdy curves and the oval of her face, for a new creative experiment.

In May 1930, he bought the Château de Boisgeloup, in Gisors, near Paris, for the work spaces that he saw in its stables and outbuildings, and with the idea of making it, in due course, the residence of Marie-Thérèse. Destiny had other plans.

He was now in a position to devote himself to monumental sculpture and painting in turn, and to explore all their possible interrelations. This would give rise to busts, imposing heads of women and a series of portraits (including the extremely well-known *The Dream*[24]), which Marie-Thérèse illuminates with her blond hair and peaceful curves.

July was spent as a family, with Olga and Paulo, in Cannes, according to their melancholy routine. In August, Pablo left Cannes, on his own, and went to pick up Marie-Thérèse, set up secretly in Juan-les-Pins, to take her to his native land in the Hispano-Suiza bought at the 1927 motor show. Spanish journalists spotted him but, oddly, did not notice the presence of Marie-Thérèse.

Back in Paris, he took the plunge. He rented a large flat at 40, Rue La Boétie, where he installed Marie-Thérèse, very near the conjugal apartment. She had now come of age, and there was no more risk of criminal proceedings.

Inexorably, the time to put his cards on the table drew near. For Pablo, 1931, the year of the Great Depression that was now affecting Europe, after the stock market crash of 1929, was not remarkable for any particular event; just the slow, sad disintegration of his marriage, and the increasing hold that Marie-Thérèse had over his inspiration, in all artistic disciplines. As Pierre Daix writes, 'never before had Picasso thus sung the praises of a woman'.[25] And, strangely, nobody seemed aware of the way the artist was now focused on a single muse. Another instance of that commercial time-lag practised by the dealers Rosenberg and Wildenstein, both focused on the artist's cubist period.

In Spain, however, political events had come to a head. In an unsophisticated kingdom with nearly 25 million inhabitants – a third of them illiterate and living in poverty, with the

Overleaf: Minotaur Caressing a Sleeping Woman, *18 June 1933, drypoint, 22.9×36.5. Vollard Suite, leaf 93 (2nd and last version), Kunstmuseum Pablo Picasso, Münster.*

Museum director Markus Müller confirms that 'Picasso is far and away the most prolific engraver of the twentieth century. Black and white and the art of drawing are his true areas of genius. The Vollard Suite is a perfect synthesis of the different stylistic movements of the 1930s and the artist himself who reveals the image of the minotaur in the context of his own personal mythology.'

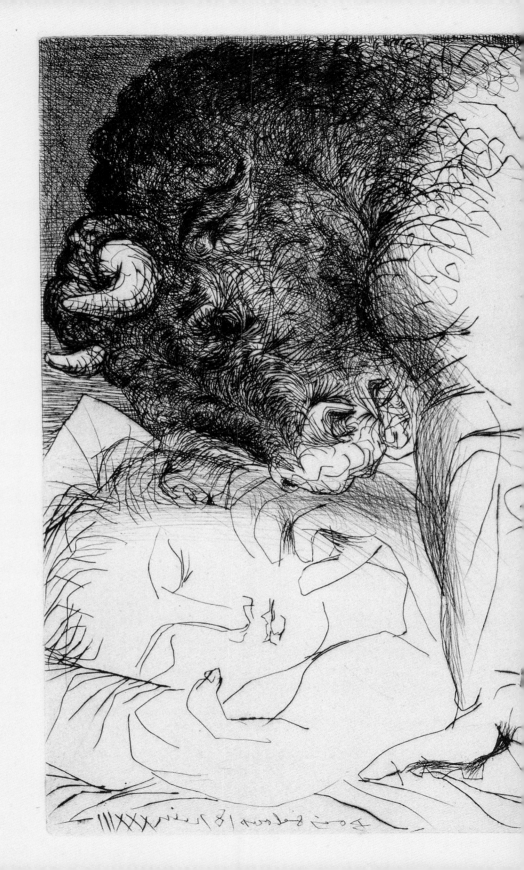

clergy playing a dominant role – monarchists and Republicans confronted each other. King Alphonse XIII and his prime minister, the successor to General Primo de Rivera (who had imposed himself in 1923 after a *pronunciamiento*, a sort of constitutional coup d'État), organised municipal elections on 12 April 1931. The anti-monarchist Socialist and Republican coalition won, took power and, without abolishing the monarchy, proclaimed the Spanish Republic. The King preferred to go into exile, believing that this would avoid a civil war. The Army and the Church, supported by the Pope, rallied around the new government, and the general elections on 28 June the same year resulted in a landslide Republican and Socialist victory. A highly progressive new Constitution was promulgated: in particular, it instituted votes for women and soldiers, reorganisation of the school system and land redistribution, and the legalisation of divorce by mutual consent. All these events would be important in Pablo's life.

In the autumn, he plunged himself into feverish preparations for a major exhibition the following year, which he expected would bring him well-deserved recognition and, probably, would get him even with his friend Matisse, now at the height of his glory, especially in the United States. 1932 was in fact the year of the most important retrospective ever devoted to the work of Picasso. Although it was largely organised by the Bernheim brothers, it took place in the Galerie Georges Petit, between 16 June to 30 July. For this exhibition, Pablo assembled two hundred and twenty-five canvases from all his 'periods', including his blue period and even earlier, right up to the latest portraits of Marie-Thérèse that he had not yet shown to anyone. He also included seven sculptures and six illustrated books. The leading collectors lent the works in their possession without hesitation. They now represented the avant-garde of modern art, faithful disciples with Rosenberg and Wildenstein as their prophets and Picasso their god. It was the cultural event of the season in Paris and an unprecedented social event. Pablo did not attend the inauguration evening.

It was at this time that he met Brassaï. This Hungarian photographer came to take pictures in the studio at the Rue La Boétie and later in December of the incredible, completely unexpected store of sculptures produced at Boisgeloup.[26] Apart from the occasion when these historic photographs were taken, most of these sculptures would not be seen again until the inventory of the Estate in 1974 (with the notable exception of a selection exhibited at the Paris retrospective in 1966 at the Petit Palais). The early summer of 1932 was spent at Boisgeloup, equipped with the basic essentials for Olga and Paulo, so as to avoid the traditional seasonal migration to the Côte d'Azur with full accoutrements and

Nude, Green Leaves and Bust, 1932, oil paint on canvas, 162.1×130, private collection. This large painting representing Marie-Thérèse was shown in 1932 in the retrospective at the Galerie Georges Petit, which revealed to the public a large number of portraits of an unknown blond young woman in a new style made up of curves and sensuality.

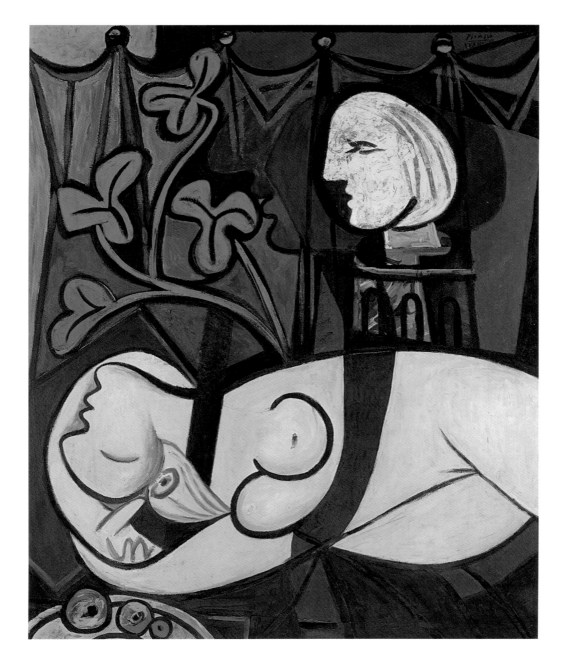

all the painting materials. Pablo did not want to be under any more constraints or to leave his studio. By this artistic 'miracle', Olga found herself, for a few short weeks, back in a situation of intimacy, the product of circumstance, even pictured by Pablo himself with his camera; but it would go no further. Cloistered far away from her Paris habits and the amusements of the Côte d'Azur, she vowed that she would never repeat the experience: in August, she left on her own with Paulo, for Juan-les-Pins. Meanwhile, Pablo shuttled to and from Paris. His double life was well organised.

In the summer of 1933, Olga, Paulo and Pablo went to Cannes again, and then on to Barcelona. This family trip was almost an official visit: Pablo had become a celebrity, honoured by the whole town as a famous son of Catalonia. In any case, Olga, now famous herself by the side of her illustrious husband, enjoyed the outward show, and especially the pomp and ceremony. But the storm was brewing. Pablo got Marie-Thérèse to come in secret and installed her in a nearby hotel, invisible and essential. And once back in Paris, he started, for the first time, to investigate the possibility of divorce, consulting a leading Parisian lawyer, Maître Henri Robert, since divorce was now permitted by the recently established Spanish Republic. Olga had completely vanished from his work. Marie-Thérèse was everywhere, in drawings, engravings, paintings and sculptures – including *Woman with a Vase,* which would be shown at the Paris Universal Exhibition in 1937, and

which now watches over Pablo's tomb in Vauvenargues.

Pablo set off again on a long journey through Spain in the summer of 1934, with Olga and Paulo. Marie-Thérèse followed. She still acquiesced in stratagems, but their correspondence shows that they had never been so close. Pablo even introduced his young mistress to his sister Lola.

In the autumn, in the chaos of his disintegrating household, with the fury of Olga, driven mad by his absences and, even worse, his silences, Pablo worked on illustrations and engravings in which the image of a little girl takes on oddly increasing importance, with the features of a Marie-Thérèse guiding a wounded Minotaur – an obsessive self-portrait, the prelude to the famous *Minotauromachy.*

Olga's suffering could no longer be borne. 'And then one day I found I was pregnant,' Marie-Thérèse would later recount. 'He fell on his knees, wept and told me it was the greatest happiness of his life.'

It was 24 December 1934. 'Tomorrow, I'll get a divorce,' he promised. He wanted to marry Marie-Thérèse, and now it was possible. He immediately set the proceedings in motion, to the despair of Olga who, although their marriage was on the rocks, did not want to divorce. They had got married with no contract, so they were subject by default to a communal estate settlement comprising moveable property

Portrait of Marie-Thérèse in a Red Beret, 15 January 1937, oil paint on canvas and charcoal, 55×46, private collection.

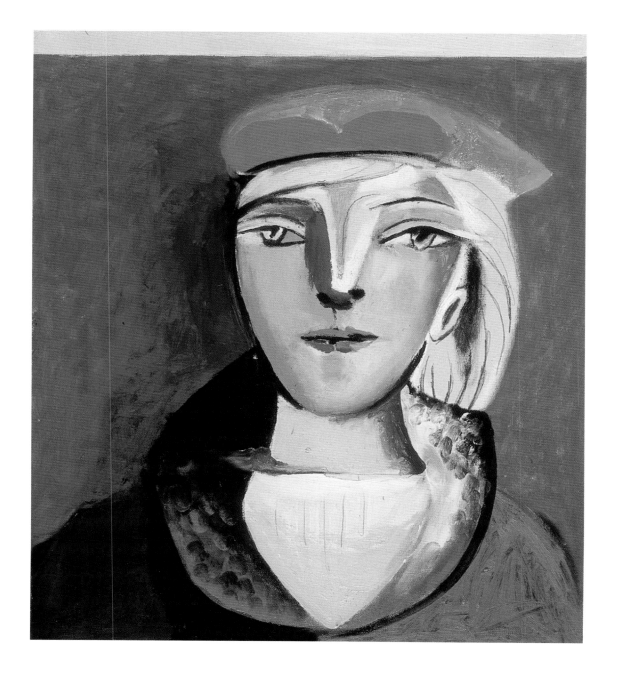

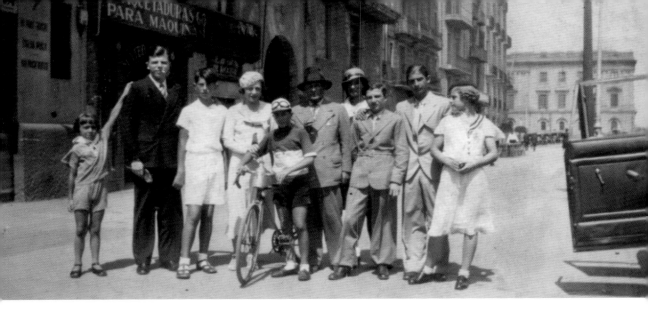

(which included the works of art) and assets acquired after marriage: so they had to submit to a division of property.

Marie-Thérèse and Pablo spent afternoons together in the Parc Montsouris, waiting for news from Maître Robert, who was officially in charge of the divorce. They were overwrought and anxious, too, because the pregnancy was progressing.

A non-conciliation order – the first step in the procedure – was issued on 29 June 1935. It authorised Pablo to pursue his petition for divorce and gave custody of Paulo to Olga. A bailiff immediately presented himself at the conjugal home to conduct the inventory of assets. Olga fainted.

She and Paulo left the apartment and went to stay in the nearby Hôtel California on the Rue de Berri, near the Champs-Élysées. The flat at number 23 was silent now. Pablo was alone. Marie-Thérèse's baby was due in less than three months. 'You realise, I have my freedom!' he announced. She did not ask him for anything.

On 5 September 1935, Marie-Thérèse gave birth to Maya. Pablo could not acknowledge her: the law prohibited it. But he stopped painting: he stayed with Marie-Thérèse and their daughter. 'He was with me all day,'

my grandmother recalled. 'He was the one that did the washing, cooked the meals; he looked after Maya; he did everything, except perhaps make the beds.'[27] He even washed the baby's nappies.

The divorce proceedings, which Pablo had hoped would be over quickly, got bogged down: Olga contested all the facts that he had cited to justify his petition. An official enquiry was granted to Pablo in April 1937 to establish the legal foundation of his grievances. Meanwhile, political events in Spain were taking their course, which did nothing to lighten the atmosphere. The failure of the Frente Popular, which had come to power in 1936 after an incompetent dissolution of the Cortès parliament, led to a coup d'État in July 1936. On 1 October, Franco was elected head of the government of the Spanish state by the military junta, which intended to take power. It was civil war.

On 20 December 1937, Pablo set up his new little family with Ambroise Vollard, at Le Tremblay-sur-Mauldre: 'Life in Paris was driving me mad,' Marie-Thérèse recounted. 'I couldn't stand it, I had no garden, I had nothing any more. I saw Picasso going out a little … I understood him. So I thought perhaps it would be better if I was in the country.'[28]

The complications surrounding his separation from Olga continued, while in the meantime, in March 1938, El Caudillo (or 'Leader') Franco had abrogated divorce in Spain by decree, and Pablo therefore had to be satisfied with an application for legal separation. On 15 February 1940, this separation was granted by the court, which awarded custody of their son Paul to Pablo, and nominated a lawyer to execute the division of property, ordering Olga to pay all the costs. Although France was now at war, and Pablo enjoyed neutral status by reason of his Spanish nationality, he applied for naturalisation: if he was French, he would be able to divorce. The application was refused: a record at police headquarters, dating from 1905, categorised him as an anarchist sympathiser!

Olga appealed against the decision of the court. Nevertheless, the Paris court of appeal confirmed the separation, finding that Olga 'made frequent violent scenes, rendering life impossible for her husband and preventing him from working or seeing his friends'. She lodged a further appeal, but the supreme court once more confirmed the judgement, on 5 January 1943.

With Olga's volcanic temperament, it is barely possible to imagine the scene if she had found out about Pablo's double life, but, incredible though it seems, Olga was still ignorant of the existence of Marie-Thérèse and Maya. It was not until after 1945, ten years after their separation, that she was told about it by her son Paul.

She must have been grateful to Pablo for this discretion, due to which she had still been able to hold her head high in the circles in which she moved. Olga was a woman of honour. She contented herself with being able thus to preserve her status as a married woman and keep up appearances. She never applied for the execution of the legal separation, and she did not initiate the procedure for the division of property to which she was entitled. She refused a fortune and lost her place in the Paris society. She remained lonely but still Madame Picasso.

Photo of the family in Barcelona, 1934. From left to right: Jaime, Juanín, Paul and Olga Picasso, Javier, Pablo, Lola (Pablo's sister), Pablín, Josefín and Lolita.

Pablo and his daughter Maya the day she was born, at the Belvédère clinic, Boulogne-Billancourt, 5 September 1935.

Pablo, Marie-Thérèse and their daughter Maya on the balcony at Boulevard Henri-IV, Ile Saint-Louis, summer 1942.

DORA MAAR

(1907-1997)

At the end of 1935, Picasso had been introduced to a young photographer, Dora Maar. She was an intellectual, a modern, independent woman, poles apart from Olga or Marie-Thérèse, who intrigued Pablo long before she seduced him.

For the moment, Pablo was devoting himself to Marie-Thérèse and Maya. It was with them that he went on three months' holiday, still in secret, in the spring of 1936, first to a hotel, then to the Villa Sainte-Geneviève in Juan-les-Pins. But the following summer, he sent them to Franceville, near Cabourg in Normandy – it was the fashion to give small children some healthy air – while he joined his friends Paul and Nusch Eluard in Mougins. They suggested an outing to Saint-Tropez, in those days a simple fishing port. There, visiting mutual friends at the Villa des Salins, he met Dora again.

Pablo told her about Olga and Paulo, and Marie-Thérèse and Maya. He was perfectly frank. Dora was playing with fire: they both enjoyed danger and its rewards.

Dora was the ideal complement to Marie-Thérèse. The latter was gentle and submissive, a little girl needing protection. Dora brought contradiction, perpetual uncertainty. One appealed to Pablo's sentimental kindness, the other to his violence. Pablo, a Scorpio with Scorpio

rising, would always seek to satisfy the two extremes of his sign.

His love-life was organised around Marie-Thérèse, a discreet, uncomplicated companion, furthermore fully occupied with their baby, and Dora, the experienced mistress, who felt that she was thus doing honour to her vocation of liberated woman. She also contributed to the political commitment of Pablo, who had renounced politics years before. Their affair took place during a period of international torment. Civil war raged in Spain; in France the Popular Front ran into fierce opposition; Mussolini was in control of Italy and carried

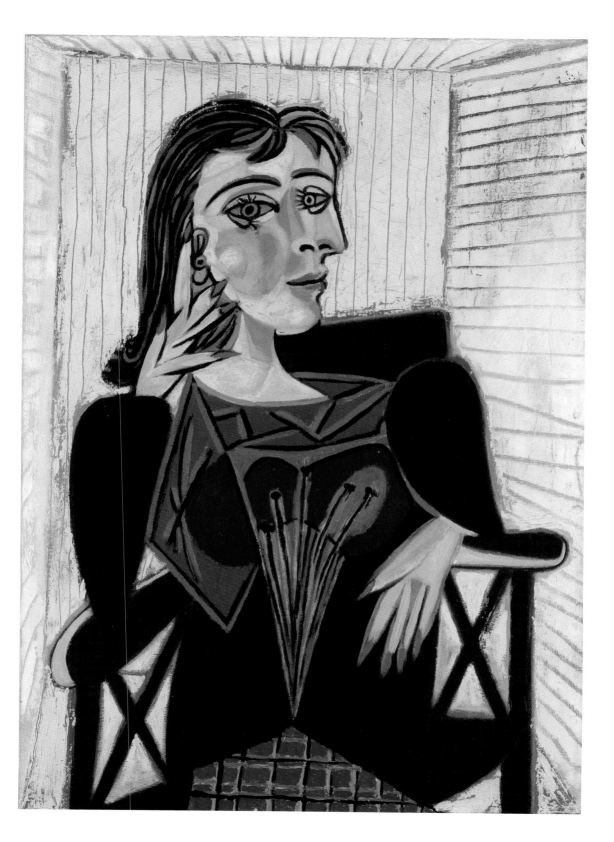

Honoré de Balzac's Le Chef-d'œuvre inconnu
(The Unknown Masterpiece), illustrated by Picasso,
published by Ambroise Vollard in 1931.

HONORÉ DE BALZAC

LE CHEF-D'ŒUVRE INCONNU

PARIS
AMBROISE VOLLARD, ÉDITEUR
28, RUE DE MARTIGNAC, 28
MCMXXXI

the war into Africa; Hitler's astounding rise continued.

A man of duality: Pablo kept my grandmother concealed, preserving the respectability of Olga, while parading publicly in Saint-Germain-des-Prés with Dora. In his work, Marie-Thérèse and Dora cohabit without difficulty. To the blond hair that had held the monopoly for many years was added the black of more elaborate styles. The agreeable soft curves of many a *Marie-Thérèse in an Armchair* are offset by the tensions in *Weeping Woman*. Pablo gives satisfaction to his duplicity: he even paints them, one after the other, in the same reclining position, in two canvases bearing the same date, 21 January 1939.

For a while, Dora considered moving in with Pablo, but she soon realised that it would be impossible to live in Olga's deserted mausoleum. Besides, Pablo had asked his old friend Jaime Sabartés to join him in Paris, and the latter had moved into the Rue La Boétie with his wife. Secretary and confidant, he was abreast of everything: the scenes and legal twists and turns with Olga,

the existence of Marie-Thérèse and Maya; he was the only person who knew about it all. He had got to know and appreciate Marie-Thérèse, and could not conceal his disapproval of Dora. No doubt he hoped that it was just a passing fancy.

But Dora was still living with her parents, in the Rue de Savoie, in the 6th arrondissement. She needed her own place. She spotted a studio to let close by, in the Rue des Grands-Augustins – the same in which Balzac is thought to have set the plot of *The Unknown Masterpiece*, which Pablo, by coincidence, had liberally illustrated. What 'objective chance', as the surrealists would say! An immense flight of stairs led up to a large room, its ceiling ornamented with beams, connected by a more modest staircase to a small adjacent flat. She brought Pablo to look at it, and he took it at once. She now had a venue for their frolics, and above all a new setting for more exciting artistic experiences.

After the coup d'État in July 1936, civil war had broken out in Spain. The army commanded by General Franco in Morocco had rebelled against the Republican government in Madrid. The military putsch caused the whole of Spain to flare up at once, and forced the government to organise resistance. Franco had the support of Mussolini's Italy and Nazi Germany. France and England boldly declared themselves neutral. The civil war, which lasted until March 1939, would leave one and a half million dead, mostly civilians.

Aided by Dora, Pablo immediately gave his support to the Republican government, which, in return, immediately appointed him director of the Prado in Madrid, Spain's principal national museum. It was a strictly honorific title, as the routed government moved all the museum's collections. 'I'm the director of an empty museum!' laughed Pablo.

Olga had gone to live very temporarily in the Château de Boisgeloup, which the courts had assigned to her as a residence. Marie-Thérèse now lived in Vollard's pretty little house in Le Tremblay-sur-Mauldre, close to Versailles, where Pablo ceaselessly photographed his little Maya, capturing her first footsteps in the English garden, amid thousands of flowers.

However, since the spring of 1937, he himself had taken up residence at 7, Rue des Grands-Augustins, while Sabartés continued to occupy his retreat in the Rue La Boétie. With Olga forgotten at Boisgeloup and Marie-Thérèse isolated near Paris, Dora Maar became the privileged witness of the dark years leading up to the war and the birth of what would become *Guernica*, ordered by the youthful but ephemeral Republican government of Spain. Fortunately for history, Dora Maar used her lens to capture the different stages of its creation. In this way, she managed to find her place, side by side with Pablo, confronting his sole true companion – the canvas.

It was the beginning of a 'political' period that would never end. Henceforth, Pablo was to give the political act of solidarity priority over his family life.

Dora Maar's real name was Theodora Markovitch. Her father, an architect of Croatian origin, is said to have built the embassy of the Austro-Hungarian Empire in Buenos Aires. French on her mother's side, Dora had lived mainly in Argentina, and spoke Spanish. Unlike Olga, an émigré by force of circumstance, Dora, the foreigner, was a wanderer with a thirst for the unknown.

She was a 'fellow traveller' of the surrealists from late 1933, but a marginal one: she was the friend of Georges Bataille until she met Picasso. With him, she formed part of the Contre-Attaque group. She learnt the technique of the cinema, and then that of photography. She made the acquaintance of Breton and Eluard. It was in their wake that she quite naturally met Picasso at the Deux Magots café, in Saint-Germain-des-Prés. Françoise Gilot later recounted Pablo's first meeting with Dora in autumn 1935: 'She was wearing black gloves embroidered with little pink flowers. She had taken off her gloves and picked up a long, pointed knife which she kept jabbing into the table between her outspread fingers. From time to time, she missed her aim by a fraction of a millimetre, and her hand was covered in blood. Pablo was fascinated. That is what awakened his interest in her. He asked Dora to give him her gloves, and he kept them in a display cabinet in the Rue des Grands-Augustins, among other souvenirs.'[29]

Dora was twenty-nine years old and Pablo was fifty-five, but they got on marvellously together. She was madly in love with him.

He was 'interested'. She gave Pablo the hardness of facial features that was missing from his aesthetic equilibrium.

All the representations of Dora Maar echo political events: she appears with strongly marked features, with red nails, black eyes and dark hair – reflections of her rebellious nature, passionately involved in the dramas that were created around her. The power of his portraits of Dora opened the way to a new form of art, clearly identified by Brigitte Léal: 'The fascination exercised over us by the image of this face, admirable yet suffering and alienated, derives indisputably from its congruence with our modern consciousness of the body, in its triple dimensions of vulnerability, ambiguity and monstrosity. There is no doubt that by signing these portraits, Picasso sounded the death knell of the beau idéal and opened the way for the aesthetic tyranny of a sort of terrible, tragic beauty, born of our contemporary history.'[30]

We know that on 26 April 1937, at the height of the civil war in Spain, the little village of Guernica, in the Basque country, was razed to the ground by the combined air forces of Spain, Italy and Germany in three hours of continuous bombing, during which new bombs developed by the Nazis were tested. Pablo found out about the carnage in press photographs brought to him by Dora. Devastated, he changed the theme of the fresco that the Republicans had ordered, the sketch for which was almost complete. He turned it into a symbol of terror and innocence massacred.

Between 1 May and 4 June that year, he carried out the forty-five preliminary studies and the different stages of this monumental work (about three and a half by eight metres in size), under Dora's illumination and her attentive lens.

Dora Maar's existence was no longer a secret to Marie-Thérèse but, due to Dora's work as a photographer, Pablo had a plausible explanation for her presence. Also, Dora would come in the morning, or very late in the evening. Marie-Thérèse used to come to the studio in the afternoon, often bringing Maya. My grandmother Marie-Thérèse herself has related, in the course of her one and only radio interview in 1974, her meeting with Dora Maar:[31] 'The monster had us wearing the same dresses by [Jacques] Heim … As there had been a mistaken delivery of pale pink slips and blouses from Nina Ricci, I telephoned Pablo's home and Inès, the chambermaid, told me that Picasso was not there … The parcel was addressed to 6, Rue de Savoie, where Dora lived. I went there.' Dora opened the door. A conversation began, acid if ostensibly polite. Dora immediately reproached her for 'having a baby on purpose'! Marie-Thérèse reminded her of the true situation, and of her own advantageous position as a young mother.

Dora Maar Seated, *1938, Indian ink, lead pencil and pastel on card, 27×21.9, Musée national Picasso-Paris.*
Overleaf: Café in Royan, *15 August 1940, oil paint on canvas, 97×130, Musée national Picasso-Paris.*

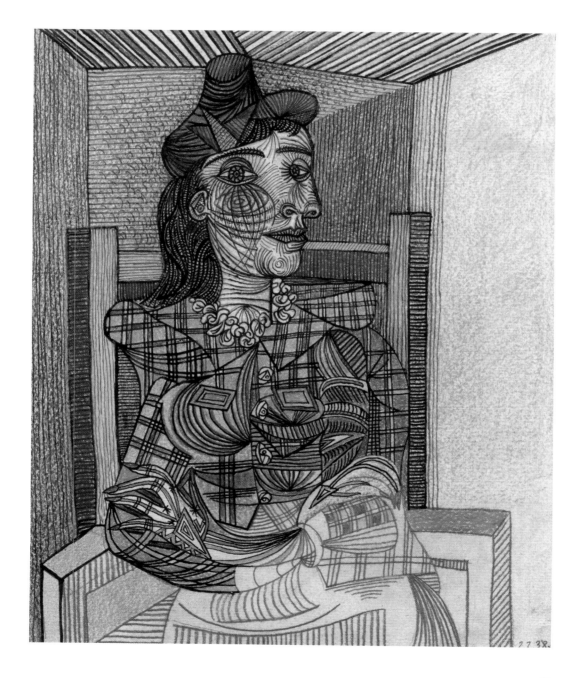

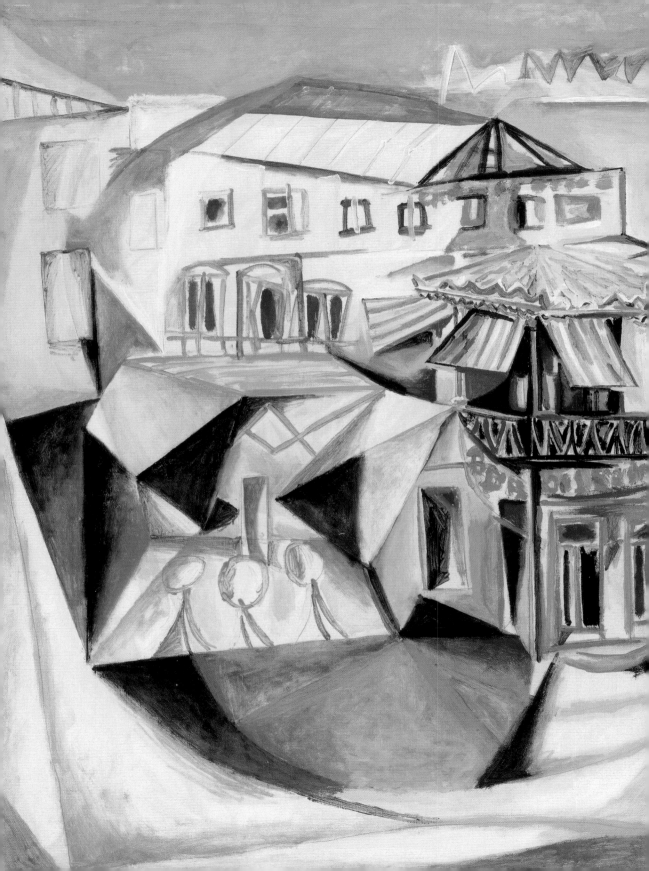

Pablo, who was doubtless in the next room, did not dare to show himself: Marie-Thérèse preferred not to force the door, and left him to sort things out with Dora.

The scene was repeated like something from comic opera. That afternoon, Marie-Thérèse went to the Grands-Augustins studio to clarify matters. Pablo thanked her for extricating him from the claws of that 'dreadful woman', as he called Dora. The door-bell rang: Dora! Pablo, ill at ease, let her in. She confronted him: 'Pablo Picasso, do you love me? Do you love me?' Pablo took Marie-Thérèse by the neck, and then by the hand, and replied, tenderly: 'Dora Maar, you know that the only woman I love is Marie-Thérèse Walter – it's as simple as that, and here she is. We understand each other.' Marie-Thérèse seized Dora by the shoulders and pushed her out of the door, in the full knowledge that this apparent victory would make no real difference. Pablo was such a mischievous devil.

'Painting is not meant for decorating apartments. It is an instrument of offence and defence against the enemy.'

The seduction of Dora Maar was more intellectual than physical in nature. Feminine though she was, her appearance was first and foremost neat and upright; her gait was the antithesis of provocative. She could not have children, and lived entirely for her love of Picasso, whose slightest actions or gestures she made sacred. Proud without being jealous, she accepted everything, or almost everything, that he made her endure. She submitted to the instability of his moods. Pablo knew who it was that he was treating so brutally. After all, hadn't she made it possible for him herself?

While Marie-Thérèse and Maya only knew the kindly, indulgent side of their companion and father – on Thursdays, and at weekends once Maya had started to go to school – Dora, obedient to his changing moods, submitted to the rituals that he imposed on her. He was the one who telephoned when he wanted to see her. She never knew, from one day to the next, whether she was to lunch or dine with him, but she had to be ready at all times, and at home if he came to see her. The more she submitted, the more the experience tended towards the limits of the bearable. But Dora found obvious satisfaction in pursuing the game, veering between submission and domination. For Pablo, this hysteria was a source of inspiration: 'To me,' he said, 'she is a woman who weeps. For years, I painted her in tormented forms, not out of sadism or for pleasure. All I could do was express the vision that imposed itself on me. It was Dora's deep-down reality.'[32]

When war was declared in France in September 1939, Marie-Thérèse, her mother Marguerite and Maya were on holiday in Royan. Pablo moved in there with them, on the first floor of the Villa Gerbier-de-Jonc. In the winter of 1940, he rented a room at the Hôtel Les Voiliers, which he used as a studio, and organised regular visits to Dora at the Hôtel du Tigre. When in Royan, Pablo always slept at the 'family' villa. The rest of the day was Dora's. It was now her turn to live an absolutely 'clandestine' life: Pablo never let himself be seen in public with her in the little spa town.

This well-organised arrangement continued until the return to Paris, in the spring of 1941. My grandmother and Maya moved to the Boulevard Henri-IV, at the tip of the Ile Saint-Louis, to a large flat where Pablo fitted out one room as his studio.

Wartime conditions now reigned in France. Rationing and queues, risk of murder, Gestapo raids, interrogations by the German military or the Vichy police, fuel shortages, curfews, false accusations – everyone lived under permanent threat. Despite his considerable financial assets, Pablo shared the chief daily concerns of the French: eating and heating. The black market provided enough fuel to keep the cast-iron kitchen range going, but not the heating system that he had had installed. At risk, due to his status as a committed Spanish painter producing 'unacceptable' art (according to the fascists), he did what he could to support the Resistance. His situation as an

émigré did not make things any easier. Now under surveillance, he could be expelled to Spain at any moment. Only his great fame and the friendship of a few admirers in the bureaucracy permitted him to indulge in a few verbal sallies. Thus he distributed postcards of *Guernica* to all the Germans who came to keep a watch on him, saying: 'Souvenir, souvenir.' And he even replied to one German officer who asked him, 'Did you really do *that* [*Guernica*]?': 'No, you did.' All this did not provide very thrilling sources of inspiration. I remember being surprised by a remark my grandmother Marie-Thérèse made about Pablo at that time: 'He was so cold, poor thing!' Looking back now, I realise that this struggle was essential for him. Nevertheless, this obsession with food for survival inspired him, in January 1941, to produce a little tragi-comic play in six acts. The characters are burlesque (The Pie, Flat-Foot, The Onion, Silence, Anxiety, Lean, and so on), and the title evocative: *Desire Caught by the Tail*.[33] Reading it, on 19 March 1944, was a delight for his friends, turned thespian for a day: Michel and Louise Leiris, Simone de Beauvoir and Jean-Paul Sartre, Raymond Queneau and Dora Maar. With Albert Camus directing, and Braque and Lacan as spectators. Brassaï recorded this extraordinary moment with his camera. What a line-up of stars!
Indeed, Pablo had been doing a little writing for several years now, especially poetry. Gertrude Stein had advised him not to spread his talents too thin. In vain. My mother Maya has a number of poems that

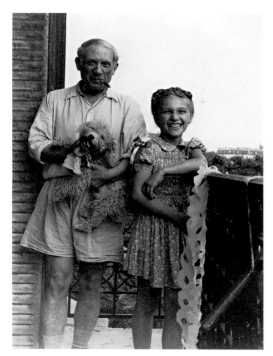

In January 1943, he went to Dora's lodgings and presented her with a copy of *Buffon's Natural History*, which he had illustrated for Vollard.[34] He dedicated it to her: '*Per Dora Maar tan rebufon*' – a pun in Catalan: 'For Dora Maar so *bufona* (sweet) and so *rebufant* (snorting with anger).'
Throughout their liaison, he gave her – as he did to Marie-Thérèse – hundreds of tokens of his affection: paintings, drawings, and especially small objects of all kinds, insignificant in appearance, but which Dora would keep all her life long.
A few months later, in May 1943, while dining with Dora and some friends at the Catalan, the little black-market restaurant opposite the Grands-Augustins studio, Pablo made the acquaintance of a very pretty young woman who could not fail to attract his attention. She was at a table with a mutual friend, the actor Alain Cuny, who had been a triumphant success in *Les Visiteurs du soir*. Pablo came over and was introduced: her name was Françoise Gilot.

In February 1944, Dora Maar aided Pablo again at the religious ceremony in honour of their old friend Max Jacob, who had died during internment at Drancy, and then at the famous reading of *Desire Caught by the Tail*. Nevertheless, inexorably and despite herself, she was drifting away from Picasso's life. In August 1944, when the events of the Liberation of Paris were at their peak, my grandfather joined Marie-Thérèse and Maya in the Boulevard Henri-IV. He had just crossed Paris on foot, at risk of his life. He

her father dedicated to her. Apart from the sincerity of expression, the magic of the 'illuminations' is especially touching. There at least, there is colour. Outside, everything is grey, without end.
Pablo endured the Occupation. His work bears witness to it: still lifes, dark colours, human or animal skulls and the like. As luck would have it, in 1939, the Museum of Modern Art in New York (founded in 1929), at the instigation of its legendary director, Alfred Barr, organised its first retrospective of Pablo's works, which it took on a triumphant tour of ten major American cities. Thus many masterpieces escaped the fate for which the Nazis might have destined them. America, which adores royalty, crowned Pablo the world's most important artist of the twentieth century. But in Paris, he was never anything more than a Spanish émigré, enjoying the special status of a neutral national, well known admittedly in his own circle, but not permitted any further existence on the artistic level.

had even been grazed by a sniper's bullet. He had made his choice, abandoning Dora Maar to her unintelligible torments on the Left Bank. As for Olga and their son Paulo, he had entrusted them to the supervision of his friend Bernhard Geiser[35] in Switzerland. Dora sank into depression. Nervous of constitution, pervaded with mysticism, she raved deliriously in public. She was taken by the police to the Sainte-Anne hospital to undergo a taxing course of psychiatric treatment based on electric shock therapy. The responsibility for this descent into madness has been laid on my grandfather. What is the truth of the matter?

In addition to taking immediate steps to put a stop to the internment at the Sainte-Anne hospital, entrusting her to the care of his friend the psychoanalyst Jacques Lacan, Pablo organised a 'gentle' separation. And we may suppose that the gradual deterioration of Dora's psychic state had its roots in a collective responsibility. Hers was a mind already prone to the most outré imaginings and a taste for adventure bolstered by the surrealists, who encouraged her in her quest for the irrational – a source of truth as they saw it. Her complex, painful relationship with Pablo, in which the lovers continually exploited new experiences in a heavily over-cerebral sexuality, was perhaps no more than the catalyst for a general loss of stability.

In August 1945, Pablo went away with her again to spend a few days in Antibes, and then bought her a house in Ménerbes, which she would keep for the rest of her life. It was certainly more of a convalescence than the continuation of an affair, which had already reached its end. She would try to stay in contact. In 1953, for example, they met up with their mutual friend Douglas Cooper, at his castle, the Château de Castille, near the Pont du Gard. Pablo, according to her, humiliated her by seducing her again in the presence of the American: the latter has no memory of this.

'An artist is not as free as you might think. This is also true of my portraits of Dora Maar. To me, she is a woman who weeps. For years, I painted her in tormented forms, not out of sadism or for pleasure. All I could do was express the vision that imposed itself on me. It was Dora's deep-down reality. You see, a painter has his limits, and they are not always what one might imagine.'

FRANÇOISE GILOT
(1921-)

Françoise was a young painter, enthusiastic and energetic, very well informed about the world of artists. Against the advice of her father, she had given up her law studies to devote herself to painting. When she met Picasso in 1943, she was aware that he was a living god of modern art, and she dreamed of showing him her pictures.

Their initial relations were cautious. Françoise knew how to play hard-to-get, and she intended to preserve her independence. She kept to the formal mode of address – *'vous'* – which probably implied more than just the pupil's respect for the master. She would use it as long as their relationship lasted. Distance is not unbecoming to certain kinds of love. No one could have been indifferent to her intelligence and curiosity. Furthermore, she stood out for the modernity of her beauty. So even before their affair had really begun, she soon started to appear in Pablo's painting, although he continued to portray Marie-Thérèse. He always proceeded like this: while continuing to represent his last companion, he introduced a few features of his new conquest. Was it a fear of solitude, or his insatiable need to seduce that urged him into these polygamous arrangements? Art at least reaped the benefit.

Marie-Thérèse realised that their relationship was reaching the end of its life. Their bond had been transformed little by little into habit, an immutable and appreciable routine. Maya alone escaped this cooling off: indeed, between 1942 and 1945 Pablo devoted an entire sketchbook of drawings to her: the famous 'blue book'. On 13 July 1944, he wrote to Marie-Thérèse: 'You have always been the best of women. I love you and embrace you with all my heart.' Thus he expresses, at the same time, his appreciation of an epoch and its conclusion.

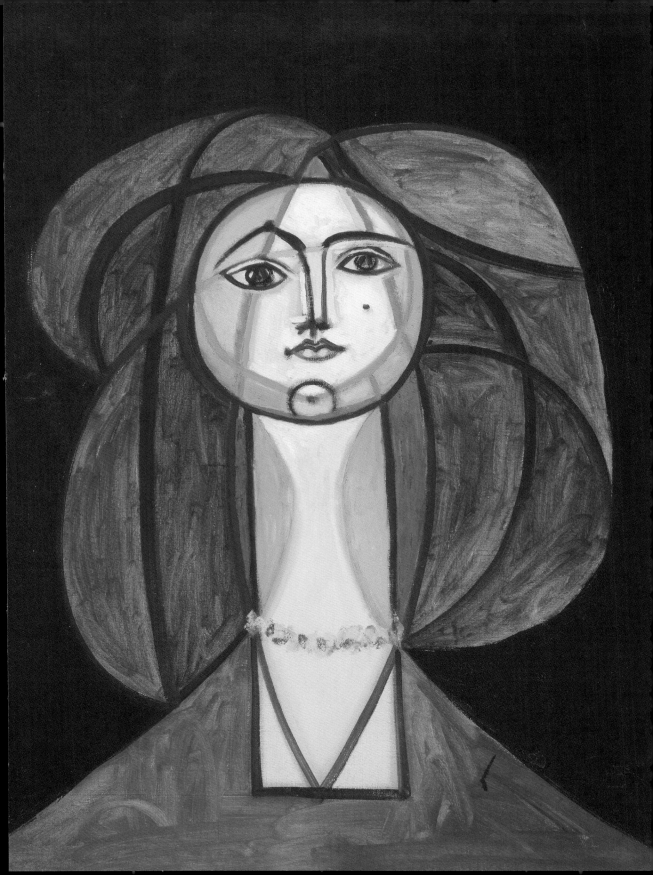

Nevertheless, he would be at her side during the Liberation of Paris.

The following autumn, the 'Marie-Thérèse period' ended in a last public celebration at the autumn Salon. The world discovered a sublimated woman who had already faded away.

At their very first meeting, in the Grands-Augustins studio where Pablo had invited her on the pretext of 'teaching her engraving', Françoise made things quite plain. When Pablo expressed surprise at the elegance of his guest's attire in view of the circumstances, she explained: 'As I don't believe you have the slightest intention of teaching me engraving, I dressed in a style which I thought more appropriate to the occasion. In other words, I have simply tried to look beautiful.'[36] Long, intimate conversations followed, during which Pablo blew hot and cold. Françoise prudently gave herself time to think things over. When Pablo, who wanted to go faster, suggested shutting her up in the little flat above the Grands-Augustins studio, she side-stepped the proposal, though with due respect. Brave but not foolhardy. Did Pablo think he could repeat the Marie-Thérèse experience with her? Françoise was far less innocent, and times had changed. Furthermore, she knew all about Picasso. As everyone did. As Pablo himself did, aware that he had other attractions to offer to supplement his natural charisma.

In the face of this resistance, Pablo, frustrated, fell for a young high-school girl

A Flower-Woman, *5 May 1946, oil paint on canvas, 146×89, private collection.*

Seated Nude Against a Green Background, *1946, painting on wood, 165×147.5, Picasso Museum, Antibes. This piece is an example of the abundant use of the colour green in works inspired by Françoise. She later revealed the secret of this preference, and also that for the colour blue: while Françoise and Pablo were on a visit to Henri Matisse, the latter immediately offered to paint a portrait of Françoise using green and blue. Back in his own studio, stimulated by another man's view of his companion, Pablo immediately painted a first portrait of Françoise with those colours, which he would use again regularly, as in* Seated Nude Against a Green Background.

Flute Player, *1951, painted ceramic soup plate, diameter 25,*
limited edition of 40 pieces, Madoura Gallery, Vallauris. During
the years in Vallauris, Pablo would execute more than 800
original pieces, which would be produced by the Madoura
gallery. What fascinated him most of all was the unpredictable
appearance of pieces when they came out of the wood-fired
kiln, due to an element of chance in the transformation of the
enamels and fired oxides. Thus he remarked: 'Pottery works like
engraving, and firing is the print. It's the moment when you know
what you've done. When the print reaches you, you are no longer
the same person as you were when you engraved it. You have
changed. So you have to correct your engraving. But with pottery,
there's nothing more you can do.'
Pablo in the Madoura workshop in Vallauris, with Jules Agard,
photographed by André Villers, 1953.

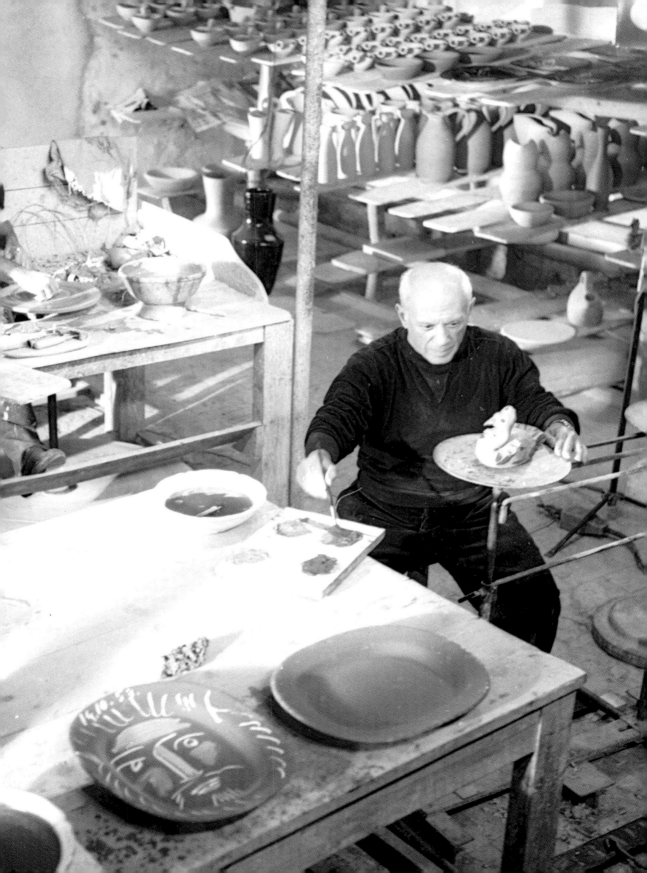

who had come to interview him. Sabartés, his zealous secretary, charmed by her candour, had organised a meeting with the master for her. The name of this young girl, barely seventeen years old (like Marie-Thérèse in earlier days), was Geneviève Laporte. She said she was a poet and a communist and, despite her youth, claimed to be in contact with the Resistance. She had what it took to make a conquest of Pablo, who was all ready to be caught on the rebound. Geneviève blushed at Pablo's declarations about art.[37]

At the same time, Françoise regally allocated a few short periods of time to Pablo, ignoring him completely for days, weeks and even months on end. 'I didn't want him to take me over ... I learnt to give no sign of life for a week or two. When I came back, he was as sweet as honey.'[38]

The beginning of their life together coincided with the completion of *A Flower-Woman* (dated 5 May 1945), a revival work composed of paint and collage. Pablo created it before her eyes, and she asked him questions about his inspiration: thus their relationship would always be respectful and intellectual in character. Marie-Thérèse did not dare to ask questions, but Françoise admitted no barriers. The lover metamorphosed into Pygmalion-patriarch. Françoise was fascinated by all the different techniques that he used, and was a privileged witness of his technical explorations, in ceramics, sculpture and engraving, for example.

Muse, mistress and companion, she was also ideally placed to glean fragments of Pablo's past from his own lips. On his part, he found her a cultured young woman capable of understanding his soul and his needs. He even almost forgot to pay attention to the requirements of their own love story. He took her to visit the places where he had loved Fernande, Eva, Olga and Dora, and told her about his passion for Marie-Thérèse: reading the latter's passionate letters was even enough to drive her away – for a while. Such an attitude would have made many a woman flee. Faithful to her uncompromising character – and her self-esteem – Françoise did indeed decide to leave the great Picasso. Defeated, he caught up with her *in extremis* and suggested that he should give her a child. Because, according to him, that was what she needed.

Françoise showered joy over Pablo's renaissance in the aftermath of the war. He rediscovered the delights of engraving and lithography with the great Fernand Mourlot in Paris, and then abandoned the capital for the Côte d'Azur. In this delightful world of vivid colours, through which he travelled with Françoise, there was no longer any question of summer society rituals as in the Olga period. He would work to the utmost there. He would live there.

In 1946, at the invitation of Romuald Dor de la Souchère, Pablo installed his studio in the magnificent Château Grimaldi in Antibes, and Françoise, who was by then pregnant, in Golfe-Juan, opposite. There he painted his new life, symbolised by the famous canvas

Claude Drawing, *1951, oil paint on canvas, 46×38, private collection.*

Claude Drawing, Françoise and Paloma, *17 May 1954, oil paint on canvas, 116×89, Musée national Picasso-Paris.*

The Joy of Life (painted between October and November 1946).

Claude was born in Paris on 15 May 1947. Pablo was a happy father once again. A youthful father. Now over sixty-five, he led an active life, dividing his time between art and politics – he had been a member of the Communist Party since October 1944. As a consequence of his celebrity status, his private life was now public knowledge. Olga, informed by Paulo of the existence of Maya and her mother, found out about Françoise in the press. Mad with rage, she came and stayed in close proximity to them (usually in Cannes, at the Hôtel Miramar, or in Juan-les-Pins, at the Belles Rives – Pablo settled the bills without hesitation) and harassed them daily in Golfe-Juan, until Pablo had to ask a police superintendent to make Olga see reason.

Pablo had briefly discovered the little village of Vallauris in 1937. He went back there in 1946 with Françoise. He returned again the following year to learn the art of ceramics with Georges and Suzanne

Ramié, at the Madoura gallery. It was the beginning of a love affair between him and this little village in the countryside inland from Cannes, overlooking Golfe-Juan. In the spring of 1948, with Françoise and Claude, he moved into a little villa, La Galloise. The house was officially the property of Françoise, as it had been bought for her by her grandmother, Anne, who refused to permit her granddaughter to live in someone else's property – a familial attitude that partially explains Françoise's inherited spirit of independence. His pride wounded, in 1949 Pablo bought a former perfumery warehouse, Le Fournas, in the young woman's name, and set up his studio there. When they separated, Françoise would sell it back to him for the same price; thus Pablo ended up paying for it twice. It was in these spacious rooms, renovated by my mother Maya (who asked to be allotted Le Fournas in her share of the estate), that I myself would spend many family summers.

The relationship between Françoise and Pablo was founded on an unusual balance of power. The large age gap gave a very intense spiritual dimension to their love. Pablo, who possessed the experience of a mature man, was always almost objectionably fatalistic: whatever will be, will be. Françoise had the temperament of a visionary, both in her artistic quest and in the way she organised her own life. She expected answers, and Pablo often wriggled out of providing them. He allowed himself

Paloma in Blue, *1952, oil paint on canvas, 81×65,*
private collection.
Paloma and Pablo, photographed by Edward Quinn.

periods of free time, often devoted to politics, in which Françoise had no part. Did she feel this distance, and had the obligatory formal mode of address ('*vous*') become a symbol of it? Yet, physically, she was the reflection of Pablo's youthful spirit. To allay the young woman's anxieties, Pablo suggested that she have another baby. To him, the family was a source of relief when he was tortured by creative effort.

Paloma was born on 19 April 1949. Pablo was now the father of four children – Paulo, Maya, Claude and Paloma. He showed them to the world. He drew with Claude and Paloma, finding nourishment in their spontaneity. This reconstructed unit, though no one said as much yet, was his real family. He happily posed for photographers on the beach. In a way, what he had suggested to Françoise as a solution seemed to have been a cure for him.

Conditions for the couple and their two children, however, were turbulent. They were surrounded by the press, supplicants, intruders, sycophants. In the correspondence of this period, a great part of which is conserved today in the Picasso Museum in Paris, very many letters from unknown people remained unopened because there was simply not enough time to deal with them.

Time – that was just what Pablo was beginning to lack. One phenomenon connected to his fame became apparent: women offered themselves to him, trying to seduce him, wanting to touch a living legend, and even – why not? – keep

a souvenir. Did he not possess every attraction? Other women resurfaced, such as Geneviève Laporte. Pablo and Françoise's life together suffered the effects.

The life of the little family had been taking shape in Vallauris. The children went to school there. My uncle Claude told me later: 'We were happy.' However, Françoise wanted to plan the children's future and preferred them to be educated in Paris. Pablo did not agree. By the end of September 1953, the break was conclusive. Confusion reigned. Françoise could not endure any more. She left, taking the children with her.

For the first time, a woman had stood up to Picasso. 'Thinking things over later,' she says, 'I realised that Picasso had never been able to bear the company of one woman for long. I knew that he had been attracted to start with by the intellectual side of our relationship ... Yet he insisted that I should have children for my own fulfilment. And now that I had become a woman, a mother and a wife, he clearly didn't like it.'[39] She had doubtless perceived that Pablo would have liked to 'store her away' and keep her, exactly as he had done with Marie-Thérèse, who had also realised what he was up to: 'He would have liked to have a large palace, with each of his women in her own room. Like the Arabs. With their children, of course.'[40]

Pablo saw Françoise again on the occasion of a grand procession for the corrida, at Vallauris, when she entered the arena on

horseback. He was fascinated – to the disgust of another woman who had just entered the circle, Jacqueline Roque. But Françoise left again the same evening. Courtesy had taken the place of amorous tension.

Over the next few years, Françoise tried to make the situation for their children as good as she could within the limits of the law. Pablo was very willing. As he was still officially married to Olga, he could not acknowledge them as their legal father, but he voluntarily became their second guardian in 1955, and in 1959 he submitted a petition to the Minister of Justice to allow them to bear his name, which was granted by the Minister of Justice in 1961.

Then, in the course of 1963, Françoise announced that (in collaboration with Carlton Lake) she had written a book about their story. He was alarmed. The publication of *Life with Picasso* in 1964[41] aroused his anger. He felt insulted, and this feeling was strongly encouraged by pressure from Jacqueline, his new wife (whom he had married in March 1961), and the insistence of his lawyer, Maître Bacqué de Sariac. Pablo brought an action. The courts judged that revelations of the private life of Françoise and Pablo were common memories; Picasso did not hold exclusive rights to them. Pablo lost the action, and the book gained significant benefit from the publicity.

After this, he increasingly shut himself away in isolation. His friends Georges Braque and Jean Cocteau had died in 1963. Claude and Paloma, who always came to see their father in the school holidays, met him that

Christmas for the last time. Inexorably, Pablo was detaching himself from the flesh of his flesh to be one with his art alone.

There would be one more meeting – a tense one – a few years later, in a street in Cannes: Claude and his father talked together for no more than a few minutes, watched absently by Jacqueline. Claude and Paloma were seen at the arena in Fréjus, attending corridas, a few rows away from Jacqueline and Pablo, but the children ignored the couple so pointedly that the only thing the journalists present could find to talk about was provocation: a challenge to their father! Or was it simply an appeal? In 1968, Claude and Paloma tried an unsuccessful legal action for 'acknowledgement of paternity'. It was not an attack on their father, but simply the wish to establish a fact. However, Pablo's entourage took it as an aggressive act. And then there was Jacqueline. It is hard to put oneself in the place of a woman who has to come to terms with the influence of her predecessor, and who is concerned to give her world and that of her husband complete protection: Pablo wanted peace. No one in the family would have access to the master any more, apart from Paulo. He himself complained, during the final years, of almost having to 'erect a barrier'. The intermediaries – caretaker, chauffeur, secretary, not to mention Jacqueline – would declare, without batting an eyelid, that 'Monsieur' was working and must not be disturbed.

Pablo with his daughter Paloma at the Château de Vauvenargues.
Pablo with his son Claude the same day in front of a Portrait of Marguerite *by Matisse. Pablo owned ten works by Matisse altogether, including a magnificent* Nature morte aux oranges, *which were included in the Picasso Donation from the artist's personal collection given to the French state by his heirs after his death.*

JACQUELINE ROQUE
(1926–1986)

December 1953. Soon after the official departure of Françoise, Pablo met a young woman named Jacqueline Roque. She was nearly twenty-eight years old.

She was a friend of Suzanne Ramié, who, together with her husband Georges, owned the Madoura gallery in Vallauris. Jacqueline helped her with the sales and regularly crossed Pablo's path.

They did not remain indifferent to each other for long. They conversed more and more frequently. Jacqueline, reserved by nature, gained in self-confidence. They shared the same traumas: she had just separated from her first husband, André Hutin, by whom she had a little daughter named Catherine. They were two lonely hearts.

Pablo noticed her sphinx-like profile; she inspired him at once. In contrast to all his previous models, this time he did not mingle the faces or hair colours of the women in his life. The canvas was blank. It was as if, in the autumn of his life, he was starting a new artist's career and a new man's life.

Jacqueline gently took Françoise's place, occupying all the space. As La Galloise belonged to Françoise, Jacqueline temporarily took Pablo into her own

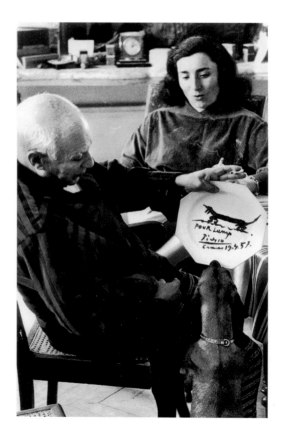

home. She lived in a villa, Le Ziquet, in Le Cannet, and so Pablo gave the mysterious title 'Portrait of Madame Z.' to all his early portraits of Jacqueline. Then, in the spring of 1955, he bought a large house in Cannes, La Californie, after seeing photographs of it,

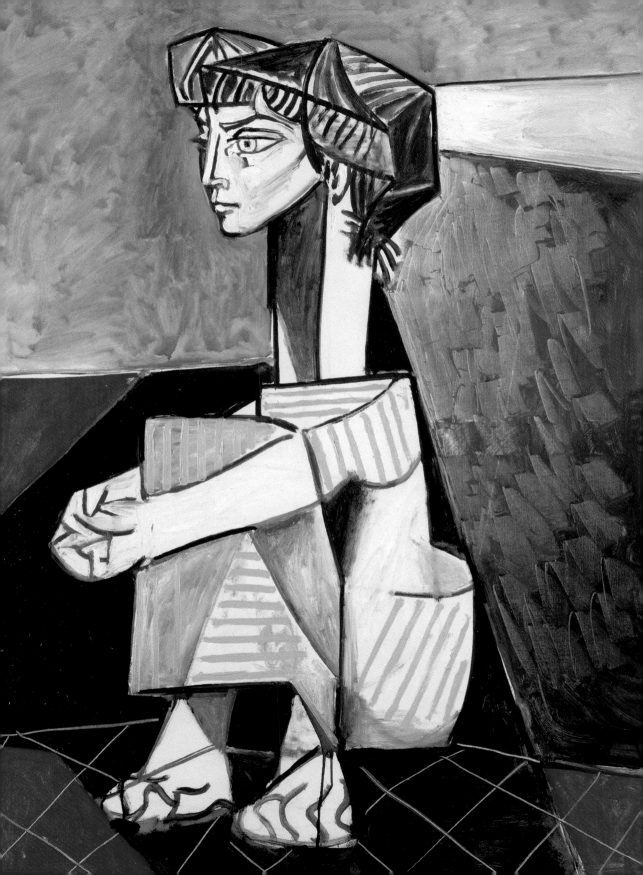

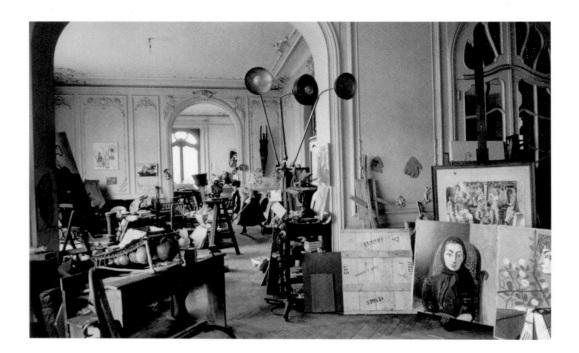

and retrieved all the possessions that he had in his various flats and in furniture storage sites in Paris. Aided by Jacqueline, he recreated a gigantic studio, an Aladdin's cave in which he deposited all his output, that is to say the greater part of his previous life.

In 1955, all the generations were mingled: Paulo, Maya, Claude and Paloma were all brought together for the summer by Pablo, watched by Jacqueline, who had to come to terms with nearly forty years of an extraordinary past that had been unknown to her. Olga had died in February, Marie-Thérèse had just turned down the marriage once promised but now become impossible, Françoise had chosen survival elsewhere.

In the autumn, they all went their separate ways, except Jacqueline and Pablo.

His old man's body might have been tired, but he regained the mettle of his youth to celebrate his new conquest. She is present in all his works.

He took inspiration from the masters of the past – he had time now. Jacqueline contributed their modern side: some fifteen *Women of Algiers*, after Delacroix (he had begun the studies for them back in 1940) between December 1954 and February 1955; fifty-odd *Meninas*, after Velázquez, in the second half of 1957; nearly thirty versions of *Luncheon on the Grass*, *after Manet*, between the summer of 1959 and Christmas 1961. And *The Rape of the Sabine Women*, in 1962, after David.

These works form part of Pablo's ongoing dialogue with his elders, like other earlier works inspired by El Greco, Cranach, Courbet, Cézanne and Rembrandt for the final period of the *Musketeers*, or by Nicolas Poussin, one of his absolute standards of reference, whose portrait he would paint later on.[42] The exhibition entitled *Picasso et les maîtres* (Picasso and the Masters), held in Paris in autumn 2008 at the Grand Palais, celebrated the meeting of these

The drawing room at La Californie, Cannes, 1957, photographed by David Douglas Duncan.

Pablo in his studio surrounded by ceramic tiles, photographed by Lucien Clergue at La Californie in 1955.

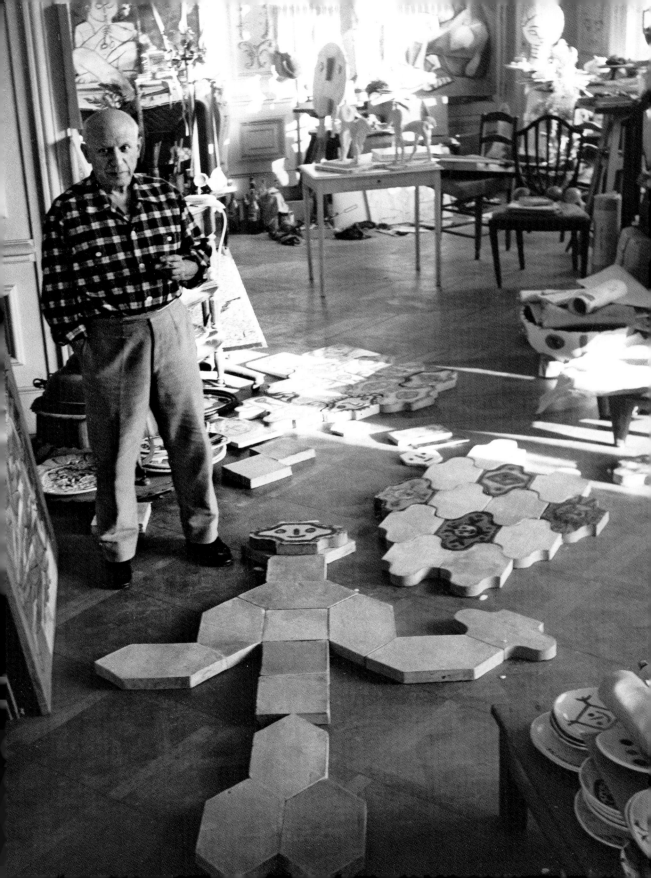

masterpieces of the history of art with those of Pablo.

It was with such a historical perspective that, in the autumn of 1958, he acquired the Château de Vauvenargues, to which his attention had been drawn by his friend Douglas Cooper, historian and collector and himself the owner of a castle. It was a rejuvenation cure. Pablo had, as he famously put it, 'bought Cézanne's *Sainte-Victoire*' and revived many memories of his past life. He and Jacqueline took possession of the place, bit by bit transforming the immense rooms of the castle into studios, decorating some of them with works of his own and works from his personal collection: Matisse, Cézanne, Courbet, Braque, Modigliani, Corot, and others. They would be more at home, he considered, in this environment steeped in history than in Cannes or Mougins. Pablo painted the bare walls of the bathroom on the first floor. From now on, morning ablutions would take place against a background of luxuriant flora and fauna. His enthusiasm lasted nearly three years. Then Vauvenargues – with its icy mistral-swept winters and burning hot summers in the end too harsh for him – became no more than a stopover on the way to the corridas of Nîmes or Arles.

On 2 March 1961, in the utmost secrecy, Pablo, now nearly eighty years old, married Jacqueline. They were forty-five years apart in age. There are those who like to say that Jacqueline's perseverance had paid off: the future of a wife is better assured than that of a mere companion. But this perseverance, of which their friend Hélène Parmelin speaks,[43] was more likely the expression of a woman's need to see her companion committed to her than just financial self-interest.

In addition, it must always be remembered that my grandfather had a horror of anything that might remind him of death. His marriage was an act of life and of love. The simple fact that their union was celebrated with no contract shows that, in Pablo's eyes, spontaneity was all. Some time before, on the occasion of the baptism of Miguel, the son of the bullfighter Dominguin and his wife Lucia Bosé, he had displayed exasperation at the horde of journalists. With this secret marriage, he cocked a snook at all those who believed it their right to know everything about him, the press in particular. Once again, he was the one to call the tune. Organising the future in any shape or form was out of the question. Whatever will be, will be! No matter what the consequences. In any case, what was the point of knowing who would inherit from him since, as he put it to Pierre Daix, he had 'worked enough for everybody'?

As for Jacqueline, who came from a middle-class Christian background and who had entered the world of art through the shop at the Madoura gallery, she had had to adapt to new morals and bring her own values face to face with Pablo's nonconformism. A marriage had official significance for her: it was a commitment made before the world. In January 1961, she had expressed in public, and in tears, her disappointment that

Pablo had not kept his promise to marry her. And she had to deal with a stream of visitors – married men with their mistresses, gay men with their boyfriends, libertine wives, suitors of every hue. She wanted to demonstrate her difference.

Jacqueline and Pablo went to live in a new home, Notre-Dame-de-Vie, in Mougins, to get away from Cannes and the villa, La Californie, from which the view over the bay had been blotted out by the construction of a large block of flats. Jacqueline organised their life as a 'young' married couple. More than La Californie, a place where everyone passed through, or the Château de Vauvenargues, too deeply marked by history, the house in Mougins became 'her' house – 'their' house. There she reinvented a lost youth, and only allowed select visitors. I have memories of this period, like the light of late afternoon with its rosy glow, in the gentle warmth of sunshine filtered through leaves. Like the photographs by David Douglas Duncan (who had already photographed Jacqueline and Pablo at La Californie and Vauvenargues) or Roberto Otero, which express a serene satisfaction. The days passed in tranquillity.

After celebrating his eightieth birthday in Vallauris, Pablo devoted himself primarily to his studio. The years at La Californie are illustrated by scenes indoors or of the Côte d'Azur. This last period marks the painter's return to his studio. Notre-Dame-de-Vie, situated on the slope of a hill, consisted of a very large main building facing the hillside.

The architecture was nothing special, but the very large, bright rooms were a perfect setting for Pablo's pictures. On the second floor was a terrace which would become his last studio. A very few privileged guests were brought here by Pablo, and by him alone, to see his latest works. Among them – a visitor and companion through a memorable evening in the summer of 1972 – was the Russian cellist Mstislav Rostropovich, now *persona non grata* in the USSR because of his support for the dissident writer Aleksandr Solzhenitsyn. For two hours, one painting followed another on Pablo's easel, and the little glasses of vodka brought by Mstislav were filled and refilled. In the morning, the cellist could not find the precious bow that he had brought with his instrument. The whole household searched high and low in vain, under the impish eye of a Pablo who seemed genuinely sympathetic. Many years after Pablo's death, Rostropovich, coming back to the house after a concert, was surprised to see his bow displayed in a glass case – together with two vodka glasses. Pablo had decided to keep a souvenir of that bibulous evening!

With the passing years, Jacqueline and Pablo built up a singular relationship as a couple. They had got past the stage of physical relations. Many of the people I have met were amused by Pablo's distinct timidity towards Jacqueline, and the rarity of his signs of affection. Taking his wife's hand in his or stroking it was not a commonplace or spontaneous action. Was this the slightly

'macho' tendency of a sun-king who had rarely had to make the slightest effort? Or vestiges of a period when convention demanded restraint in public, in spite of his irrepressible desire to break the rules? No one has ever described Pablo as a demonstrative lover in public – not Olga, nor Marie-Thérèse, Dora or Françoise. With the last three, there was also the inescapable problem of adultery. Jacqueline was not excepted from this reserve. But she was able to take the initiative, and probably to forestall the desire.

Pablo's vitality continued to express itself in creation. At the end of 1965, and for a whole year, he devoted himself to drawing and engraving, giving up painting completely. He had exhausted himself with the unbelievable number of portraits of Jacqueline that he had executed in recent years, and was exhausted too by a growing erotic oeuvre, which Louise Leiris's gallery found difficult to present without calling down the anathema of the censors. Thus Pablo received a visit from the police of the arrondissement one day.

On the physical side, Pablo had undergone an operation on his gall bladder, in deepest secrecy – both out of vanity and to avoid journalistic speculations about his health. He and Jacqueline discreetly took the train to Paris, and then went to the American hospital in Neuilly, where he was registered under the name of Ruiz. Rumour has it that he also had an operation on his prostate – a disaster for the tireless man that he had been in the past, but now, in common with all men of his age, could no longer be, whatever he might try in order to prove the contrary. The only weakness he admitted to was a slight loss of hearing.

In the spring of 1967, he was expelled from his studios in the Rue des Grands-Augustins, which he had not been back to for a dozen years, but which, to him, remained the living token of his life in Paris, and the dark years. Despite the friendship shown him by André Malraux, then Minister of State for Cultural Affairs, and despite the national homage organised the previous year by the conservative Jean Leymarie, there was no escaping the policy of releasing unoccupied housing.

In truth, Pablo was paying the price for his communist commitment. In return, he refused the Légion d'Honneur which he was awarded, somewhat tactlessly, the same year, and which he would refuse again in 1971. After all, that was all in the past. He saw himself as a perennial man of the future.

And to prove that he was still a living, contemporary artist, he produced, in succession, the canvases of the *Musketeers*, then pictures of circus people, depicting clowns vibrant with colours and joy. Between early 1969 and early 1970, he produced about a hundred and sixty-five paintings of impressive size. To confirm his painstaking fervour and his perpetual daring, an exhibition of this output was organised in May 1970, at the instigation of Yvonne Zervos, in the majestic,

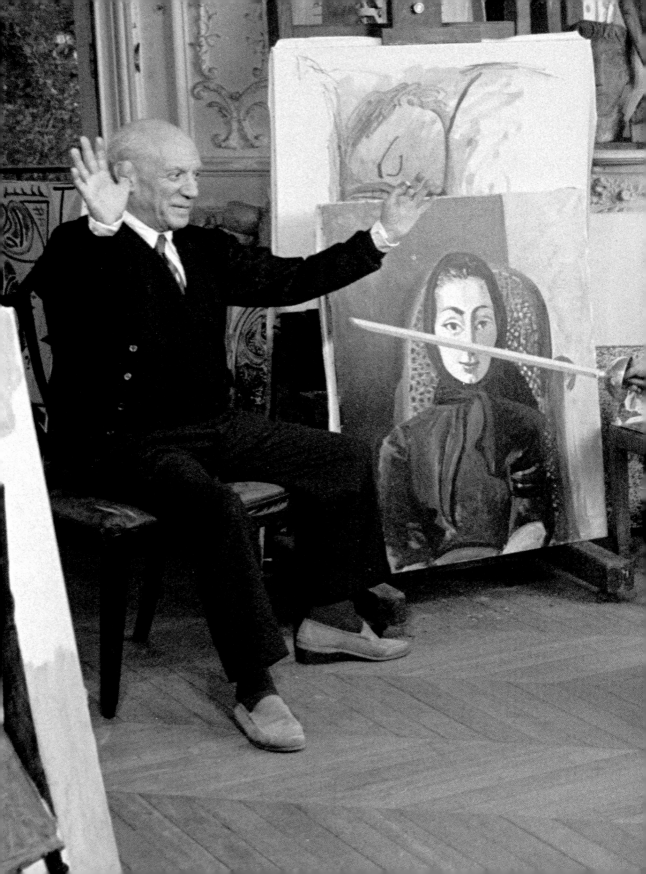

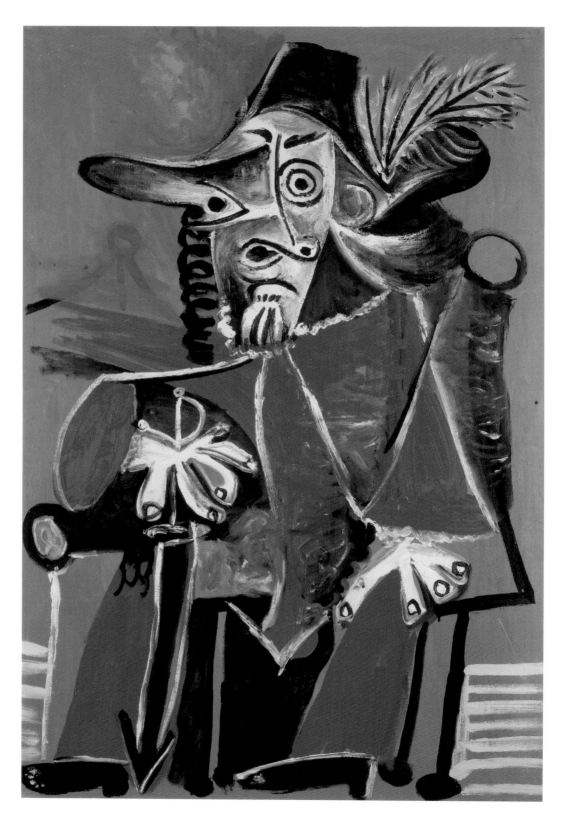

The Musketeer, *1969, oil paint on canvas, 195×130, private collection.*

Pablo receiving his personal collection of old masters at the Château de Vauvenargues in 1959 with his son Paul and Jacqueline, photographed by David Douglas Duncan.

ancestral Palais des Papes in Avignon. Stupefaction! Picasso was still alive! What with his inevitable detractors and his faithful *aficionados*, he was a topic of conversation and turned the spotlight on himself. Still alive! As he said once to my mother Maya: 'Let them speak ill or good, as long as they talk about it!'

In October 1971, to celebrate the artist's ninetieth birthday – and outshining the national tribute of 1966, which had occupied the whole of the Grand Palais, the Petit Palais, the National Library and a number of other galleries in a gigantic retrospective – the President of the Republic, Georges Pompidou, arranged for eight of Picasso's paintings to be hung in the Grande Galerie of the Louvre museum, face to face with classic masterpieces of French art. It was a historic event. The works of a living artist were hung in the Louvre for the first time: *Harlequin*, *Seated Woman*, *Seated Nude* rubbed shoulders with the masters of the past. Pablo, impatient, asked Roland Dumas,

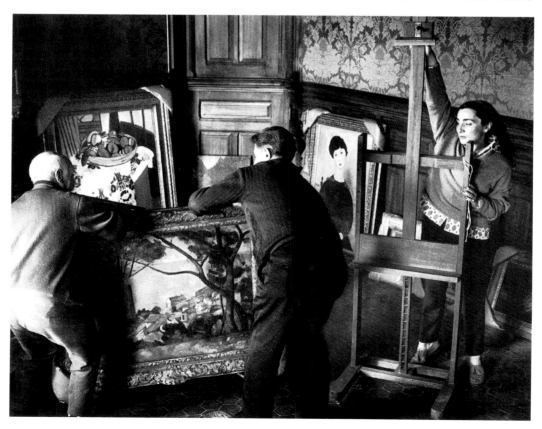

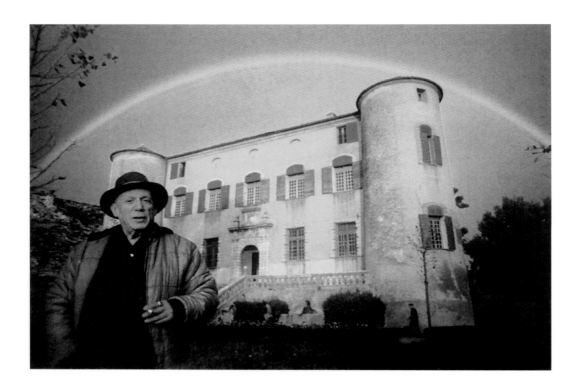

who had come to Mougins, to tell him all about the exhibition: 'Does my *Harlequin* hold its own against Watteau's *Gilles*?' Pablo and Jacqueline did not make the trip. Aware that his condition would not permit it, that his health was fragile, Pablo naturally abandoned the idea of making an appearance, but he took a lively interest in this retrospective, questioning everyone who had been to it at great length. His friend Jean Leymarie having repeatedly alerted the cultural authorities to the way that France was failing to recognise Picasso, the country – even if it had not given him his own museum – had at last shown that it was equal to the situation.

President Pompidou told journalists that Picasso was 'a volcano that never sleeps'. But now, in the autumn of 1972, Pablo was growing weaker. A serious attack of flu, made worse by bronchitis, kept him bedridden for several weeks: he lived with a respirator ready to hand, just in case. He

did not work any more. At Christmas, he was still in bed. In fact, he regularly dined in bed, in the company of Jacqueline and a few visitors. For New Year's Eve in Notre-Dame-de-Vie, Jacqueline had invited Hélène Parmelin and Edouard Pignon, his faithful lawyer from Cannes, Armand Antébi and his wife, and the Spanish publisher Gustavo Gili and his wife. Everyone was aware that Pablo was in bed on the floor above, and the party threatened to turn gloomy. 'A movement was heard in the house. Footsteps, voices. Pignon said: "It's Picasso!" The door opened with the usual sound of the little bells hung above it, which tinkled when they were touched. And Picasso and Jacqueline made their entrance.

'Arm in arm. Beaming. Superb: they had spruced themselves up. Coming in like that to take us by surprise, as happy as if they'd made a good joke. Kissing, talking at the same time – he got merrier and merrier. He even drank a little champagne, and

he rarely drank anything. He laughed till he cried. There were flowers everywhere. Presents. A real party. Midnight arrived in triumph, with all its kissing, good wishes and extravagance.'[44] Hélène Parmelin couldn't get over it. The next day, 1 January 1973, Jacqueline sighed, 'Thank God, we made the turn of the year.'

As January advanced, Pablo seemed to regain his strength. His considerable production shows his inexhaustible energy. Jacqueline suggested another exhibition in Avignon as a follow-up to the resounding success of 1970 and to display the important work done in the past year.

The closer he drew to the inevitable, the more firmly he rejected it. And so did Jacqueline. 'Leave me in peace,' he said all the time. Hélène Parmelin concludes: 'He only obeyed a single imperative now: painting.' Jacqueline looked after everything else. Accounts of this period are rare, because there were few visitors. Jacqueline and

Pablo formed a self-sufficient unit: 'She called him "my lord", or "my master", and did not address him familiarly in public ... lover, model, assistant, nurse, permanent partner in conversation, she was all those things! She was able to protect him from the flood of visitors who incessantly came knocking at the door. That was the most important thing. She was the inflexible guardian of that space of liberty and creation indispensable to Picasso's work.'[45] In the long corridor that connected the main rooms and led to the lift, a bench, known as the 'station platform', was used for waiting or resting – waiting, when Pablo was talking to someone in a reception room; resting, for Pablo himself, too weak to walk

The Château de Vauvenargues photographed by David Douglas Duncan in the autumn of 1958.

The bathroom of the Château de Vauvenargues and its fresco, photographed by David Douglas Duncan.

Overleaf: Pablo in his studio on the first floor of the Château de Vauvenargues, photographed by David Douglas Duncan in 1962.

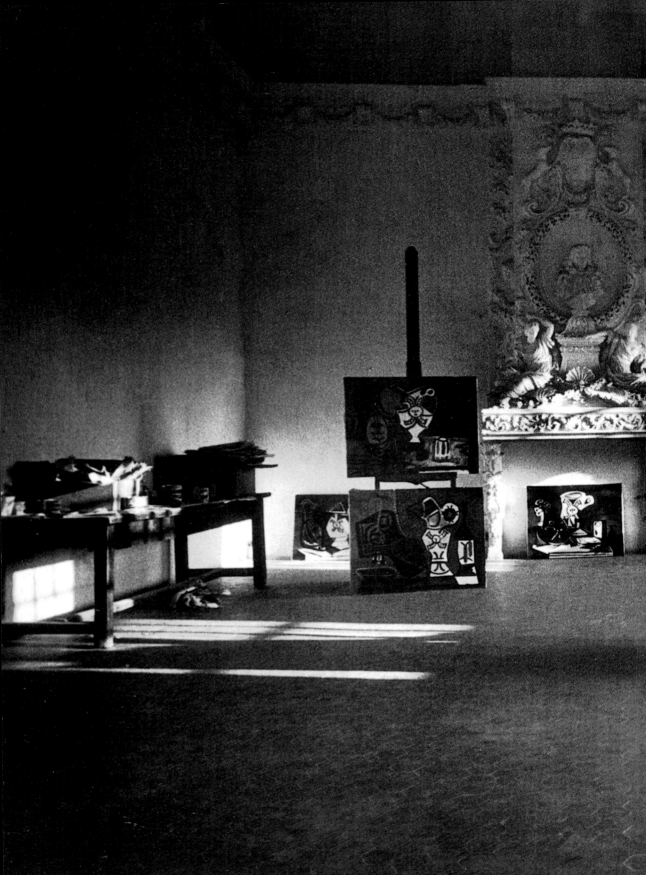

Pablo in the bathroom at Vauvenargues, catching a scorpion in the bath, photographed by David Douglas Duncan in April 1959. Pablo had painted the faun over the bath-tub early the previous month.

Pablo and Manitas de Plata, at Notre-Dame-de-Vie in Mougins, photographed by Lucien Clergue in 1968.

Woman with a Cat Sitting in an Armchair, 1964, oil paint on canvas, 146×97, collection of Suzanne and Jean Planque, Musée Granet, Aix-en-Provence.

The first few years spent in the mas of Notre-Dame-de-Vie are notable for a very large number of portraits of women, all inspired by Jacqueline. What the old man could not give his young wife, the artist offered to his muse.

Overleaf: Pablo devouring a fish. Its backbone would later be moulded in clay at La Californie. Photograph by David Douglas Duncan, April 1957.

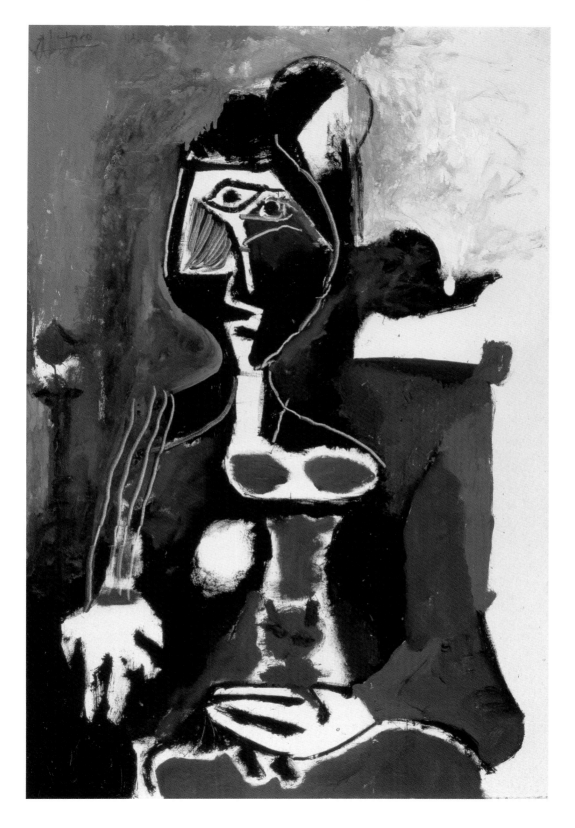

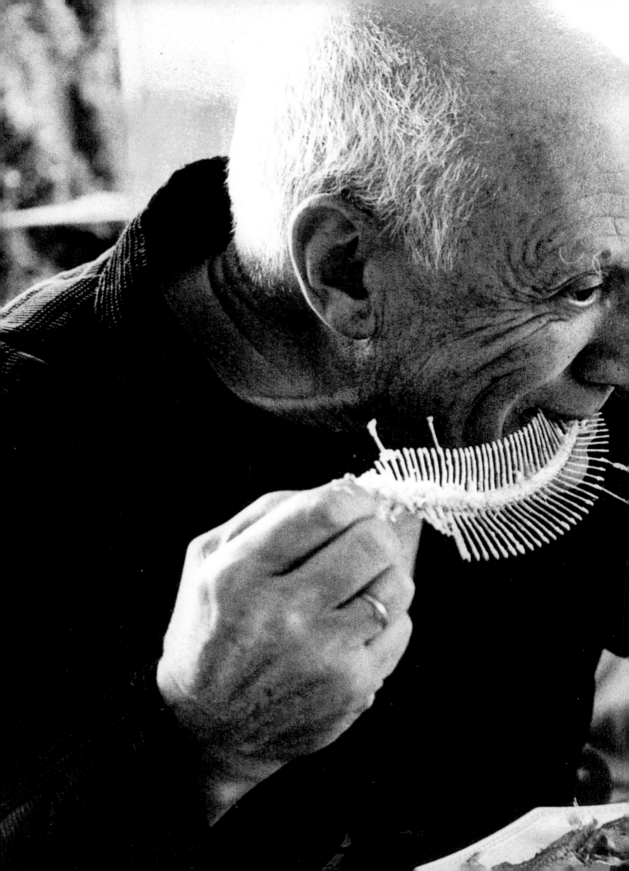

long distances. Being allowed to wait on the 'station platform' was itself a privilege when some waited in vain at the gate of the property.

Paulo, his elder son, who was his secretary in Paris, had a final conversation with Pablo at the end of February, before going back to the capital. Bit by bit, everyone tried to have a meeting with Pablo, without realising, or without wanting to admit, that it would be the last. Pablo's artistic frenzy left him no more time to take an interest in anything other than his work, or in any person except Jacqueline. Anyway, no one would have dreamed of distracting him.

He probably left the world of the living to enter the magic world of his art, the world of immortality. The year before, he had executed a number of self-portraits – an emaciated face, still showing the colour of life, but dominated by two great black eye-sockets staring at the viewer with both strength and anxiety. Between life and death. Pablo said at the time that he had reached something. All these self-portraits were shown in December 1972 at the Leiris gallery in Paris, but Pablo did not keep a single one.

On 7 April, just as he was starting a day of 'work', as he always rightly liked to call it, he felt unwell. His physician, Dr Rance, came at once. A Paris lung specialist, Dr Bernal, was summoned, and arrived in the evening. After dinner, Pablo felt that he was suffocating. Out in the corridor, Jacqueline's daughter Catherine had understood that the end was near. 'He can't do this to me!' her mother objected, in revolt. 'He can't leave me alone!' In the morning, Pablo woke up, very weak. The lawyer, Maître Antébi, was called, in case Pablo wanted to give him any official instructions. The sick man was lucid, but his body was gradually giving up. He asked the specialist from Paris if he was married. The answer was no. Pablo looked at Jacqueline, took her hand, a gesture so unusual for him, and said: 'You should get married. It's worth it!' Then, in a serious tone, he added, 'Jacqueline, you must tell Antébi...' And he passed away, on that grey morning. A life of nearly ninety-two years, exceptional from every point of view, had just reached its end.

And although I did not know it yet, a grandfather had just been born for me.

Pablo and the photographer David Douglas Duncan at La Californie, photographed by Gjon Mili in 1960.

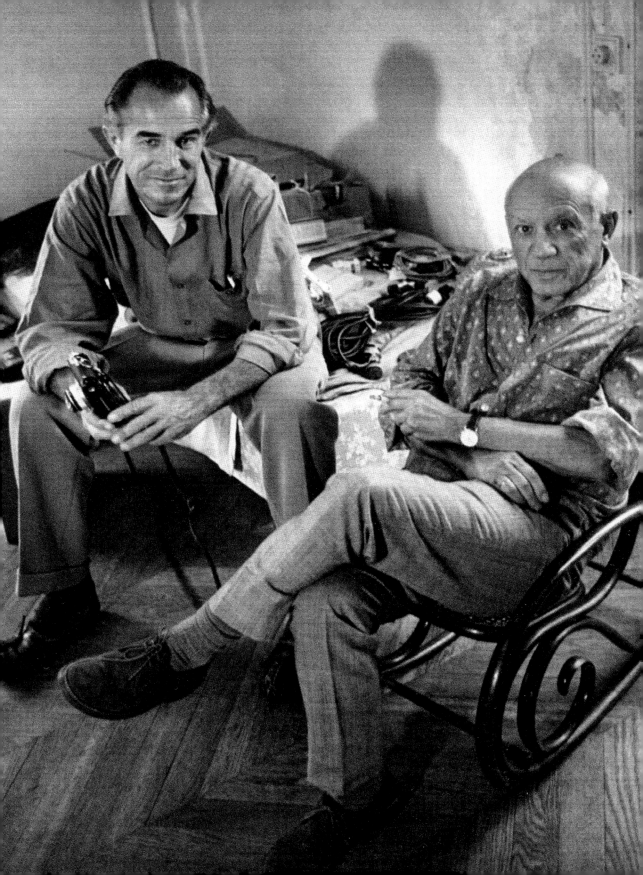

PICASSO AND POLITICS

'Others talk - I work!'[46]

Pablo Picasso

The whole of Pablo Picasso's work reflects a unique dynamic: rejection of rules. From his initial academicism to the mastery of his own genius, my grandfather rejected everything. He imposed his own standards, created a language, which might be adopted by others – and immediately called it into question himself. He was equally contemptuous of being hemmed in by a pre-existing framework and of the tyranny of a new order. Above all, he hated and feared the word 'end'. What other artist has ever been able to create so many clearly defined 'periods' and leave them systematically when others became trapped in them forever? My grandfather had a knack for bouncing back at any time, at the very moment when he was thought to be finished. A traditional artist and simultaneously an eternal revolutionary: is that what genius is?

I say 'revolutionary': the word irresistibly evokes politics. Picasso signed up to the French Communist Party in 1944. Other artists and intellectuals had already joined its ranks. But before becoming the famous, militant activist of the Party, Pablo had already undertaken other equally specific commitments on his own account. Was he a bad communist simply because he was a reputed billionaire? Most of the criticism centres on this theme, and it attaches little significance either to all that had happened before he joined or to all that came later. My grandfather's political career was as much artistic expression as personal commitment. It is very simplistic to associate his inspiration with nothing more than the 'subject' of a work, but at the same time it would be absurd to deny that the 'idea' was always the first cause. People inspired him as much as events did. His work did not stem from models alone, *far less from* 'political' models, but in spite of his multiple emotional commitments, it was always his conscience that prevailed. This search for meaning is something with which specialists in his work are well acquainted.

Analysis of this oeuvre is no easy task. On the one hand, one must avoid seeking endless explanations for what springs to the eye in a canvas; on the other hand, it is essential to go beyond the mere appearance of easy execution that some have judged, and condemned, too hastily. The smallest brush-stroke was the answer to a question, an intellectual problem or 'merely' research into a medium or a process, or an interplay of lines or views. No one that I have met ever heard Picasso talk of his painting as if it were

a pretext, which would be a confidence trick, or a means, not an end. It is never possible to dissociate the intention from the work. Such attempts to reduce Picasso to no more than an entertainer, or an alchemist transforming painting into an immense swindle, are pure whims, or fantasies. Pablo endured these facile criticisms in every period, but he never managed to remain completely indifferent to the sarcasm of the simple-minded. They wounded him, but he persevered. Although he never felt possessed by a divine mission, he was fully aware that he possessed a talent out of the ordinary and that it was his duty to use it. Thus he was already conscious of a form of immortality which would outlive the incomprehension of a handful of contemporaries.

His painting both re-records reality and reveals what our uninitiated eyes cannot perceive. Hélène Parmelin, his friend and correspondent in his last years, writes perceptively: 'His passion burned with such intensity, the truth of his painting personality came through with such force, that you felt like seizing these people by the scruff of the neck and telling them: this is the man you have represented as "a man who couldn't care less", a "phoney", a manipulator of smoke and mirrors and a money-grabber. Even a fool and a clown. He suffered cruelly from this, more than people think. Because it seemed to him, as to every creator, that the way into his work should be as natural as the work itself.'[47]

Pablo understood criticism when it extended his work or when, with regard to the public, it acted like a chemical developer. Otherwise, he concluded philosophically that time would tell. After all, had he not heard the teachers in art schools inveighing against the impressionists and the fauvists? He could not understand criticism when it went no further than appearances, or reproached him for straying from the beaten track.

He had lived through the xenophobic French politics of the First World War, which branded cubist 'émigrés' as purveyors of Boche art, in the pay of the enemy. He had endured Nazi propaganda against degenerate art, of which he was held to be the leader. If criticism did not help him, it did strengthen his perseverance. Through his work, he lived out an ongoing passion in two senses, both aesthetic and political.

Each work executed was a necessary link in his creative drive. Whether a simple study or a final work, each piece had its own place and its own function.

The commercial value of his work lagged behind, far behind. His immense output was the result of a need that had long since ceased to be financial in character. Success had enabled him to free himself from all material pressures and to act in accordance with his desires, as his huge legacy dazzlingly attests. There were no discards, no rejects.

My grandfather's political vision was a precondition: a well-considered act in response to a given reality. Whether or not this act was revolutionary, the commitment had meaning. It led to the making of a decision, a voluntary act. Hence the importance of origins, for the understanding

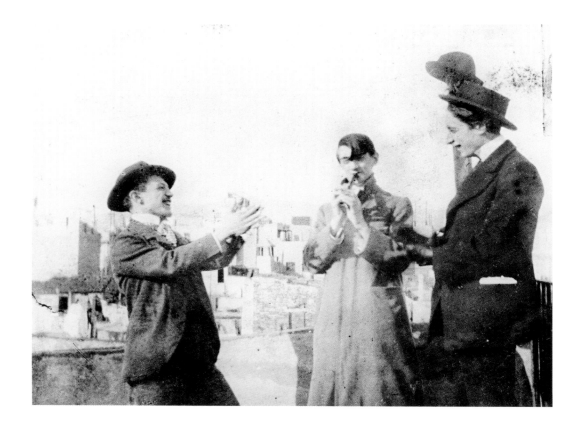

of his journey, his thinking, his reactions
and rebellions.

After a somewhat nomadic childhood, from
Malaga to A Coruña and then Barcelona,
Pablo had already chosen his path as an
adolescent: he would be a painter like
his father. But above all, unlike the latter,
he would be an artist. He passed the
competitive entrance examinations with
unblushing ease and entered the Barcelona
school of fine art. His father, disconcerted
yet fascinated by his son's outstanding
talent, then rented a studio for him in the
Calle de la Plata, close to the family flat.
At a very early age, Pablo was already
displaying an anticonformist character
and he drew far more nourishment for his
painting from his surroundings than from
the academic tuition. He could not easily
be satisfied by what the school tried to
teach him methodically: he had already

mastered all those techniques. He decided
to move to Madrid, alone – and he was
only sixteen years old. His father enrolled
him on a course at the Royal Academy of
San Fernando. Pablo, however, preferred
to study the masterpieces of the Prado
museum, *in situ*, and to amuse himself by
seeking the dubious pleasures of the seedy
areas of the capital. Later, after discovering
the meaning of the word 'freedom' at Horta
del Ebro, he would frequent the cafés of
Barcelona, the only havens for free spirits at
that time. The trend was towards anarchist
thought – a daily provocation, and very
dangerous, in a rigid, monarchist Spain with
little tolerance for any modernist deviancy.
There Pablo experimented with freedom,
and developed a courage equal to anything.
Barcelona, as the nineteenth century drew
to a close, was industrialising. Before the
very eyes of the young painter, a substantial

urban proletariat was coming into being, also testifying to the chronic agricultural stagnation from which Spain was suffering. This situation engendered mounting social unrest, already revolutionary in character, and frequent strikes. Anarchism found fertile soil there – and was bloodily repressed: the Republic, a taboo word, was still far off. Another subject of burning interest was Catalan independence. Gradually, discussions around the café tables of Els Quatre Gats led to Picasso developing his own political awareness.

At the time, he followed the leftist trend supported by his comrades, who scorned bourgeois art and were radically opposed to the Sant Lluc artists' circle, a 'respectable haven for academic painters, good Catholics patronized by the Church, the State and businessmen of high standing',[48] as Patrick O'Brian emphasises. Ideas jostled in Pablo's head, making the reaction that he was preparing to express on canvas so much the more violent.

The fact is that, while Pablo accepted anarchist postulates, he was nevertheless conscious of reality, sometimes far removed from the fantasies of café debate. Yet he knew that though it might be remote from political action in the ordinary sense of the term, art was a formidable weapon. Confronted with the 'system' and its injustice, with the 'system' and its rules, art must be the liberating antidote!

Isidre Nonell was a Catalan painter who took an interest in dropouts, gypsies and beggars. He exerted a definite political influence on the young Pablo. In 1900, they were both involved in the magazine *Pèl y Ploma*, established by Miquel Utrillo. Its purpose was to chronicle the development of painting and literature at the turn of the century. This avant-garde Spanish magazine took its inspiration from the Paris magazine *La Plume*, fought academicism in all its forms and kept its readers abreast of the different movements in modern art. Barcelona was not only a city in the throes of industrial expansion, it was also the capital of new ideas in matters of literature, philosophy, music, painting and architecture. The 'modernist' intellectuals of the Quatre Gats took the young prodigy under their wing to such effect that, as Raymond Bachollet remarks, 'for some ten years, the city [would be] his training ground and experimental zone, but also a protective cocoon, a sort of base camp, from which he would launch his various expeditions to Madrid and Paris, and to which he could retreat in case of difficulty'.[49]

Paris, he thought, was where everything was born and played out. The French Revolution had taken place barely a hundred years before, but it was at least a century in advance of Spain. At the Quatre Gats, the authority of those who had been to Paris was palpable. They had seen the other side! Pablo visited the French capital for the first time in October 1900 with his friends Casagemas and Pallarés, on the occasion of the Universal Exhibition. He was among the 'academic' representatives of Spain: however, in Paris, he discovered a

community of Catalans – Casas, Utrillo, Fontbona, Isern, Pidelaserra, Junyent and others. It was also the occasion for his first encounters with the 'modern' art market and its new proponents, such as the Catalan Manyac, a very useful intermediary and translator, and Berthe Weill, the latter's principal client.

After this short stay in Paris, Pablo returned to Barcelona to celebrate Christmas with his family. Then he moved to Madrid, with a project, shared with Francisco Soler, for a new magazine, the general character of which was inspired by *Pèl y Ploma* and of which he was to be artistic director: he named it *Arte Joven* (literally, 'Young Art'). He had certainly fully grasped the advantages of a press medium to spread new ideas much more rapidly, and to serve as a vehicle for his own vision of modernity. What were the published objectives of this magazine? 'Repudiation of traditional models, rejection of the bourgeoisie, with its hypocrisy and its taste for appearances, a determination to make use of mockery, to choose popular subjects, and to paint the wretched, the sordid and the grotesque.' Other contributors to *Arte Joven* included the writer Miguel de Unamuno, the poet Cornuti, the poet and sculptor Alberto Lozano, the essayist Azorín (who invented the expression 'generation of 98'[50]) and a few other bold spirits. Their approach was ambitious and generous, but the difficulties of the task soon overcame their initial enthusiasm, and the magazine ceased publication after its fifth issue.

During these vital years, Picasso constructed his own dialectic of a man of the left, which would permanently guide his political career. From the idealism of a young man eager to solve the world's problems, he would move towards the realism which would enable him to reconstruct this world through art. Some have tried to simplify his political commitment, deciding that he had been 'persuaded' of the rightness of communist ideas at the end of the Second World War. This is mistaken. His long intellectual progression provides sufficient evidence that the theses of communism came closest to his political ideal, but that they were not its starting point.

Back in Paris for good in April 1904, Pablo, as we have seen, encountered the greatest material difficulties in his life. Logically enough, the paintings of his 'blue' period reflect this suffering and, their subjects apart, constitute a faithful representation of his day-to-day reality. He saw the misery of the people. It became part of him. Even the period that followed, happier, more 'rose-coloured', does not remove him from this simplicity of ordinary people. He would go to the Médrano circus in Montmartre, and the Commedia dell'Arte, which inspired numerous paintings on the theme of acrobats and harlequins, but in the evening would also go to the Moulin Rouge, the Casino de Paris, or the music halls that were fashionable at the time. Thence, at this period, there emerges an erotic art, inspired by both his experiences and his fantasies, and far removed from the 'morals'

that Pablo would always handle with irony and daring.

With his first companion, Fernande Olivier, Pablo frequented the artistic circles of Paris. He made the acquaintance of collectors, and rubbed shoulders with avant-garde artists. He liked to patronise Le Lapin Agile and the bistros of Montmartre. In this way he made friends with Guillaume Apollinaire, André Salmon, Juan Gris, Marie Laurencin, Leo Stein. Gertrude Stein, Leo's sister, introduced him to Matisse – a pivotal encounter, which was to shape two lives, made up of give and take, competition and constancy in their differences.

This plethora of talents, this licence to be different within the group and yet to be in harmony, in a joyful alchemy, brought a 'human' response to Pablo's anxieties. He developed a personal conscience amid this multitude of influences, in which freedom was the common denominator. He engaged in fruitful dialogues with anyone, but easily retained control of the subject. It cannot be denied that he had a presence that impressed those around him, an intense blend of intimacy in conversation and indifference – an indifference that could sometimes be baffling. He would shift from one to the other quite tactlessly, but with no malice.

Pablo was beginning to earn a living. It would be going too far to say earn a 'better' living, what with difficulties in everyday life that are scarcely conceivable in France today. To us, the few surviving photographs of the Bateau-Lavoir seem picturesque. But behind this picturesqueness was cold and

hunger. The Bateau-Lavoir, built of odds and ends, was simply a reflection of the precariousness of people's lives. Yet they believed in it, all of them together, each in his own way. Hope is the first form of courage. At the height of his success, even when very rich, my grandfather remained a simple man, a man of solidarity, a man of the people. A man *for* the people, in a spirit of universality. communism appeared to him in its stated intention of bringing happiness to nations: he would believe it, like so many others. As the second decade of the twentieth century dawned, he could afford to buy basic essentials, and even allow himself a few extras. But he was deaf to the bourgeois siren song. He very quickly imposed his own methods on dealers. He hated parting with his works, and very soon he did not sell what he could, but what he wanted to. And here again, he overturned all the rules and set minimum prices.

But this does not mean that Pablo abandoned his anarchist ideals. Just as, in 1898, he had already given his support to the Cuban people, who were fighting to throw off the Spanish yoke,[51] in 1909 he took part in a demonstration in favour of Francisco Ferrer, 'Spanish revolutionary, ardent defender of secularism, executed by firing squad after a simulacrum of a trial'.[52] To Pablo, protesting against the execution of Ferrer was symbolic of the fight against 'black Spain'.

He was far from indifferent to all that happened outside his studio. He read the press, and in the various photographs taken

at different times in his life, a newspaper is always to be seen laid down beside him or his easel. *L'Excelsior* or *Figaro* – later on *L'Humanité* or *Lettres françaises* – these do not serve as substitutes for a palette or as the trivial details visible in some of his works; they were read attentively, sometimes subverted or deliberately incorporated in a work to endow it with a specific meaning.

When, in 1912, Pablo started to patronise the Café de l'Ermitage on the Boulevard Rochechouart, close to his new studio, he quickly joined in with the futurist movement. He was beguiled by this group of Italian writers and painters who had been heralding a revolution in art since 1909. But the Futurists had no political legitimacy: their movement was founded on art alone. In it, Pablo found tricks of style rather than any conviction.

Because he was Spanish, and Spain was neutral, he took no part in the war in 1914. In a deserted Paris, where he watched, powerless, as Eva died and his friends came back wounded, Pablo moved in a world far away from the sphere of military action – which, in any case, he considered futile butchery. But continuing to paint is in itself an act of resistance, as has been stressed by the art dealer Daniel-Henry Kahnweiler, an immigrant of German origin, who had his gallery seized and the greater part of his collection dispersed at low prices to destroy the value of 'modern' painters.[53] Similarly, accepting Cocteau's invitation to work with the Ballets Russes was a revolutionary

action. In Picasso, the political animal always slept with one eye open: even under the appearance of well-ordered, bourgeois life imposed on him by Olga, there slumbered the rebel of painting, the warrior champion of pacifist ideals. That said, since October 1917, she too had become an immigrant in France and henceforth would share the same feeling.

In early 1925, Pablo was wavering between the intellectual awakening of the militant and the artistic daring of the adulterous lover. He would quickly adopt both courses. His new friends now were the surrealists, led by André Breton. The author of *Clair de terre* became a stimulating partner in discussion, and a spiritual guide. Throughout his political career, in Barcelona, Madrid or Paris, when he was moving in cubist, futurist or, last of all, surrealist circles, Pablo, though he never really admitted it, felt a need to espouse ideals, a wish to belong to a group and be part of a community that would be artistic and at the same time political. The eternal outsider liked to be aware of others around him, but also to distance himself so as to progress.

The international events of the 1930s, first in Spain and then in the whole of Europe, were to make a deep impression on him. Pablo the pacifist, the man of the left, could not bear to see Spain fall into the hands of the fascists. In 1932, he signed the 'protest against the indictment of Aragon on charges of "incitement to murder for purposes of anarchist propaganda" after the publication of *Front rouge'*.[54] In April 1935, he sent a

telegram to Hitler asking him to spare the lives of Albert Kayser and Rudolf Klauss, two German antifascists condemned to death. The war would lead him to commit himself more than ever before. His appointment to the management of the Prado museum, on 19 September 1936, was proof enough of the interest that the Republicans took in his work and its influence. Picasso was a mentor. No doubt it was also a manoeuvre whose importance Pablo had not yet grasped, any more than he had grasped his own importance – and the weapon, the issue that artists and intellectuals had now become in political debate.

Picasso reacted by instinct. Gérard Gosselin gives a perfect description of his action in a time of emergency: 'As honorary president of the France-Spain Committee, he came to the aid of the Spanish Republicans, signed petitions, issued appeals, subscribed to collections, sold works for their benefit. The photos of battles, especially those by Robert Capa published in *L'Humanité*, *Ce soir*, *Vu* or *Regards*, descriptions of the bombing of civilians and the atrocities committed by Franco's partisans influenced his creativity.'[55] Encouraged at that stage by Dora Maar, Pablo took the full measure of activist commitment. He published *The Dream and Lie of Franco*, a sort of strip cartoon of these tragic events, in which he supported the Spanish Republic without heeding the very real danger to which he might be exposing himself. The work is in fact a surrealist poem illustrated with etchings of the horrors of war – slaughtered women, burning houses,

and a monstrous shape that must represent Franco. A set of illustrations expressing the hideous chaos, the madness and cruel absurdity of war, the total rejection and the disgust that Picasso felt for war and rightist values, it is his most explicit denunciation of the horrors of the Spanish conflict.

Yet he would also proclaim for all to hear: 'I am a royalist. In Spain, there is a king, and I am a royalist.'[56] This was a way of answering silly questions, according to Pierre Daix, just as, when people started talking about 'negro art', he would retort, conclusively: 'Never heard of it!'

His political commitment translated not into words but into action. The archives show numerous sums of money paid to the National Committee for Spanish Relief, especially at the end of 1938 and the beginning of 1939. He also initiated the organisation of two food supply centres for children, in Barcelona and Madrid. For these, the artist who so much hated parting with his works did not hesitate to put a number of them on sale.

At the moment of the terrible bombing of the little Basque town of Guernica, on 26 April 1937, Dora Maar was with Pablo. She was the one who got things moving: their love was a 'militant' liaison. They stood together in the face of this tragedy.

To those who were spreading a rumour that he was a reactionary artist, committed to the right, his reply, with some 'editing' by Dora, was: 'The war in Spain is the battle of the reactionaries against the people and against freedom. The whole of my life as

an artist has been nothing but a continual struggle against reaction and the death of art. In the panel that I am working on now, and which I shall call *Guernica*, I express very clearly my horror of the military caste which has dragged Spain down to sink in an ocean of pain and death.'

This action laid the foundations for a commitment which would grow unceasingly from then on. *Guernica* was presented at the Spanish pavilion of the Paris Universal Exhibition on 12 July 1937. The Exhibition had opened on 24 May, with the German and Soviet pavilions opposite each other and oddly similar in their 'monumentalism' and military severity. *Guernica* created a striking contrast – incredibly, the Spanish Republicans would deplore its lack of 'popular realism'.

After the Universal Exhibition, Pablo agreed to lend a set of works, including *Guernica*, for the organisation of an international tour, the profits of which would be used to welcome and assist Spanish refugees in France.

Thus the fresco would be exhibited in Sweden (1938), London and Manchester (1939), and at the Valentine gallery in New York, in May 1939, before being included in the important retrospective at the Museum of Modern Art, which kept it in store at Pablo's request, thus probably saving it from destruction.

At the same time, events internationally were gaining pace. Germany annexed Austria in March 1938. France played the waiting game. Malaga was besieged. Barcelona, bombed by the Germans and the Italians, finally fell into the hands of Franco's forces in 1939, followed by Madrid in March, just as Hitler entered Prague.

Pablo, having lived in France for nearly forty years now, was torn between his French head and his Spanish heart. But in the storm that was sweeping across Europe, what did geographical origins matter? It was important that voices should be raised – including his. Thus, as Patrick O'Brian observes,[57] Picasso was reproached for having introduced a work of propaganda into art with *Guernica*, as propaganda could not be art – art should have nothing to do with politics, or with morals!

This was not Picasso's view. He would say: 'Artists who live and work with spiritual values cannot and must not remain indifferent to a conflict in which the highest values of humanity and civilisation are at stake.' It should be added that even if his initial reaction was to adopt a proselytising position, the humanist dominated the political man: though he might be a Republican militant, he was first and foremost a militant for peace. The bombing of Guernica was like an electric shock: the 'massacre of the innocents' of our time. The necessity of asserting his pacifist convictions took the form of a painted manifesto against Franco's party and its allies. A response appropriate to the circumstances.

Tomato Plant, 7 August 1944, oil paint on canvas, 91×71.8, private collection. This work, which was owned for a time by the dealer Paul Rosenberg, was sold by auction at Sotheby's in November 2012.

The Spanish Civil War was a rehearsal for the Second World War. This was a time for either defiance or submission. Pierre Daix told me that Pablo forgave those who, like Jean Cocteau, had associated to some degree with the Germans; but he would never forgive those of his friends who had collaborated actively with Franco's people – André Salmon or Max Jacob, for example. The latter, who had written a number of very ambiguous poems, 'got the telling-off of his life from [my] grandfather, who never forgave Salmon, or Dalí either. For people who were on Franco's side, it was final!' (as Pierre Daix told me once).

In March 1939, Pablo, together with Jean Cassia, Louis Aragon, José Bergamín and Georges Bloch, signed a petition to save the Spanish intellectuals who were being held prisoner in the French camp of Saint-Cyprien. And after the fall of Barcelona, he took in his Vilató nephews, who had fought on the Republican side and fled; indeed, he helped a large number of Spanish refugees in the same way.

Doña María died in Barcelona in January 1938, at the age of eighty-three. Despite his unshakable attachment to his mother, Pablo did not go to the funeral because Franco's forces entered the town at the same time. He made the irrevocable decision that he would never set foot in Spain again as long as Franco was in power. And he kept his word: he was never to return, as he died two years before El Caudillo.

The great retrospective by the Museum of Modern Art that opened in New York and was then taken on tour to the largest American cities brought my grandfather extraordinary international fame. The United States found in Picasso an energy and a freedom that echoed their fundamental values. He was now celebrated for his political commitment as much as his aesthetic revolution.

Nevertheless, despite numerous incentives to flee abroad, Pablo stayed on in the gloom of occupied Paris, in the little flat next to his studio in the Rue des Grands-Augustins. He had already forsaken his native land once, and had no intention of abandoning France at a time when she needed support.

A few months earlier, he had come across Matisse, who was hesitating over whether to leave for Brazil – he eventually settled in Vence – and magnificently summed up his opinion of those responsible for the defeat of 1940 with the words: 'Our generals are no better than the School of Fine Art!'

Pablo at that time was the most emblematic, and the most embarrassing, of Franco's opponents. His papers were in order and he had nothing to fear legally – apart from the fact that Vichy could organise his repatriation to Spain for 'discretionary' reasons at any time. Thus he lived in continual fear of being escorted to the border. All the more so since, as I have already mentioned, he had a police record ever since the episode in Barcelona, when he had consorted with anarchists.

While he was in Royan, at the beginning of the war, a painter had asked him: 'What are we going to do with the Germans at our

heels?' And my grandfather had answered: 'Exhibit!' In fact, compromised as he was in spite of everything in the eyes of the Germans, he was formally prohibited from exhibiting in Paris. He put most of his paintings in two armoured vaults at the National Bank of Commerce and Industry, on Boulevard des Italiens, Paris, for safety. Matisse had an adjacent vault. By a subtle manipulation, Pablo managed to defeat the vigilance of the German officers responsible for checking the contents of the bank's vaults: he put his own works in Matisse's vault, and vice versa, so that when they were inspected, each of the two vaults apparently contained nothing but trifles – just a few canvases of that 'degenerate' art which the Germans considered of no importance.

In a prevailing climate of insecurity and want, he went back to work, in particular to sculpture, despite the severe shortage of all the basic materials: clay, plaster and, of course, bronze. Shut away in his freezing studio, he still held his head high: 'This was not the time for a creative artist to fail, retreat or give up working,' he would later say, and he embarked on 'organised' artistic resistance. Above all, he had to ensure the protection of his two 'families', who depended on him – Olga and Paulo, Marie-Thérèse and Maya. He could not afford to put them in danger, or even at risk. Free but at the same time a prisoner, he conducted a policy of 'committed wait-and-see'. He turned his art into a medium of resistance, the only way he could combat the German oppressor. To leave a trace:

emaciated women, still lifes of wretched meals, sculpted skulls. His *Bull Skull, Fruit, Pitcher* or the daring *Dawn Serenade* (a transposition of a romantic work by Titian into the Nazi prison system) in 1942, *The Death's Head*, *The Pitcher* and the celebrated *Man with a Lamb* the following year: his works during the Occupation are harsh, morbid – testimonies to a reality from which he could not free himself.

In December 1942, Hitler ordered the arrest and deportation of all Jews and 'other enemies' of the Reich – communists, freemasons and gypsies. Max Jacob was sent to Drancy, where he would die in 1944; Kahnweiler, wanted by the Gestapo, hid in the 'free zone'. In the autumn of 1943, Picasso received a letter from the German authorities (specifically, the German work allocation office) requiring him to report for a physical fitness examination prior to leaving for Essen for compulsory work service.[58]

No one knows by what miracle he managed to escape – probably intervention by the German sculptor Breker, idolised by the Nazis. On several occasions, too, the former deputy director of National Security, André-Louis Dubois, had to help him to overcome the administrative difficulties resulting from his alien status without going through the Spanish embassy.

The Occupation authorities missed no opportunity to pay him a visit. Pierre Daix relates: 'Warned by Dora Maar in January 1943 that the Gestapo were in his home, he [Picasso] arrived at the Rue des Grands-Augustins just as the Germans were leaving.

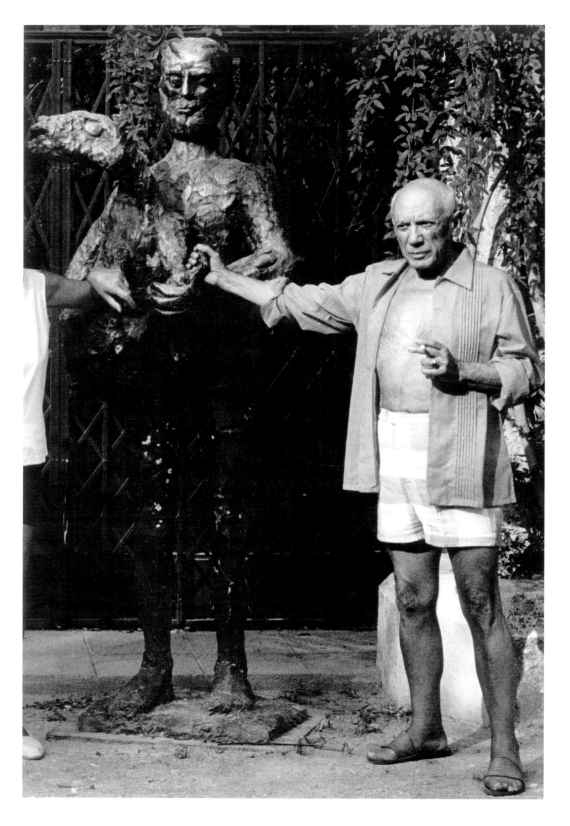

"They insulted me," Picasso told her, "They called me a degenerate, a communist and a Jew. They put their boots through my canvases."'⁵⁹ He had to be continually on his guard. Even so, he managed to renew his alien's card. In his memoirs, Dubois relates that Picasso did not remain detached or inactive in the face of threats: 'They [the fascists] have given us the pox,' declared Pablo. 'Lots of people are infected, even if they don't realise. But it'll show up! And those poor people, all those poor people! Are they going to throw them to the lions? Well, they won't take just anything and just anyone. They'll stand up for themselves. There will be strikes, and when that happens, am I just to watch from my balcony as if I was at the theatre? No, it's out of the question. I shall be out in the streets with them.'⁶⁰ And he was out in the street for the Liberation of Paris. On 25 August 1944,

General Leclerc's troops entered the capital. Pablo was with my grandmother Marie-Thérèse in the Boulevard Henri-IV. As soon as the confrontations in the city had begun, he had left Saint-Germain-des-Prés and gone to the Ile Saint-Louis, in spite of the permanent threat of snipers. Maya, who was only nine years old at the time, remembers those days of chaos, when you had to be especially careful of cornered German marksmen positioned on the rooftops. She also remembers that she and Pablo cut out paper chains which they hung over the balcony of the flat later, when the shooting stopped, to welcome the soldiers who had liberated them.

Pablo and The Man with a Lamb, *at Notre-Dame-de-Vie, photographed by Lucien Clergue in 1965.*
Bull's Head, *spring 1942, leather and metal, Musée national Picasso-Paris.*

On that historic day, the most surprising thing was that large numbers of American soldiers wanted to meet Picasso. In America, he had become a symbol. Some of them had found his address on the Boulevard Henri-IV. 'When the Americans arrived,' my mother told me – her memories of this other 'landing' were always fresh – 'they started by photographing the latest work by Picasso. A big picture of me in my little red and white pinafore [the same picture that had pride of place in the dining room of my childhood home, in Marseilles] and an American helmet were arranged on a Spanish chair. The Americans thought it made a lovely photo: the American helmet on the chair and the painting by Picasso behind it.'

O'Brian also observes that 'the Liberation overwhelmed the whole of France with joy, and Picasso was as happy as all his other friends. Even so, for him it was the beginning of an imprisonment in his own myth and his banishment from the society of ordinary men, a sentence that would never be lifted for the rest of his life.' Picasso had escaped Pablo! His fame would swiftly grow out of all control. Françoise Gilot, whom he met in 1943, remembers: 'All at once, Picasso had become "the man of the day". In the weeks that followed the Liberation, you couldn't walk across his studio without tripping over the recumbent body of some young GI. They all came to see Picasso, but they were so exhausted that they had hardly reached the studio when they fell asleep. On one occasion, I counted twenty, dozing in different parts of the studio. To start with, most of them were young writers, artists or intellectuals: after that, it was tourists. Picasso's studio must have been at the top of their list of sights, up there with the Eiffel tower.'[61]

Very soon, the communists appealed to my grandfather to join the Party. After all, the Soviets had also contributed to bringing an end to the war and putting the Nazis to flight in Eastern Europe. In these days of Liberation, communism prospered thanks to energetically conducted pacifist propaganda: the collectivist experiment, it was claimed, brought happiness to the people. Many of Pablo's friends, mostly former members of the Resistance, had joined. The Popular Front of 1936 had left a taste of nostalgia behind it.

So Picasso turned to the communists. They were the ones who best embodied the ideals that he had always defended: liberty, equality and solidarity. 'I came to the Communist Party as you come to drink at a spring,' he said.

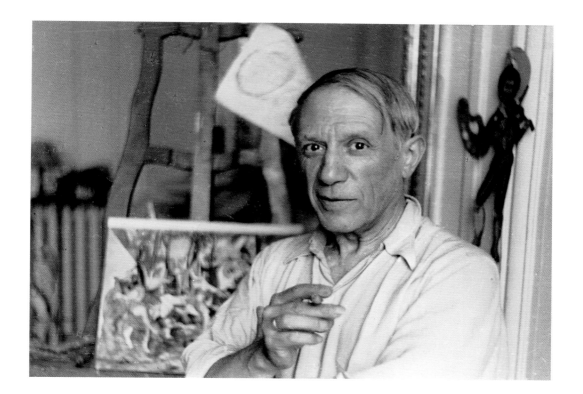

On 4 October 1944, he officially became a member of the French Communist Party. Marcel Cachin, editor of *L'Humanité*, and Jacques Duclos, secretary of the Communist Party, were delighted at this enrolment. Aragon, Eluard, Fougeron and Camus were also members of the PCF at this time. Pablo was being received back into a sort of intellectual family. No doubt he harboured the feeling – illusory and transitory though it was – of getting away from his status as the perennial outsider, of belonging to a group as in the old days when he used to argue things out with his friends at the Quatre Gats. He was not unaware that his personality, his work and his fame isolated him physically and psychologically. And this was not to mention the utopian dream, widespread as it was, of a new world order with nations freed from state frontiers. To him, communism was a form of Esperanto. *L'Humanité* devoted half its front page to his membership.

On 6 October, *Ce soir* reproduced a declaration by Picasso: 'We have just interviewed Pablo Picasso about the reasons that caused him to join the *"Party of the Executed"*. This is what he said: "During the days of the Liberation, I was on my balcony, when shots rang out. There were men firing from the rooftops, and others firing from the street. And as I did not want to be in the middle, I made my choice."' *L'Humanité* published another long interview with him on 21 October 1944: he was by then a recognised artist, represented in the great museums of the world – except in France – and particularly celebrated and appreciated in the United States, an invaluable propaganda asset for Soviet communism. 'Many people,' O'Brian recalls, 'were stupefied when he joined them [the communists]. According to the art dealers, this action was completely contrary to his interests: it was obvious that some American collectors would stop buying works

produced by a communist – and he was soon asked why he had become a member of the Party. Picasso replied, in an interview that he gave to Pol Gaillard for the New York magazine *New Masses*, and which was also published in *L'Humanité*: "I would much prefer to answer you with a picture, because I am not a writer, but as it is not very easy to transmit my colours by telegram, I will try to tell you in words. My membership of the Communist Party is the logical continuation of my whole life and all my work. Because, I am proud to say, I have never considered painting to be a mere pleasurable distraction; what I have tried to do with drawing and colour, since these are my weapons, is to penetrate ever further into the depths of knowledge of the world and of people, so that this knowledge may liberate us a little more every day. I have tried to say, in my own way, what I hold to be the most true, the most just, the best; and naturally, this was always the most beautiful: the greatest artists know this very well. Yes, I am conscious that I have always battled, by my painting, as a true revolutionary, but I now realize that even that is not enough; these years of terrible oppression have shown me that I should be fighting, not only through my art, but with my whole self, so I turned to the Communist Party without the slightest hesitation because, deep down, I have been with it for a long time ... I am back with my brothers."'[62]

He would return to this enthusiastic declaration more than once, qualifying it, for fear that it should be misappropriated.

According to Patrick O'Brian, 'Picasso provided a simpler, more personal, possibly more convincing explanation: "You see, I'm not French, I'm Spanish," he said. "I am against Franco. The only way to make this plain was to join the Communist Party and so prove that I was on the opposing side."'[63] Be that as it may, after the Liberation, he received support from the National Writers' Committee and a good number of intellectuals who understood his fundamental humanism. And at the end of 1944, he was nominated President of the Committee of Friends of Spain, which brought Spanish refugees and opponents of Franco together. For Pablo, it was the start of a new period of creativity. On the one hand, because he was now bringing his work to the attention of a majority of people for whom it was their first contact with the art of their epoch; on the other hand, because he was now trying his hand at drawings for the press, contributing illustrations very regularly to *Le Patriote*, a communist daily newspaper managed by Georges Tabaraud, first published on the occasion of the Carnival of Nice, in 1951. And for the periodicals of the Party, it was financial manna from heaven: 'The newspapers ... were self-financing, often through militant selling and subscriptions,' Gérard Gosselin explains. 'A Picasso drawing on the front page of *Le Patriote*, *L'Humanité Dimanche* or *Lettres françaises* immediately boosted sales. Lithographs made from these drawings, signed by Picasso and sold for the benefit of this press, constituted a significant financial resource.'[64]

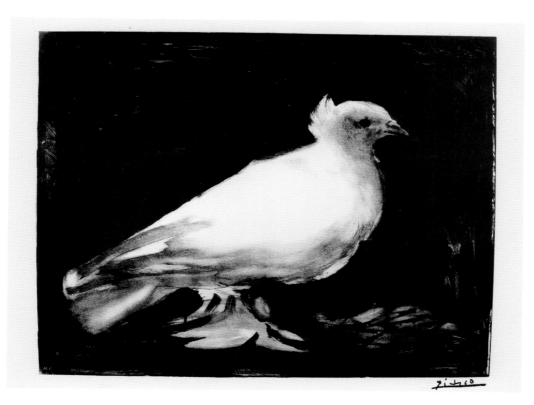

In June 1945, Pablo participated in the 20th congress of the French Communist Party. He showed his commitment by executing several portraits of Maurice Thorez, the leader of the Party. At the same time, his oeuvre is sprinkled with symbols of the political convictions that he defended.

Truth to tell, his canvases were not exactly in harmony with the aesthetics of the Party, which, officially, preferred the realist art preached by Moscow. But Pablo would always arrogate to himself the right to say and do what seemed right to him, and in his own way. Thus he executed three major political works: *The Mass Grave* in the spring of 1945, *Monument to the Spanish who Died for France* in December 1945 (exhibited, with *Dawn Serenade*, at the Art and Resistance salon of 1946) and, in 1951, *Massacre in Korea.*[65] In addition, between 1952 and 1958, he painted *War and Peace*, denouncing the ravages of war.

Since 1946, Pablo had been residing on the Côte d'Azur with his new companion, Françoise Gilot, and then their children, Claude and Paloma. In 1950, he received the certificate of honorary citizenship from the hands of the communist mayor of Vallauris, Paul Derigon. It should perhaps be recalled that the Côte d'Azur voted massively for the Communist Party at that period, like the rest of France. The Yalta agreement had officially recognised the Soviet regime, the Resistance had cleared it of blame for its errors, and equally for its horrors, and voting communist had become a perfectly ordinary thing to do. Pablo was much in evidence on the international scene at that time: in September 1948, he accompanied Paul Eduard to Wroclaw, in Poland, for the Congress of Intellectuals in the Defence of Peace, and spoke in support of Pablo Neruda, persecuted in Chile: 'Neruda,' he declared, 'has always supported the cause of unfortunates who demand justice. Today,

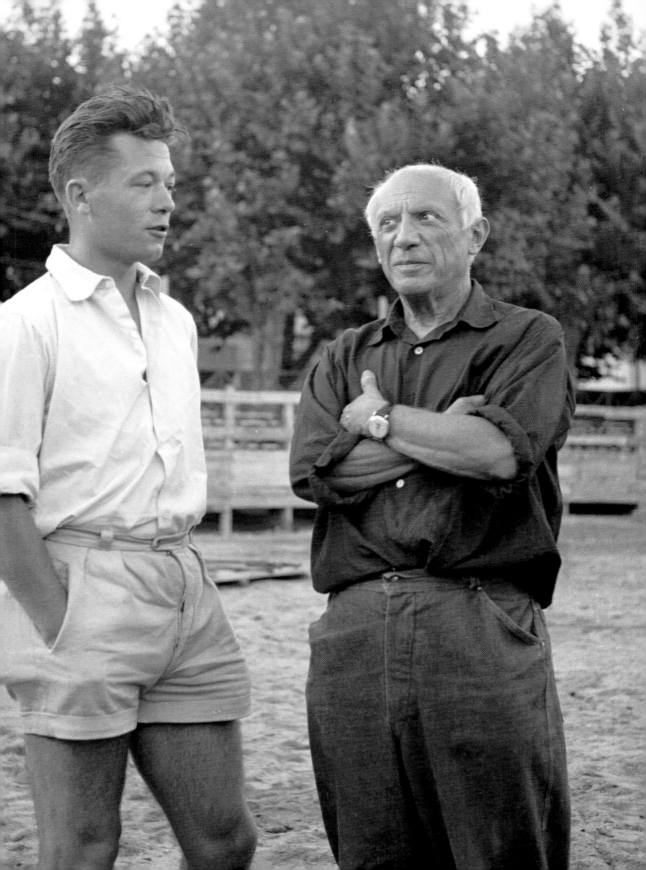

he is a persecuted man. Let us demand that Pablo Neruda should have the right to express himself freely wherever he wishes.'[66] He then paid a visit to the Warsaw ghetto, followed by that of Cracow, before going to Auschwitz and Birkenau. 'It was necessary to come here to understand.'

He did not return from his travels unchanged. He took up the very ancient symbol of the dove, the bird which fed Jupiter, the favourite bird of Venus, the same that announced the end of the Flood. He made it the universal secular symbol of peace, friendship and freedom. From then on, he created innumerable *Doves for Peace* – including the poster chosen by Aragon for the Peace Congress at the Salle Pleyel, Paris, in April 1949. And when Françoise Gilot gave birth to his second daughter, he named her Paloma ('Dove' in Spanish).

A year later, in October, Pablo attended the second Peace Congress, in England. The poster used the image of a dove again – on the wing, this time. In November 1950, he was awarded the Lenin Prize for Peace.

It took the death of Stalin to make a radical change to his position with respect to the Communist Party. And yet it was the Party that took this unfortunate initiative.

Until then, Pablo had been convinced, like so many others, of the perfection of the Father of Nations: indeed, he had drawn the famous *To Your health, Stalin!* at the time when Eluard and Aragon, too, were heaping praise on the leader of the Soviet Union in their poems.

So on that day, 5 March 1953, it was natural that *Les Lettres françaises* should ask him

for a portrait in homage to the deceased for the front page of the next issue. Picasso had never seen Stalin and knew little about him, but since the request came from Aragon, Françoise Gilot dug up a somewhat outdated photograph from an old newspaper. Without any preconceived notions, then, Pablo produced a portrait, quite true to life, and even flattering, since it rejuvenated Stalin. Reactions were legion. 'I had the revelation,' Pierre Daix reports, 'of a portrait of the young Stalin, strongly resembling a photo dating from 1903 or 1904. The execution was simultaneously naïve and astonishingly positive.' 'I saw the young Stalin,' says Aragon, 'with the Georgian cast of features extremely marked.' 'He did not deform Stalin's face,' Elsa Triolet adds, 'he even respected it. But he dared to change it – he dared!'

That was the whole problem: he had dared. He had dared to interpret the face of the god. And he had revealed an unexpected aspect of Stalin – more friendly without a doubt, less official, though still striking. But not at all 'realist'. The communist readers of the *Lettres françaises* reproached him for it. 'A portrait like this does not measure up to the stature of the immortal genius of him that we love best.' Of course, at this distance in time, we can afford to smile at such devotion – especially as Picasso's action had been entirely devoid of malice. Nevertheless, on the front page of *L'Humanité* of 18 March, the secretary of the Communist Party 'categorically takes exception to the publication in *Les Lettres françaises* of

12th March of the portrait of the great Stalin drawn by comrade Picasso'. And the directing authorities did not omit to administer a severe rebuke to Aragon, 'who struggles elsewhere for the development of realist art'.

The affair of the portrait almost became a political issue, and once more turned the spotlight on the realist trend which was encouraged by the Popular Front, and which became the official aesthetic of the PCF. This could not fail to wound Pablo. The incident was closed with the publication on the front page of *L'Humanité* of a photo of Maurice Thorez with Aragon and Picasso on 27 January 1954 to calm things down.

But Pablo was not going to forget. One day, when Aragon reproached him, in the same spirit, because his painting did not properly symbolise his adherence to the theses of the Party, he retorted: 'You just dress up in shorts, take your hoop and go and play in the Luxembourg gardens, but don't talk to me about painting – painting is my business, not yours!' A stinging reply that showed that Pablo's commitment did not stop at communist phraseology, and that even if he liked to feel part of a group, he did not feel bound by the words or decisions of anyone else.

From then on, he began to distance himself from the Party – all the more so because of the chaotic international situation. The Warsaw Pact, signed in 1955, was more a legitimisation of Soviet military presence in the people's democracies of the East than a riposte to the Nato agreements. This 'treaty of friendship, cooperation and mutual assistance'

revealed its true colours with the intervention in Hungary. On the occasion of the 20th Party Congress in the USSR, Khrushchev denounced the excesses of the Father of Nations. The French Communist Party preferred to remain Stalinist, which induced Pablo to be a co-signatory (together with some French intellectuals, including his friends Hélène Parmelin and Edouard Pignon) of a letter to the Central Committee of the PCF reproaching the Party and the daily paper *L'Humanité* for their silence on the repression in Hungary, and calling for an extraordinary congress. The Committee preferred not to reply. Pablo understood that he had come up against the limits of the system.

Out of loyalty, he conserved his Party card and his links with his political family, with its good and bad times; but he began gently to distance himself. At the beginning of the 1960s, he contented himself with seeing his Party member friends just to keep himself up to date. This 'red billionaire' lacking solidarity with 'the hope of the human race' that opponents of the PCF made him out to be, this time with a view to destroying the credibility of the Party in the eyes of the public, was no longer the out-and-out Communist, committed until his last breath. After being the PCF's great asset, he had become the unwilling instrument of its denigration. But what did it matter? He was now devoting his time solely to his painting, free again, and more so than he had ever been.

In May 1962, he received the gold medal of the Lenin prize, awarded by a committee

chaired by Aragon. It was the second time that Pablo had been honoured with the prize. This act of homage was at the same time an attempt by the Party to win him back and a gesture of reconciliation by Aragon. But it came too late. Pablo, who hardly gave any attention now to noises from outside, gave even less to things like medals.

A large number of ceremonies to celebrate his eightieth birthday had already taken place in 1961. But the major tribute came five years later in Paris. It was celebrated on 19 November 1966 with an exhibition at the Grand Palais (paintings), another at the Petit Palais (drawings, and especially sculptures, the real revelation of this event), and a third at the National Library (engravings). Malraux, the Minister of Cultural Affairs at the time, with whom Pablo had always had a rather awkward relationship, had entrusted the organisation to Jean Leymarie, curator at Grenoble museum and one of Pablo's close friends.

Pablo's communism had been an irritation to the right-wing government in power, especially to de Gaulle, a complete stranger to modern art. With the exception of a few privileged people – including Georges Salles, director of the Museums of France after the war, who would try to bridge the gap which he referred to as the 'divorce between the genius and the State', and Jean Cassou, director of the Museum of Modern Art, writer and former hero of the Resistance – Picasso was not on very good terms with the French cultural administration. That was why my grandfather lent hitherto unpublished work to the Petit Palais alone: this was administered by the City of Paris, and not by the central directorate of cultural affairs. He did not want to appear to be making any concessions to a government which had never thought to exhibit his works in any national museum.

It was symptomatic that no one remembered to send him an invitation. Furious, he fired off a telegram to Malraux: 'Do you think I am dead?' And the future author of La Tête d'obsidienne[67] replied: 'Do you think I am the Minister?'

The grand retrospective in Paris attracted nearly a million visitors. But, in parallel with all these honours, Pablo was forced to empty his flat and the historic studio in Rue des Grands-Augustins, witnesses to nearly forty years of his life in Paris. He was simultaneously sad and mad with rage. The administration was indiscriminately applying a general directive on unoccupied accommodation, and Pablo would never forgive Malraux.

As a further gaffe, an attempt was made to award him, automatically, the decoration of the Légion d'honneur, which he had never asked for. He politely refused it. In 1971, when Jacques Duhamel, the new Minister of Cultural Affairs, came to Mougins specially to offer him the same decoration with the title of Commander, my grandfather refused again: he had not forgotten his expulsion.

It was only with the arrival of Georges and Claude Pompidou that France made up for its phenomenal backwardness as regards modern art. The shortage of Picasso's works on the market and the absence of the necessary budget allocations made large-

scale purchases unthinkable. But as early as 1969, the President of the Republic had his eye on the payment in kind which would be likely to result from the Pablo Picasso Succession. The Malraux Law of 1968 had instituted this principle, decreeing that inheritance taxes could be settled by handing over to the State works of art or collector's items. Picasso would prove to represent its most brilliant illustration. In the meantime, it would be wise to pay Picasso political tribute commensurate with his stature (the Louvre museum was Pompidou's suggestion) for the painter's ninetieth birthday – an event aimed to reconcile Pablo with the French Republic. Nevertheless, it came too late. His

independence of the political world was henceforth total, and sincere. He did not need the government or politicians to live. Any more than he needed the communists: it was through Roland Dumas, his lawyer, that he thanked his comrades for the solemn tribute that the Party had paid him, with a poem read by a very aged Aragon, infused with official regrets.

Pablo's sole political act in his last years was inspired by the famous visit from Mstislav Rostropovich, when he came to Notre-Dame-de-Vie in 1972. Pablo was going to be ninety-one years old. He absolutely insisted that a photograph should be published of himself in the company of the great cellist persecuted by the USSR. It duly appeared in *Les Lettres françaises* on 10 October 1972, and bears witness yet again to his commitment to the cause of freedom, at the same time 'explicitly' demonstrating support of the weekly magazine, which had recently had its financial aid from the Party withdrawn for having supported intellectuals suffering harassment in the USSR. But Pablo's final political gesture would turn out to be posthumous.

In November 1969, he called his lawyer Roland Dumas, as he had just received two letters from his dealer, Kahnweiler, which had made him furious. The director of the Madrid museum of art had permitted himself, on the grounds of Picasso having supposedly declared that '*Guernica* belonged to the youth of Spain' to demand that the picture be sent to Madrid.

For Pablo there was no question of *Guernica* going to Spain as long as Franco lived.

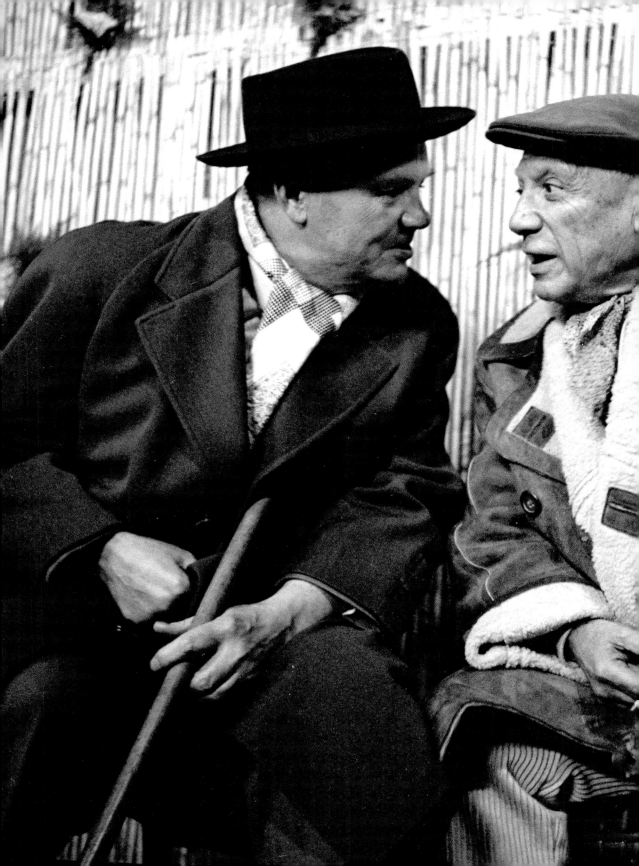

He had not bequeathed *Guernica* to the youth of Spain, but to the Spanish Republic. Uneasy about what might become of the work, he made his wishes clear to his lawyer on 15 December 1969: 'This picture must go to Spain, but not until the day when a Republican government has been re-established in my native land. Until then, this painting and the studies associated with it will remain in store under the guardianship of the Museum of Modern Art.' The lawyer prepared a text to be signed by Pablo and sent to MoMA. To avoid any possible future dispute, he astutely suggested that my grandfather should refer to the 'civil liberties' which had 'become a notion clearly codified in public international law' instead of a 'Republican government'.[68]

After Pablo's death, on 8 April 1973, when his will was going through probate, a text was signed by all the successors recognising that the painting did not constitute part of the estate. Franco was still in power. However, he died on 20 November 1975. Adolfo Suarez became head of government. Pressure began to rise, and at the highest level. The Republican refugees in France wrote every week to Roland Dumas to remind him of the moral requirement on him not to confuse a republic with a constitutional monarchy, while the Cortes, the Spanish parliament, passed a law in the autumn of 1977 demanding that the picture be handed over, citing the democratisation of the new state, now once more a monarchy. On 15 April 1978, the American Senate adopted a resolution, 'noting the return of democracy in

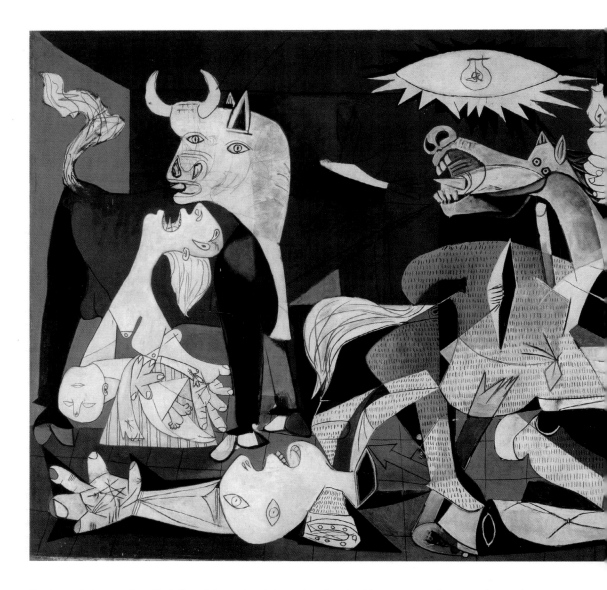

Spain and demanding that the picture should be returned to the people and government of democratic Spain in the very near future'. On their side, the mayors of many large towns in Spain claimed *Guernica* as the due of their municipalities. Roland Dumas secured an interview with Adolfo Suárez, on 19 February 1979. Also present were the Minister of Foreign Affairs and the ambassador Quintanilla. Official relations settled down.

Guernica, 1937, oil paint on canvas, 349.3×776.6, Museo Nacional Centro de Arte Reina Sofia, Madrid.

One last incident was to threaten the project for *Guernica's* entry – not return, since the work had never been in the country before – into Spain. On 23 February 1981, an attempted putsch gave reason to suppose that Spain's old demons were back. One Colonel Tejero, commander of the Civil Guard, fired several shots within the very walls of the Cortes, in front of the members of parliament and Prime Minister Suárez, who bravely remained upright in his seat. The Army and the King joined forces to defend the State. The putsch was aborted within a few hours.

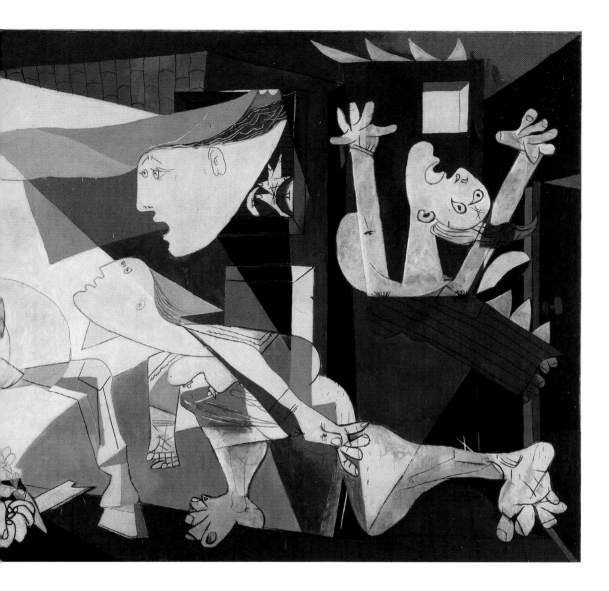

Thus it was the King, Juan Carlos, who managed to inspire Dumas' confidence, speaking very freely to him of the democratic renewals in progress. He had initially thought that the picture should go to the Basque country, as the victims of the bombing of Guernica were Basque. The lawyer then suggested a more unifying solution: 'I do not believe that it would be right to satisfy one section of the population rather than another on the occasion of an event of historic import. It is true that the Basques have claims, but the work itself has a far greater compass than the massacre of 1937.'

Jacqueline Picasso, Pablo's widow, recalled in March 1980 that Pablo had been nominated director of the Prado museum in Madrid (in September 1936), and confirmed that the painter had chosen Madrid as the home for *Guernica*.

At last, on 10 September 1981, after forty years in exile, the work that best symbolised my grandfather's whole political commitment ended its journey in Spain in the place for which he had destined it.

PICASSO AND THE FAMILY

'In the end, there's only love.' [69]
Pablo Picasso

PABLO'S CHILDHOOD

As soon as he was born, on 25 October 1881, in Malaga, southern Andalusia, Pablo was the family's little treasure. His father, Don José Ruiz Blasco, then forty-one years old, teacher of drawing but also curator of the little regional museum; his mother, Doña María Picasso López, twenty-six years old; and his maternal grandmother, Doña Inés Picasso: all were all in ecstasies. So were his two aunts, Eladia and Heliodora, who had come to live with Don José after their vines had been ravaged by phylloxera, and who had ever since been embroidering braid on the uniforms of railway employees.

In 1884, the family was further enlarged with the birth of a first sister, María de los Dolores, known as Lola, and then in 1887, of another, María de la Concepción, known as Conchita, who died of diphtheria in 1895, to Pablo's great sorrow.

It was in this tribe that my grandfather acquired his sense of solidarity, of belonging to a group, which he would seek his whole life long and would also communicate to his loved ones. The 'families' that he created around himself would have little of the traditional to them, but deep in his heart he cherished a nostalgia for that 'family of Spain', which would always be his refuge and, in a way, give him absolution for his escapades. Pablo was very superstitious, as we shall see in due course. The Spain of his childhood was a hotbed of superstitions, and, for him, respect for family traditions was the only effective protection against the evil eye. Through this attitude, he was able to obtain pardon for his 'bad' actions.

In 1891, the whole Ruiz Picasso family left the hot climate of Andalusia and moved to the north, to A Coruña. Don José, who had lost his curator's post in Malaga (of an empty museum, it must be said), was appointed teacher of drawing in a secondary school.

He drew a less comfortable salary, but little by little, material conditions improved. On the other hand, the Atlantic climate, very damp and windy, did not suit anyone, and in 1896 the family moved again – to Barcelona: Don José had had the unexpected opportunity to exchange with a colleague who wanted to move to A Coruña.

Patrick O'Brian gives a perfect description of Pablo's happy childhood: 'These early years were relatively carefree for a child who knew almost nothing of the struggle for life, and for whom the family's overcrowded, rather squalid flat was as natural as the brilliant, almost perpetual sunshine that flooded the square.' [70] Apart

from his father, Pablo was the only male in the family. Pampered by his aunts and his cousins, adored by his mother, he was a little emperor.

With his father, relations were more difficult. As he grew up, Pablo, who had always had the deepest respect for his father's work, began to realise that the latter had great difficulty in earning enough from his painting to support the whole household. To make matters worse, Don José, nearly fifty years old, had lost confidence in his own talent. 'The portraits that Picasso drew of his father reveal a tired, worn-out man, at the end of his strength, undermined by disappointment, often close to despair.' Their relationship was highly complex. Be that as it may, in 1901 Pablo signed himself without distinction 'P. Ruiz Picasso', 'P.R. Picasso' or simply 'R. Picasso', but from 1902 on, only 'Picasso' is found: he stopped using his father's name, a very unusual decision in Spain. At the same time, he always spoke of his father with affection and respect. In his 'Conversations' with Brassaï, Pablo makes an archetype of his father. 'Every time I draw a man, I automatically think of my father. To me, Don José is everything a man should be, and that will never change as long as I live.'[71] At the age of fifteen, Pablo went to the Barcelona art school, La Lonja or Llotja (in Catalan), as its pupils called it. His father rented a small room for him near the family flat. On his first day at the school, he met Manuel Pallarés, five years his elder, who would be his guide through his premature passage into adulthood.

Like any impatient adolescent, Pablo soon separated himself from his family. He eagerly explored other worlds, that of the cafés, where he found the company of artists and intellectuals, that of the brothels, where he quickly lost his innocence, and that of the museums, where he could at last contemplate the works of the masters. Each time, it was the opportunity for a frantic recreation of a new family around a community of original ideas.

FIRST ASPIRATIONS TO FATHERHOOD

Pablo's propensity to be satisfied with the love that money could buy persisted later on in Madrid. It was not until his second journey to Paris, where he settled in 1904, that he began to have a real love-life, at nearly twenty-three years of age.

In Paris, life was difficult. The family cocoon that he had always known was not there. Illusions were gone. Romances ended in nothing. From the first of his Parisian conquests onwards, he thought seriously about becoming a father: it was in 1904, with Madeleine, a rather flighty model. This first 'serious' affair, in spite of its libertine air, conducted discreetly over several months, culminated in a pregnancy which ended in a miscarriage. From this episode, in all its banality, sprang the splendid *Mother and Child* pictures of the 'rose' period, centred on a child that was never born. If Pablo was not a natural father, then he would be a

pictorial father who could not refrain from keeping quantities of his 'children'.

In August that year, he met Fernande Olivier. They were the same age. As their passionate relationship was gradually transformed into a life together, Pablo began once more, from September 1905, to think about having a child. According to Pierre Daix, he had been much struck by all the little babies he had seen in France, the way they were wrapped up and taken for walks, so different from Spanish customs. Unfortunately, Fernande had had an abortion which had left her sterile, as often happened in those days, the operation having been performed under deplorable conditions, with disastrous consequences.

This wish to have a child, in spite of their difficult circumstances, turned into a diffident desire for adoption. In April 1907, Fernande went to the orphanage in the Rue Caulaincourt and came back with a girl of twelve or thirteen, Raymonde, who was really an adolescent, and whose presence soon became a burden. Aware that she had made an error of judgement, Fernande took the girl back to the orphanage in July. Pablo was deeply shocked by this casual attitude, which provoked their first separation, while he was working on *Les Demoiselles d'Avignon,* in an emotional world in which feeling, compassion and suffering were the driving forces of his inspiration.

The separation did not last. Pablo made things up again with Fernande – a second attempt that was rather miserable but lasted a long time, from 1907 to 1912. During this period, Pablo devoted himself essentially to the discussion of cubism, in real artistic duels with his friend Georges Braque. Then he met Eva Gouel, at that time the girlfriend of the painter Marcoussis. If it was not love at first sight, it had all the markings of it. Their affair, which began with something of a sensual debauch, would remain Pablo's lost paradise for ever. Eva's illness put an end to all their plans. The woman who was perhaps his greatest love, possibly because their affair was so ephemeral, would never give him the joy of fatherhood. She died of cancer in December 1915.

OLGA AND PAULO

The profound sadness that followed Eva's death and the feverish desperation with which Pablo launched into a whole series of affairs with no future, pushed him back into an exploration of the mechanics of women – poles apart from any plan to found a family. This was the period of the Ballets Russes, *Parade*, Erik Satie and Cocteau. We know that Pablo went to join Sergei Diaghilev company in Rome in January 1917, and that he met Olga Khokhlova there. It was with her that he became acquainted with fatherhood, in 1921. His late development – he was now nearly forty – is explained by previous failures, and not by a desire to remain a bachelor or any egocentric complacency. Olga arrived like a good omen for Pablo, an antidote to misfortune. Duly respecting the preliminaries and proprieties

that were important to her, he married her in July 1918. Olga became pregnant in the summer of 1920, and little Paul, known as Paulo, was born on 4 February 1921.

All Pablo's paternal tenderness, so long repressed, could now at long last express itself in the most beautiful drawings and watercolours, in a complete breakaway from his previous endeavours. Not only did Pablo return to a serenity of form, but this neoclassical style greatly pleased his new dealers, Paul Rosenberg and Georges Wildenstein, who at last earned Pablo a lot of money, and encouraged him to make use of his talent as a portraitist. Hence all the evocative Paulo's: *Paulo in a White Cap* (1922), *Paul on his Donkey* (1923), *Paul Drawing* (1923), *Paul Dressed as Harlequin* (1924), *Paulo Dressed as Pierrot* (1925), *Paulo on his Rocking Horse* (1926), and so on. Paulo became the medium for a whole collection of traditional images. With Paulo, Pablo at last transposed the inspiration of his youth – academicism, acrobats, naïve themes – onto a being who was flesh of his flesh.

During their stay in Fontainebleau, in the summer of 1921, Pablo shared the soothing intimacy of Olga and the baby. Little by little, in that big house, the figurative evolved into extraordinary forms, monumental, almost statuesque. The small figure of Olga and her refined clothing disappears, giving way to impressive figures with stocky bodies and thick features, wearing simple garments, in a timeless world that was almost monochrome.

Very soon, however, the deterioration of his relationship with Olga inexorably turned Pablo away from Paulo. The boy, looked after by a nurse, was taken far away from his parents. Paulo, as he grew, was no longer a source of inspiration. He gradually faded out of the picture.

It has been asserted that Pablo saw nothing more in him than a characterless pretext for paintings. Or even an artistic rival, thus crediting Paulo with a superhuman ambition, inevitably doomed! But Pablo was proud of his first son: he had fun with him, drawing nourishment from his childish spontaneity. Paulo the child could not but be a perfect subject of inspiration for the artist whose first-born son he was. His paternity expressed itself in acts of love, and in acts of painting, which for him were one and the same. The photographs and films of this period which have come to light, and have recently been archived by my cousin Bernard, Paulo's younger son, testify to the happiness of this time for Olga, Pablo and their son.

In reality, although he did indeed cease to be a model for the artist, the principal cause was the geographical distance that came between them from 1935 (the date of Olga and Pablo's official separation); and also because subsequent themes – minotaurs, painters, soldiers and musketeers – were radically different from the realities of Paulo's life.

In addition, since 1927, another model had captured Pablo's attention: Marie-Thérèse. Pablo was a father, but above all a man and a truly inspired lover.

Olga had laid out a programme of daily life in accordance with her dreams and her sense of the respectable, making Picasso live in grand style, with a nurse, chambermaid, cook and chauffeur, to which he seemed more or less to have adapted himself. It was reflected in the education of his son. Little Paulo was therefore taught in style. Olga had decided that he should have a private tutor. He was dressed like a little prince, and had to stay well away from his father's studio, with its paint stains. In photographs by Man Ray, he can be seen looking straight at the camera, his hair neatly slicked down, a little cramped in his double-breasted suit, immaculate. Son of Picasso though he was, Paulo had a childhood which was indistinguishable from that of the son of a banker or a captain of industry. The trouble was that neither factory nor chief executive's office awaited him! Being the son of a painter was enough to set him apart from the social class of which his mother dreamed. Furthermore, being taught by a private tutor deprived him of any social environment and further contributed to marginalising him.

It was not until he was about ten that Olga consented to enrol him in Hattemer private school, in Paris. His general level was far behind that of his classmates, and he would never manage to adapt. When he was introduced to his half-sister Maya, after the Second World War, he told her sadly: 'You are so lucky to go to school!'

Olga's authority in the running of the house, social life and Paulo's education frequently ran up against Pablo's conflicting example. Absorbed in artistic creation in his studio on the floor above, he mostly saw his son at mealtimes – an opportunity for him to break the rules of good behaviour laid down by Olga, and to initiate his son in disobedience. Olga got cross, while the little boy loved it. The father drew closer to his son with each piece of mischief, each infringement of protocol.

He even installed a little electric train for Paulo in his studio – indescribably chaotic and a real incitement to crime, in total opposition to the precepts of Olga. It was probably here that they forged their relationship, in these breaches of the rules. Despite the strictness of his daily life, regulated to the last millimetre, here Paulo acquired the ease of manner that would be part of his charm later on.

In 1923, the portraits of Olga, including mother-and-child pictures, already reveal a face transformed, according to the habit subsequently followed many times by Picasso, of including the feminine inspiration of the moment. This particular muse, very attractive without any doubt, was called Sara Murphy. She was his well-known American friend, who had settled in Paris, daughter of an industrial millionaire and the wife of a fashionable painter. Pablo executed quantities of works in which the face of Sara or her daughter are more and more clearly identifiable, but he carefully abstained from making any mention of her in the titles that he and his dealers gave to these works. Already harassed by Olga's

Pensive Olga, 1923, pastel and black pencil, 104×71, Musée national Picasso-Paris.

jealousy, he persisted in giving the drawings his wife's name, despite all the evidence to the contrary.

1923 was the year when the inspiration of Sara was at its height, and that of Olga came to an end. It is probable, though, that the affair between Pablo and the rich American was never more than speculation – in spite of the interest in her that Pablo demonstratively displayed.

And then Pablo met my (future) grandmother, Marie-Thérèse Walter, in January 1927. It was time to regain the freedom that stimulated creativity. Olga's ideal of bourgeois perfection, which was certainly sincere, and which he had appreciated for some time as a real discovery, had stifled his instincts of independence. My grandfather needed to re-establish an equilibrium. He set up a double life.

Pablo petitioned for divorce as soon as Marie-Thérèse became pregnant. The main argument of Pablo's petition was that Olga, 'with her difficult character, made frequent violent scenes, rendering life impossible for her husband and preventing him from working or seeing his friends'. It was backed by statements from many witnesses. In almost daily lawyers' letters delivered by writ-server, Olga denied all the allegations made by Pablo in his petition, and used every possible means to hold up the proceedings. Pablo was mad with rage, especially when Olga had seals put on his studio as an official measure to make sure that none of his works could escape a potential inventory. In fact, this was more in the nature of moral pressure:

Olga still believed that by preventing him from working, she could force him to return home. An official enquiry into the couple's circumstances was ordered, in a second hearing by the Seine court on 15 April 1937, in consequence of Olga's challenges to Pablo's allegations. The enquiry and the counter-enquiry would not be carried out until the spring of 1938. Among the evidence gathered on this occasion, the testimony of Georges Braque in support of Pablo clearly revealed the tensions: 'When he came to see his friend Picasso shortly after his [own] marriage, the reception given him by his wife was such that he decided not to come again.' As for Jaime Sabartés, he recalls that Olga 'often came and pestered her husband at his home, insulting him in coarse terms either face to face or by telephone'. The non-conciliation order of 1935, however, had specifically prohibited her from acting in this way, and all Olga achieved by doing this and uttering threats in public, was to make her own situation worse and, unknowingly, strengthen the position of Marie-Thérèse, Pablo's peaceful refuge.

If Olga had been quick to accept the inevitability of this divorce, her life in the years that followed might have been easier. Pablo hated problems, and Olga was creating growing problems for him. Her unshakeable opposition to the divorce, combined with the continual scenes that she inflicted on those around her, led everyone to suppose that what she was clinging to was not a love that seemed highly implausible, but her status as 'Madame Picasso'. And the importance of that status outweighed

all the material advantages that she could have gained from an official separation. Olga knew that there would have to be a division of all the assets of the household, therefore including the pictures – or at least their commercial value. But neither of them ever mentioned this point throughout the proceedings. Olga wanted to stay married; Pablo wanted his freedom. In the end, they would both get what they wanted. But the theory that Pablo wanted to avoid divorce for sordid reasons of money or the division of his works is without foundation.

My cousin Bernard has also drawn my attention to a distressing fact. When Pablo decided to divorce in 1935, Olga found herself alone. Admittedly, she was Pablo's wife, but she was also a Russian émigré whose circle of friends was primarily a social circle. Her world crumbled about her. She had no close family, because her only relatives had been swept away by the revolution in Russia and she had never seen them again. All this undoubtedly affected her sanity.

On 25 October 1941, despite all Olga's stalling tactics, and after the long soap opera with all its twists and turns, the Paris court of appeal confirmed the official separation. It was Pablo's birthday, and he got his present – his freedom. But Olga's obstinacy had its consequences: Pablo, still legally married, could not marry Marie-Thérèse or acknowledge their daughter Maya. Later on, he would no more be able to marry Françoise Gilot (whom he met in 1943), or acknowledge their children, Claude and Paloma.

As for the teenage Paulo, his initiation into adult life took place out in the street, to get away from the house where his parents were continually expressing their anger until their separation in 1935. Jacques Prévert, his father's poet friend, often took him in after his wanderings in Pigalle or excursions to Saint-Germain-des-Prés. He thus avoided receiving yet another scolding from his mother. Paulo was big for his age; he could fool everyone around him and associated with people older than him. Even Braque took a liking to him, and they stayed friends. They both had the same passion for motor cars.

Paulo was the one who was most exposed in this maelstrom of antagonistic desires. He was torn between his parents, especially when, after the war, Olga took it into her head to follow Pablo everywhere and insult him publicly in his presence. 'During the summer of 1947,' recounts Françoise Gilot,[72] 'every time we went to the beach (her son Paulo often came with us), she [Olga] would come and sit down close to us … When I went out with Claude, Olga was never far away, threatening us and accusing me of stealing her husband.' Pablo also received almost daily letters of reproach and insult, monotonous, obsessive litanies on the recurring theme: 'You are not what you were. Your son is a good-for-nothing, too, and he's going from bad to worse. Like you.' The scandals that Olga created in public inevitably estranged Paulo from his mother. He, too, had to put up with her scenes. 'She [Olga] would go on at Pablo,' Françoise Gilot remembers, 'and he would pretend not to

hear and would even turn his back on her. So then she would turn to Paulo: "Listen, you know perfectly well that I'm here and I want to talk to your father. I must speak to him. I've got something very important to tell him" Paulo would appear not to hear her.'[73] At that time, Pablo and Olga had been officially separated for more than twelve years. Thus, through the actions of his mother alone, Paulo suffered the prolongation of the heart-rending events of his childhood. In 1949, he gave her a grandson, Pablito, born to his companion Emilienne Lotte, whom he married the following year. A granddaughter, Marina, was born in 1950. The divorce proceedings between Paulo and Emilienne, begun in the spring of 1951, destroyed any chance of a reconciliation between Olga and Pablo, although they shared the same eldest grandchildren and the same daughter-in-law. Oddly – and there seems to be no explanation for this – the operation for the division of Pablo and Olga's assets never took place, after the supreme court's judgement of 1943. Certainly, the war did not help, and neither did the fact that Olga resided in Switzerland until the end of the conflict. But she did nothing to force Pablo to act. A division of assets would imply acceptance of their separation. And in 1948, she was still keeping up the pretence that she was living with her husband.

By an irony of fate, if Olga had asserted her claim to half the couple's assets (that is to say, for practical purposes, half of Pablo's works made until their legal separation), Paulo would have inherited 'directly' on his mother's death in 1955. The relationship between Pablo, his son Paulo and the latter's children, Pablito and Marina, would then have been completely altered. Failing that, as the couple had been separated but not divorced, Paulo, as his mother's heir, could have laid a legal claim to his mother's share of the assets in 1955. He took no steps in that direction. It was a fact that Paulo was particularly fond of his father, and would never have thought of stripping him of half of his oeuvre.

If Olga remained Madame Picasso for ever, she had lost Pablo for good. Appearances had been kept up, but that was all. Pablo would keep all his works, even if, when he decided on divorce, he had tacitly accepted in advance that he would have to part with some of them. He paid Olga's allowance – and many other occasional expenses – automatically. Olga did not move into the Château de Boisgeloup, of which she had the use, but lived in one hotel after another, as she felt inclined, always at Pablo's expense. At the end of her life, she settled in Cannes, in the Beau-Soleil clinic (76, Boulevard Carnot). From there she wrote to Pablo regularly, often by telegram, as if they had parted only the previous day, asking him to take care to pay the medical fees. He never replied, but he paid the bills.

It is probable that he also felt responsible, if not blameworthy, for the childhood that he had contributed to giving his son. He accepted the burden, come what may, and never ceased to provide for all Paulo's needs. A peculiar dialogue developed between them, composed of things left unsaid.

MARIE-THÉRÈSE AND MAYA

My mother Maya was born on 5 September 1935, at the Belvédère clinic in Boulogne-Billancourt. In the register of births, she appears as María de la Concepción, in memory of her father's sister who had died. The customary diminutive is Conchita, but María very soon became Maya – in imitation of the little girl herself who couldn't pronounce her own first name properly. Olga retained custody of her son; Pablo consoled himself with the adoration that he lavished on his daughter. If Maya had not existed, Pablo would certainly have suffered from the absence of Paulo. For good or ill, Maya took his place. With her, every moment was a marvel. For my grandfather, who was fifty-four years old in 1935, life with Marie-Thérèse and Maya was truly a rejuvenation – a return to simple living, free of constraints, with no receptions or fashionable balls. Since the mid-1920s, his participation in the surrealist movement had taken place in the discomfort of a married life in contradiction with his artistic set. The 'Marie-Thérèse period', which started in 1931, marked Pablo's return to the closely related fields of emotion and creation. He himself had probably too easily accepted the society life into which Olga and their friends had drawn him. He had been flattered by it for a while, until he lost contact with the real world. He alone was responsible for this loss of reality. He had lived according to appearances; he was no longer the prism, but only a reflection.

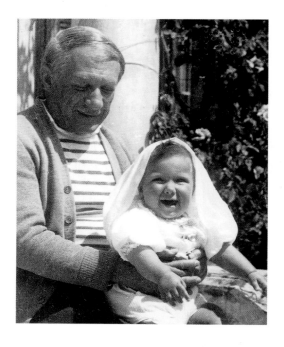

Just as he had dressed his little son in paint fourteen years before, so now his tenderness for Maya is reflected in his canvases as much as in his poems and letters. Writing had replaced painting for the few months in 1935 when he was denied access to his studio. My mother has masses of these intimate pieces of writing which make nonsense of the reputation for heartlessness that has been alleged against him. Brigitte Léal describes Maya, in company with Pablo, as a 'radiant child overflowing with energy, with her mother's blond hair and blue eyes, but looking strikingly like him [and] who would always be his most faithful ally. ... While Maya was a small child, he kept a sort of continuous

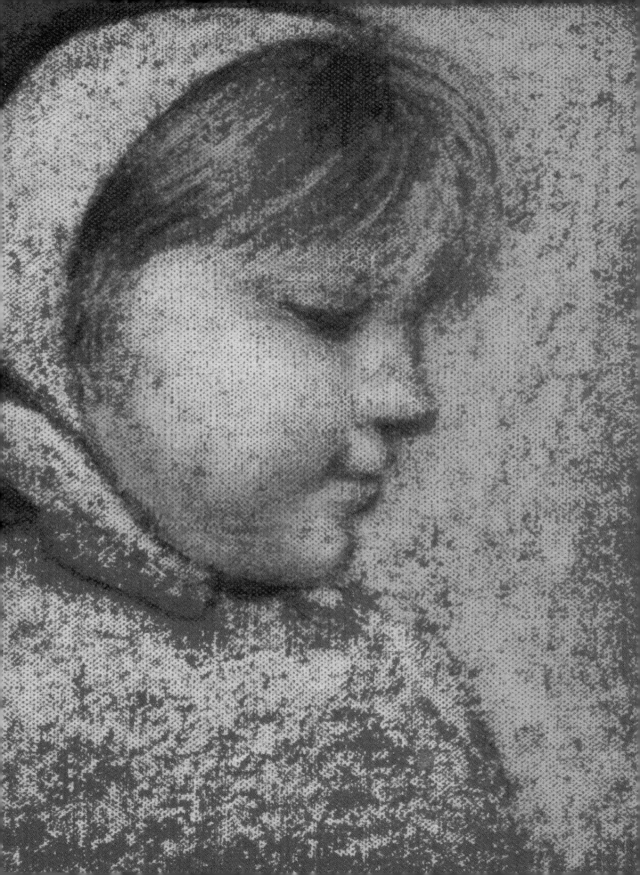

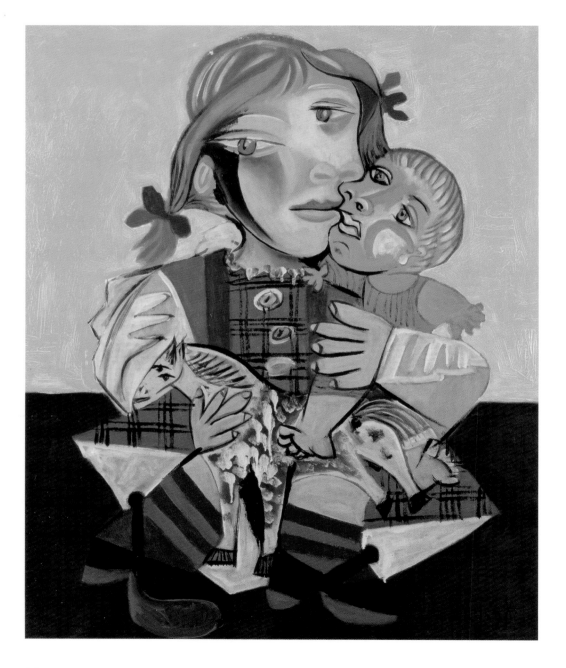

daughter, and then of Maya on her own, a baby at the breast or a joyful little girl: magnificent works on the theme of *Mother and Child* (1935–6), followed by the chronicle of a happy childhood: *Maya and the First Snow* (1936), *Maya in a Red Pinafore* (1937), *Maya and her Doll* (1938), *Maya in the Boat* (1938) and so on. When war was suddenly declared, in September 1939, Marie-Thérèse and Maya, who were then on holiday in Royan, stayed there, until the spring of 1941. Pablo concealed from Marie-Thérèse the existence of Dora (his mistress since the summer of 1936), and kept the latter in absolute submission to the overall situation (as regards Olga, too). Pablo needed both women.

On the beach, Maya played with Aube, the little daughter of Jacqueline Lamba and André Breton, to whom Pablo recommended Royan. After the armistice in June 1940, the general situation settled into defeat. My grandfather arranged for my grandmother and her daughter to return to Paris, to the new flat on the Boulevard Henri-IV. My grandparents' relationship had now lasted for fourteen years. Nevertheless, Marie-Thérèse had intuition. Pablo could not lie to her about the new state of affairs. She was now aware of the details of Pablo's love-life: she knew that she had to share him, but he told her that she took priority. She had her own territory. She could also visit Pablo whenever she liked at his studio in the Rue des Grands-Augustins.

diary in his sketchbooks, describing at intervals of days, sometimes even hours, in close detail, the metamorphoses of the little girl. Their pages display a succession of astonishing close-ups, as it were snapshots, in which Picasso tries to seize instants in a life that grows, elusive and changeable, from one second to another. We see her in her sleep, sucking her thumb, dreaming, or roaring with laughter, in all her physical and emotional intimacy; a little blond tornado with a look of her parents.'[74]

Pablo executed an impressive number of drawings of Marie-Thérèse and their

As for Dora, she knew that in spite of all the love that she felt she was getting from Pablo, his true passion was for another. Maya was brought up believing 'the fiction that her father worked a long way away', as Françoise Gilot would explain later. My grandfather had created a world for himself and Marie-Thérèse; he had brushed every difficulty aside, and my grandmother shut herself away in it for fear he would disappear. Pablo was the driving force of her life, just as she was the driving force of his art.

Paulo was twenty-four years old when he made the acquaintance of his half-sister Maya. It gave him indescribable joy. In Switzerland, where Pablo had sent him during the war, he was then working at the Office for the Co-ordination of Actions in Support of France at the French embassy in Geneva. He would stay there until the department was dissolved in October 1946. During this period, after the liberation of the capital, he frequently undertook the long journey to Paris and back by motorcycle. This was when they met.

According to Maya, Pablo decided to introduce them to each other because the war was over and people were happy. 'Paulo took it very well. He was very glad to have something of his own at last. He took me around everywhere on his motorbike,' she relates.

Maya took her first communion in what looked like a perfect family: her father Pablo, her mother Marie-Thérèse and her grandmother Mémé, her brother Paulo, her maternal aunt Geneviève, and her Spanish first cousins, Javier and Josefín Vilató. It was a happy day, and Pablo seemed to breathe easy, at last.

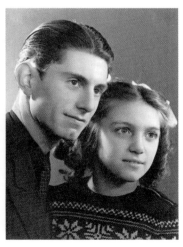

When Olga learnt of the existence of Marie-Thérèse, from the lips of her own son, there was nothing public or humiliating about it. In any case, she was indifferent: was she not still 'Madame Picasso'? Contrary to certain completely fabricated anecdotes, the two women were never to meet.

In contrast, if silence had always ruled where Marie-Thérèse and Maya were concerned, this was far from true of the new affair between Pablo and Françoise Gilot, which appeared in the light of day after the war. The time of the media had come. Magazines all over the world published a photograph of Pablo Picasso with a very beautiful pregnant young woman on his arm, then introducing himself to the journalists as the happy father of a son, Claude, and lastly of a daughter, Paloma. A painter of genius, worldwide celebrity, Communist billionaire, a father at the age of sixty-eight! Love, talent, glory,

money, and that virile ardour towards an intelligent, cultured young beauty. It was a paparazzo's dream.

Paul and Maya on a motorcycle in Chamonix in August 1946.

Paul and Maya in 1945. Their father had just introduced them to each other. Paul insisted that this unexpected meeting should be recorded for posterity.

Maya and her father Pablo at La Californie, photographed by Man Ray during the summer of 1955.

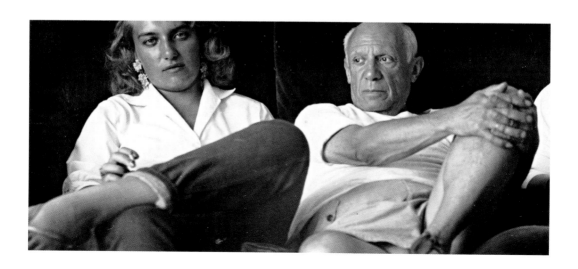

FRANÇOISE, CLAUDE AND PALOMA

Pablo's relationship with Françoise Gilot, which began in May 1943, was expressed after the war in the joy of life regained, for the artist as for the whole world. The natural culmination of this climate of euphoria was the birth of Claude, on 15 May 1947, and then that of Paloma, on 19 April 1949.

After 1946, Pablo made frequent trips with Françoise to the Côte d'Azur, to Juan-les-Pins, Ménerbes, Vallauris, Golfe-Juan or Antibes. At the Château Grimaldi, he painted *Joy of Life*, symbolising the new world of peace; the work is still there. Finally, in 1947 he moved into a villa in Vallauris, La Galloise, which belonged officially to Françoise, then the studio close to *Fournas*, before settling in Cannes in 1955, where he bought La Californie.

The family was complete. He had introduced Paulo to Maya. Françoise introduced the two older children to their young siblings, Claude and Paloma. In her book, she says that it seemed sensible to her to make this unusual family live together: 'When Marie-Thérèse and her Maya came down to the south, Pablo went on visiting them twice a week. In the summer of 1949, I suggested that he should invite them to our house, as they were in Juan-les-Pins. Not because I was naïve, but because I thought it was better that Maya should get to know her half-brother Claude and her half-sister Paloma – you only had to glance at any issue of *Match* or other paper to see him [Pablo]

stretched out on the sand with his new family. The climate of our relations relaxed and became normal.'[75]

Maya has told me about her first visit, which was traumatic for her. Claude and Paloma were the living proof that the miraculous cocoon that she had believed in, made up just of her father and mother, no longer existed. Young as she was, she quickly realised that the children were vulnerable, soon confronted by the inexplicable tensions between Pablo, Olga and Françoise, and a whole circle of courtiers changing their allegiance with each dispute. She immediately decided to protect them in her own way, to look after them like a nanny, and to lighten the general atmosphere if possible: Françoise would thank her later on for her kindness.

These years of family life are studded with photos. Pablo never tired of showing himself off as the patriarch with his four children around him. Paulo, now an adult, got his father back, after all those years. All of a sudden he was the eldest of a large family whose existence he had never suspected. Maya became her father's special confidante.

Claude and Paloma, in turn, were an undeniable source of inspiration. Pablo, now nearly seventy, found in them a renewed image of innocence. And he loved spending time with his children. Inès Sassier, his chambermaid, who was more like his housekeeper, and an irreplaceable witness who spent nearly forty years with my grandfather, has told me about it. In them,

175

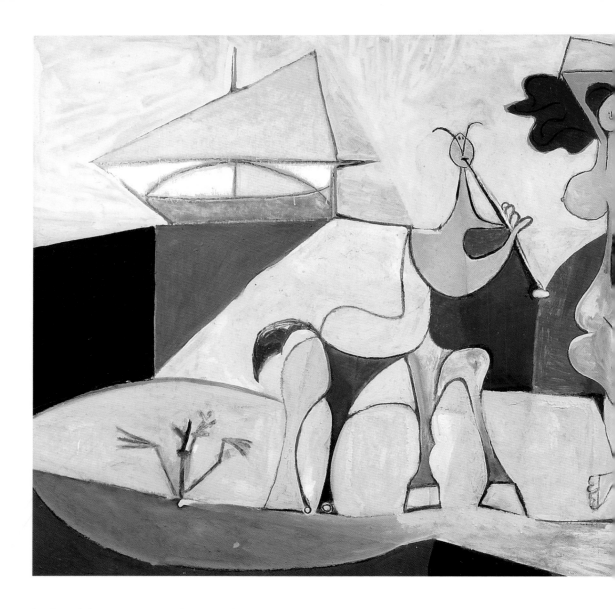

he found the spontaneity, the immediate grasp of things and the natural intuition that are at the heart of his own work. His celebrated statement 'I don't seek, I find' – so characteristic of his personality – is a perfect illustration of the situation at the time. Gérard, the son of Inès, born in 1946, was one of this group of children: 'Picasso,' he recalls today, 'would sometimes stop painting, and we used to talk at table, or we all painted together. He would do cut-outs for us. When he was with children, he was a child himself. He put himself on our level.' There are lovely portraits of Claude and Paloma that testify to this happy atmosphere: *Claude with a Ball* (1948), *Claude and Paloma Playing* (1950), *Claude Writing* (1951), *Claude Drawing with Françoise and Paloma* (1954). My grandfather observed the children's games and their spontaneous actions with close attention; he was like a camera lens moving close up to them to capture these moments. He said once that it had taken him sixty years to learn to draw like them.

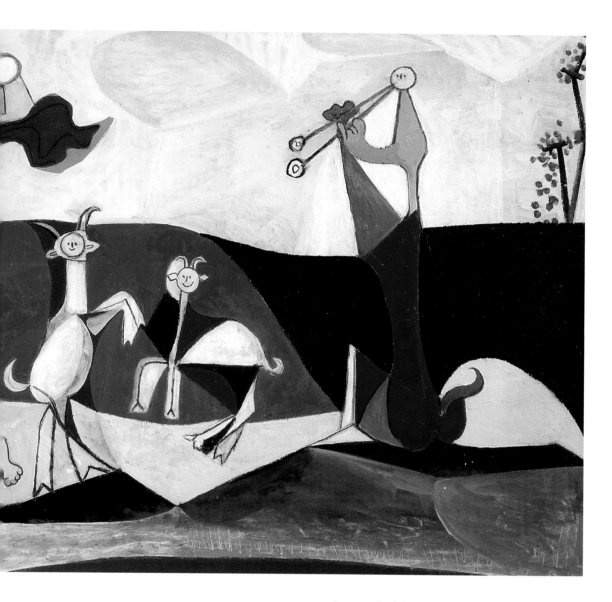

About children:
'When I was their age, I drew like
Raphael, but it's taken me a whole
lifetime to learn to draw like them.'

The Joy of Life, *1946, oil on fibreboard, 120×250,*
Musée Picasso, Antibes.

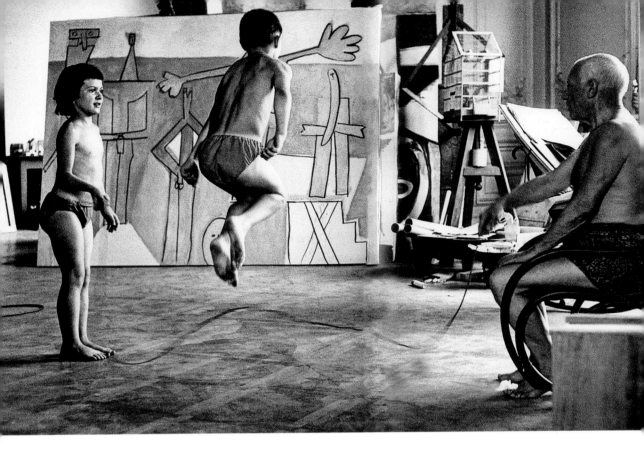

In addition, he used to make small objects
for them – figurines of wood, cardboard or
fabric – with affection and meticulous care.
Pablo would always have time for Claude,
Paloma and their friend Gérard who, in 1955,
would join Cathy (the daughter of Jacqueline
Roque, Pablo's future companion). But it
was also in exchange for children's toys
that he stole from them: little cars, a lorry, a
horse on wheels – pretty things that would
be used for beautiful sculptures and other
unexpected constructions.

Even Cocteau couldn't get over it: 'If he
touched one of his son's toys, it would cease
to be a toy. I have seen him, while we talked,
kneading a yellow cotton-wool chick that
you can buy in the general store. When
he put it back on the table, this chick had
become a Hokusai chick ... His genius as
multi-talented dabbler grew young again in

*Paloma, Claude and their father playing with a skipping rope in
front of* The Bathers at La Garoupe, *at the villa La Californie,
photographed by David Douglas Duncan in July 1957.*
*Claude, Paloma, Gérard Sassier and Catherine Hutin in fancy
dress in the garden at La Californie, 1957.*
*Pablo, Françoise and their two children Claude and Paloma, at
La Galloise, photographed by Edward Quinn in 1952.*

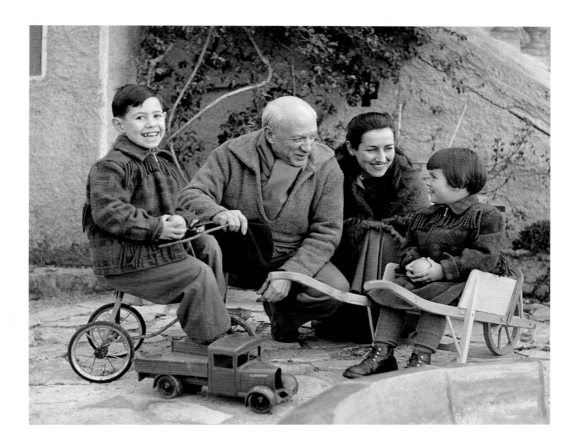

this daily artistic companionship. With a few snips of the scissors, he would invent light, mobile sculptures made of paper[76] (*Woman with Outstretched Arms*, 1961) and creations in linoleum (*Dancing Harlequin*, 1950). A whole amusing bestiary would take shape under his fingers, using forks and matches (*The Stork*, 1951), or his son Claude's little cars which would provide the materials for the head in *The Monkey and her Baby* (1951), one of the most superb mother-and-child pieces ever created.'[77]

These incredible reconstructions followed the no less breathtaking *Little Girl Skipping* (1950) and *Pregnant Woman* (1949–50, of which the plaster original, incidentally, was acquired at the end of 2003 by the New York Museum of Modern Art).

The departure of Françoise Gilot, with Claude and Paloma, at the end of the summer of 1953, was a terrible blow to my grandfather. 'My children have been taken away from me,' he complained. Yet they came back regularly: at Christmas and Easter and for the summer holidays. Pablo loved children and loved to play with them. Occasionally, however, he would simply give them a wave before going up to his studio on the second floor. He would shut himself away for the day, obeying the summons of other goddesses.

In 1954, Jacqueline Roque had made her appearance. Her daughter, Catherine Hutin, known as Cathy, who was born in 1948 of her mother's first marriage, joined the gang. Incidentally, Gérard Sassier, whose godfather was Paulo, remembers that sometimes, to call the children, 'we said 1946, 1947, 1948 or 1949'. 1946 was Gérard; 1947, Claude; 1948, Catherine; and 1949, Paloma.

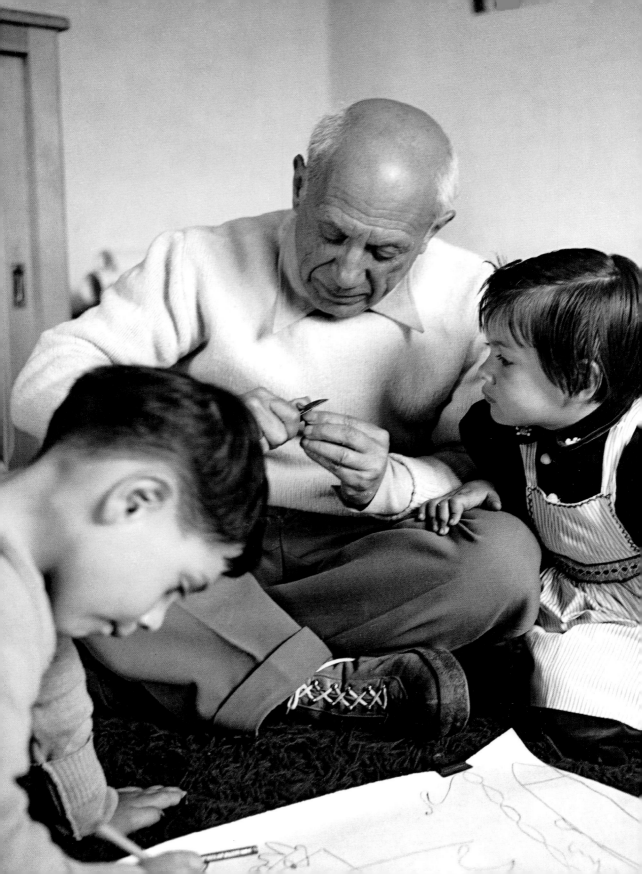

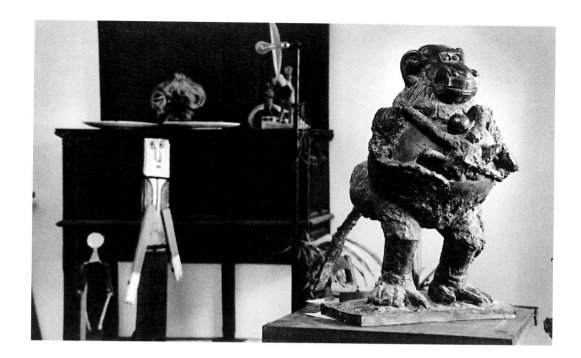

And there were also Paulo's children, who lived a few kilometres away. First of all came Pablito, Pablo's first grandson. In the autumn of 1949, in a curious merry-go-round of little ones, Paulo took a set of photos, on the same day, in the same place, at the foot of the steps of La Galloise in Vallauris: Pablo holding his own daughter Paloma, born the previous May, with plump little cheeks (which gave the artist huge pleasure in his portraits); Paulo himself, holding his own son Pablito in one arm and his half-brother Claude in the other – a nephew and an uncle scarcely any older than him! Pablo was jubilant. His great pride was to belong still to the category of reproductive males.

Paulo and Emilienne's second child, their daughter Marina, was born a year later, on 14 November 1950, six months after their wedding. Strangely, Paulo did not introduce her to his father. Relations between the couple had grown very bad at that time, and, a few weeks after Marina was born, they started separation proceedings. Pablo

did not meet his granddaughter until several months after she had come into the world. My grandmother, Marie-Thérèse, who divided her time between Paris and Juan-les-Pins, had made friends with Emilienne, who lived in Golfe-Juan, down below Vallauris. While out for a walk along the edge of the beach at Easter with Emilienne and her daughter, she spotted Pablo in the distance. She naturally called out a greeting, and hastened to introduce Marina to him: 'Look, let me introduce your granddaughter!' Paulo had not told Pablo about her. Later, Maya asked if Pablito and Marina, Paulo's children, could come to La Californie to meet Claude and Paloma, in the summer of 1955. She considered it normal that children of the same age and the same family should be acquainted and spend time together. But Paulo had completely severed all links

Pablo carving a figurine for his children Claude and Paloma, photographed by Edward Quinn in 1952.
The Monkey and her Baby, *in front of two* Standing Woman *assemblages, photographed by David Douglas Duncan at Notre-Dame-de-Vie in 1974.*

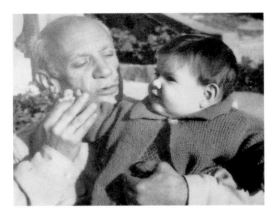

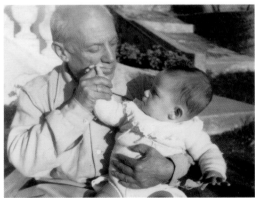

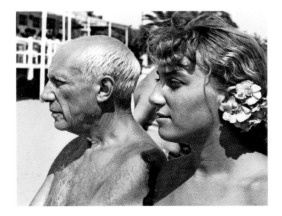

between his children and the world of his father, since his separation from Emilienne. Emilienne had a tendency to hold forth in public about her fantasy relationship with her (ex-) father-in-law, and he preferred that nothing should provide any fodder for gossip. The fact that Pablito and Marina should suffer the normal fate of the children of divorced parents, who are victims, certainly saddened him.

However, at the end of the summer, after observing this ballet of emotions, Maya decided to leave the Picasso world. Unexpectedly, because she was now grown up but also a woman, she had become her father's confidante, almost part of the nobleman's retinue. She realised that her own freedom was at stake. She needed to take wing on her own. Pablo could hardly believe it: 'Impossible! Daring to leave me!' Maya went away to Spain and joined her cousins in Barcelona. Bit by bit, the geographical distance would gradually separate her from her father, though they would always stay in contact. She got married and gradually constructed her own world, well away from her father's love-life, kept abreast of events by Marie-Thérèse and Paulo. It was from them that Pablo learnt of my birth and that of my brother and sister.

Pablo and his daughter Paloma at La Galloise in the autumn of 1949.
The same day, Pablo and his grandson Pablito, Paul's son.
Pablo and Maya on the beach at Golfe-Juan in August 1952.
Javier Vilató, Paloma, Germaine Lascaux, Françoise, Paul, Madame Cuttoli, Pablo, Claude and Maya at Madame Cuttoli's house in Cap d'Antibes, photographed by Edward Quinn in 1954.

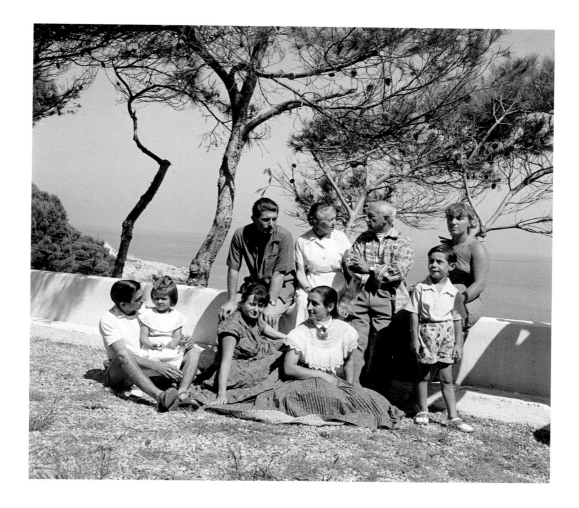

JACQUELINE AND CATHERINE

Pablo Picasso had met Jacqueline Roque in 1953. Jacqueline's visits became more frequent the following year, but remained very discreet. After Olga's death, in February 1955, and after Marie-Thérèse, sensibly enough, had refused his unexpected proposal of marriage, Pablo was a free man. From then on, he lived with Jacqueline and her daughter Catherine. With the latter, he was attentive, very present, worrying if she did not come home in the evening at the appointed time; even – revealing some of the defects of an Andalusian father – possessive and authoritarian.

Jean Leymarie's daughters, close friends of Catherine's, often came to play with her. The ballet of children danced on around Pablo.

But enough of the *paterfamilias*! Now nearly eighty years old, he rediscovered the reflexes of a young lover in the company of Jacqueline – his muse and companion, whom he married in March 1961.

Now that his children were grown up, he took his inspiration from the works he had copied long ago in Madrid: Murillo's *Los Bobos* and Velázquez's *Las Meninas*. 'With them,' Jacqueline said later to André Malraux, 'Pablo really wanted to settle up.' He would have no more children. He was too old now.

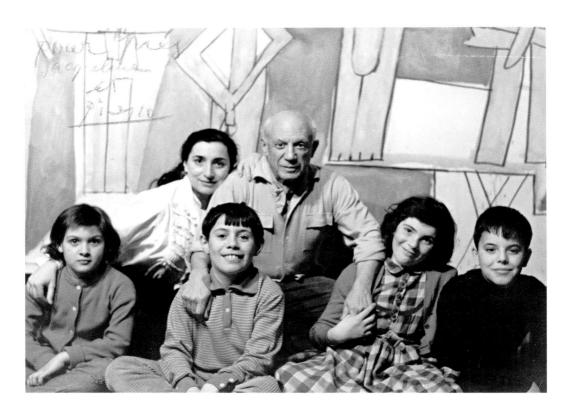

PICASSO AND HIS TRIBE

Roland Penrose has written an amusing description of La Californie: an 'enormous, ugly construction, afflicted with all the ostentatious marks of middle-class wealth at the beginning of the century'. To Pablo, it offered other attractions: space and light, a large number of rooms and in excellent condition: no building works or any particular alterations were needed when he bought it on 6 April 1955, for barely 12 million old francs (about 261,000 euros), before the Côte d'Azur was overtaken by property overpricing. It had a large gate and was surrounded by high, barred railings with painted metal plates behind them, so that it was impossible to see anything through them. Pablo could at last enjoy a degree of privacy that he never had at La Galloise in Vallauris.

Lucette and Antoine Pellegrino were the caretakers. Lucette was in fact the official caretaker, and she was assisted by her husband, a horticulturist who worked elsewhere but devoted his free time to the garden of the big house. They had been engaged by the previous owner, Mr Bonnet, who had always maintained his fine white mansion. Antoine had been born in March 1915, Lucette in July 1921.

In June 1955, Jacqueline, Maya and Pablo left Paris and moved to a villa, Ziquet, in Antibes (which Jacqueline had bought in return for a life annuity, and which was still occupied by the 'assignor' and her thirty-odd dogs). They were waiting for their furniture to arrive from Paris before moving into La Californie. Lucette, with all her present-day vigour, has told me about the life of the household in 1955, during that first summer: there was Pablo, with Jacqueline, his companion since the previous year, Paulo, Maya, the little ones Claude and Paloma; Cathy, Jacqueline's daughter, came and joined them for the school holidays.

The younger ones played together in the garden. When Pablo came out of his studio, they drew pictures together in the house, on a large round mahogany table. Pablo often joined Claude and Paloma in their room on the first floor, and helped them to make small objects. They gave each other advice and provided inspiration for each other – even Pablo.

At the bottom of the garden, there were a small ceramic head of a woman in classical style; some stone columns, rather grandly known as the 'green theatre'; and a little house on the right – a 'hunting lodge', the previous owner called it. At the time of the move, Pablo's bronze sculptures[78] were left out of doors, but not the plaster ones often seen in photos, such as *Pregnant Woman* (1949–50) or others in clay, which were far too fragile and therefore stored inside; the bronzes would be brought in to join them permanently in the autumn.[79] A *Head of Marie-Thérèse*, in bronze, dominated a

small basin on the right in the garden. At the very bottom, on the left, *The Man with a Lamb* (1943) was concealed; at its foot, Claude, Paloma and their little friend Gérard secretly hid their box of treasures. *The Man with a Lamb*, hidden behind the foliage, thus escaped the numerous photographs of La Californie, and remained the children's secret companion.

Pablo also brought his ceramics from Vallauris. There was never a potter's kiln at La Californie, but in the basement he installed a large press on which he printed engravings with the help of the Crommelynck brothers, who came south to visit him. A cook, Marie, with her nineteen-year-old daughter Monique, came to help at the end of July 1955, on Françoise's recommendation. Until the end of August, Maya, Jacqueline and Pablo went every day to the Victorine film studios in Nice, where Henri-Georges Clouzot was shooting *Le mystère Picasso* (*The Mystery of Picasso*).[80] Early in that same month of August, Maya suggested to her father that one Sunday, when there was no filming, he should bring Pablito and Marina, the children of Paulo, who had been obliged to live far away from them for four years.

Jacqueline, Pablo and his two children Paloma and Claude, with Cathy and Gérard, in front of a study for The Bathers, *in the studio at La Californie, 1957.*

Cathy, Paloma, Claude and Gérard on the main staircase of the Château de Vauvenargues, 1958.

Overleaf: The Man with a Lamb *(1943) and* Owl *(1950) in the garden of La Californie, photographed by David Douglas Duncan in 1959.*

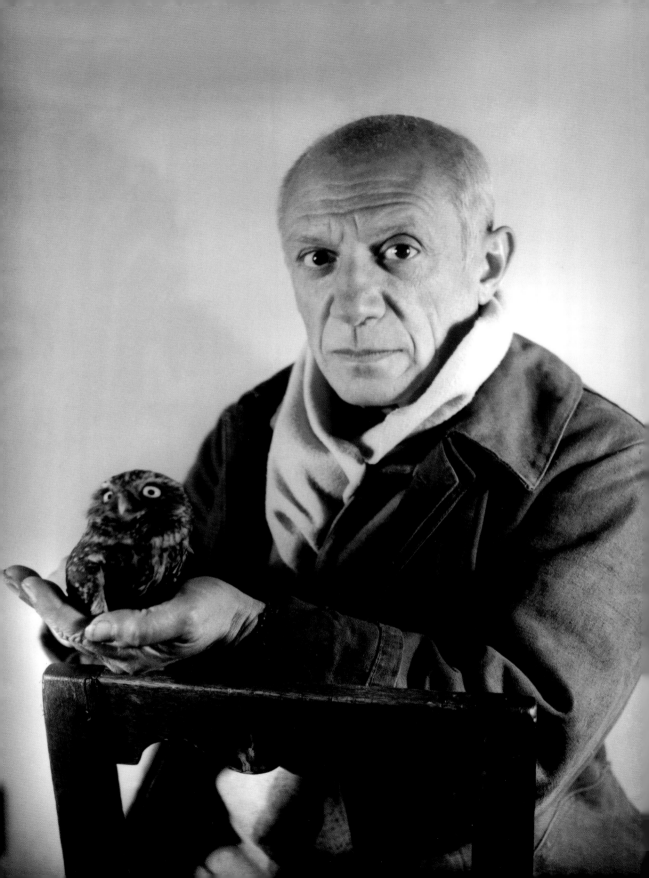

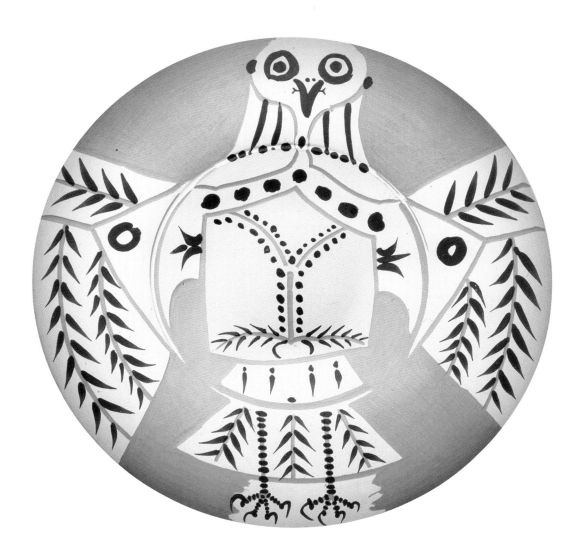

Pablo and his owl photographed by Michel Sima in 1946. This little owl had got lost. After taking it in, Pablo made it the theme of several paintings reminiscent of the world of his still lifes under the Occupation.

White Owl on a Red Ground, *1957, painted ceramic, diameter 45.5, dish produced in 200 numbered pieces, Madoura Gallery, Vallauris.*

By the decision of the divorce court, Emilienne had full custody of the children; the courts had made no provision for visits from their father. So she was the one to decide.

Paul went and picked them up in Golfe-Juan, brought them over and left at once. Pablito had fun with the other children of his age. Marina, only four and half years old, cried all the time, frightened by all these unknown people.

They would come back to La Californie with their father. But Lucette, the caretaker, has sad memories of unexpected visits when their mother Emilienne brought them: 'Paulo never came with them. Their mother came as far as Bel Respiro, the house next door

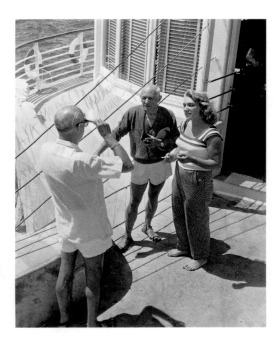

to La Californie, and sent the children alone to the gate – but they were never allowed to come inside. Madame Jacqueline had given orders. Don't let anyone in: "Not even God himself. Monsieur is working!" Sometimes they brought little notes, which I always passed on to Madame Jacqueline. But I never saw those children in the house again. Never!'

During that month, August 1955, my grandmother Marie-Thérèse also visited Pablo, who asked Jacqueline to leave them alone. She did so, confident now of her own position with respect to her companion. Marie-Thérèse came again on rare occasions, always on a bicycle – a laudable sporting achievement, getting up to the villa perched high above Cannes. These visits demonstrate the good relations that she still maintained with Pablo, as well as Jacqueline's admirable patience.

Inès, the faithful one-time chambermaid, now housekeeper, who had stayed in Paris in the Rue des Grands-Augustins, came to La Californie in the school holidays with her son Gérard. A household help named France Aime came in daily. Last of all, a little nanny-goat came to join the team: she had been given to Pablo by Jacqueline at Christmas 1956, and all the children loved her. Her name was Esmeralda – though Pablo always called her 'Biquette', in reference to the well-known French nursery rhyme ('*Ah ! tu sortiras, Biquette, Biquette...*'). Esmeralda frequented all the ground-floor rooms without distinction and had the freedom of the garden, where she ate all the grass.

Antoine, the caretaker, warned Pablo that it was not good for her and it would be better to give her hay. My grandfather, who adored the little creature and allowed her all sorts of liberties, decided that there was no need to turn the house into a small farm, even if there were already three dogs (the boxer Yan; Lump, a dachshund; and Perro, a Dalmatian). Biquette slept every night in a box in the corridor on the first floor, next door to the room usually used by Claude and Paloma, and the one where Gérard slept.

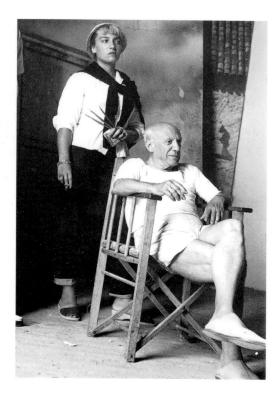

One Sunday, Gabriel, the son of the caretakers, whose job it was to carry the animal up to the first floor for the night, found her 'asleep' in the garden – in actual fact, she was dead, her stomach distended with the grass that she ate all the time. Pablo was not at home. The caretakers, in tears, thought their last hour had come: 'We had let the goat die!' Pablo came back. Lucette took him aside and explained the tragedy and what had caused it. Pablo declared solemnly: 'It's a good thing she died. She wasn't an intelligent goat!' Biquette was never replaced.

So life at La Californie jogged along until 1958. Visitors who were always admitted were few: Kahnweiler and the Leirises, the ceramicists Georges and Suzanne Ramié of Vallauris, the painter Edouard Pignon and his wife, the writer Hélène Parmelin, Sapone the tailor, Arias the barber, the Cannes lawyer Maître Antébi, the journalist Georges Tabaraud. And occasionally, there were more unexpected visitors: the President of the United States, Harry Truman; Gary Cooper; Brigitte Bardot – and Maurice Thorez, the general secretary of the PCF, whom Lucette obstinately refused to admit, and who had to leave to go and telephone Pablo, who was in the house all the time!

And, always, the children, Claude and Paloma, Cathy, Gérard, often accompanied by Gabriel, would come together for the school holidays. I rediscovered quantities of photographs of all the joyous horde who would enliven the atmosphere at La Californie. As for Paulo, he stayed there

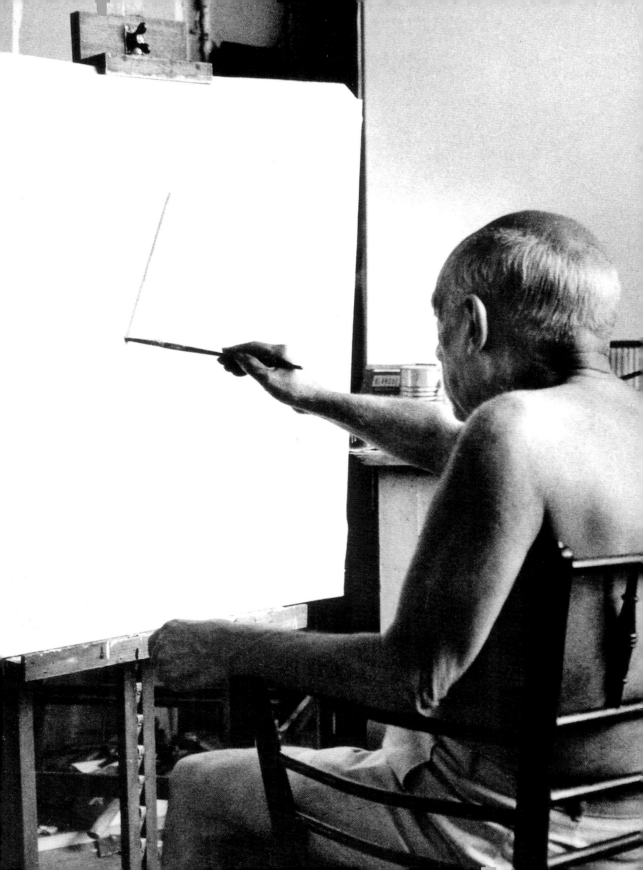

occasionally when he travelled to the south, accompanied by Christine. He came back rarely after 1959, and then it was with their new baby Bernard.

In September 1958, Pablo bought the Château de Vauvenargues, near Aix-en-Provence: Cézanne country. He did not move in with Jacqueline until January 1959 – it took so long to install central heating. In Vauvenargues, with its hilly landscapes, he found all the inspiration he needed for 'Spanish' painting. He also executed still lifes, which had now become 'ideograms', according to the analysis of Pierre Daix.

During the holidays, Pablo had Claude and Paloma come to him. Inès and Gérard then joined them. Gérard and Claude went riding, to forget the stifling heat of summer and the dullness of this Provençal scrubland, which was too isolated for their taste. It was also the opportunity to visit the bullring of Arles and there, each time, to confront the shock of the bulls – and the photographers.

The construction of a block of flats that completely blocked the view put Pablo right off La Californie. Finally, in 1960, he bought the big house in Mougins, Notre-Dame-de-Vie. No one came to La Californie any more. The sculptures in the garden were transferred to Mougins.

The goat Esmeralda chained to another goat cast in bronze and representing her in the garden at La Californie, while Pablo and Jacqueline had gone out for a walk. Photographed by David Douglas Duncan in April 1957.

The Goat, 1950, bronze. This example is to be found on the patio of the Museum of Modern Art in New York. Its director Glenn Lowry reiterates that 'the museum has built up an extraordinary collection of Picasso's works using all his techniques and covering the whole of his long and prolific career'.

Overleaf: Brigitte Bardot and Pablo photographed at La Californie in 1956, during the Cannes Film Festival.

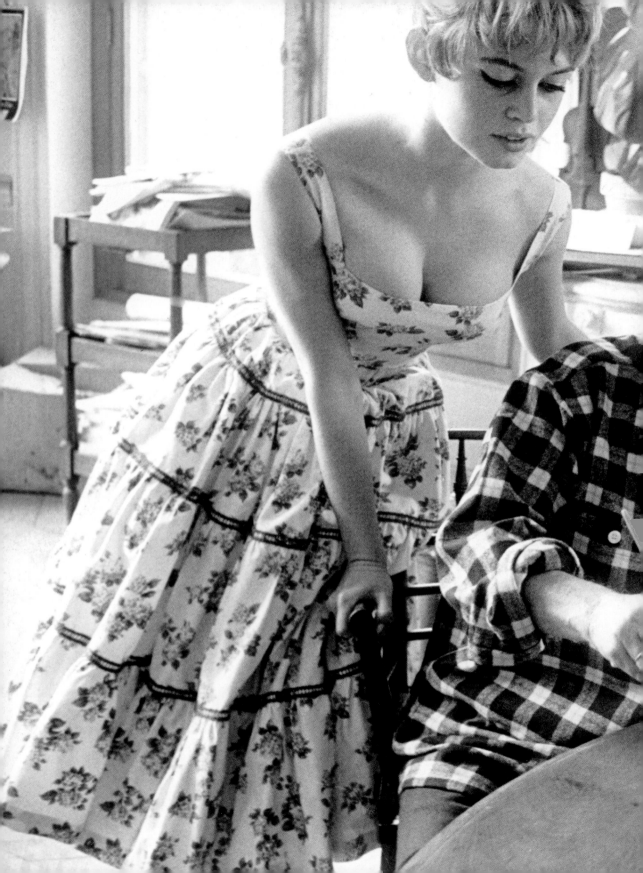

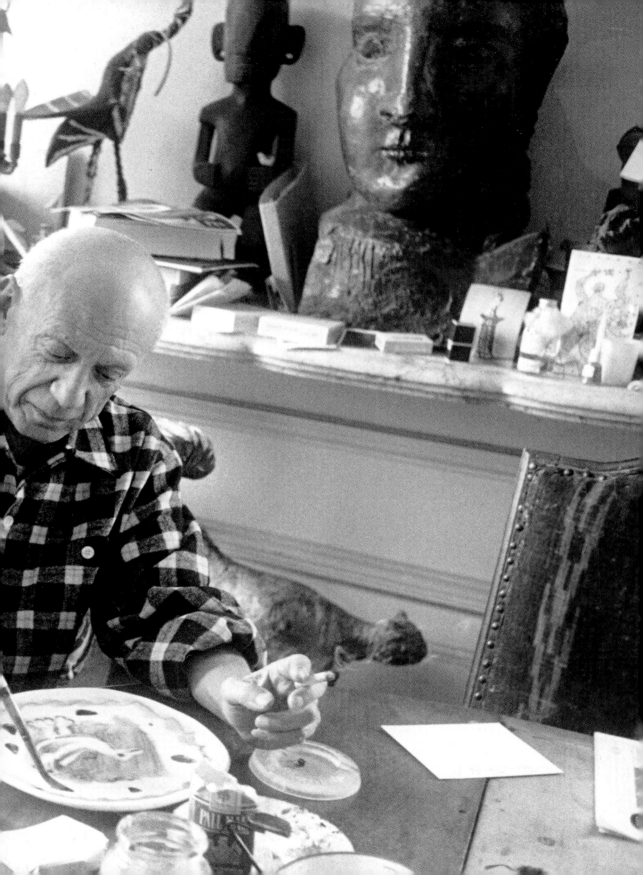

A RECONSTITUTED FAMILY

My mother married my father in 1960. I am the first child of this marriage – then came my brother Richard and, much later, our sister Diana.

We discovered quite naturally, on the walls of our house, that Pablo Picasso was our grandfather. But we were still too small to ask questions or to wonder about these grandparents who never came to see us. We had a happy, studious childhood, respecting such values as school, work, merit and recognition in mutual affection. It was a reassuring, uneventful day-to-day existence, far removed from the striking complexity of the Picasso family as it was then.

Pablo Picasso had four children: that is a fact. So many articles, after the war, recounted the travels of Paulo or Maya here and there, in France, Spain or elsewhere. So many others celebrated the births of Claude and Paloma. However, things were not quite so simple. And the difference, for us, was that everything, or almost everything, was made public. With approximations and mistakes, sometimes small and sometimes monstrous, a legend was woven around the man, which further added to the incomprehension of the artist's genius. In many people's eyes, the more complicated, the better.

Legally married to Olga, Pablo Picasso had wanted to divorce, but had not been able to, which *ipso facto* prevented him from marrying Marie-Thérèse or acknowledging Maya.

The reason was that until the reform of the French filiation law on 3 January 1972, which came into force the following August, it was impossible for a married man to acknowledge a child born outside his marriage. This was the case for Pablo. He was married in 1935 when Maya was born, and still married in 1947 and in 1949, the respective years of birth of Claude and Paloma. Picasso's natural children were all born in a legal context of adultery, and as such were classified as adulterous issue. The word 'adulterous' seems incongruous when one realises that all conjugal relations between Olga and Pablo had ceased long before the births of Maya, Claude and Paloma, but, in law, they persisted. There was no escape for Pablo, or for the children.

Furthermore, according to the law prior to 1972, he could not even acknowledge them on the death of Olga, although, in 1955, that event freed him from the bonds of his marriage. The procedure to do it simply did not exist. He would have had to marry again. He proposed to my grandmother, but she refused him.

The Napoleonic Code was particularly inhuman on this point. It prohibited the illegitimate child (despite its absolute innocence) from undertaking a paternity search, and excluded any possibility of voluntary acknowledgement on the part of the father who, into the bargain, could not perform any official act of generosity, by donation or testament, towards the 'child of sin'. He could make a will in favour of his

dog or the Salvation Army, but not of his biological offspring!

Three little Picassos were not the only ones concerned. In 1972, more than two million children were victims of these aberrations.

The aim of the law was specifically to avoid 'scandal': the child might be outlawed from society, but the married father remained protected from any disturbance. (In the same spirit, if it was the wife who had committed adultery – a much rarer circumstance – her child was automatically held to be the offspring of her husband.) Hence the vogue for extra-marital affairs, servant-girls made pregnant, and so on – men had nothing to fear: no scandal, no risk to their estate.

Few people today realise how appalling this law was for the children, who were victims even if they had been conceived in love. One may also imagine the psychological trauma affecting some children who, discovering that their father had sired other children 'elsewhere', had nothing other than the superiority conferred by being 'legitimate' to console them. Just read Maupassant's *Pierre and Jean*.

The law of 21 December 2001, which henceforth placed on a footing of equality any filiation, legitimate, natural (the term 'adulterous' disappeared from the Civil Code in 1972) or by adoption, has restored a relationship founded upon love, and no longer solely on a future division of assets. The parents are now responsible; the children no longer are.

Thus the law prevented Pablo from acknowledging Maya, Claude and Paloma. Even after the reform of 1972, he could not acknowledge them spontaneously; there was a necessary judicial procedure to be undergone: a 'paternity search'. What matter? He had wanted these children, just as he had wanted his son Paulo, his only officially legitimate son, and if the law did not bring them together, then love would be their bond. We need look no further than the artistic inspiration engendered by each birth. Picasso's four children all have equal 'artistic legitimacy', as any lover of modern art knows. In day-to-day affairs, he made no distinction between Paulo and the others.

It cannot be thought that Paulo gained the least advantage from his 'legitimate' filiation: he never gloried in it. It would have been ridiculous at a family level as well as morally. Paulo had a strong moral sense, and he would never have reproached Maya, Claude or Paloma regarding a situation for which they were in no way responsible. For that matter, when Pablito was born, in early May 1949, Paulo himself was not yet married to Emilienne, though Emilienne was still married, as she had been since October 1944, to a man called René Mossé, owner of a pottery workshop in Vallauris. Emilienne had met René when he had just been left by his wife after the birth in 1935 of their fifth child, a boy named Daniel. Thus, when barely twenty years old, she had found herself 'Maman' to five children who were not hers. She took up this burden with true

Pablo and his four children Paloma, Maya, Claude and Paul at La Galloise, photographed by Edward Quinn at Christmas 1953.

courage, unhesitatingly bringing them up like her own children and protecting both them and their father during the war, when they were living in Marseilles. At this time, she was the official manager of René's little building business: her husband, being of Jewish birth, was at the mercy of the Gestapo.

At the end of the war, Emilienne decided that she would no longer be imposed upon, but would live her own life. However, by agreement with René, she kept the youngest child, Daniel, who had been 'given' to her when he was only fourteen months old. The little boy would always call her his true mother.

This self-assured young woman made the acquaintance of Paulo, five years her junior, soon after the latter returned from Switzerland. She became pregnant in the summer of 1948. Since she was still married to René, Emilienne was therefore in an adulterous relationship with Paulo in the eyes of the law. Worse still, her child-to-be would be held legally to be the son of her husband, René Mossé, and not of Paulo. Thus Pablo junior – soon nicknamed Pablito, to avoid confusion – was born adulterous issue. Emilienne obtained a divorce a few weeks later, at the end of 1949.

For a year, Pablito remained their natural child until they married on 10 May 1950, before being acknowledged by Paul while Emilienne was expecting their second child, Marina. It can truly be said that our family went through every possible legal situation, and that one, which was extremely rare,

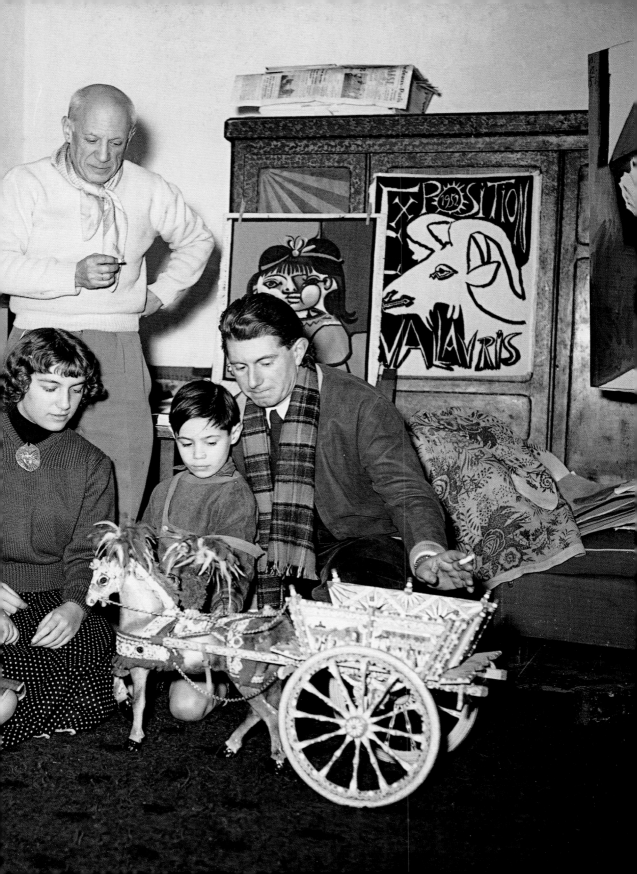

is a new illustration showing that even Paulo, a legitimate child *par excellence*, cared little for social conventions.

As for young Daniel Mossé, who was fifteen years old when Pablito and Marina, his brother and sister born of love, came into the world, he was a privileged witness of the romance between Paulo and Emilienne and then of a new family, but also of the terrible quarrels that tore them apart, including those between Paulo and his own mother Olga. He would continue to live with the little ones, even after the separation of Emilienne and Paulo in the spring of 1951. A few years later, when he himself had embarked on a working life, he used to come back regularly to visit his 'Maman' and the children.

Paulo repeated the process of free love with Christine, his next companion, when his second son, Bernard, was born in 1959: he only married Bernard's mother three years later. Burdening his brother and sisters with ostracism would have been a loathsome act which he would not have countenanced for a moment.

During the filiation acknowledgement procedures for Maya, Claude and Paloma, which naturally followed the reform of 1972, Paulo demonstrated perfect rectitude. He never contested the filiation of his brother and sisters – he could have been tempted to, bearing in mind his share of the inheritance, seriously reduced by the arrival of his siblings. Once more, however, love was stronger than legitimacy.

The question of Pablo Picasso's children took on a new dimension on the death of my grandfather in April 1973.

It is extraordinary that one may be the son of one of the world's most celebrated men, that the whole world may be aware of the fact through repeated news reports, that all the evidence may exist, but one may not be permitted to launch a paternity search because the cause is 'illicit'.

Picasso knew about the legal situation created by the continuation of his marriage. But that would not have stopped him from living and loving elsewhere. He had even imagined the absurdity that he could marry Maya, since he was not legally her father and, as he put it: 'It would displease everyone.' Completely 'Picasso-esque'.

Under the constraints imposed by the law, in 1955 he became Claude and Paloma's second guardian, nominated by a trusteeship council, although he was their absolutely uncontested biological father. There can be no doubt about his desire to make use of all the possibilities available under the law to declare himself in whatever way he could. The same procedure no longer made much sense in the case of Maya, who was already twenty years old. Claude and Paloma had their mother, Françoise. This meant that Pablo could not be their guardian, but he could be their second guardian, eligible to take the place of their mother in the event of her decease. It should be remembered that Pablo and Françoise, separated in 1953, still conserved good,

responsible relations. Had Pablo not told her, in 1954: 'The reward of love is friendship'?[81] Later, following mutual agreement between Pablo and Françoise, and with the formal agreement of Paulo, which was very important, an application for a change of surname for Claude and Paloma was lodged with the Minister for Justice and published in the *Journal officiel* of 12 May 1959. Pablo requested that the children should bear his name. On the conclusion of this procedure, the *Journal officiel* proclaimed on 10 January 1961 that Claude and Paloma should henceforth bear the name of Ruiz Picasso – the name of their second guardian. In addition, Pablo had asked Maya to join this application for a change of name. An identical request was therefore published in the *Journal officiel*.

My grandfather's lawyer, Maître Bernard Bacqué de Sariac, had charge of the three cases. A historical enigma arises: he did not pursue Maya's procedure at the Ministry of Justice, and returned the documents to my mother – ten years later – without explanation. Perhaps it was thought that presenting the cases simultaneously might be detrimental to one of them: as Maya, Claude and Paloma were not born of the same mother, the Minister for Justice might have feared that it was going too far (a married father who had married again in 1961: three children, two different mothers). Avant-gardism and scandal might be tolerated from the artistic point of view, but were less practised in the stuffy atmosphere of legal bodies, especially as the highly

conservative society of the 1960s was still a long way from undertaking the least reform of filiation law. The lawyer made no comment and did not disclose his strategy to anyone. On top of everything else, he telephoned Maya regularly, pretending that the case was running its course, from appeal procedures to the High Court. He took his secret with him to the grave. In any case Maya, married since 1960, now bore her husband's name, in accordance with the law of the time.

Only Claude (in August 1968) and Paloma (in February 1971), when they came of age – and in spite of the Civil Code, which constituted an impediment – instituted an action for a 'court declaration of paternity outside marriage'. At that time, such a procedure did not exist under that name. It was necessary to innovate!

Maître Antébi has shown me my grandfather's handwritten attestation dated 18 December 1968, relating to Claude. I admired the remarkable regularity and energy of his handwriting – he was then over eighty-seven years old.

In it, he denies the rumour that he 'objected to the procedure' undertaken by Claude and Paloma, and freely acknowledges his adulterous paternity as defined by the law. But on 14 April 1970 for Claude and 30 November 1971 for Paloma, the regional court in Grasse declared, logically enough, that their petitions were inadmissible, since 'their principal demand sought to establish an adulterous filiation', which was prohibited

by law. So Pablo declared his paternity, but the judges could not accept his declaration! The court of Aix-en-Provence confirmed this refusal on appeal, on 3 May 1971 for Claude, and on 20 November 1972 for Paloma. Claude's appeal to the high court was refused again on 27 June 1972.

Most astounding of all was that a court of appeal and a High Court had given their rulings in June and November 1972 in respect of an obsolete law – in the full knowledge that a new law on filiation had been promulgated to take effect on 1 August 1972.

In accordance with the unavoidable procedure put in place by this major reform, Maya was the first to embark upon proceedings before the regional court of Grasse, on 13 December 1972, with the aim of being recognised as the natural daughter of Pablo Picasso – the term 'adulterous' having by then been definitively eradicated from the texts.

The law of 1972 authorised the declaration of paternity on the birth of a child born outside the bonds of marriage, even if the father was already married to another woman (or the converse for a mother who was already married). Retroactively, it provided for the regularisation of natural paternity, but only through adjudication by the courts. A free and spontaneous act of acknowledgement by the biological father would only be authorised by a law enacted on 8 January 1993! So the children had to embark upon a judicial paternity search procedure to authenticate their filiation and in due course claim their rights to the Succession.

On 8 February 1973, two months before the death of Pablo, Claude and Paloma in turn embarked on a new court procedure with a view to being declared his natural offspring.

The reform laid down a time limit for this procedure: the applicant must not be more than twenty-three years of age. Maya, Claude and Paloma were all older. They would therefore remain forever the children of Pablo Picasso, the artist in the museums, but not the children of Pablo Picasso the man.

The lawyers criticised the inconsistency created by an age limit, and the legislature introduced numerous mitigating clauses. In the early spring of that year, 1973, Pablo was living the last few weeks of his life in seclusion at his home in Mougins and, more than ever, was devoting himself entirely to his work. He had had a bad winter, exhausted by an attack of bronchitis. And he took a very poor view of the action of his children before the courts. Not that he contested the fact of his paternity, but to him it was washing the family's dirty linen in public: what rumours and gossip would be generated! Involuntarily, he too declared the matter 'out of time', in his own way, by passing away on the morning of 8 April.

The court in Grasse pronounced judgement on 29 June 1973 at the request of Maya, and refused her on the grounds of her age.

The essentials of the matter were not given any weight.

During the hearing relating to Claude and Paloma, the matter was settled in an hour and a half. On 12 March 1974, the same court recognised Pablo's paternity for Claude and Paloma. In the lost actions of 1970, 1971 and 1972, Pablo had nevertheless declared that he was their father. Now, according to the new law (article 12, paragraph 2), a judgement delivered under the regime of the former law would henceforth have the effect that the new law would have attached to it.

Jacqueline and Paulo did not appeal against this decision, which shows that there was never any intention on their part to create any kind of conflict between the heirs or to oppose a reality that had always been accepted as fact.

My mother, on her side, took time to think things over before appealing. She had been deeply distressed by the judges' decision, probably believing her case to be hopeless. Furthermore, her father had just died, and the situation was being depicted by the media as battle lines drawn up around the inheritance: they saw demands for recognition of filiation as solely motivated by financial interest. Would Maya have the courage to start proceedings again in such a context? Simply in order to be her father's daughter, now that it had become possible?

It was at the request of Jacqueline, disgusted by the judgement of the court that had refused Maya what it had granted to Claude and Paloma, that Maître Roland Dumas urged her to contact Maître Paul Lombard to appeal against the decision. Still she hesitated. She was exhausted by the case to be built up, the supporting documents to be submitted, again and again. But she also thought about us, her children, and the unbearable contradiction of remaining for ever on the margins of the Picasso family despite knowing that we were his grandchildren. She lodged her appeal at the very beginning of October 1973. The procedure started again.

In the spring of 1974, at the meeting of the heirs convened by the first notary in charge of the Succession, those present were Jacqueline, Paulo, Claude, Paloma and Maya. The meeting, once again, proved the solidarity of the family. Nothing could be undertaken without Maya. In an aside, Paulo himself said that whatever the outcome of the court action, 'we will find a solution'. This single little sentence shows what an upright man Paulo was: he loved his sister and, like their father, would make sure that love triumphed over 'legitimacy'.

At the end of this general meeting, despite the fact that Maya had not asked for anything at all, she received a large cheque as an advance on her inheritance, although there was no legal justification for it.

Paul Lombard conducted the whole appeal procedure, and all pay tribute to the case that he put together and the arguments that he presented at the hearing before the court – on 8 April 1974, one year to the day after

Pablo's death. He skirted the procedural restriction linked to age and pleaded Maya's 'possession of status', in the legal expression: a legal notion that related only to legitimate children but that he brilliantly applied to natural children. The certitude of Maya's filiation, factually uncontested, rendered it morally impossible for the court to ignore it, and on 6 June 1974, the judges of the court of appeal of Aix-en-Provence finally yielded to the self-evident: María Walter, known as Maya, married name Widmaier, should bear the name of her father, Ruiz Picasso.

However, the court actually based its decision of recognition on a different article of the law: Pablo had always paid Maya an allowance defined as a subsistence allowance, even during the last two years before his death. The parental bond was thus demonstrated. The decision was based on the law, and not on the jurisprudence of 'possession of status' in which many believed at the time.

My mother was born again that day. And she shared her happiness with all those natural children who, thanks to her case, were going to be able to regain their identity. She always remained immensely proud of that. In that summer, in the year 1974, all the legitimate heirs of Pablo Picasso were at last united: his widow Jacqueline and his four children, Paul, Maya, Claude and Paloma. A family properly reconstituted.

THE TRAGEDY OF PABLITO

My grandfather died, as I have said, on the morning of 8 April, and the news of his death was broadcast by the media at about one o'clock. Ever since he had been known to be ill, numerous journalists had been calling the house in Mougins for information. A German press agency had telephoned, and Pablo had answered the telephone himself: 'We have just been told that Pablo Picasso is dead. Is it true?' And Pablo replied calmly, 'No. Are you?'

Maître Antébi had been asked by his friend, the public prosecutor of Grasse, to inform him as soon as the death occurred. An unexpected visit by Pablito, Paulo's son, who had climbed over the railings the previous summer – after being turned away at the gate – and the media coverage of the paternity acknowledgement suits, worried the authorities, who wanted to avoid any public scandal.

On the morning of 8 April, while Jacqueline wept, completely lost, Maître Antébi informed the Prefect and the Minister for Cultural Affairs, and then started preparing to inform the family and close friends. But the media had got there first. Meanwhile the gendarmerie had cordoned off the gates of Notre-Dame-de-Vie to filter visitors. In addition, ever since the Pablito incident, the whole property had been surrounded by railings topped with formidable barbed wire.

Paulo, who had not been telephoned by Jacqueline, and to whom my mother Maya had not dared to announce the news she had heard on the television, found out when he made a phone call to Notre-Dame-de-Vie. He arrived in Mougins in the late afternoon. He was absolutely calm, in contrast to Jacqueline, who was completely prostrate. She refused to see anyone, and screamed when any visitor was announced at the gate: even Manuel Pallarés, Pablo's old fellow-traveller, who was ninety-seven years old and had come from Barcelona, was turned away. Paulo called Maya back and advised her not to come. Jacqueline was inconsolable, and refused to listen to reason. When Paulo was told that his own son Pablito was at the gate of the villa, he decided, on his own initiative, that it was not the right moment to admit him. According to Maître Antébi, because he was on such bad terms with Pablito, Paulo feared that he would behave in a manner inappropriate to the circumstances, in full view of the watching media. The gate remained closed.

After being turned away, Pablito roamed the streets of Golfe-Juan, with a placard around his neck which said: 'I am Picasso's grandson and they refuse to let me into my grandfather's house!'

The long-dreaded scandal had broken. Three days later, in desperation, Pablito drank a bottle of bleach. His mother Emilienne and his sister Marina found him lying in a pool of blood. During the three months that his death-throes in hospital lasted, they took turns to watch by his bedside. My grandmother Marie-Thérèse provided them with every comfort in her power, and paid the hospital fees. Emilienne paid tribute to her generosity. She told the daily newspaper *Nice-Matin* that she owed her survival to Marie-Thérèse: 'She was absolutely perfect. Up to the very last, she did everything possible to alleviate my son's suffering. Today she is the one who is paying for Marina's studies in England and who gives me a living allowance. To pay for all these expenses, she has not hesitated to sell one of the canvases that Picasso gave her.'[82] What Paulo could not provide, my grandmother gave with generosity.

Her sincere affection may seem surprising in view of the fact that these children were those of Olga's son – an emotional tangle that would certainly not have displeased Pablo, reinforcing his principle that a united family needs no laws.

Suggestions have been made in the sensational press that my grandfather might have been among those more or less 'responsible' for Pablito's death. But it is only fair to remember that Pablo was then extremely old, and lived as a recluse, for nothing but his art. At that stage, he was not thinking of his children, his grandchildren, his friends or the rest of the world.

I never knew Pablito. Perhaps he suffered from bearing the Picasso name without reaping the benefits that he dreamed of. Perhaps the gate shut against him by his father catalysed his sufferings as a child of divorced parents. This trivial action took on

gigantic proportions. His money troubles, his difficulties at school: in his eyes, all this should have come to an end on his grandfather's death. But his *father* was not dead! Above all, Pablito must have been seeking recognition that he really existed: he, Picasso's first grandson.

Here again, the news of his death, on 11 July 1973, reached me through the media, in this instance the radio, and I had to tell my parents myself. My mother was deeply distressed, not least because she knew how very much her own mother, Marie-Thérèse, was fond of Pablito and Marina. She too had visited him in hospital, and she never forgot the long conversation she had with him. Pablito admitted to her that he would never have committed the act if he could have imagined the pain that he was suffering; he had thought he would die immediately. That day, she gave him a little lead soldier that had belonged to Pablo and which he had given to her when she was a little girl. She thought to herself sadly that he would not survive the irreparable injury that he had done himself. His death was a shock for the whole family. My own mother was unable to go to the funeral. She sent a floral tribute from us all. My grandmother Marie-Thérèse attended, and left a wreath with a ribbon bearing the affectionate message: 'To my grandson.' Paloma was there, too, and stayed close to Emilienne and Marina the whole time. Claude was in the United States. It is claimed that Paulo was also there, in the background, but his face cannot be seen in any picture, despite the horde of photographers. Marina does not remember seeing him there, and neither, apparently, does anyone else.

Maya remembers advising Paulo at the time that he should take care of Marina, and help her, since he was now their father's principal heir and as such could receive advances from the notary, who had already opened succession proceedings. But for Marina, nothing could ever replace the presence of a brother or the affection of a close-knit family. She did not want to see her father again, nor did she see him before his death in June 1975.

THE DEATH OF PAULO

Paulo had wanted to be divorced from Emilienne a few months after the birth of their daughter Marina. Their separation took effect from the spring of 1951. The non-conciliation order was issued in September 1952 and the divorce was decreed on 2 June 1953, by the regional court of Grasse, for reciprocal fault.
Relations between Paulo and Emilienne were at their worst during this period and were never to improve, though Paulo seemed to have the situation under control. Pablito and Marina, of whom Emilienne had custody, were the primary victims. My grandfather hated problems, and reserved all his time for his work: 'If Paulo has family problems, let him deal with them himself. If he needs money, there's plenty! But don't

interfere with my timetable,' he said. But according to Daix, 'that was as far as he would go. Anything beyond that was out of the question. If Paulo had brought the children, I'm certain Pablo would have been delighted to see them.'

Nevertheless, Pablo worried about the situation and proposed to look after the children. He made an official application, but a court decision (of 12 March 1957) refused, and instead ordered an investigation by the social services, followed, incidentally, by a police enquiry launched at the request of the public prosecutor. Emilienne was worried, and suggested that Picasso wanted to snatch her children from her and send them to Spain or the USSR. An insuperable barrier grew up between them.

In 1955, one event followed another. Paulo met a pretty young woman, Christiane Pauplin, always known as Christine. He fell in love with her. That same year, Olga died. Paulo was his mother's legal heir. He received from Pablo the use of the Château de Boisgeloup, which had been allotted to Olga in 1935 (but where she never lived), and certain modest items of property. For him, life went on, divided between Paris, where he lived and where his wife Christine worked, and the Côte d'Azur, where he went whenever his father needed him. Since leaving his administrative post at the Ministry of Foreign Affairs on the Quai d'Orsay, Paulo had in fact replaced Marcel Boudin, the chauffeur whom his father had sacked in 1953. This situation only lasted a year, after which he became his secretary. He provided the link with Pablo's

affairs in Paris, since he lived there and his father never went near the capital any more. In fact, it is in his capacity as secretary that Paulo is mentioned in all official documents. Paulo had a very peaceful, loving relationship with Christine, and she gave birth to Bernard on 3 September 1959. Christine and Paulo were married in March 1962, a year after Jacqueline and Pablo – which did not fail to amuse my grandfather again, happy to cock a snook at another generation like this. Father and son, both 'young husbands'.

All the accounts of Paulo are in accordance. He was a man who was full of kindness and spontaneity, with a passion for the simple pleasures of machinery: of cars, motorcycles and speed. A joyous reveller with nothing of the rich kid about him – even if he was financially dependent on his father. All this changed with his mother's inheritance, because he became more responsible. 'Before the death of his mother Olga,' Pierre Daix relates, 'Paulo was an independent lad who enjoyed the good things in life, not in the least the anxious sort, and ... an excellent chauffeur.' Afterwards, he became more serious. His father's death only accentuated this characteristic. The importance of his new burden of responsibilities constituted a test for which he had not been prepared. Nevertheless, he could display distinct authority and an unexpected composure. Paulo's relations with his father blended mutual affection and a delightful spirit of rebelliousness. Pablo knew that, by nature,

Paulo was isolated from everyone. He was much older than Maya, Claude and Paloma. He was the same age as Françoise Gilot. But he was the 'son' – not a confidant, not a mate, not a work contact. He had not been to university. He was in Switzerland during the war, and after that, back in Paris, he had got the job at the Quai d'Orsay, but he had never learnt any particular calling. On the other hand, he was a gifted mechanic, especially with motorcycles; he was a very good racing rider, and one of his best friends was the champion Georges Monneret, who helped him to perfect his technique. During a professional race between Monaco and Nice, Paulo finished second. Pablo was very proud of his son but, for fear that he might have an accident and be killed, he discouraged him from following this path. Paulo was nearly thirty at the time – but he didn't dare defy his father.

In 1950, one summer's day in Vallauris, Pablo received Philippe de Rothschild, owner of the Mouton-Rothschild vineyard, who wanted a sculpture for the entrance to his estate, in the spirit of the celebrated *Man with a Lamb* in Vallauris. He mistook Françoise for Olga, and exclaimed: 'But they told me you were paralysed!' Olga was in a clinic in Cannes at the time, half-disabled according to rumour. 'It's unbelievable that you can have such a grown-up son!' Paulo roared with laughter. 'You know, I was a premature baby, extremely premature. In fact, I was born before she was.' Then, rolling up his trouser legs to the knees, he began running all round the room, close to the floor, waving his arms and calling: 'Mummy... Mummy!' Claude, who was

three, loved it and followed behind, imitating him. Rothschild's face was a sight!

Paulo had made a number of friends in the world of the corrida. He often went, with Pablo and the whole family, to the bullrings of Arles, Nîmes or Vallauris. He liked to stay in the *burladero*, the enclosure surrounding the ring, from where he taunted the bulls, and often approached the infuriated animals with great courage. One of his best friends in Nîmes was the *apoderado* – bullfighters' agent – Paco Muñoz. Paulo often accompanied him, especially on his trips between Nîmes and Vichy. Pablo, for whom the corrida was always a moment of intense excitement – in which he found all the old atmosphere of his long-lost Spain – looked with benevolence on this friendship and hoped that Paulo would become a part of the bullfighting world, to which he seemed well suited. But Paulo did not take this passing interest any further.

I met my uncle Paulo on several occasions. He was a tall, fine-looking man with an air of authority and salt-and-pepper hair. I remember how close he and my mother seemed to be. Doubtless his discussions with Maya reminded her of happy times with my father. Despite their difference in age, they belonged to the same, pre-war generation. In 1968, Paulo asked Maya to come to Boisgeloup, where his children, Pablito and Marina, were staying for a month. Paulo was a bit ill at ease with these 'reunions': apparently, it was the first time for many years that he had spent so long with his children.

Maya accepted, and took me and my brother Richard with her.

I was very much impressed by the property, not because it was in particularly good condition, but because it seemed enormous, and – supreme 'luxury' in my eyes – it had its own chapel! Christine, Paulo's wife, was there, and I remember thinking that she was very pretty and very kind to us. Pablito was a cheerful boy, whose face lit up with his brilliant smile. He beamed. He was nearly nineteen, and tall. In contrast, his sister did not talk much. They were both starting their final year at school in September. I was rather shy, and did not know what to say to them. Their (half-) brother Bernard jumped about in all directions for joy and, as we were very nearly the same age, we were delighted to run about with him.

We took photos. Paulo seemed very happy. Everyone was smiling.

Barely two months after the death of Pablo, on 7 June 1973, in the midst of all the court filiation procedures, Paulo, provisionally the sole inheriting descendant, came to ask my mother her advice.

They talked for a long time, about the past and the present. He was bewildered by all that had happened. Jacqueline was now taking all the initiatives, and he was having difficulty finding his place. Maya advised him to hire a personal lawyer. Not that Roland Dumas, Pablo and Jacqueline's lawyer of long standing, would have given bad advice, but the respective situations of Jacqueline and Paulo were very different.

Paulo then suggested to my mother that they should go together to Vauvenargues, where their father was buried. He regretted all the things that had happened in connection with the funeral, the hurried burial in the garden, without family or close friends, and with no official tribute. He regretted giving way to Jacqueline's despair, and having turned away Maya, Claude, Paloma, Marie-Thérèse, Pablito and all Pablo's old friends. Everything had been crammed into a few hours. He had not been ready.

Jacqueline was in Vauvenargues. She readily agreed that Maya and we three, Maya's children (our sister Diana had been born), should join her there with Paulo. The visit made a lasting impression on me, although there was only the one tomb – I had never been to a cemetery. So this grandfather, born just a few weeks before as far as I was concerned, was there, dead. I also met Jacqueline for the first time: she was dressed all in black.

On the way home, Maya stopped in Aix-en-Provence, and Paulo came and sat in our car. While we dozed off, they talked for nearly two hours. I knew nothing at all about the complexity of the situation, but I knew that there was an indissoluble bond between them.

Jacqueline's original solicitor, Maître Darmon, had very reasonably opened the succession proceedings. He could scarcely have imagined the titanic task that he would have to accomplish to complete them. Any succession had to be 'declared', in its totality, within a period of six months. It was obvious

that this would not be possible because of the huge number of works of art to be inventoried and valued. Furthermore, there were heirs in very diverse situations.

To begin with, Paulo and Jacqueline together had officially opposed the nomination of a legal administrator. They wisely reconsidered this decision, but prudently waited for the court's decisions on filiation. Once all the legitimate heirs had been identified, an order dated 12 July 1974 confirmed the nomination of a legal administrator: Maître Pierre Zécri. The settlement of the Succession began at last, with the five heirs and their advisers. In the summer of 1974, a projected calendar was drawn up. Maître Pierre Zécri had Maître Maurice Rheims nominated as expert. They drew up a methodological memorandum. They both had the feeling that they were going to have an enormous surprise on their hands.

Starting in September, regular meetings began. I remember my mother leaving for Paris every month, taking the famous 'Phocéen', the night train from Marseilles to the capital. Not once did my mother say that she had been present at any argument during these meetings, the purpose of which was to reach a settlement quickly. The famous 'trials', which in reality were merely procedures, were already ancient history. On the contrary, relations between the heirs were good. Common sense prevailed throughout.

Then an unexpected tragedy struck on 5 June 1975. That morning, my mother woke me up to go to school as usual; her eyes were red and she dried her tear-stained cheeks with difficulty. She said: 'My brother Paulo is dead.' I was dumbfounded. 'But what happened?' I asked her. 'It was cancer of the liver. He'd been very ill for some time; he'd been better lately, and he was in Spain with his wife Christine. He had telephoned me to say he was feeling well. He had even driven the car. And then, in Barcelona, it suddenly got worse. They brought him back to Montpellier in an ambulance and flew him to Paris. He died suddenly in the hospital yesterday. Christine phoned me this morning.' Paulo officially left a widow and their son Bernard, and a daughter, Marina, from his first marriage to Emilienne Lotte. Marina and her mother were still living in Golfe-Juan. Marina hastened to Paris. My uncle Claude had sent her a one-way plane ticket: he did not know when she would leave again; it would be up to her to choose. On the other hand, he knew that she would now have the means to organise things: Maya, Claude and Paloma asked Pierre Zécri, the legal administrator, to pay her a considerable advance on her inheritance, such as they themselves had received.

Paulo was buried in Paris, in the Montparnasse cemetery. The whole family, dressed in mourning once again, were assembled: it was a bright, sunny day. Old friends were there, together with the lawyers dealing with the Succession. In the large hearse, in front of Paulo's coffin, rode Christine, his widow, their son Bernard, Maya and Marina.

The atmosphere was gloomy. Each of us was trying to forget the past. Pablo had died two years before, Pablito had committed suicide the same year, and now Paulo had passed away. Three generations wiped out. It was certainly hardest for Marina, who had lost her family: an absent grandfather, an inaccessible image; a father 'in spite of himself'; and a brother who had despaired, so near and yet so far. In the hearse, her gaze lost in the distance, she said: 'No more court proceedings – never again!' Too remote from all of us, she too must have believed that there had been rifts between the members of the family. She was not aware of their sacred bond of union.

There were now two estates to deal with: on the one hand, that of Pablo with his four heirs, Jacqueline, Maya, Claude and Paloma; and, following on from it, that of Paulo with his three heirs, Christine and his children Marina and Bernard. Marina was then twenty-four years old; her (half-) brother Bernard was only just fifteen.

Mourning notwithstanding, it was necessary to keep up with the inventories and meetings. Marina's lawyer had distinguished himself in 1973, by an absurd action in favour of her mother Emilienne, who had attempted to 'participate' in Pablo's estate in that year, arguing that Paulo had no right to 'renounce' the estate of his mother Olga in 1955, and that, in consequence, Emilienne ought to have benefited from it at the time of their divorce (although it was decreed on 2 June 1953), since they had been married in joint ownership of property. The action was ridiculous. But of course

Emilienne had immediately attracted the attention, however briefly, of the journalists of the region; all this must have had its effect on Paulo, already tormented by his son's suicide. It was a time of waiting and watching.

THE SUICIDE OF MARIE-THÉRÈSE

Through all these years, my mother had always shown herself to us as determined and gentle. She had never allowed us to perceive her worries. She was invariably optimistic and honest. Our father, who was more interested in sailing than in the Succession, compensated for the influence of the 'Picasso' world which sometimes threatened to loom too large in our lives. His resistance must have given us stability even if we were not aware of it.
We lived in Marseilles, a long way from the other members of the family. Maya kept in touch with the others, mostly by telephone. Especially with her mother, Marie-Thérèse, whom she phoned regularly.
Until 20 October 1977, when my mother woke me and told me that my grandmother had died the day before.
At first I thought she meant my father's mother, Marcelle, who was already over eighty. 'No, it's Baba, my mother,' and she couldn't hold back her tears. Shortly afterwards, I saw her set off in the car with her friend and lawyer, Marie-France Pestel-Debord, for Juan-les-Pins, where Baba lived.

My father, thinking I was old enough to understand, then told me that Marie-Thérèse, my grandmother, had killed herself. My mother did not yet know: the Antibes police had just told her, by telephone, that Marie-Thérèse had 'had an accident' – with no further explanation of her death. My father decided that he would say nothing to my brother or sister. As usual, in the course of the day, the media started talking about it, and it was even mentioned on the eight o'clock news that evening, but he managed to switch off the sound in time.
For my mother, who had arrived in the meantime, the world had fallen apart. Marie-Thérèse had left nine letters – including one of a single page for Maya, which the police never passed on to her. According to a detective inspector, Marie-Thérèse simply asked her forgiveness. In contrast, there was one nine pages long for Marina: was it ever handed over to her? According to the letters that Maya received from her mother, the very close relationship between my grandmother and Marina had deteriorated seriously after June 1975. Marina had not replied to requests for the repayment of large sums of money that my grandmother had lent to her before Paulo's death.

My mother told me later that Marie-Thérèse had lost her sense of personal contact with Pablo, which had been maintained unbroken ever since they met in 1927, and which was only interrupted on 8 April 1973 by the death of her only love.

Marie-Thérèse and Pablo had talked again on the telephone only a week before he died. She had noticed that he was not well. She had warned Maya, her presentiment confirmed by the very feeble handwriting of Pablo's last letter, which had arrived on the morning of the telephone call.

Marie-Thérèse had lived in a virtual world, sublimated by Picasso, protected by him from the outer world. He had always paid her a sizeable allowance, up to the spring of 1973. The allowance was no longer paid. More important: their spiritual bond was broken. She had to face the outside world alone. Fifty years after they first met, she had chosen to join him. She had hanged herself in the garage of her lovely house.

Although they had conversed regularly by telephone, my mother now discovered, with infinite sadness, the world that Marie-Thérèse had inhabited and the reality that she had had to face since the death of Pablo. Cut off from him, at first she had continued to do good for people around her, buying someone a coffee or someone else a fur coat, paying for a car or a trip abroad for another, settling a bill for cosmetic surgery for a close relation – all unaware that she was merely purchasing friends. When Marie-Thérèse had had to start counting her pennies, these 'dear' friends had melted away.

Her death added yet another building block to the edifice of fantasy that the Picasso legend had now become. Six months later (because her body had had to be conserved in the morgue pending the completion of the CID investigation), my mother attended Marie-Thérèse's funeral in Antibes, alone, surrounded by a crowd of journalists and photographers: significantly, she has erased all their sound and fury from her memory.

MARINA'S PROBLEMS

Time resumed its flow. But we were now aware that we needed to protect ourselves from the spiritual dominance of Picasso. This worrying dominance was not exerted by the man himself, but by our relationship to him and his work. We had to be ourselves before being Picasso. For his heirs, the fact of possessing his works ought to have been no more than a fact of life – of their life. But was it possible?

My mother had always lived with her father's works. She had hardened her heart and trained herself for life. And then we had arrived, and she had fought for us. As for Claude and Paloma, they had the advantage of being young adults, with their lives before them. They too had been brought up by their mother away from Picasso's influence. Even so, she had taken steps in advance, with Pablo's agreement, to protect their rights.

The one we were worried about was Bernard, so spontaneous, so favoured, and so fragile; he needed someone to look after him. So Claude became his second father and his friend, usefully complementing the

natural affection of Christine, mother of a boy who was far too young to inherit.

Ever since the age of twenty-two, Marina had been living with her companion, Dr René Abguillerm, a married man at the time, twenty-five years her senior and a sort of second father himself. He was already the father of two daughters, Véronique and Florence, usually called Flocy. Marina had met him, she revealed, when she was fifteen. She was going through a difficult stage. The headmaster at Chateaubriand private school had asked Dr Abguillerm, a psychology specialist, to visit Emilienne Lotte and her children, because he suspected a serious problem. The romantic attachment between Marina and the doctor only began seriously in 1973, after the death of Pablito. When Marina received the first advances on the legacy of her father Paulo, from the summer of 1975, their relationship became very much easier on the practical level. They lived on the Côte d'Azur, at the aptly named *Marina Baie des Anges*, between Antibes and Nice. With Gaël, their son, born in the autumn of 1976, Marina had rediscovered her grandfather's hunger for freedom, emancipating herself from laws and allowing love to triumph. What matter that René was still married? She was not only René's mistress, she was also the mother of their child. Legitimate, natural or adulterous child: these terms had ceased to have any importance to her. Marina and René separated, but were then reconciled, and a second child followed, a daughter: she was named Flore in memory of René's mother,

who had tragically been killed in Vietnam. For Marina, love triumphed again over legitimacy. Just as it had for our grandfather. But the second separation of Marina from her companion, soon after the birth of Flore, was terrible, as recounted by the latter. Marina lodged a complaint of assault and battery and attempted murder. The press took it up. The doctor, who had gone and settled in Thailand and then Cambodia, working for a humanitarian organisation, was convicted in absentia without his knowledge, but was completely exonerated by the courts when he discovered the proceedings on his return several years later. Marina was still close to her mother at this time. She seemed to have a family. We did not know how ephemeral all these happy times had been, and that Marina would have to go through a long process of psychotherapy which would go on, as she told us later, for fourteen years.

As for Dr Abguillerm, he contacted me in autumn 2002 and regularly sent me touching letters describing his adventurous life on the other side of the world and his relations with Marina, and continually asking me for news of their children, Gaël and Flore: he suffered from not being able to see them any more. He never gave up hope, but he never saw them again. He passed away in 2012.

THE SUICIDE
OF JACQUELINE

Last of all, there was Jacqueline, 'Picasso's widow', rather like being Queen Mother. She would have preferred it if the world had ended on 8 April 1973. The world had lived on; her own world had been turned upside down. Now the Succession would be settled and the Picasso Museum in Paris would open to the public with the unbelievable collection of which she had been the guardian for close on twenty years. She no longer had a function.

She, who had set the scene for the end of her husband's life, made her exit in one last memorable event. She organised a major exhibition of her collection in Madrid, under the patronage of the Spanish sovereigns, down to the last detail. On the opening night, 15 October 1986, she put a pistol to her head and went to join Pablo.

She now rests in Pablo's tomb, in Vauvenargues, watched over by the Sainte-Victoire mountain.

Her daughter, Catherine Hutin, issue of her first marriage, became her sole heir. In one of the ironies of life, she thus received a significant share of the Picasso estate, since her mother had been the principal legatee without having to pay death duties. There was therefore a second, very important Donation, including some extraordinary portraits of Jacqueline, and twenty-four notebooks of essential drawings. They went to the Picasso Museum in 1990.

As for Catherine's collection, it was revealed in part, for the first time, at the opening of the Pinacothèque de Paris in November 2003, in a first exhibition affectionately entitled 'Jacqueline's Collection'. In 2017 another major exhibition in Landerneau (in Brittany) at the Leclerc foundation reminded the impressive size of her collection and how she intended to carefully keep it. Catherine, now divorced from her Brazilian husband, lives with their two adopted children. She and my mother Maya were very close at the time of Jacqueline's death. They shared the same grief of having lost their mothers in similar tragedies. Just as Marie-Thérèse had not been able to survive the death of Pablo, the love of her life, so Jacqueline could not live on after the setting of her sun.

This final episode was the last to contribute to all the excesses of the Pablo Picasso legend. It combined all the ingredients to fuel the most fantastic imaginings – but also, unfortunately, sordid tales and offensive rumours.

PICASSO AND MONEY

'Living modestly with a lot of money in your pocket.'
Pablo Picasso

Pablo and money: the subject is intriguing, fascinating; it is the stuff of dreams. Sometimes it is irritating. Picasso was undoubtedly the wealthiest artist in the history of the human race. He left his relations – most unexpectedly – the largest inheritance, in both size and value, ever to be shared among any painter's family. It was as if he had discovered an ancient alchemist's secret, such was his ability to transmute every brush-stroke into gold. And that is not counting the record sums attained by the sale of his works. Approximately four tenths of his total output were inherited by his heirs. These constitute, jointly and severally (with the exception of his widow Jacqueline, who died in 1986, and her heir, her daughter Catherine Hutin), a Joint Ownership which holds and exercises moral rights over the whole of his oeuvre, his name, his image – and derived rights. According to the law, moral rights are non-assignable and are transmitted primarily by descent. It is probably the best organised Joint Ownership for the protection and promotion of such an inheritance in the world today, and extends far beyond the individual interests of the heirs of which it is constituted.

Associating art with money seems disagreeable, or even unacceptable. There are people who prefer penniless painters to millionaire artists. Yet money has always financed art. Would Michelangelo have painted the Sistine Chapel without Julius II, or Raphael the rooms of the Vatican without the Medicis? What would Chambord be without Francis I – or Versailles without Louis XIV? Is it possible today to put on a major exhibition without a sponsor? Artists have always sought to sell their talent, because they are involved in society and all its mechanisms. They do it without any embarrassment. The United States of America has carried on this dialogue, with the success and influence that are well known, far beyond their borders, while some countries (France is one of them) regard money with suspicion – a state of affairs that is not without hypocrisy. In fact, money is the sole measure of a work of art – that object devoid of rationality. And paradoxically, in a society which exalts the commodity, its value is not the product of measurable investment, of time spent mixing ingredients of known price, but of an abstract consensus – an emotion.

As I mentioned earlier, my grandfather came from a modest family; it was of middle-class origins, though the Ruiz Blasco y Picasso household had to tighten its belt to make ends meet. Pablo's childhood, in Malaga,

A Coruña and finally Barcelona, was governed by these relatively straitened circumstances. Pablo's father, my great-grandfather Don José, painter and teacher of drawing, earned barely enough to support his family. He quickly discerned that his son possessed exceptional artistic gifts, but his training and his loyal state employee's character set limits to his ambition: Pablo, he thought, would make an excellent drawing teacher and a brilliant successor to his own post. Trained in the academicism of a God-fearing Spain, Don José imagined his son at the most as a highly talented portrait painter, who would supplement his monthly salary with commissions from bourgeois families. Artistically, Don José had his own speciality: pigeons and doves. They would be little Pablo's first subjects.

All this was promisingly conformist. Don José liked tradition, which reassured him in his day-to-day existence. But unfortunately, this orderly life was beset with misfortunes: his post as curator of Malaga's little museum was abolished. This event probably awoke in Pablo the desire to explore elsewhere, and to act differently.

Another member of the family became aware of the child's talent and 'contributed', in the material sense, to developing it. His doctor uncle Don Salvador, who was said to be rich and was head of the family out of necessity, provided for the needs of young Pablo, and then of the art student who set off for Madrid in 1897 to train at the Royal Academy of San Fernando. Don Salvador thus takes his place in the history of art patrons: he enhanced his own social status and expected Pablo to obtain some academic prizes which he could be proud of in return for his investment.

But Pablo was bored by the courses and preferred the experience gained in nocturnal encounters, in the life of the seedier streets of the city and in visits to the Prado museum. Don Salvador observed that Pablo was not attending classes any more, and cut off his allowance.

Pablo had never known cold or hunger. Suddenly, he found himself on the slippery slope into poverty, and then to genuine want. This period of his life was to be decisive in forming his attitude to people and things. Finding himself thus in need brutally defined his relationship to reality – and to money. Even so, material difficulties did not turn him aside from his vocation. Picasso started from nothing! The heritage that he was to build up in the seventy-five years after his experiences in Madrid was the fruit of his own toil and obstinate determination alone. And although we may not like to admit it, his career also owed much to his business sense – first and foremost, his refusal to be pushed around. It was not the product of a life spent languishing and complaining – neither was it mere good fortune.

So Pablo was master of his own destiny. He had to buckle down. He had plans for the immediate future. He was not going to wait for the death of some rich uncle in America or anywhere else. Had his father not taught him that a living is earned through work?

If art cannot exist without money, then money cannot exist without work – which makes art a pure product of human 'genius', in the sense of 'man as maker' more than of 'the exceptional man'.

Pablo travelled a lot. Madrid, Barcelona, Paris. They were long, dusty, uncomfortable journeys, in third-class carriages with wooden benches, drawn by noisy steam locomotives.

In Paris, where he went in 1900 for the Universal Exhibition, he realised that a wind of change was beginning to shake the world, and that he must be among the shakers. That was what finally led him to settle in the French capital in 1904.

I have already related how a few friends, Catalan like himself, put him in touch with some art dealers. He still had to overcome the almost carnal relationship that bound him to his works – or should I say his 'children'? Pablo never liked selling his creations. To begin with, his talent had developed under the benevolent eyes of his father and uncle, not under pressure of commercial need. But now he had to make choices in order to survive.

When the task of settling the Succession began in 1973, all these 'children', in different houses, had to be inventoried. Throughout his life, my grandfather had kept the works that he liked, the 'Picasso's Picassos', which nothing would induce him to part with. Of course he had had to sell more works at the start of his career; his 'production' was still limited by his scanty resources, and he would only keep a few canvases from his

blue, rose or cubist periods. But as soon as he began to suffer less from lack of money or time, his production increased, and he could keep works more often.

The Paris Picasso Museum, created from the Donation made by his heirs in settlement of death duties, is the exact reflection of the treasures retained by my grandfather, and brings together a wide selection of works from every period of his life: all those that he had never been willing to exchange for money.

When Pablo arrived in Paris, at the height of his 'blue' period, his existence was particularly precarious. He did not have enough to eat – or not every day. His only resources came from the sale of his paintings: meagre enough resources, since the few dozen francs that he received from them had to cover the cost of fresh canvases and paints, as well as food.

At that stage, he had not yet entered the circle of the art dealers. His first contact with the Paris dealers came through a Catalan émigré named Manyac, who purchased a few of his early canvases. He acted as interpreter – and took his cut in passing.

He introduced Picasso to the great Ambroise Vollard. But the promising success of 1901 (several dozen francs, at a time when 10 francs represented a little over 40 euros in today's money – a tidy little sum) was not confirmed: instead of the flurry of colours of Belle Époque Paris, Pablo was now painting dark figures, sad and emaciated, reflections of his own day-to-day life – but

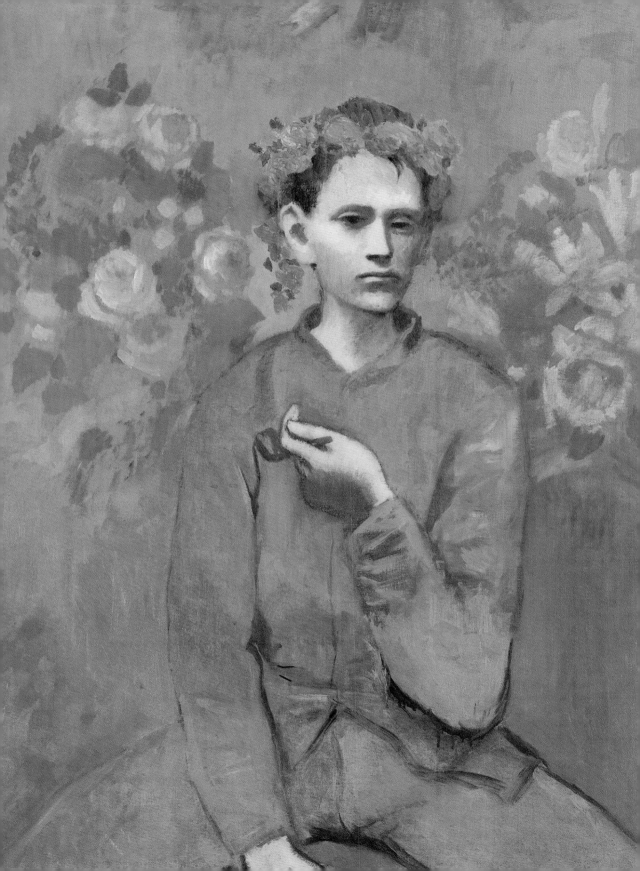

not that of his clients. The suicide of his friend Casagemas cast a gloom over him. In addition, he was worried that he had found a style which was admittedly popular, but which threatened to entrap him. Just like this Manyac character, who provided him with lodging but whose demonstrative, not to mention ambiguous affection was beginning to feel stifling.

His paintings were no longer selling. What should he do?

Pablo went back to Barcelona, and after a short period of uncertainty, returned to Paris to put up a fight. He could negotiate as readily with a difficult 'second-hand dealer' like Clovis Sagot as with that committed 'debutante', Berthe Weill. Ambroise Vollard, however, came back to him, and in 1906 and 1907, in successive purchases, bought a considerable portion of his output. This included the preparatory sketches for *Les Demoiselles d'Avignon* . At the same time, two rich Americans, Leo Stein and especially his sister Gertrude, were entering Picasso's life.

Pablo was thus beginning to be talked about within the Parisian microcosm – consisting, at that time, of no more than ten people. A young dealer of German origin, Daniel-Henry Kahnweiler, discovered him during an impromptu visit to the Bateau-Lavoir, in 1907. Pablo had just finished *Les Demoiselles d'Avignon*, a historic moment in the swing towards modern art. But Kahnweiler did not become his model dealer until 1911.

Picasso's negotiating talents immediately took him by surprise. After the success of his first cubist canvases, Picasso's standing soared: he received about 150 francs (60 euros today) for a canvas of the 1906–7 period, but this rose to 3,000 francs (about 12,000 euros) in 1911. Pablo signed an exclusive contract with Kahnweiler at the end of 1912, but he set his own conditions and prices – in tune with the burgeoning market. They even fell out during the 1914 war when, on the eve of the German attack, Kahnweiler, a German national, took refuge in Italy. The works in his gallery were seized, and he could not honour his debt to Picasso. The latter demanded the repayment of the debt in full before he would agree to start doing business with him again, in 1923. Meanwhile, Pablo had met a dealer called Léonce Rosenberg (at Kahnweiler's home, incidentally): Rosenberg replaced Kahnweiler during the war. However, he did not have 'vision', and made way for his brother Paul, friend of the celebrated Eugenia Errazuriz, a personality in Parisian life and Pablo's 'modernist' confidante: it was she who made the introductions.

Paul Rosenberg and his partner Georges Wildenstein deserve the credit for kick-starting Picasso's international reputation. The former covered Europe, the latter the United States. The agreement concluded in 1918 organised Picasso's media exposure and standing for the next twenty years. The canvases that these dealers chose to put on sale – which were proposed by Pablo – certainly corresponded to what the public was capable of appreciating at that stage. But the pair gave a false impression

of Pablo's oeuvre by exhibiting such and such an older work while refusing to buy a more recent canvas that they held, rightly or wrongly, to be less 'commercial'.

On the other hand, from the financial point of view, they met the requirements of their client to perfection. Not least because this was the beginning of a flamboyant period with Olga; Pablo was keeping up an expensive lifestyle.

Kahnweiler would maintain his relationship with Pablo until the end of his life; but the artist would always keep him, with great skill, in competition with other dealers. He would make appointments with them in his studio at intervals of half an hour, so that they would meet in the hall! He never could allow anyone else to call the tune.

So does this mean that Pablo, from his early youth, had nurtured ambitions that were more financial than artistic? That his painting followed a 'career plan'? I do not think so. It was just that, at the age of twenty, in Maslow's hierarchy of needs, he was still at the physiological stage. Cubist but realist, he had grasped the fact that life is impossible without money.

Some biographers have made accusations that he was a miser, all based on declarations by Marina, who has forgotten that he paid for her own education and that of her brother; but these are outweighed by countless examples of his generosity. During the inventory for the Succession, between 1973 and the end of 1976, an astonishing number of letters from unknown people were discovered – it has been calculated that in the 1950s and 1960s he received more than a hundred appeals every day – and these did not all go unanswered.

But one fact should be remembered: in those days, in the society of the beginning of the twentieth century, poverty and destitution led to death. There was as yet nothing of the arsenal of social protection and solidarity that we know today. No charity evenings, no telethon appeals, no unemployment benefit. Life expectancy alone was shorter than today.

My grandfather lived during this period, and he lived sparingly. He had saved his own skin, and very soon he provided for the needs of many people. This experience of extreme poverty had taught him a 'responsible' attitude towards money: not to spend it needlessly because it should be used for essentials, to provide the vital minimum, for himself and those dear to him – his wife, companions and children, his Spanish family, friends in circumstances of destitution, former mistresses, political causes or employees – not to mention the upkeep of houses that had become depots for the storage of a gigantic oeuvre. Nor the countless requests for donations. Pablo ended up laden with responsibilities that he had never sought. He preferred to devote his time to his art.

It is difficult to conclude that such foresight constituted avarice, or even simple parsimony.

As for the dealers, my grandfather strung them along. He showed them what he felt inclined to sell them, and not what they

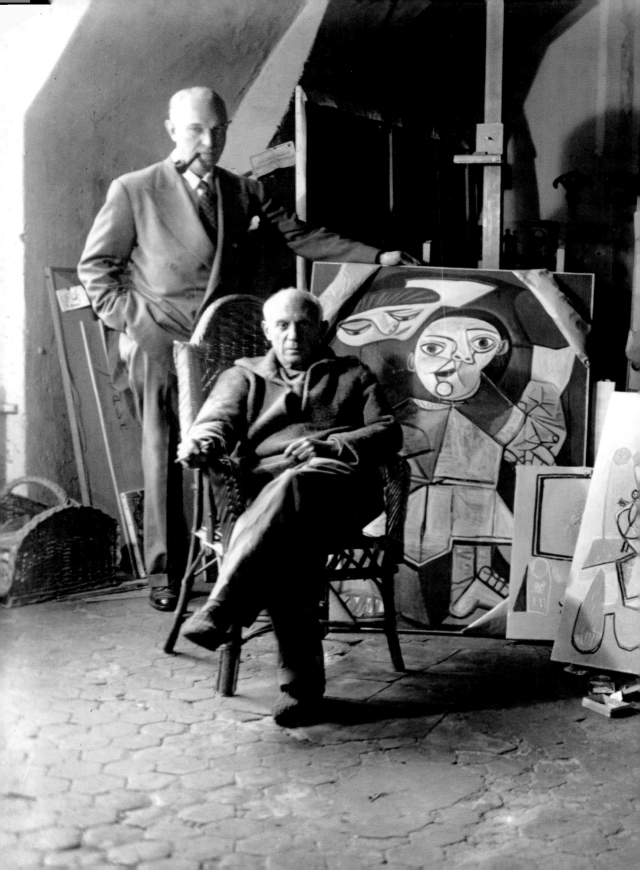

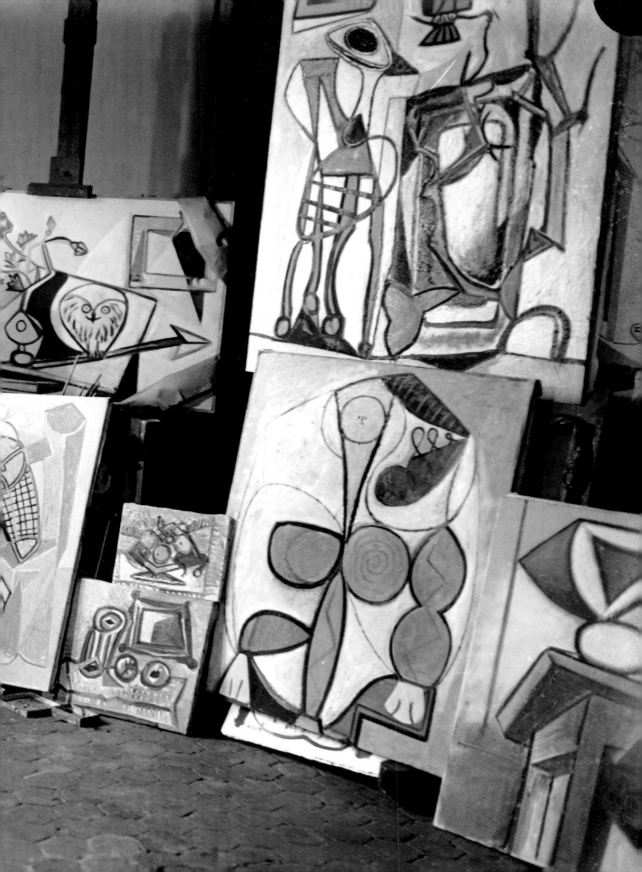

could buy from him. Even with Rosenberg and Wildenstein, he would in the end pre-select what they 'would like', without ever painting for them to order. The price fixed for each work was a challenge that it was up to them to take up. Picasso played with them. One day, he even joked to Kahnweiler: 'Good news! I've given you a raise!' In fact, he had just increased the price, fixed by him, for his works – not Kahnweiler's percentage. If he gained more, so did his dealer, because his percentage was worth more. Why should he be satisfied with an unchanging quota? Figures apart, he wanted to defend the interests of all artists. He was the leader of an informal union. By according an ever-increasing value to art, he aimed to erase the stereotype of the doomed artist, the starving painter – such as he had known at the Bateau-Lavoir. His epoch was that of the international art market; he had grasped how it worked, and intended to dominate it. In politics, he believed in the revolt of the proletariat and in progressive ideas – the well-known 'Grand Soir'. In art, he saw himself as the new symbol of the artist's relationship with the world. Art would be pioneering. Art would be value.

But this does not mean that he sold his soul, since he did not create to meet the wishes of the dealers. Each to his own field. The sincerity of his work is evidence enough. Thus, from 1910 on, Pablo's standard of living improved considerably. With Fernande Olivier, his first 'official' companion, whom he had met at the Bateau-Lavoir, he moved into a handsome flat in the Boulevard

de Clichy. In the well-loved traditions of Montmartre, they organised convivial dinners, evenings that lasted into the small hours, faithful to the bohemian spirit.

He and Fernande separated at the beginning of 1912. His lifestyle was now more than comfortable. With his cubist canvases, he had become known, and recognised. He was leader of the 'trend'. And at the Café de l'Ermitage, in the Boulevard Rochechouart, his eyes met those of Eva Gouel. A few months later, they set up house together in Montparnasse.

Until Eva's decease, in December 1915, his existence was happy, reclusive, almost carefree, despite the background of the war. After the young woman's death, as I have related, Pablo tried to forget his grief in affairs with no future. He was wealthy enough to be able to keep several relationships on the go at once.

The year 1913 was notable for the extraordinary sale of works purchased by a group of discreet investors forming an association evocatively named 'La Peau de l'Ours' ('the bearskin' – a reference to the proverbial advice: 'Don't sell the bearskin until you've killed the bear'). The group was founded in 1903 on the occasion of the autumn Salon which would unveil the art of the new century. La Peau de l'Ours had a ten-year plan: each year, it would buy works by promising contemporary artists, which would all be sold at the end of this period. Its annual budget was 2,750 francs (about 9,300 euros). The originator of this 'consortium' was a dealer named André

Level, who had managed to persuade, among others, his three brothers and a cousin to participate in the venture. As a matter of fact, he was the only specialist, and the idea was more of a gamble than an investment. He looked for clients among the artists themselves –Matisse, for example – and among the more avant-garde dealers. In fact, only one gallery was offering 'modern' works at the time: that of Berthe Weill. Madame Weill had adopted a policy of very moderate commissions, in the order of 20% on sales – with no price guarantee. Level bought three Matisses and twelve Picassos for the 2,750 francs that he had to spend. In 1906, he asked his associates to devote the greater part of their budget to a single artist: Picasso.

The activity of La Peau de l'Ours awoke the interest of the Paris galleries and the dealers. Bernheim-Jeune signed up Matisse. Sagot, Vollard, Udhe and Kahnweiler fought for the favours of Picasso. Even Ambroise Vollard started buying again. The growth in the art market over ten years was such that in 1922 La Peau de l'Ours, which had a fixed annual budget, could only afford to buy works by second-rate artists.

So the following year, Level began the programmed sale of the forty-five works accumulated over ten years. He organised an auction sale – the twentieth century's very first in the art world – after a major advertising campaign in the press and the preparation of a high-class, exhaustive catalogue. On 2 March 1914, the sale room filled up with eminent collectors, well-known dealers (including Ambroise Vollard and the German Heinrich Thannhauser), celebrity intellectuals and Paris socialites. It was a real society event. The sale realised four times the total investment. The twelve major Picassos purchased by Level – including *The Family of Acrobats*, *Three Dutch Girls* and *Harlequin on a Horse* – obtained staggering prices.

In the more sanctimonious press, there was outcry. The media accused foreign buyers ('Germans', what's more, at a time when the movement demanding revenge for the war of 1870 held the high ground) of seeking to subvert young traditionalist painters and pushing them into copying 'grotesque works' in order to sabotage French art! These were misguided reactions. The market had understood; the market had made its choice.

More incredible still was the voluntary decision by La Peau de l'Ours to pay the author of each work 20% of its sale price at auction. To allow each artist to share in the increase in value of his work! It was the very first instance of 'resale right', six years before its official creation. This revolutionary act set the seal on the friendship between Picasso and Level, which lasted until the death of the latter, in 1946.

I have already described how, from 1917 on, Olga Khokhlova initiated Pablo into the customs of the Parisian establishment – just as he enabled her at last to lead a life in accord with her upbringing and aspirations. The pair were united in their ambition to enter high society. After their wedding, they

refurbished a bourgeois residence, opulently furnished, which Olga managed with skill and taste. She got Pablo accustomed to the dinners and dances of polite society, and 'recognition' was certainly not displeasing to him.

Olga's character is less atypical than it seems in Pablo's romantic career. Her role in his development was by no means negligible. Olga was the answer to Pablo's social ambitions, conscious or unacknowledged. Pablo was now approaching forty, and reaping the dividends of his art: the only thing he still lacked was a family and its correlation – social status. With Olga, his heart and his head were satisfied.

Although Pablo could calculate, he did not worry about extravagant expenses, and he always complied with Olga's requests: furniture, furs from Révillon, jewels from Chaumet, clothes from Chanel, Fairyland or Jean Patou. He was proud to have an elegant wife. Even in their worst quarrels, money was never a source of discord between them.

Meanwhile, Pablo never hesitated to help his family or friends in need. He regularly sent money to his mother, a widow since 1913. She had gone to live with her daughter Lola and her husband, Dr Juan Vilató, in Barcelona. He bailed out his brother-in-law, whose business was collapsing – and the couple now had six children, five boys and a girl. After the death of his sister Lola, in 1958, he took back all his early works that he had entrusted to her, mostly paintings and drawings; in 1970 he added them (together with fifty-eight canvases of the *Meninas*) to the donation that his Catalan friend Jaime Sabartés had made in 1963 to the town of Barcelona. But in compensation, he gave his niece and each nephew a portrait of their mother and five paintings from the end of the *Musketeers* period.

I remember our cousin Javier Vilató, one of Lola's sons, a talented painter who died in 2001. I have never met anyone so happy to have been part of Picasso's life. In his eyes I rediscovered the spontaneity of the beaming young man in the background of Robert Capa's photo immortalising Pablo the sunshade-bearer, with Françoise Gilot, on the beach in Golfe-Juan in 1948. It was from him that I gained a better understanding of what was represented, for my grandfather, by the feeling of having a real family, with 'tribal' relationships, based on the sense of clan, and not on financial exchanges. To my grandfather, this 'Spanish' family truly deserved his care. It was dignified, brave and untouched by the tittle-tattle that annoyed him so much.

Throughout his life, Pablo paid living allowances: to his wife Olga, their son Paulo, his children Claude and Paloma, my grandmother Marie-Thérèse – the only one who refused was Françoise Gilot. And my mother Maya requested that the allowance destined for her should be transferred to her mother, Marie-Thérèse.

He refused nothing to his son Paulo, which has been taken as the reason for his alleged psychological dependence. But between

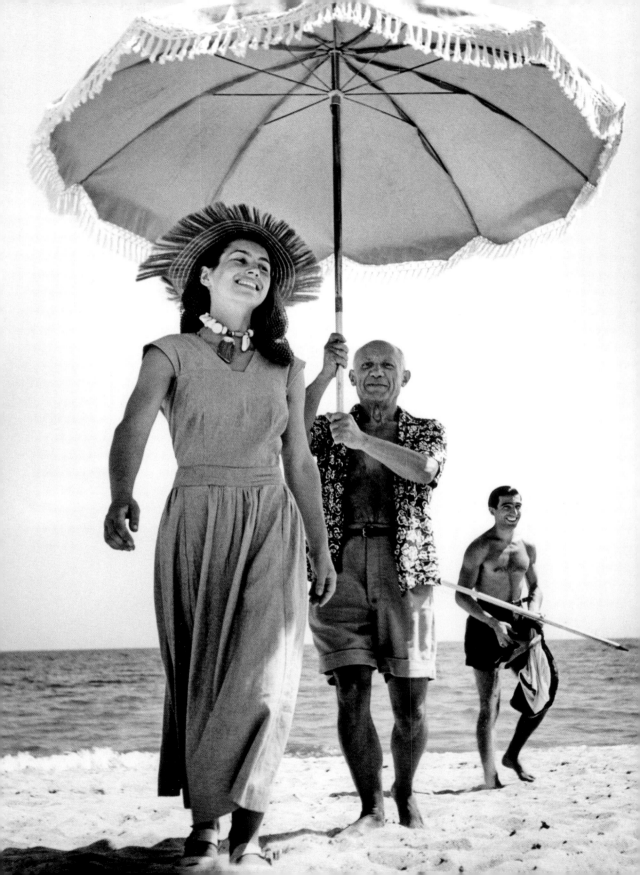

Pablo and his son Paulo, there was an exclusive relationship that few people have understood. There was mutual affection, and a subtle game between father and son made up of cheekiness and trials of strength. It is dangerously simplistic to try, as some have done, to reduce their relationship to a mere question of money: Pablo, perpetually popular, wooed, probably cheated, knew that there were some who would offer him spontaneity and honesty. Paulo was one of those privileged few.

On Olga's death in 1955, when the principle of joint ownership of property resulting from his parents' marriage came into application by default, Paulo could have inherited the half of the couple's property that had belonged, in principle, to his mother – that is to say, half of Pablo's fortune in 1935, the year of their official separation (i.e. the date of the first writ that instituted the procedure). He took no steps in this direction. In 1955, Picasso's fortune consisted essentially of works of art: would they have had to be sold? Taking his share would have been a sort of robbery of his father. Paulo preferred to keep their personal relationship unimpaired.

Pablo was fully aware of the legal situation, and did not try to influence his son in any way: he did not refuse the alternative, but neither did he propose it. Money was no more than a detail between them.

All things considered, there is not the slightest evidence that the financial assistance that Pablo was able to give to his family, to Olga or Marie-Thérèse, to Paulo, Claude or Paloma, ever gave rise to any moral bargaining. Whatever the nature or quality of his relationships, real affection or open conflict, he took full responsibility for his decisions – with firm and, basically, natural commitment. And if there were things that failed or got forgotten, everything was swiftly put right again.

My mother Maya, the daughter of Pablo and Marie-Thérèse, born in 1935, always adopted the same attitude of independence where money was concerned. Pablo was very proud of her. In Maya, he had found the ideal confidante. Furthermore, she resembled him. Like him, she was not much concerned with material possessions. In the mid-1950s, he offered to buy her a flat overlooking the port of Saint-Tropez: she refused. Then it was a large, five-acre plot on Tahiti beach in Pampelonne: she refused again. 'I don't need it,' she often replied. She had seen all the different appeals that her father used to receive, and she had realised the risks: when you take on a debt, you lose your freedom. She left him in the autumn of 1955 to go and live in Spain: she was coming of age, she owed nothing to anyone either morally or financially, and she had her woman's dreams to fulfil. Pablo could not do without her; she was perfectly able to do without her father. It was probably this 'audacity' that forced Pablo to respect Maya. On her return, in 1959, she met my father, a naval officer. They were married at the end of 1960, and Pablo gave my mother, as a dowry, 25 million francs (equivalent to over 400,000 euros

in today's money). Who can still accuse him of being miserly?

As for Claude and Paloma, after the separation between their mother Françoise and their father Pablo at the end of 1953, they received a living allowance right up to his death. The publication of Françoise Gilot's book, in 1964,[83] made Pablo furious, but did not in any way affect the financial help that he gave to the children.

As regards the next generation – which is mine, that of Pablo's grandchildren – there are seven of us. In broadly chronological order: Marina and her half-brother Bernard (Paulo's children), Richard, Diana and me (Maya's children), and Jasmin (son of Claude and his first wife Sydney) and his half-brother Solal (son of Claude and his companion Sylvie Vautier).

Marina and her brother Pablito were first and foremost the children of Paulo and Emilienne. Emilienne was especially proud to be the daughter-in-law of Pablo Picasso and, according to Marina,[84] considered that she could lay claim to the supposed lifestyle of her famous and fabulously wealthy father-in-law. Unfortunately, she had only married his son! After their separation, in the spring of 1951, she had to make do with the allowance, apparently variable, that Paulo paid her out of his own allowance accorded to him by Pablo. The couple separated shortly after the birth of their daughter. The adventure had petered out. After this, Emilienne – who lived with her two children and Daniel, aged sixteen, the younger son of her first husband René, whom she had wanted to look after

– encountered great financial difficulties. Admittedly, she refused to work, an attitude which rapidly became a problem, and which was quite foreign to our grandfather. There were acrimonious arguments with respect to the divorce decree: the appeal action instituted by Emilienne to obtain a more generous allowance from Paulo than that originally set by the court lasted five years. Because she had married Paulo under the full joint ownership of property regime, she thought that, after the death of Olga (Paulo's mother), in February 1955, she could get her hands on her share of Olga's estate, which ought to have gone to Paulo. This was primarily a way of getting Pablo involved in the proceedings. Between 1955 and 1958, Jacqueline and Pablo expressed, with increasing clarity, their wish to have nothing more to do with her. The gates of La Californie remained closed. Since Emilienne had official custody of her children, Pablito and Marina, the latter were the involuntary victims of these disputes. All Emilienne's attempts to send them ahead as an advance guard were met with a polite but firm refusal by the caretaker.

The final divorce judgement of January 1958 settled the situation of Paulo and Emilienne's children definitively, and for the worse, placed them in the exclusive custody of their mother. Meanwhile, Pablo, aware of the storm in the midst of which the children lived, submitted a petition, as I mentioned earlier, to obtain custody; this request automatically entailed an investigation by the social services, followed by a police

The photographer Lucien Clergue and Pablo in a street in Arles, 1956.

enquiry. In spite of his good intentions, his own position as a 'multiple' father and Emilienne's prevarication led to the defeat of his proposal.

The allowance that Emilienne claimed in her court action was revised downwards. A social worker, Madame Boeuf, working in Nice, was commissioned to examine the financial and moral situation provided for the children by Emilienne, and to consider their placement in appropriate institutions. Faithful to his principles, and abidingly concerned about the situation of Pablito and Marina, Pablo decided that he would pay their school fees himself: first, at the Protestant primary school of La Colline, then at the private school of Chateaubriand. Pablo always refused to give money directly to Emilienne because he was certain that it would never be used for the benefit of the children. But faced with the extravagance of the latter, Jacqueline and Pablo, doubtless reluctantly, kept their distance from them, as she had exclusive custody.

DO WHAT YOU WANT TO DO

According to Maya, Pablo never looked to the future. He could never have said: 'You shall have that later.' No, when he gave something, he gave it at once, or he gave the means to obtain it. Thus, as a philosophical father, he gave my mother one of his first pairs of shoes (he gave the other to his own mother), because he considered

that it was something essential on this earth. It was a symbol. He said that no man or woman is free until the day they walk for the first time without the aid of their father or mother.

Pablo was born at a time when children could legally work, when the difficulties of everyday life were held to be character-forming, and when sickness and death prowled about families. The younger ones helped the older ones, in an eternal cycle of renewal. The foundation of society was work, especially since the Industrial Revolution of the nineteenth century and the decay of the fortunes of the Ancien Régime. The entrepreneurs were the new masters.

Pablo's view was that the purpose of help should always be the self-fulfilment of the other person – and should never be given from a passing sense of pity. 'The essential thing,' he would say, 'is to do what you want to do.' He had made that his motto: the key to his freedom and his success.

According to Jean Leymarie, the eminent art historian, 'Picasso was extremely generous; that is to say, he wanted everyone to be fulfilled in what he was. It follows that ... you must do your job conscientiously, and you must reap the fruits of your toil. I do art criticism, and he gave me the tools to understand ... but on the other hand, he told me several times: "If you need money or anything, just let me know."'

In the same strain, the well-known photographer André Villers told me that in 1953 he had a small camera and an ambition to become a photographer. He often passed Picasso in the street and they greeted each other shyly. One day, Pablo noticed that he hadn't got his camera. The young man explained that it was broken. 'It's as if you'd been robbed of your eyes!' exclaimed Pablo. The next day, Pablo sent him a superb professional Rolleiflex.

Villers also told me that when the painter Hans Hartung had to go back to Spain with their friend, the sculptor Julio González, in 1942, they received a large envelope full of money from Pablo for their Spanish political friends; and when the sculptor Germaine Richier had health problems, he sent her a little note: 'I've just sold a gouache. It's for you. If I'm ever in difficulties, I shall remember that you're there.'

Another photographer, Lucien Clergue, had a similar piece of luck. He became one of Pablo's close friends, and was able to capture rare moments in my grandfather's life. He is one of photography's greatest artists and was the first photographer in France to be admitted to the Académie des Beaux-Arts, of which he was elected President in 2013.

Françoise Gilot has given a precise description of her visit with Pablo to the Bateau-Lavoir in Montmartre, in the 1950s: 'We climbed the hill up to the Rue des Saules. There, he knocked at the door of a house and went straight in. I saw a little old woman, thin, ill and toothless, lying on her bed. I waited with my back against the door while Pablo talked to her in a low voice. After

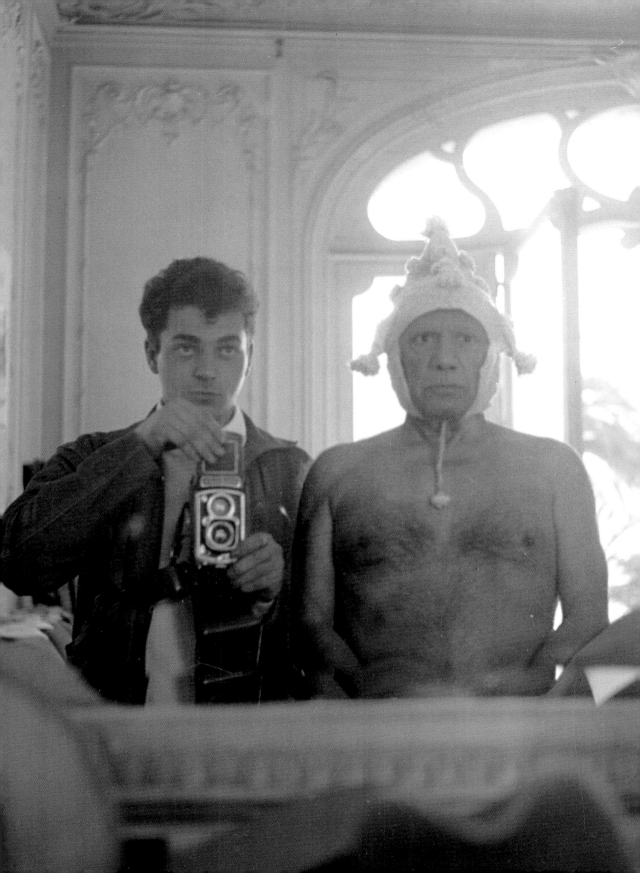

a few moments, he put a little money on the table. She thanked him with tears in her eyes, and we left. Pablo didn't say anything. I asked him why he had taken me to see this woman. "I want you to learn about life," he told me gently. "That woman's name is Germaine Pichot. When she was young and very pretty, she tormented one of my painter friends so much that he killed himself. When he and I arrived in Paris, the first people we met were the laundresses that she worked for. We'd been given their address in Spain, and they quite often invited us to a meal. She turned plenty of heads, but now she is old, poor and wretched."'[85]

Françoise Gilot has never for a single moment cast any doubt on Picasso's generosity, although she has amused herself with a humorous description of the frantic sessions counting and recounting wads of notes carefully locked up in a trunk. 'When he came home, he often asked me, "Where's the money?" I would answer, "In the trunk", because wherever he went, he took an old Hermès trunk with him, containing five or six million in notes, so that he would always have "enough to hand to buy a packet of cigarettes". "You count it," he would say, "and I'll help you." He took out all the money, pinned together in wads of ten, and made little piles. He counted one wad and made it eleven notes. He passed it to me, and I made it ten. So he started again and only got nine. That made Pablo very suspicious, so we set to work to check every wad. ... He made more and more mistakes, and we had to do a recount more and more often. Sometimes

this ritual could go on for an hour. We never both made the same total. In the end, Pablo would get fed up and say it would be all right, whether the count was right or not.'[86]

Patrick O'Brian relates that in 1958: 'Alice Derain and Marcelle Braque told him that Fernande, now deaf, old and arthritic, was not only ill but had no money left; [Pablo] took an envelope, stuffed a million francs into it (enough to live on for at least a year) and sent it to Fernande, although she had mortified him cruelly in 1933 when she published her book, *Picasso et ses amis*.'[87] Heinz Berggruen, dealer and collector, shows the same spirit: 'Everything that I saw of him myself was generosity in person. He did lithographs for me; he didn't ask me to pay anything.' The young dealer with the mischievous eyes, who had set up in Paris in 1948, had met my grandfather two years later and won him over. Pablo wanted to help him, but professionally, by providing him with the raw materials for his trade – pictures to sell.

At a pinch, one could accuse Pablo of showing off with money. For example, Heinz Berggruen recounts how he took one of the new 500 franc notes created by de Gaulle's government, and drew a small corrida scene on it, remarking: 'Now it's worth 1,000 francs.'

Various entertaining anecdotes show how my grandfather was perfectly aware of the value of his work, and how he liked to make fun of people who came to see him because of what his painting was worth rather than

for himself. It was the other side of the coin, and he was fully conscious of it. For example, there was a Paris antique dealer in the 1950s who asked him, on the beach in Golfe-Juan, to draw a picture for him. Picasso pulled a few crayons out of his bag and rapidly sketched a few lines on the ample belly of the antique dealer, who didn't dare to move, and afterwards complained that he couldn't wash or even turn over in bed for fear of rubbing out an authentic Picasso.[88]

Douglas Cooper, collector and art historian, suffered a similar misfortune. He had damaged the side of his car, a black Citroën. In the meantime, before it went back to a bodywork repair shop, Pablo drew on it in chalk – a splendid drawing that turned the car into a work of art worth a fortune. He suggested going to the beach in it. Cooper kept worrying that the drawing would disappear, what with the dust and the speed. Which is what inevitably happened, because Pablo said they should keep going – the trip seemed unending. When they arrived, the drawing had disappeared. Pablo thought it was a wonderful joke.
Pablo's generosity was 'intelligent'. All witnesses agree: he was always willing to give, provided his action made sense. He would give easily, and large amounts; but not if he considered that there was no immediate need. But he also made sure that he did not make the person he was helping feel uncomfortable. Maya remembers that her father would never refuse to lend money to someone. She says, 'What he often did

was to give someone a picture, and then he said: "I've given you the picture, but I'll take it back – I'll buy it from you." And he handed over the money, saying: "As I know you're going to have to sell this picture, and you won't get the same price for it as I would, I'll buy it from you. I'll pay so much for it." And he would give them the sum corresponding to this sale, which was fictitious, but real.' He did not like to hurt people or belittle them. He had had a disagreeable experience himself in his early days in Paris. One morning during the winter of 1907–8, flat broke, he took his courage in both hands and went and rang the door-bell of Leo Stein, Gertrude's brother. 'Before Les Demoiselles d'Avignon,' Picasso related to Georges Tabaraud, 'he always used to compare me with Raphael... Leo wasn't up yet; he received me in bed. He was smoking a cigarette and reading the papers. I tried to tell him my story: I hadn't come to beg, I just wanted an advance on a painting which he would like, and which he or his sister would buy one day. Leo interrupted me with this little sentence, which I have never forgotten: "Why do you go on painting horrors that nobody wants?" He wouldn't listen to me, he just opened a drawer by his bed and threw me a 20-franc piece as if I was a beggar. I hadn't come to beg, and I was tempted to throw it back at him, together with the armchair and his bedside table. But I had no more paints, no more canvas, no more fuel and no more bread, so I took the 20 francs and left.'[89]
Accounts of his generosity are innumerable. All the rest is idle chatter by people who

never knew him or are writing a story for themselves to justify their own existence and claim a connection with Picasso.

My grandfather was also discreet about his generosity. This is laudable in principle, but less so in reality; in their ignorance, some people accuse him relentlessly of selfishness. However, he was quite indifferent to these rumours. And he certainly had no need to make public display of his generosity. Because of Pablo's absolutely unique situation, of wealth as much as celebrity, he received more appeals than anyone. The large charitable organisations did not yet exist. Today, celebrities act to stimulate the generosity of the public, but they do not take its place. What Pablo was asked to give at that time was money.

I am proud to say that this sense of solidarity that my grandfather always displayed has been handed down to the whole of our family. Like him, Maya, Claude and Paloma have always anonymously given their time and a great deal of their money, within the limits of what they could manage, either to medical research or to humanitarian or charitable causes. They may not be pleased with me for revealing this, but it is worth mentioning their example. I remember how I often questioned my mother about the invitations that she used to receive from medical research institutions. Their managers thought, she replied, that in view of her support, she could take part in the galas organised to thank donors and collect further funds – although she invariably preferred to remain anonymous, however

great her contribution. So she never replied to these invitations. She often spent entire days at the hospital, at the bedsides of cancer patients, to bring them her good humour as well. I would see her come home deeply affected, but so glad to have been able to share her smiles with them.

My reason for revealing these matters here is that I am extremely proud of it. Out of loyalty to her way of doing things, and in accordance with my own resources, I also try, as indeed millions of French citizens do, to respond to our great national causes.

The Marina Picasso Foundation, founded in the early 1990s in Thu Duc, on the northern outskirts of Ho Chi Minh City, for the purpose of aiding Vietnamese orphans, was a further illustration of this family tradition of solidarity. It was not a public foundation in the ordinary sense, since it did not campaign for external donations and was funded solely by Marina. The decision of the Vietnamese authorities, some years ago, to reform the procedures for adoption by foreigners in the wake of scandals that had come to light in several orphanages where some children were not in fact orphans, put an end to Marina's involvement (her orphanage has become a state institution) but not to her generous actions, especially in aid of children and adolescents in difficulty. Through this 'redistribution', to which each of us wishes to contribute – in the awareness that we have been exceptionally privileged by accident of birth and the work of our ancestor – Pablo has gained a sort

of second life. It is true that the inheritance that he left his descendants has provided them with the means to perform their own acts of generosity.

He was, however, it must be said, parsimonious with his time. This frustrating feeling that time was flying led him, unknowingly, to offend, disappoint and even humiliate many people. Sometimes his door remained closed even to his children and grandchildren. And this race against time gathered speed as he grew old. Even Paulo, his eldest child, had to announce himself when he arrived on the Côte d'Azur. He did it quite naturally, and did not take umbrage if he was told on the phone: 'Monsieur would rather you came tomorrow!' He knew that his father disliked being interrupted when he was working.

As long as he still had control of his fame, Pablo remained accessible. But after the war, he became a public figure known worldwide. The time that he could have devoted to his family was gradually whittled away by all the people wanting to meet him; it had to be broken up too much. Paulo and Maya, his two eldest children, enjoyed a degree of independence by then; the younger ones, Claude and Paloma, were still too small to visit their father alone. When their parents separated, in the autumn of 1953, this growing incommunicability was accentuated. Yet Pablo exerted himself to receive them for the school holidays and some weekends, just as most separated parents do. Jacqueline's arrival in his life was not the only isolating factor.

Neither must it be forgotten that in the 1950s Pablo, the 'young' father, was already seventy years old. The children, completely unintentionally, could not fail to accentuate the swift passage of time in his eyes. Gérard Sassier, an observer of long standing, remembers this constant preoccupation: not to waste time; to devote himself exclusively to his work. 'That was all that interested him. Things to buy, other activities, no. Except where time was concerned, he was not the slightest bit stingy!' He lived first and foremost in and through his work. Money was nothing but a means that allowed him to indulge his passion, even if, ultimately it was also its result. Daniel-Henry Kahnweiler confirms in his 'Conversations' that one of the things that was most important to him was creativity. One day, 'he had been burgled: the thieves had taken all his linen but left the pictures. He wasn't pleased: he would have preferred them to steal the pictures.'[90] Now he was forced to deal with domestic emergencies and buy more sheets – and that bored him rigid. The pictures were of little importance: he would have painted some more (despite the slight vexation that the linen had been more attractive than his pictures)!

His passion for his work was perhaps excessive. In comparison with this passion, money counted for nothing. My grandfather had a *physical* need to create. Patrick O'Brian tells the following anecdote: 'While he was still very impecunious, Vollard ordered a copy of *Child with a Pigeon*. "Picasso looked at me in surprise," Vollard

relates. "But I wouldn't take any pleasure in copying my own picture; how do you expect me to paint without delight?"'

This is indeed the heart of the matter: working filled him with happiness. He no longer needed to worry about the material aspects of life, because as early as 1916, his life was safe from penury. 'I would like to live like a poor man with a lot of money,' he told Kahnweiler one day. And the dealer comments: 'In the end, that was his secret. Picasso wanted to live like a poor man, and continue to live like a poor man, but without having to worry about the future. That was what he meant: to have no financial worries.' He was perfectly aware that his market value was climbing phenomenally. That made him very cautious, alarmed him sometimes, and annoyed him frequently. Coquetry or false modesty, some will say. Maître Antébi, however, speaks of his satisfaction, in parallel to his irritation: 'He purred,' he jokes. Even so, in the last analysis, he felt that there was something irrational about it. Maître Antébi also remembers that after my grandfather's death, a suitcase was found under his bed, filled to bursting with 500-franc notes. 'For bad times, in case he had to leave in a hurry!'

When Pablo acquired property, he was only buying spaces that would benefit his work. They were not investments; he never sold his properties. Moreover, he continued to pay the rent on places (such as the Rue La Boétie and the Rue des Grands-Augustins) that he never set foot in any longer, and from which, incidentally, he had been expelled for leaving them unoccupied. In this way, at his death, he owned the Château de Boisgeloup, the property known as Le Fournas, the villa named La Californie, the Château de Vauvenargues and the farmhouse, Notre-Dame-de-Vie. He took no part personally in the purchases, and always left his lawyer and banker to deal with the formalities and the price. Paperwork was a waste of time. He was delighted to acquire new studio space like this, and additional room to store his works.

The only exception was the Château de Vauvenargues, near Aix-en-Provence. Certainly, the place was enormous and very convenient, but, as he told Kahnweiler proudly: 'I've bought the Sainte-Victoire.' He was joining Cézanne.
It was probably my grandfather's most impulsive and most romantic purchase.

THE ESTATE

This 'emotional' accumulation of his works would become the Picasso estate. In an official report, Maître Maurice Rheims, the Succession expert responsible for the inventory, describes the artistic treasure left by Pablo Picasso in these words: 'The collection of canvases that the painter kept until his death seems to us to have been constructed in several ways:
– first, the works for which he had a particular fondness. We think here of those

from the start of his career, some of which he repurchased;

– next, the canvases that he kept either because they represented personal memories or because they bore witness to different stages in his technique or his vision;

– lastly, works created in the last years of his life and which he had not yet thought ready to be entrusted to the dealers.'

In addition, and assembled by the same process of preservation, there were drawings, sculptures, ceramics, engravings, lithographs, linocuts, tapestries and books. When Pablo passed away on 8 April 1973, no one guessed that he left the largest estate that any painter had ever built up. Only Jacqueline, his widow, knew the incalculable number of his works – or rather, she knew that it really was incalculable.

But in this succession, things took on an untypical dimension because of the works of art. I remember my mother surprising everyone during the final share-out by jumping for joy when she found that her lot contained such and such a work that she had seen as a child, and that brought so many memories to mind. She would have been just as happy if she had only received half of her due. She had gone off to live her life in the certainty that she would get nothing, because that was the law. Her relationship with her father had thus been untainted by any 'expectations', and in consequence was absolutely disinterested financially.

After my grandfather's death, while the press devoted column after column to calculating the value of his estate and of each of our respective shares, within the Succession a magical enchantment drove out any mercenary sentiments. As each of Picasso's houses was opened, one after the other, in 1974, a whole century came back to life. Art took over again. And each person, Paulo, Maya, Claude and Paloma, rediscovered long-lost memories, often intact – as if time had stopped upon their departure. Jacqueline acted as head of the family, or perhaps it would be preferable to say 'guardian of the temple'.

Maître Hini, one of the lawyers dealing with the Succession, recalls his visit to La Californie, the villa in Cannes that Pablo had abandoned in 1961, in which all the studios had been closed: 'I remember the first full-scale inventory session in La Californie. I had gone down in the course of the day with Maître Rheims. The doors were opened. We were all astounded. It was the cave of Ali Baba. I saw hundreds of paintings arranged one against the other. I saw the studio. Maurice Rheims waxed lyrical because Pablo Picasso did not use a palette, but squeezed his tubes onto newspapers. He said: "Oh my goodness, it's the Master's hand," when he saw the old newspapers on the floor.' And Paul Lombard said: 'I'd never seen anything like it in my life ... it was strewn with works by Picasso, papers lying on the floor... At one point, I stepped on a letter; I bent down and picked it up. I was as if thunderstruck: it was a letter from Apollinaire to Picasso.'

'8 April 1973. I was twenty-one years old, the youngest clerk working for Maurice Rheims. We were in the middle of an auction of modern prints in the Espace Cardin, when the death of Picasso was announced at midday. The sale was stopped, and a minute's silence was observed. The following year, at the end of September 1974, I was present at the start of the Picasso Succession as assistant to Maurice Rheims, who had been appointed to value the assets inventoried in Picasso's house La Californie, which had been his depot and furniture store. The whole of the artist's day-to-day life was revealed: accumulations of objects, alone or in groups, on the walls, furniture, easels, tables, sofas, armchairs, paintings, drawings, sculptures, pottery, prints; hundreds of cardboard boxes full. In the basement, the printing press and all the packages brought from his different residences, his mail, press cuttings, bags full of pieces of string knotted in a figure-of-eight, in the company of Ingres, Delacroix and Seurat, among others. Upstairs, canvases arranged for storage. They had been photographed by Duncan. A sort of organised chaos, with a logic of its own which would help us to carry out the necessary inventory properly. The three months that Maurice Rheims had estimated to perform this task, distributed among La Californie, Notre-Dame-de-Vie and the Château de Vauvenargues, turned into seven years before the completion of the first computerised inventory of the artist's works, due to the number of objects listed: some sixty thousand!'

For Maurice Rheims, the well-informed expert and collector, it was a nirvana, where work and enthusiasm overcame his habitual reserve. To him, 'as we climbed the steps, each of us had the feeling we were entering the house of Raphael'.

Ever since Jacqueline and Pablo had moved to Vauvenargues, and then to Mougins, the studios on the ground and first floors of the big villa in Cannes had remained closed. Now the big house echoed once more with sounds and cries of amazement as in the old days, when Claude and Paloma spent their holidays there. The place was pervaded with a sense of eternity. A memory of a time of ease and happiness, of the joy of life, when the war was over, with brothers and sisters united by one and the same father. I loved it when my mother, in her turn, related all the rediscoveries that she had made. She had little thought of the inheritance. She was picking up the threads of an exceptional life that she had chosen to interrupt nearly twenty years earlier. And to her, Claude and Paloma were still the children that she had known and protected. She must almost have expected to see her father come in at the door, delighted with having played the joke of his death!

The inventories on the Côte d'Azur were interminable. Maître Zécri and Maître Rheims organised two teams: one of archivists, and one of handlers responsible for security, packing and transport to Paris. Each had his own speciality: paintings, engravings, drawings, and so on. It was necessary to identify, number and value the entire contents of the villa in Mougins, the Fournas studio in Vallauris, the villa in Cannes and the Château de Vauvenargues, and to retrieve the works constituting Pablo's last exhibition in Avignon.[91] This meticulous task took nearly three years. The report by Maurice Rheims is almost a novel – and certainly a moving document: 'One can have no idea of the state in which we found the pieces stored in La Californie without looking at the photographs that were taken before the work began. The word "untidiness" would not be appropriate here. It would be sacrilege; let us rather say that throughout our stay in the South, we were faced with dwellings inhabited, one and the other (Notre-Dame-de-Vie and La Californie), by genius, and that genius has its own conception of tidiness. Thus, scattered around the rooms, we found the notebooks containing preparatory sketches for *Les Demoiselles d'Avignon,* rolled up and folded and pushed into the neck of a bottle; a panel illustrating a bullfight, of considerable importance and value, left under a pile of old newspapers, prints from some of the rarest editions, half lost in portfolios in company with advertising leaflets. Thus in the cellar, astray among objects of no value, we found drawings by Degas and Seurat. This propensity for arranging the most beautiful things according to a system known only to the master and those of his immediate entourage would confront us again at Notre-Dame-de-Vie. There, mixed up with magazines and

exhibition catalogues, we found bibliophiles' masterpieces entirely decorated by hand by the artist, and in the garage, buried under piles of books protected by a tarpaulin, we dug up a very old sketchbook of original studies executed by Chirico.'

In the course of the inventory, nearly sixty thousand index cards were drawn up, specifying the probable date of creation of each object, checked where necessary with the aid of an impressive bibliography. There followed an inventory number, a description of the object, its dimensions, the date or signature if present, its state of preservation and any other relevant information on the back. Last came the estimated value.

The culmination of this long task was an impressive list:

- 1,885 paintings;
- 7,089 drawings;
- 1,228 sculptures;
- 6,112 lithographs;
- 2,800 ceramic pieces;
- 18,095 engravings;
- 3,181 prints;
- 149 notebooks containing 4,659 sketches and studies;
- 8 carpets and 11 tapestries;

To these were added all the land and property and transferable securities, including cash at banks totalling tens of millions of francs of the time.

Regarding this last point, it emerged that my grandfather did absolutely nothing with this financial income, which he rejected on principle, considering that the fruit of his work was all that counted. Indeed, he had never touched the dividends and capital gains resulting from the investments made by his bankers.

Maître Rheims, who had assessed the value of each property and every object, even the smallest, under the authority of the legal administrator and with an abatement justified by the number of objects, estimated the total assets of the estate at the exact figure of 1,372,903,256 francs, equivalent to nearly 860 million euros in today's money (even if the actual real value of the heirs' collections must be counted in billions euros today). Maître Zécri had recommended the heirs to be very cautious and to exercise the greatest discretion towards the media. But this exceptional figure, supposedly secret, did not remain so. Estimates in this general order were rumoured.

The growth in the art market since the beginning of the twenty-first century makes it impossible to calculate this value today, but the record prices at auctions continue to demonstrate the dominance of Pablo's work. The price of just ten of his major works now would be enough to cover the whole of the inventory!

In parallel to the meticulous inventory of Maître Rheims, the heirs had been seeking solutions, trying to be as just and as humane as possible.

The atypical position of Jacqueline, my grandfather's widow, merits particular attention. In principle, she ought to have received half of the couple's joint assets, but, for one thing, she was born when her husband was already forty-five years old;

From left to right (standing): Maître Rheims, Maître Magnan, Maître Rivoire, Claude Picasso, M. Geraudie (clerk to Maître Lefebvre), Maître Zécri, Maître Lefebvre, Maître Hini, Maître Bredin, Maître Verdeil, Maître Caire. From left to right (seated): Paloma Picasso, Maître Leplat, Marina Picasso, Maître Ferrebœuf, Maître Weil-Curiel, Maître Dumas, Maître Darmon, Maya Picasso, Maître Lombard, Olivier (son of Maya), Bernard Picasso, Christine Picasso, Maître Bacqué de Sariac. Only Jacqueline Picasso is absent. She is represented by her adviser, Maître Dumas.

their marriage had lasted twelve years after six years of cohabitation (i.e. about one fifth of Pablo's life); and, above all, it was essential to settle the question of the assets owned jointly with Olga, who had died in 1955, and the rights of Pablo's four children with respect to these two sets of jointly owned assets. By mutual agreement, it was decided that the date of the non-conciliation order (authorising the divorce proceedings) between Pablo and his first wife Olga, 29 June 1935, should logically be taken as the effective end of this first co-ownership. The date of Pablo's second marriage, to Jacqueline, 2 March 1961, was taken as the beginning of the second co-ownership, which lasted up to the death of her husband. In this second case, consideration was also given to the destiny of the unknown paintings of the period, 'undisclosed' (and

forming part of the 'community'), and of the paintings held to be 'disclosed'. There were also the paintings dedicated to Jacqueline (and therefore given to her, separately from the Succession, as gifts through custom and practice), which had to be indexed in case their cumulative value should exceed the portion of the estate at the disposal of the deceased for this purpose!

All this, obviously, was extremely complex. But the rights of each person had to be respected. The sum obtained after these laborious calculations would be shared between the late Paulo, Maya, Claude and Paloma, in proportion to their respective situations with regard to the law: technically the value of a half share in the value of the portion due to Paulo (as legitimate offspring) to be divided among Maya, Claude and Paloma (as natural offspring).

After that, Paulo's estate would be dealt with: his children Marina and Bernard would receive equal shares in their father's share, incorporating in addition Olga's recalculated inheritance. Paulo's widow, Christine (married to him under a prenuptial agreement), would receive a quarter of the usufruct of her deceased husband's share. All the works of art in the estate were divided into lots of equal value, both financially and artistically. Thus each of the heirs received a large number of masterpieces in an equitable division. Maître Rheims had made up ten lots (in particular for the paintings); and sometimes twenty or thirty lots, depending on the number of objects, for the other categories, to achieve equality of value more easily. A draw was then conducted for the allocation: three lots for Jacqueline, one for Maya, one for Claude, one for Paloma, two for Marina and two for Bernard. The two successions had been combined before the lots were drawn. Similarly, the single Donation (entitled 'Dation' in French to make a difference with an usual donation as a gift) concerned both successions in combination, to improve homogeneity, and had been withdrawn from the assets of the estate in advance.

Jacqueline Picasso was the principal beneficiary of my grandfather's estate. Firstly, because she kept all the works that Pablo had dedicated to her, which escaped inclusion in the assets of the estate (as donations made between spouses, or gifts through custom and practice); secondly,

because she had absolutely no death duties to pay (due to her status as his widow, married under the property community regime by default). She thus received the largest share.

Although they did not figure among the direct heirs of Pablo Picasso, but were only the heirs of his son Paulo, Marina and Bernard each received a half share in their father's share, and thus ended up the second most important beneficiaries in absolute terms, even if they had to pay their father's death duties, and then their own. Their respective shares were thus cut by about 40%.

Then came Maya, Claude and Paloma, ranking equally; they had to pay death duties of about 20%. Last of all was Christine, Paulo's widow.

The houses had been shared out by mutual agreement:

– Jacqueline retained her residences (Notre-Dame-de-Vie in Mougins, a Société Civile Immobilière company property of which she was the official tenant, and the Château de Vauvenargues, another SCI property, which she had also asked should be allocated to her);

– Maya had asked for the studio, Le Fournas, the former ceramic factory that she knew well;

– Marina had asked for the imposing villa in Cannes (La Californie);

– Bernard had asked for the Château de Boisgeloup, where he had spent his childhood, and which his father Paulo had designated for him in a summary will.

The value of these properties was of course deducted from the heirs' rights to the artworks and other assets in their respective shares.

These personal selections constituted elements of the 'preferential choices'. In fact, Marina in first place, on her arrival in the Paulo succession, had asked that she be given priority with regard to what she referred to as 'gifts through custom and practice'. This relates to gifts that parents commonly give to their children. In her opinion, she had been deprived of these in her childhood.

Taking into consideration her dissatisfaction at not having had these 'gifts', and with a view to avoiding any friction, the other heirs agreed that this should be apportioned to her: a 'preferential choice' valued at several million francs of the period, among the objects inventoried in the estate. Obviously, the legal designation of these supposed 'gifts' – after the decease of the supposed donors, and arbitrarily calculating their degree of generosity – had no lawful basis. Furthermore, Marina never possessed the legal status of an heir of Pablo Picasso, but of Paul Picasso. Since the amount 'given' could not be considered either a legacy or a donation – nor, of course, could it escape taxation – it was reintroduced into the assets of the estate and allocated to Marina, as a compromise, via a 'preferential choice' deducted from the total succession to be shared.

This original procedure had the merit, for the other heirs, of being transparent and of respecting tax legislation, because of which the whole affair was under close scrutiny, and, in the end, of costing them nothing.

This initiative on the part of Marina also had an indirect beneficial effect, since it set in motion the attribution of another 'preferential choice' for each of the heirs, including herself a second time. It enabled each heir to choose the works that he or she preferred to a value of several million francs each. This was a good decision which injected some human feeling into the general atmosphere, which had become very oppressively organisational. So here again, as in other cases, there was no sordid squabbling. My mother Maya suggested to us, her children, that we should each choose one of our grandfather's paintings that we would enjoy: so my brother Richard, my sister Diana and I each chose a work with great care – but also quite spontaneously. Finally, as is often the case in complex successions, Marina bought back the share of the usufruct due to her mother Christine, which unequivocally simplified their relations.

Overleaf: The Studio at La Californie, *30 March 1956, Cannes, oil paint on canvas, 114×146 cm. It was in Cannes that Picasso achieved worldwide fame, in this house frequented by celebrities, politicians, various art dealers and photographers. Requests for assistance flooded in by post every day.*

THE 'DATION'
AS THE DONATION

The inventory was finished in the course of 1977. The 'preferential choices' were declared in the course of 1978. On 21 July 1976, Dominique Bozo, former curator of the collections of the Musée National d'Art Moderne/Centre Georges Pompidou, was appointed to be the director of the future Picasso Museum by Michel Guy, Secretary of State for Culture and the Environment. The idea of a major Picasso museum for France had been put forward several years earlier by the President of the Republic, Georges Pompidou, during the splendid ceremonies of 1971 that paid tribute to the painter. Apart from Pablo's personal collection, which was expected to be the core of a probable Donation, France had not had the opportunity or the resources to build up an exceptional collection in his lifetime. The appointment of Dominique Bozo coincided with Michel Guy's suggestion to the heirs that they should withdraw the Donation from the estate *before* the share-out and not, as is usually the case, from each of the portions after they had been dispersed, and that this should be done on the basis of a proposal put together by the heirs. As Bozo explained, the objective was not 'to assemble a collection of great works alone, but to form a living museum which would show the development of Picasso'.[92] The State would therefore ask the heirs for works selected in advance.

The Minister also nominated Jean Leymarie, former director of the Museum of Modern Art and one of my grandfather's close friends, and lastly, in 1978, Michèle Richet, also a former curator in the same establishment.

Dominique Bozo describes his surprise when he saw the inventory drawn up by Maître Rheims: 'I was amazed: I discovered both quantity and quality. There were not only superb unknown works, but also numerous outstanding masterpieces which Picasso had kept. I knew immediately that I was not faced with the contents of a studio, but with a genuine, deliberate, carefully planned collection.' From the spring of 1975 onwards, this trio of experts was able to examine and make their own choice of inventoried works. Dominique Bozo and Jean Leymarie strove to maintain a balance between the major popular works of each period and the representation of all the techniques employed, giving preference to sets of work (including the preparatory studies) – something it had never been possible to achieve before.

The list compiled by the State was compared with that of the heirs' 'preferential choices' for purposes of arbitration. In the event, no difficulties arose, and the heirs even agreed that the State should add a few works to perfect the coherence of the final Donation. Last of all, a committee independent of the art market was convened for three days. It comprised Pierre Daix, Roland Penrose and Maurice Besset

(former curator of Grenoble Museum, and professor at the University of Geneva), who met to 'confirm' the official choices.

The works constituting the future Donation were transferred to the Palais de Tokyo in Paris at the end of 1978. In a way, it was putting the cart before the horse to hand over the artworks before the official agreement had been signed, but there was perfect osmosis among all concerned. After all, as the Minister of Finance (and future President of the Republic) Valéry Giscard d'Estaing had declared, on the death of Picasso: 'Exceptional cases demand exceptional measures!'

The Ministry of Finance thus received the official Donation proposal early in 1979. A committee of curators, an artistic council of the association of national museums and an inter-ministerial commission, with Hubert Landais (Director of Museums of France) as its spokesman, studied the artistic importance of this Donation proposal, officially emanating from the heirs, but also designed with the involvement of other specialists from the same ministry. After a favourable opinion expressed by the Ministry of Culture in March 1979, the Ministry of Finance officially accepted the Donation in September 1979.

Due to lack of space, a reduced selection from the works in the Picasso Donation was exhibited to the public in October 1979, at the Grand Palais, in Paris. I realised the breadth and diversity of my grandfather's oeuvre at the inauguration by the President of the Republic, Valéry Giscard d'Estaing, and Jean-Philippe Lecat, the new Minister for Culture and Communication.

It was the admirable Malraux law of December 1968, organising the principle of the 'Dation', which had made it possible, with the agreement of the State, to donate works of art in lieu of death duties. This law was passed with a view to protecting the artistic heritage of France and to ensuring that heirs would not be forced to sell important works, sometimes at cut prices to foreign buyers, to pay death duties.

The Picasso Succession was certainly the most emblematic illustration of this law. First, there was the financial necessity which, in the absence of this law, would have forced the heirs to put nearly a quarter (by value) of the works in the Succession on the market; this would probably have caused a sharp drop in the price of Picassos all over the world. Furthermore, incredibly, France had neglected the work of Picasso in its national collections. MoMA, the Museum of Modern Art in New York, had already had a priceless collection of nearly a thousand works for many years, including *Les Demoiselles d'Avignon,* not to mention the incomparable *Guernica*, at that time on provisional 'political' deposit. France had no more than a few works scattered here and there, mostly at the instigation of Georges Salles, Jean Cassou and Jean Leymarie. There were thus dual attractions to the Picasso Donation project: it would pay off the taxes *and* give a Picasso museum to France.

It was immediately suggested that a special museum be designed to house the Donation. From the properties in its possession the Conseil de Paris chose the Hôtel Aubert de Fontenay, known as the Hôtel Salé (in reference to the salt tax that had enabled the *fermier-général* to build his residence). It was thus rented to the State on a long, ninety-nine-year lease. A budget of 20 million francs (over 12 million present-day euros) was allocated for essential restoration works, entrusted to the architect Bernard Vitry; part of the exterior restoration, however, was also financed by the State. The architect Roland Simounet was given the task of converting the interior, and produced a design of great modernity – the gentle gradients that he introduced were a perfect success – which nevertheless respected the heritage of the past in all its splendour.

The lower-ground floors, consisting of magnificent vaulted cellars of dressed stone, previously used for the canteens of a neighbouring government department, displayed paintings representing Maya, Claude and Paloma, portraits of Marie-Thérèse, Dora, Françoise and Jacqueline, and the famous sculptures of *The Goat* and the *Little Girl Skipping* – among many other masterpieces. They were presented along a timeline running through all the rooms in the museum. As one moved from floor to floor, one passed through the periods of youth, then portraits of Olga and Paulo, and Marie-Thérèse too. Thus the whole of Picasso's life and work was covered.

Our whole family was present for the inauguration by the President of the Republic, François Mitterrand, and Jack Lang, then Minister for Culture.

In the autumn of 2009, the museum closed its doors for large-scale renovation works, to reopen five years later, at the behest of Anne Baldassari, who had taken over as director in 2005 and later became President of the government-owned corporation of the Picasso National Museum. With this operation, she redefined the whole building, doubling the exhibition space to over 50,000 square feet by relocating the administrative departments to neighbouring buildings. She also inaugurated a daring programme of travelling exhibitions, with two selections from among the collection's masterpieces which were to tour the world which enabled the financing of two thirds of a budget of over 50 millions euros. The idea was to rethink the way the works are introduced to the public and the different scientific and educational activities.

The architect Jean-François Bodin was commissioned to carry out this in-depth transformation into a museum fit for the twenty-first century. After a conflict with the Ministry of Culture and Communication, Anne Baldassari was dismissed in May 2014 and replaced by Laurent Le Bon, acclaimed curator and former director of Centre Pompidou-Metz who set the re-opening of the museum on the following 25 October, a symbolic date as birthday of Pablo. A rebirth in many senses!

PICASSO JOINT OWNERSHIP (THE INDIVISION)

In 1977, a journalist wrote: 'The most important thing that the beneficiaries of the Picasso legacy inherit is a responsibility: that of managing his glory and his posthumous treasure.'[93] She was right.

During the settlement of the Succession, the exercise of moral right was also organised. This is a very important right. It covers the right of disclosure, the right to paternity, the right to respect of the work and the right of rescission. Pablo Picasso administered it while he was alive. The moral right then passed to his descendants, acting as joint owners.

Thus the 'Indivision Picasso' – a concept under French law; the indivisible Picasso Joint Ownership – was naturally formed, consisting of Pablo's children Maya, Claude and Paloma and, from June 1975 on, his grandchildren Marina and Bernard, succeeding to the rights of their deceased parent Paulo. Initially, Pablo's widow Jacqueline was also a member.

The Picasso Joint Ownership collectively possesses the moral right to adjudicate on the use, reproduction and representation of his work, in whatever form. This moral right, which is obviously non-transferable, lasts for seventy years from the death of the artist, that is to say until 2043.

In 1973, Picasso's works were the most reproduced in the world. Pablo himself was cognisant of the requests for traditional reproductions for postcards, posters, exhibition catalogues and books, but he had delegated his powers to SPADEM (Société de la Propriété Artistique des Dessins et Modèles), one of the leading French copyright protection organisations. For this type of reproduction there are pre-established scales of charges for use. For less typical uses, however (clothing or tableware, for example), he himself had to accept, modify or refuse specific requests in the framework of licences for use.

The same mode of operation was passed on to the Joint Ownership. Meetings of all the members of the Joint Ownership were therefore quickly arranged, usually quarterly, initially on the premises of SPADEM, since the latter received all the requests from potential users.

In 1976, my uncle, Claude Picasso, suggested that a non-trading company be formed to manage all these rights, and to constitute a means of operation to which each member would contribute, and which would serve as a permanent meeting place and centre of information. This company was able to centralise extremely comprehensive documentation on Picasso's oeuvre, with a whole collection of books, catalogues, photos and a set of the inventory index cards. It formed a complement to SPADEM, and was also able to act against counterfeiters and pirates and any sorts of illegal use. Regrettably, it failed to stand up to the desire for independence that each of the heirs now sought in their private lives. Nevertheless, it was the prelude to a much

more useful and effective structure, the Picasso Administration, twenty years later. In the spring of 1980, SPADEM, alerted by its American equivalent and agent ARS (Artists Rights Society), noted that large numbers of products reproducing works by Picasso, all apparently originating in the United States, were to be found on sale in shops, although no prior authorisation had been requested for their production or sale. The great diversity of these products, and the fact that they all appeared at the same time, was surprising; furthermore, they did not resemble the general run of pirated products, such as T-shirts, scarves and other poorly manufactured bits and pieces. Could this be the work of a particularly powerful counterfeiters' operation? Another odd feature: curiously, all the different works by Picasso that were reproduced were those inherited by Marina.

After some rapid investigations, several licence holders were identified in the United States. They all claimed to have legally signed licence agreements with an American company, Jackie Fine Arts, which was immediately contacted and required to explain matters. Its director, Mr Finesod, stated that he had purchased from Marina Picasso the reproduction rights to the works that she had inherited, through the intermediary of a Swiss company. Marina, then, had sold the reproduction rights to her works – rights held to be indivisible and non-transferable, since they belonged to the Joint Ownership as a whole. The system operated discreetly, protected by the anonymity of a string of companies: Marina had sold 'her' rights in exchange for a guaranteed sum of 22.5 million dollars (over fifteen years), representing about 60 million present-day euros, to a Swiss company, Paraselenes, which had sold them on to Art Masters International (AMI) – a company based in Delaware, in the United States. AMI had then licensed them to Jackie Fine Arts, a company based in New York State, which in its turn had sub-licensed them to a variety of American marketing companies! Jackie Fine Arts could create products of every conceivable kind, without any sort of constraint. It was free to adapt images of the works, or even modify them, without requesting any authorisation from the members of the Joint Ownership, since the contract made no reference to any monitoring procedure. Only one clause in the contract made any reference to moral rights, which it defined in these terms: the honour, reputation or memory of Pablo Picasso must not be tainted.

Not only had the fire been ignited, but it had also spread fast, with forty-odd licences 'in good standing'. The heirs found themselves flung willy-nilly into business of every kind. Maya was informed in early September 1980, when we were on holiday in the United States, and it almost made her ill. In return for ceasing its 'counterfeiting' activity, Jackie Fine Arts, pleading good faith, and under pressure from the numerous licensee companies that were now operational, claimed the equivalent of nearly 1 billion present-day euros in damages from the five

members of the Joint Ownership. This would have meant ruin for the heirs and, if they lost their case despite having right on their side, would have forced them to put all their Picasso works on the market. It would have meant the certain collapse of the Picasso art market, and would have bankrupted galleries and put museums and collectors at risk.

The heirs were in a dilemma: should they use the law to contest the agreement that had been signed and embark on a lengthy court action in the United States, with no certainty of winning before the American courts; or reorganise the sub-licences issued, classifying them and reintroducing absolute respect for the exercise of moral rights by the Joint Ownership.

In October 1980, after a marathon fortnight of day-and-night meetings, an agreement was reached. Marina attended the first meeting. She did not return the next day, and never attended any other meeting. In the event, it took fifteen years of non-stop discussions, of shuttling back and forth, to achieve respect of the agreement by the sub-licensees. These never-ending discussions cost the Joint Ownership a fortune, both in lawyers' fees and in loss of revenue (incidentally, not even wanted). The Joint Ownership had been organised, after the successions were settled, by an agreement concluded in October 1980 for five years, and renewed provisionally in 1986. In June 1988, my mother resigned from SPADEM (which each member of the Joint Ownership had been obliged to join

personally); this prevented the copyright company from functioning autonomously. It now had to obtain Maya's individual approval for any request that it handled. To Claude and Bernard it was unthinkable that the Joint Ownership should be replaced by one or more incompatible managements. In company with Paloma and Marina, they asked the Joint Ownership judge who sat in the regional court to rule on the conflict. During the proceedings, my mother suggested that the judge should award to each member the right to completely independent management of the works that he or she had inherited. In other words, a complete break-up of the Joint Ownership. But then what would happen to works in public custody (held by museums, galleries, collectors, and others)? Who would manage the rights to these works? And what about the management of the Picasso name and image?

A communal and collective structure would still be required.

My mother thought that direct management would be more efficient and less costly (SPADEM took a fixed commission of about 25% on all sums received for member artists, and a total of 50% for foreign countries, including the salary of its local agent), and its administrative procedures were slow. It seemed to her that the Joint Ownership would need considerable resources to protect Pablo's name and oeuvre, when faced with the growing counterfeit market all over the world. The Jackie Fine Arts affair and the proliferation of new 'authorised'

products had awakened the curiosity of pirates, now fully convinced of the attractions of the name and work of the artistic genius.

Claude, Paloma, Marina and Bernard, however, came to an agreement in which they stated that they preferred a Joint Ownership, and would remain in it together. My uncle Claude was appointed its administrator by the Joint Ownership judge, with the 'option' for him to be a member of SPADEM representing the Joint Ownership. This point was suggested by my mother, and it proved very useful when SPADEM went into liquidation in 1995, enabling him to resign in time and not see the Picasso Joint Ownership go down with it.

In his official function, Claude now managed the joint rights on the works of Pablo Picasso – something that was also known as the 'monopoly', because these rights applied to the works in their totality. He also had a mandate from each of the members of the Joint Ownership to act in the matter of brand names: the name of Picasso was now to be managed as a brand, as regards both registration and use. This was a legal obligation.

It was early 1995 and the Picasso brand had apparently become a reality – and a real problem. Registration of illegal brands by malicious (or at best, ill-informed) companies and individuals had multiplied all over the world. Protection on grounds of copyright alone was no longer possible.

Thus the unexpected use of the 'Picasso' brand was not a postulate for our family but a consequence.

Pablo Picasso is the world's most reproduced artist legally (he alone accounts for 40% of the world market in lawful world production of artists' graphic works), but he is also the most 'pirated', with all the associated threats to the respect of the original works (authenticity, colours and integrity) and to the nature of the products sold (often unacceptable in spirit). Apart from its financial aspect, which remains important but secondary, the Joint Ownership has always had an ethical purpose.

Picasso had thus become a commercial brand, just like Coca-Cola, Disney or Nike: a brand known as such, which sold products often far removed from the world of the artist and his reputation. In Taiwan, indeed, a catalogue was seized offering a whole range of household goods stamped 'Picasso': carpeting sold by the yard, lampshades, curtains, saucepans, electric fans, shoes, toilet paper and more, reproducing here a 'simplified version of a work', there the signature on its own as a maker's mark. After that, it was only a small step to believing that such business had the blessing of our family. A step often taken without a second thought!

In a sense, the oeuvre of Picasso (and of many other artists) should be self-sufficient, in museums, exhibitions and books. But the public also likes to see it again on some

sort of familiar object. One need look no further than the success of museum shops, for instance, and the thousands of objects that reproduce the work of artists. Picasso's popularity is such that it creates a craze to which a response must be made: to do nothing is to leave the field free to those who would rush in, regardless of legality, which would have lasting ill effects on the artist and his oeuvre, and would not gladden the hearts of those who own his works.

Thus until the end of 1995, the Picasso Joint Ownership, legally under the management of my uncle Claude, was represented by SPADEM. This organisation had representatives all over the world, and handled the rights of nearly four million different artists. The reproduction rights that it received for Picasso's works represented huge sums: up to 40% of SPADEM's annual turnover.

In spite of this considerable revenue, in 1995 SPADEM began to suffer serious cash-flow problems. In the face of this situation, Claude resigned in order to protect the interests of the Joint Ownership members and Pablo as far as possible.

It was necessary to move one stage further, so the Picasso Administration was created for the direct management of the joint rights in its charge. There was no alternative, because of the overall volume of affairs to be dealt with and the financial flows involved. A legal entity – a company – obviously had to take the place of the sole figure of the administrator.

The Picasso Administration is thus an EURL (in French law, a limited-liability organisation defined as a single-person enterprise), with Claude Picasso the sole shareholder, in his capacity as 'legal administrator'. It acts in the name of the Picasso Joint Ownership. This resumption of control by my uncle marked the establishment of renewed discussions among the members of the Joint Ownership, with the exception of Marina. The Paris office of the Picasso Administration became the centre for information, which previously had always been inadequate, and through which all questions could now be answered. Claude took the necessary steps to restore the monopoly, that is to say, to organise international representation (with twenty-two correspondents around the world), to bring the necessary legal actions to counter fraudulent usage of the works and the name – and from now on even the very image of Pablo Picasso. A survey carried out in 1998 actually revealed over seven hundred illegal 'Picasso' brands worldwide, in all classes of products and services.

Thus, although Picasso's heirs never particularly wanted to engage in merchandising, it has been forced upon them. Admittedly, there was always some merchandising, even in my grandfather's time: postcards and posters were the ancestors of modern licensed products. In the 1950s, Pablo was even amused to see shirts and dresses – one-off models – made from fabrics using some of his works 'duplicated' many times. That was

long before this fashion appeared on a large scale.

Today, to my knowledge, there must be about ten licence agreements to use the name and work of my grandfather. We are far from the imaginings of those who see Picasso everywhere. By comparison, it is perhaps little known that there about two hundred and fifty licences relating to René Magritte, but they are never talked about. As regards Picasso, this sensible moderation is the demonstration of a radical resumption of control, and of strict vigilance. The income from the licences is sufficient to cover the running costs of the Picasso Administration, providing, in particular, the resources necessary to protect the name and oeuvre of the artist and to finance legal action against brands

or counterfeiting when necessary – and also to meet the cost of lawyers' fees and ensure the proper operation of the licences to reproduce works.

Derivative products, as the Picasso Administration sees them, are founded on the values of fame, identity, confidence and reputation. The good old days of the postcard are gone, and the heirs have had to get to grips with the realities of the modern world, to be innovative without ever tarnishing the reputation of the work or the artist, and to maintain a balanced approach. Armed with personal experience gained in large companies, often spanning the globe, in 1994 I decided to develop my own consultancy, bringing together enterprises and skills. I placed it at the service of the Picasso Administration, to which

I suggested, in 1996, developments in partnership with major industrial groups, in the context of the creation of products that could legitimately reproduce the name or work of Picasso. For example, I had learnt that in Argentina the Succession was confronted with worrying problems of the illegal registration of the 'Picasso' brand for lorry trailers. We had also heard of 'Picasso' bicycles in China. Thus, in 1997, I devised an 'automobile' project in the framework of an active defence strategy, which culminated in 1998 in an agreement with Citroën cars manufacturer which I proposed in detail and which has had an enormous impact. Many journalists have asked me what Pablo would have thought of this. Without wishing to respond in his name, I would reply that – in view of his career, notwithstanding the political intentions in his art – innovation and experimentation with new techniques always excited his curiosity. My grandfather strove unceasingly to set himself apart from anything that might imprison him, including himself. He was at the head of real revolutions (including cubism, collage, sculpture, ceramics, linocuts and sheet metal). Giving the name of an artist to a car was something that had never been done. It was a minor revolution. He would have appreciated that. He would have been amused to see his name on a car: did he not come to Paris at the beginning of the twentieth century, unknown and penniless, to see the Universal Exhibition? It is now his name that has become universal! And if I refer to the use that he himself made of

posters and advertising brands (Pernod, Kub, Bass, Le Bon Marché, Suze, and others) in his cubist work, I can only observe that he took part, as a spectator, in the blossoming of a new activity, and that he appreciated its colourful creativity. He did not turn his back on it. On the contrary, he was already making a place for himself in a modernity that blended art and advertising. After all, advertising is quite often in the vanguard of creativity.

The Picasso Joint Ownership continues to control all use of the name and work of Pablo Picasso, but it now has a powerful partner. The revenue from this unusual automobile licence is also sufficient to cover the cost of this necessary policy of defending the name and memory of Picasso. The activities of the Picasso Administration thus continue to work in the best interests of the memory of Pablo. Truth to tell, management of the licensing policy is almost a minor matter compared with the time spent collaborating with contacts all over the world on exclusively cultural subjects. Everyday activity aims to favour the projects of publishers of books and magazines, producers of television broadcasts and, these days, of multimedia publications, by organising ever more fully documented access to images of the works of Pablo Picasso. The Picasso Administration acts as a centre for coordination between these diverse demands and the custodians of information and documents (including the images). Picasso's heirs have close links with

most of the exhibitions organised all over the world. Many of the works and, often, masterpieces, labelled 'private collection', regularly originate from the collections of Maya, Claude or Paloma. Those belonging to Bernard show his identity and that of his wife, gallery owner Almine Rech, under the name of their foundation, FABA. Only the works belonging to Marina appear with the frequent designation 'Marina Picasso collection', often associated with the Galerie Krugier of Geneva.

The retrospective exhibitions have made their mark in an enduring way: *Picasso and Cubism* in 1980, *Picasso and the Portrait* in 1996, *Matisse/Picasso* in 2002, *Picasso and the Masters* in 2008, *Picasso/Black and White* in 2012, *Picasso.Mania* in 2015 (for which my sister Diana was a co-curator) or *Picasso 1932* in 2018 in France and abroad in the most respected institutions like MoMA, Grand-Palais or Tate Modern. To this is added the dynamic policy of the Paris Picasso Museum, led by its President Laurent Le Bon, who developed a programme entitled *Picasso – Méditerranée* with dozens of exhibitions and several seminars in Europe and, for the first time in Morocco, from 2017 to 2019. These are just a few of many examples, because every year, hundreds of thousands of visitors are drawn to dozens of exhibitions in museums around the world, not to mention the work of the independent galleries. Thus the exhibitions of the Gagosian galleries in New York, London or Paris have celebrated Picasso

and sculpture, Marie-Thérèse, Françoise or even Maya recently.

The emblematic travelling Picasso exhibitions of the last few years, especially those of the Paris Picasso Museum, have also made it possible to show certain masterpieces and, in some cases, to reveal to the public works previously unpublished or no more than glimpsed in the past. Organising these events is no small task. As for the auction sales, they provide a regular opportunity to evaluate the enthusiasm of collectors for the oeuvre of Pablo Picasso and for the history of the works themselves; each sale catalogue constitutes an exhaustive presentation of scientific research, with experts and art historians working hand in hand. In the background behind these record sale prices, including the world record-to-date in an auction sale of the *Women of Algiers* masterpiece in May 2015, lie the exceptional artistic and personal adventures of my grandfather.

The art of Picasso has accompanied the expansion in the market for twentieth-century art. Happily, anyone can still be filled with an emotion beyond price when contemplating one of his works, restoring to his art its human quality: more of the heart than of the head.

Dora Maar with a Cat, 1941, oil paint on canvas, 130×92, private collection. This work, sold at Sotheby's in May 2006 for over US$96 million, ranks among world records for auction sale prices.

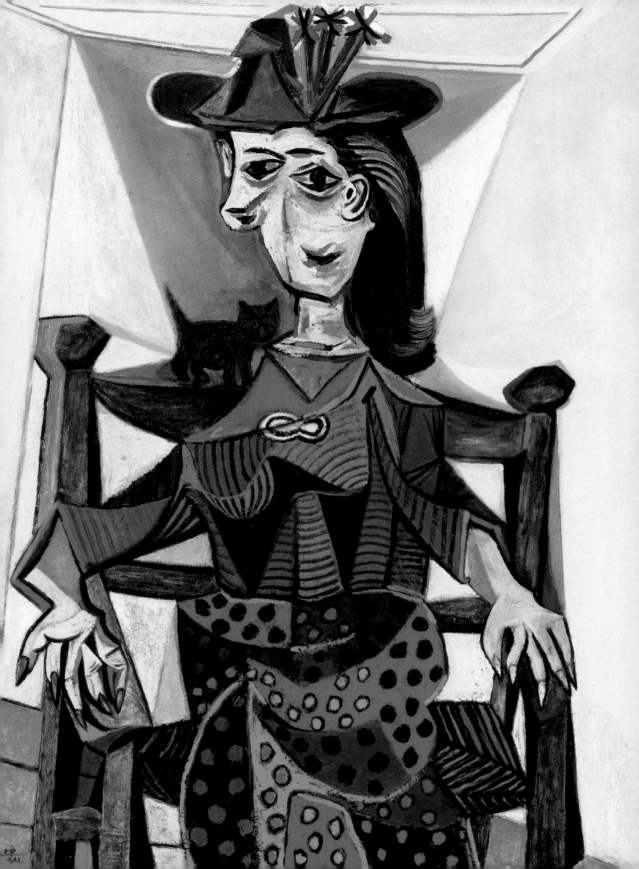

PICASSO AND DEATH

'Everything happens as it will, even death.'[94]
Pablo Picasso

If there is one characteristic among all those often attributed to my grandfather which he really deserved, it is that he was superstitious. He was born in nineteenth-century Spain, a country in thrall to the most medieval Catholicism, going far beyond the precepts of the Vatican; a rigid, austere Spain fashioned by the Inquisition. The values of Spanish society were those of the Church; and the peril of ending up in hell for the slightest transgression was taken very seriously. The Ruiz y Picasso family might not have been fervent practising Catholics, but they could not escape from this national tradition, which, even if it was not expressed in daily attendance at Mass, manifested itself in a whole ceremonial of superstitious rites and precautions. Everything was either good or evil, propitious or ill-fated, of God or of the Devil!

To my grandfather, religion was never the answer to metaphysical questions. Prayer and placing oneself in the hands of God never seemed to him a solution to the troubles of the human condition. Confronted with death and horror, he expressed his uncertainties through his work.

He was born among the dead. On 25 October 1881, just after 11 o'clock at night, Doña María was delivered of a stillborn son. After several minutes of effort had failed to revive the baby, the lifeless little body was laid on a table. His uncle Don Salvador, an excellent doctor, nevertheless observed the child with suspicion and, surprisingly, held his lighted cigar close to the face of the newborn child, who came back to life with 'a roar of anger'.

Was it a miracle? Was it a sign from beyond the grave, from Don Pablo, doctor of theology and canon of Malaga cathedral, who had died in that same month of October three years before? The family worshipped his memory, and decided to pay homage to him by giving the name of Pablo to the first-born male heir of the Ruiz family, brought back from the dead against all hope.

Two weeks later, on 10 November 1881, Pablo was baptised at St James's church, in Malaga, and received a quantity of Christian names that would have satisfied a whole collection of saints: Pablo Diego José Francisco de Paula Juan Nepomuceno María de los Remedios Cipriano Santíssima Trinidad Ruiz y Picasso.

He would need no more than 'Pablo Picasso', later on, to become famous.

The first time Pablo really came face to face with death was 10 January 1895. His little sister Conchita passed away at the age of eight after an attack of diphtheria.

Pablo was then thirteen years old, and he had not quite taken the decision to become a painter. He was not very fond of school, and genuinely preferred punishments, when he was shut up in a little 'cell' – quiet at last. He took advantage of these moments to devote himself to drawing. Just before his little sister died, however, he issued a challenge to Heaven: he would sacrifice his talent and renounce painting if young Conchita recovered.

Conchita did not survive. God had no heart. Furthermore, impiously placing the same value on his sister's life and his talent had inevitably led the Almighty to punish him. It was he, Pablo, who was responsible for her death. *Or, on the other hand,* perhaps it was a sign from God who wanted him to be a painter, and this predestination placed him above mankind, just as it had already placed him above Conchita's life. If there was no divine intervention involved, a certain magic could be discerned in the matter.

This decision – superhuman, almost divine, concerning his painter's destiny – could explain why Pablo felt that he was possessed by a mission. Should it then be a surprise if thereafter everything was secondary in importance to his art – including other people?

This formative event also led to his fatalism: the way he had, throughout his life, of not taking initiative, but of leaving things to destiny.

'From that moment,' his friend Jean Leymarie would recall, 'Picasso subjected himself to a discipline which he obeyed unfailingly. He would eat soup and very light foods, so as to preserve his strength for work. I realised that, too, when he refused to receive his friends: he very much wanted to; he loved them. His friends thought that he was imagining things, that he was being disagreeable, and so on. But he just couldn't, because he was absorbed in a task. And I think that is fundamental to understanding Picasso.'

Max Jacob was struck by this asceticism. Pablo had the means, after 1910–12, to lead a comfortable life, but he remained indifferent to material possessions. Except for the period with Olga, he always preferred to lead a simple, frugal life, always directed towards a spiritual objective, 'committed' – always artistic.

Pablo distinguished between God and the divine. He always claimed to be an atheist, yet his oeuvre often makes references to religious themes. The academic training that he had received in Spain during his adolescence had had an undeniable impact on his work, despite all his resistance to 'oppression'. Goya, El Greco and Velázquez, who painted many religious scenes, also contributed greatly to orienting his painting towards Christian themes.

Thus he had only just arrived in Barcelona when he executed the drawing of *Christ Blessing the Devil*, the obvious expression of the profound conflict raging within him. Several religious subjects followed: *The Flight into Egypt*, *Altar to the Blessed Virgin*, *Christ Appearing to a Nun*, *Christ Adored by Angels*, *The Annunciation*, *The Resurrection*,

First Communion, *1896, Barcelona, oil paint on canvas, 116×118, Museu Picasso Barcelona, gift of Pablo Picasso, 1970. This canvas, which Pablo kept all his life, bears witness to his precocious genius. It symbolises both the hold of religion over Spanish society at the end of the nineteenth century and the academicism that dominated in the art schools, but it also pays tribute to his father Don José and his little sister Lola. It was presented at the Barcelona Fine Art Exhibition in 1896. Together with the large painting of* Science and Charity, *it is among the greatest masterpieces in the Museu Picasso in Barcelona. In addition to the initial donations made by Jaime Sabartés (572 works and documents) and Pablo Picasso himself (nearly 3,000 works and documents), which make up the core of the museum's exceptional collection, it includes complementary donations by the artist's heirs (157 engravings in 1979 and 63 engravings in 1983).*

and others. These canvases are more than simple academicism: they represent a rite of passage, an exorcism.

Certainly, religious themes were essential for the famous fine-art competitive examinations, and failing to master them would have been suicidal. But to Pablo, Catholicism, with its plethora of rules and threats, seemed to offer strangulation, not hope. He was filled with an exuberant passion for freedom.

Thus, when he finished his large painting *Science and Charity* in the autumn of 1896, he perfected a certain form of academicism, and opened a door. He was fifteen years old. The ambivalence of the theme – between the prayer of the nun and the knowledge of the physician (who bears the face of the artist's father) – is daring in itself. The (impious) equation between hope and certainty is a profession of faith – or rather, of absence of faith. It seems that prayer is no longer the last resort, and that science will finally perform the miracle of healing.

But Pablo's revolt against tradition was limited by his obligation (awful word!) to execute large conventional canvases, the only kind capable of making him a reputation in exhibitions. Pierre Daix speaks with justice of 'the great academic machine'. Pablo was already starting on a form of expression that would be subversive, unconventional, determinedly innovative – barely comprehensible by his contemporaries, who were challenged in their beliefs.

The political situation in Barcelona at that time, in late February 1899, led him to paint morbid subjects. Death prowled the streets of this town where riots were rife. The lure of anarchism mingled with the revolt against the useless war waged in Cuba against the United States.

In February 1901, when he heard of the suicide of his friend Casagemas in Paris, Pablo was in Madrid. The news shattered him and he returned to Paris to exorcise his grief and his remorse at having been unable to do anything. He had seen his friend suffer so much for an unattainable woman. The tragedy was the inspiration for *The Burial of Casagemas*, a highly symbolic canvas, the exorcism of his own morbid ideas, which asserts the close thematic links between life, death, childhood and love – and the unavoidable reality of prostitution, which devastates the heart.

In 1903, *Life* symbolised the miracle of creation, at the heart of the desolation which pervades human beings. This was the last canvas of his 'blue' period: Pablo, who had great difficulty parting from his works, as I have said, sold this one quickly, as if to close the door on a period of tragedy, now past and gone. He was ready to take up fresh challenges and new colours.

Four years later, he had a mystical encounter, which drastically altered his perceptions, at the Musée de l'Homme, Trocadéro. He discovered African sculptures and masks.

African art had already been winning over minds for several years, especially among artists. His neighbour at the Bateau-Lavoir, Vlaminck, had several sculptures

from Dahomey and the Ivory Coast. He sold a mask to their friend Derain, who showed it to Matisse and Picasso. Matisse was enthusiastic and bought an African statuette (which, by the way, he believed to be Egyptian) and showed it to Gertrude and Leo Stein. That was how Picasso came across it.

The dispute is ongoing: had Pablo discovered African statuettes and masks before he painted *Les Demoiselles d'Avignon,* or after he had finished the canvas? I accept his own version, given to Malraux in *La Tête d'obsidienne*: 'People are always talking about "African" influence on me. What can I say? We all of us liked fetishes. Van Gogh says: "Japanese art is something we all had in common." For us, it was the "Africans". Their forms did not have any more influence on me than on Matisse. Or on Derain. But to them, the masks were just sculptures like any others. When Matisse showed me his first African head, he spoke of Egyptian art ... The masks were not sculptures like any other. Far from it. They were magical things. And why not the Egyptians, or the Chaldeans? We had never noticed. They were primitives, not magicians. The "Africans" were intercessors – I've known the French word since that time. Against everything; against unknown, threatening spirits. I always looked at fetishes. I understood: me too, I'm against everything. Me too, I think that everything is the unknown – the enemy! Everything! Not the details! Women, children, animals, tobacco, gambling – but everything! I have

grasped what the Africans' sculpture was used for. Why sculpt like that, and not some other way? After all, they weren't cubists! ... But all fetishes were used for the same thing. They were weapons. To help people cease to be subject to the spirits, but to become independent. They were tools. If we give form to the spirits, we become independent.'[95]

Pablo provides an intellectual explanation for this influence, where other painters simply felt an artistic emotion. After all, as Pablo said of his friend Braque: 'He doesn't understand these things at all – he's not superstitious!'

At another point in his conversation with André Malraux, Pablo asserts that *Les Demoiselles d'Avignon* was his 'first exorcism painting'. He even adds: 'Nature has to exist, or we couldn't violate her.'

From that moment on, Picasso seems to have freed himself from conventional artistic constraints, and even the expression of his religious fantasies liberates him without ever verging on the blasphemous. Already a rebel in his anarchist political convictions, henceforth he was the same in his art, on which he no longer imposed any rules at all. But he remained unfailingly attached to amulets and other superstitions.

According to Patrick O'Brian, his opposition to the Church was not clear-cut: 'He retained a deep religious sense, deep but also obscure, Manichean, and in many respects far from anything that could possibly be called Christian.' He makes it clear that Pablo hated the smallest allusion to 'his fear

of the end, although it reached such a pitch that the slightest illness alarmed him; as for death itself, he avoided all mention of it as much as ever he could, except silently, in his art, and he often took refuge in anger'. Roland Dumas has confirmed that even for *Guernica*, making a will was out of the question. Pablo reluctantly named Roland Dumas, just in case. He had managed to allude to the inevitable without pronouncing the word 'death'. And he also managed to write a document specifying his 'last will' without naming it as such.

He weakened on occasion in his doubts about God, be it under the influence of some passing happiness, or in the name of yet another superstition: 'Accepting Françoise Gilot's promises of eternal love in a church, with the blessing of holy water, or remarking to Matisse that in times of trouble, it was pleasant to have God on one's side.'

And one day, he told Hélène Parmelin: 'If a painting is really good, it is because it has been touched by the hand of God.' But, at the same time, he denied His existence at regular intervals.

As for the Catholic tradition in which he had been brought up, the most convincing aspect of his relation to it is his silence on the subject.

Nevertheless, on 21 June 1942, Pablo became godfather to his daughter Maya (who had been born on 5 September 1935). Even if the religious pledge was primarily because it was the wish of Marie-Thérèse, and so that Maya could be registered for a Catholic school on the Ile Saint-Louis, it was also a way in which Pablo could make his paternity official: a godfather, etymologically, is a progenitor. Despite the legal impossibility of divorcing and acknowledging Maya, Pablo was endeavouring to create a bond, even if it was no less fictitious than a baptism. The Church came to the rescue. It should be remembered that Maya's real name was María de la Concepción, an extremely religious given name and, in the eyes of his Spanish family, a satisfactory demonstration of his strong attachment to the Church, in appearance at least.

More disturbing is that this was actually Maya's second baptism. In fact, like her father, Maya had been 'stillborn'. At the Belvédère clinic, in Boulogne-Billancourt, her mother had given birth under general anaesthetic – it was the dangerous medical fashion of the time. Marie-Thérèse felt and remembered nothing of the delivery, but there were complications: Maya did not move when she was born. Frightened, Pablo had carried out an emergency baptism, throwing water over the lifeless little body as a priest would have done, to administer the first and last sacraments of the Church. And Maya came back to life!

In an emergency, and despite his misgivings about religion, he was not capable of turning his back on his ancestral traditions, and he could not set his resolve to deprive his child of access to the other world to which he held the key – the ritual of a sacrament.

In his oeuvre, as Patrick O'Brian recalls in this connection, 'apart from a few set-pieces of his boyhood, such as *First Communion* and *The Old Woman Receiving Holy Oil from a Choirboy*, some adolescent biblical scenes (including a fine *The Flight into Egypt*), and a few imprecise hagiographical pictures, he produced almost nothing with an evidently religious bearing until the *Crucifixion* drawings (1927), his strange *Calvary* of 1930 and the 1932 drawings based on the Isenheim altarpiece. Then silence again until the Christ-figures in the bull-fight engravings of 1959, although many other painters, atheist, agnostic, Jewish, vaguely Christian or ardently Catholic, were working for the Church. Some authorities see no religious significance whatever in the *Calvary*, and others find it blasphemous ... Picasso's declaration on the *Crucifixion* strikes me as valid, moving, a furious cry of protest, the expression of strong emotion that certainly lies within the wide limits of Catholicism.'[96]

So what are we to think of the portrait of *The Young Nicolas Poussin* (1971), painted in the image, unavowed, of a Christ haloed with celestial light, as if to render sacred Pablo's absolute admiration for the painter? It is true that this late piece crops up at a time when my grandfather could no longer escape the idea of approaching death. Is this flamboyant portrait a prudent homage? A confession? In March 1973, he himself chose which painting should figure on the cover of the catalogue for the exhibition at the Palais des Papes in Avignon, which opened the following May. He did not live to see it.

My grandfather was always prudent. He might have lost his fundamental belief, but he was unable to get away from the demands of form or from its most superstitious expressions.

In Pablo's eyes, communion with other human beings was not achieved through prayer, but through his work. It was his duty to express the ills of humanity and to communicate a message of hope and peace. He had a very high opinion of his creations, which surpassed their creator. Every true creative artist, at some point in his life, issues a challenge: 'Down with style! Does God have a style? He made the guitar, the harlequin, the basset hound, the cat, the owl, the dove. Like me. The elephant and the whale, fair enough, but the elephant and the squirrel? What a jumble! He made what doesn't exist. So do I. He even made painting. So do I.'[97]

Pablo 'deified' his oeuvre – in a secular way. Justice prevailed over morality, equality and liberty over the Judaeo-Christian principles of our civilisation. He translated the indescribable, the horrific. He was the witness of a reality, not of a celestial ideal. Like God, according to him.

Portrait of a Man (the Young Poussin), *1971, oil paint on canvas, 73×60, private collection.*
Overleaf: Corrida, Death of the Torero, *19 September 1933, Boisgeloup, oil paint on canvas, 31×40, Musée national Picasso-Paris.*

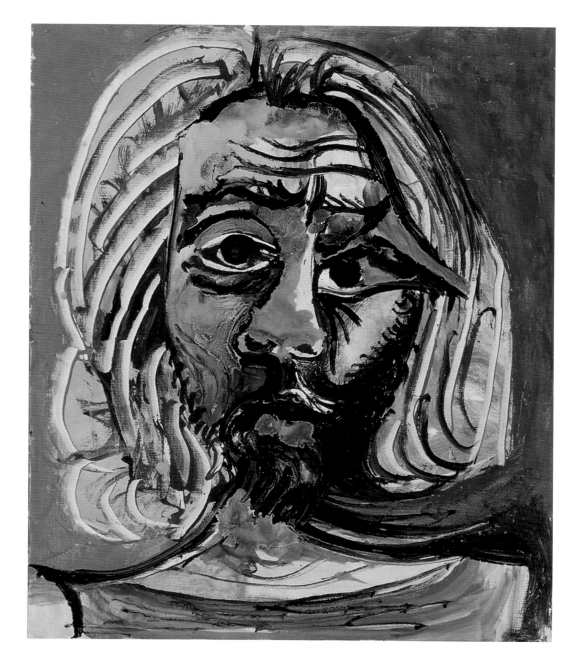

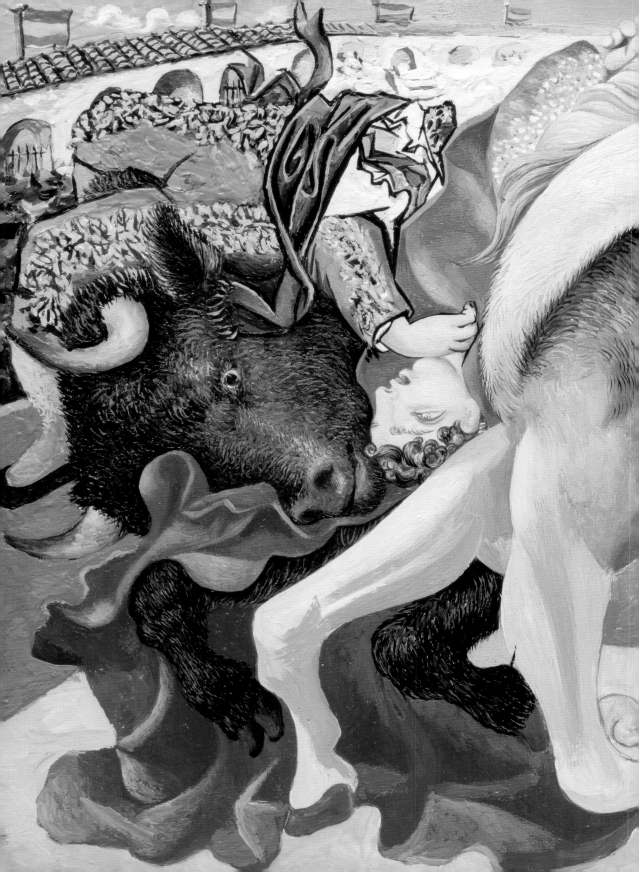

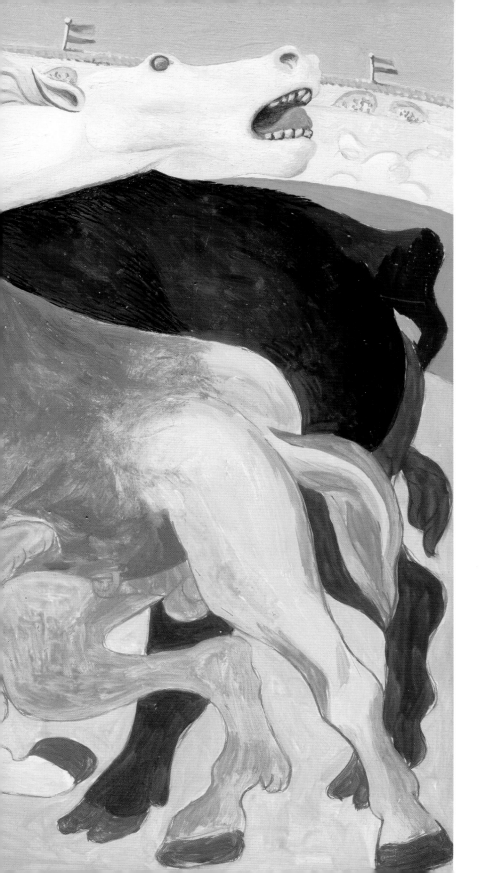

Hence the transcription of beauty or horror in everything. Even the famous *Doves of Peace* – which came into being in the post-war period of hope; a wonderful allegory of an ideal world in which peace would reign over humanity – are a weapon, a last bastion to bring humankind back to their senses just when they were taking leave of them. Their mission is not to lull the spectator to sleep, but to awaken them. That is the weapon of the pacifist; the only weapon available to the artist.

This religion which he had received and then rejected, so that nothing remained of it but superstition, inspired Pablo with a mistrust that was all the stronger because he had known it in its most rigorous form, in his native country of Spain. The Church was everywhere, controlling both the school system and the greater part of the agricultural land. But this religion, this Church, failing to provide any real aid, also suggested a whole system of almost pagan imagery, the remnants of immemorial beliefs. The most commonplace superstitions terrified Pablo, as my mother relates: a black cat crossing your path, an umbrella left open in the house, or a pair of scissors on a bed, being given a present made of cloth ('it's used for wiping away tears') – everything represented a threat to him. Françoise Gilot also remembers his superstition about bread being put on the table the wrong way up.

His fetish objects included keys. 'It is true that keys have often preyed on my mind,' he said. 'In the series with people bathing, there is always a door which they are trying to open with a big key.'[98] It seems clear that those who are outside and want to come in use a key, perhaps a 'bad' one, just as those who wish to communicate with others use language, which is sometimes misunderstood, sometimes even incomprehensible. Is Pablo's art not a key? Maya often told me that, although her mother Marie-Thérèse was very good at sewing, her father 'would not let her have his trousers. It was forbidden to clean them: he was too frightened that everything in his pockets might get lost – quite apart from his keys'.

Pablo regularly sent nail and hair clippings to Marie-Thérèse so that she could preserve them and thus prevent them from falling into the malevolent hands of specialists in black magic or voodoo! When her mother died in 1977, Maya found these relics preciously wrapped up in tissue paper. Françoise Gilot confirms this superstition: 'The most prudent thing to do was to take the hair clippings in little bags to a secret place where they could be got rid of in safety. Pablo would wait for months with his hair too long before making up his mind to visit a barber. If anyone made the slightest allusion to it, there was a scene.'[99] This fear lasted until he decided he could trust his barber, Eugenio Arias, and let him take charge of cutting his hair – the barber destroyed the clippings at the end of each visit!

Françoise Gilot also describes the ceremonies to be observed before leaving

the house: 'Every time we went on a journey, however short, we all had to come together in one room and sit there in silence for at least two minutes, after which we could leave easy in our minds. If one of the children [Claude or Paloma] started laughing or talking, we had to start all over again. Otherwise, Pablo refused to leave. He would say, with a laugh: "Oh! I just do it to amuse myself. I know there's no sense in it, but still…"'[100]

More surprising still were the spiritualist séances that Pablo would go to by himself. This is probably one of the most unexpected aspects of my grandfather. I was told about them by Adrien Maeght: 'In 1947, Marguerite Ben Houra [one of his mother's friends] used to organise spiritualist evenings during which she would communicate with spirits! Pablo was simultaneously terrified and impressed by these séances.'

His ultimate superstition was his refusal to write a will: 'It attracts death,' he would say to anyone rash enough to mention the matter. But this detestation of official documents also showed itself in another domain. Pablo could never make up his mind to sign a marriage contract, with either Olga or Jacqueline: a marriage contract meant that the marriage, a positive action *par excellence*, would end in divorce. No, this matter, like all others, must be left to destiny. So as not to put a curse on the union, separation should not be mentioned. Pablo's dauntless optimism! Abstaining from drawing up a marriage contract came to the same thing as trusting that all would be well.

This superstition, we may remark, makes a nonsense of the accusations of anxiety about material possessions that some have tried to level at my grandfather. To refrain from signing a contract of separation of property implied submitting to the general regime of joint ownership and, hence, envisaging with equanimity the obligation to share his fortune, in the event of separation. In fact, Picasso hated all such procedures, and preferred to say: 'We won't do anything as long as I'm still here, still alive, still going; the succession will be when I'm dead, but I don't want to die!' According to Roland Dumas, Jacqueline had adopted Pablo's philosophy, and didn't want to hear any talk about what might happen later. 'She shared his superstition. I think she loved him deeply, and she saved him from worrying about getting old.'

In those last years, Pablo lived untouched by time. Apart from the presence of Jacqueline's daughter Catherine, now a teenager, he did not see any other children, who could have reminded him that every day took him further away from his own youth.

'The succession,' Pierre Daix explains, 'implied his death; and what interested him was living. …When anyone asked him questions, he would reply: "I've done enough to leave enough for everybody!"'

Overleaf: Minotaur and Dead Mare Outside a Cave, *6 May 1936, Juan-les-Pins, gouache and Indian ink on paper, 50×65, Musée national Picasso-Paris.*

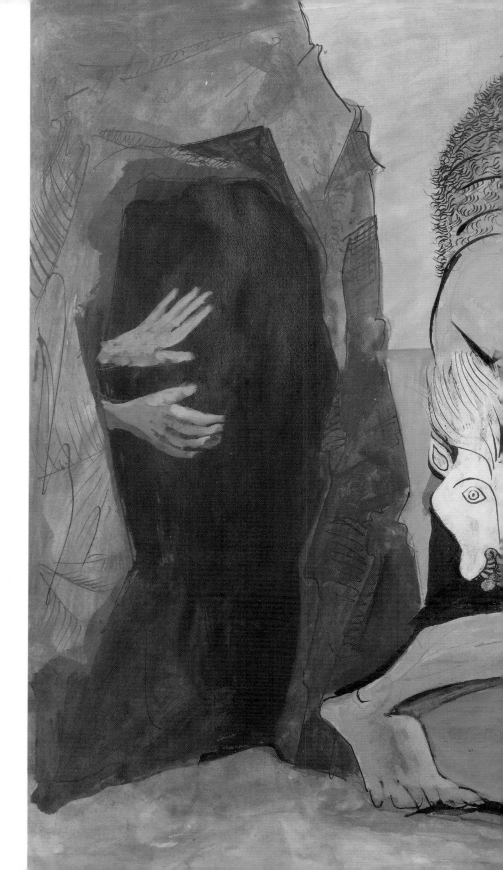

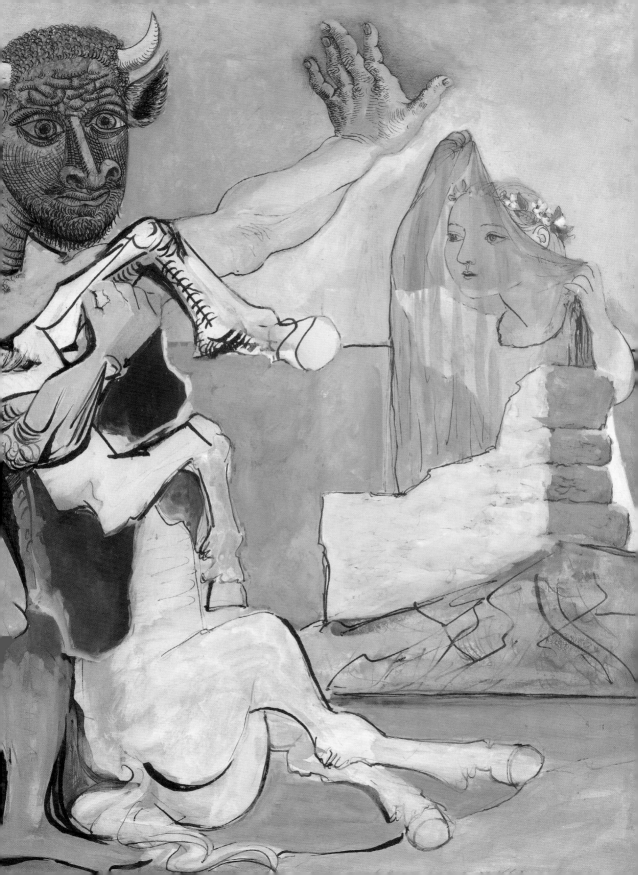

Above all: no mention of his death.

At the same time, Pablo looked death in the eye. During the last months of his life, he painted self-portraits whose eyes expressed all the power with which death could inspire him, almost as if he was fighting a battle between him and himself.

Looking death in the eye is a very Spanish attitude – the positive aspect of *machismo*. The reality of death is such that one must know how to face it, and how to reject it. In this connection, Pierre Daix remembers a visit to Mougins in June 1972. Pablo had taken him to see the famous *Self-portrait* in coloured crayon. It shows a human skull from which two oversized eyes stand out, wild, seeking life, in a last gush of pastel shades. When he came back in October, it was still in the studio. Pablo had gone on working, with no other company but that *memento mori* self-portrait. He took Daix over to look at the drawing again: 'That is when I really had the feeling that I was seeing him for the last time.'

In actual fact, my grandfather did not flee death. He wanted to understand it – without attracting it. Hence the almost infantile superstition which made him keep away from the subject by all possible means. The photographer Luc Fournol remembers how a mutual friend had gone to see Pablo. He found him observing the heads of a number of dead goats rotting on a balustrade! 'I think,' he says, 'that death interested him very much.' More striking still is the disclosure by Francis Roux, owner of the Colombe d'Or restaurant in Saint-Paul-de-

Vence. In 1953, when his father died, Francis installed the open coffin in an alcove in front of the bar, at the entrance to the restaurant: 'I was alone beside the coffin, and the only man I saw there was Picasso. He stayed there ten feet away, motionless, without saying a word, for twenty minutes.'

It was a homage; it was also certainly an analysis. As if Pablo wanted to feel – to experience – death.

A persistent rumour has it that my grandfather never went to funerals, out of fear of death. But in fact there were plenty of funerals that he attended, and many memorial services in which he took part of his own accord. He made the journey to Barcelona specially to go to the funeral of his father, Don José. Furthermore, for that occasion he executed a special portrait of his father using paper cut out of the daily newspaper *Excelsior*, dated 3 May 1913 (the date of Don José's death), keeping the letters 'sior', the Spanish equivalent of 'Monsieur'; proof, if any were needed, that it did not worry him to make a posthumous tribute. There was also the painful ordeal of the burial of Eva, his brief love, taken from him in 1915. Then that of his friend Guillaume Apollinaire, who died of influenza in November 1918. He was unable to attend the funeral of his mother in 1939, because of General Franco's arrival in power, and the siege of Barcelona. But the funeral vigils for his Communist friends, Jean-Richard Bloch in 1947 and Paul Eluard in 1952, have been forgotten. He also paid a glowing tribute on the death of Marcel Cachin, the historic

leader of the Party, in 1958. And he once said to his friend the photographer André Villers, 'I think about death from morning to night: she is the mistress who never leaves you!' This fatalism is apparent again in his declaration to Malraux: 'There comes a time in life, if you have worked a great deal, when shapes arise on their own; pictures come on their own; you don't have to do anything! ... Everything comes as it will. Like death.' And the corrida fascinated him because it symbolised the supernatural power of death: the man conquers the bull, which is obviously the instrument of death. Man kills death. Of course, it all depends on the talent with which the torero assesses his adversary, charms him, deceives him and conquers him. Could it not be the same with death? Pablo's creative power was the engine of his life. His undisputed energy continually repulsed fatigue, the feeling of ageing, or the impression of having said enough. Already, as a tiny child, he demanded pencils, yelling 'Piz, piz' (from the Spanish word *lapiz*, 'pencil') – even before he could say 'Mama'. And on the very morning of his death, he demanded that his secretary should bring him paper and pencil. Art is life. Express yourself, fight against time, never waste a second. And express yourself again. But Pablo never tried to imagine the future. He lived in the present. Depending on whether the present brought him delight or anxiety, he fixed the one or the other on the canvas. Pierre Daix has told me how Pablo's fatalist side surprised him at their first meeting, at the end of the Second World

War: 'I was not an optimistic person. Pablo, at heart, also saw the period to come in grey tones. To him *The Mass Grave* was the expression of what he feared. Afterwards, there was the *Art and Resistance* exhibition and *Homage to the Spanish who Died for France*, which is a sarcastic homage. Fundamentally, there was a sort of communion between us; we were on the same wavelength – unlike the members of the Communist Party, who regretted that he painted such dark pieces.'

A few months later, Pablo would regain *The Joy of Life*.

Wasting time made him ill. Death was at the very end of the road, but illness, or rather the fear of illness, had long been a daily obsession. This panicky fear went back to his childhood, and Conchita's death. In the Spain of that period, fatal infectious illnesses were part of ordinary life. Epidemics often left families in mourning. Death was an everyday occurrence.

Fernande Olivier, Pablo's companion at the beginning of the century, bemoaned his sullen mood on seeing her ill in bed. And they had left the idyllic little Spanish village of Gósol in a hurry because the inn-keeper's daughter had caught typhoid. Terrified that an epidemic might be about to devastate

Overleaf: The Bull (version 3), *18 December 1945, print, 32.5×44.4, Musée national Picasso-Paris. Markus Müller, director of the Kunstmuseum in Münster, comments that 'the graphic techniques of engraving enabled Picasso to make prints all through the creative process, and it was this very metamorphosis of a piece that interested him'.*

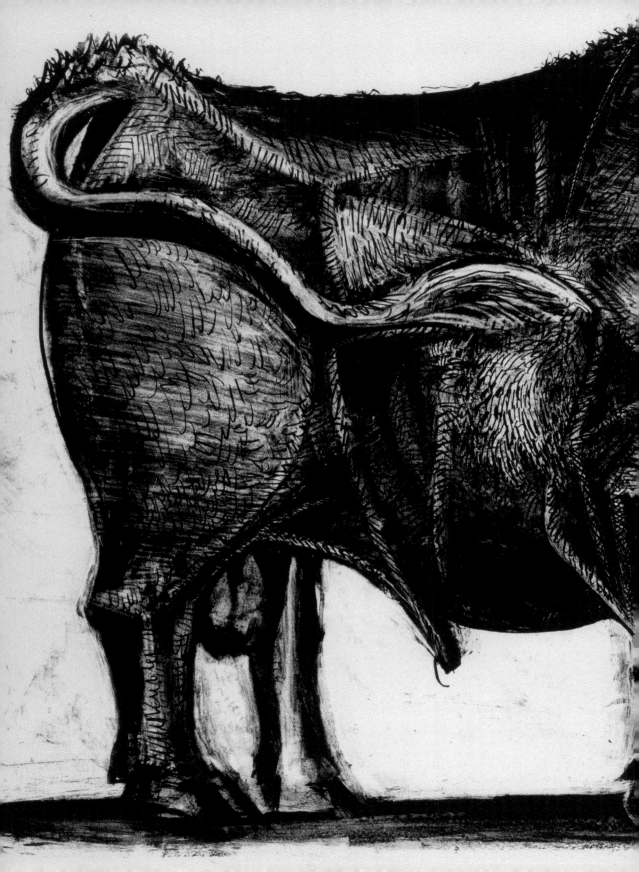

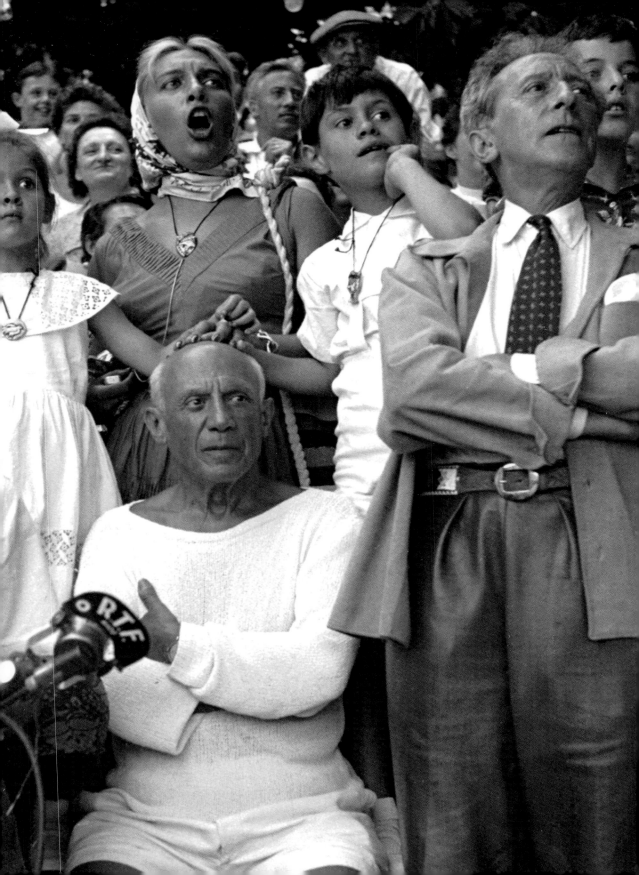

the whole Iberian peninsula, Pablo had insisted on returning to Paris that same day. According to Pierre Daix, every time he had the least thing wrong with him, it took on gargantuan proportions. He was a chronic hypochondriac. From the anxieties natural to youth to the obsession of the old man, he had forged a discipline for living, based on a dietary asceticism whose virtues he preached to others ad nauseam. No over-indulgence in good food, no alcohol – but probably over-indulgence in cigarettes which, miraculously, had no ill effects except at the very end of his life. Yes, a true miracle!

Yet apart from the operation on his gall bladder at the age of eighty-five, he never had any real problems with his health. On that occasion, he went to the American hospital in Neuilly for the operation. It was a matter of honour that he should display no sign of 'weakness', especially where his physical form was concerned. In these circumstances, a stay in hospital appeared to him like a visit to the antechamber of death.

Despite his great age and the inexorable awareness that he was ageing, Pablo had always been very animated. He was in control of everything. When Ernst Beyeler came to see him with a project for an exhibition of 'ninety paintings for his ninetieth birthday', my grandfather called out, as he left: 'We'll meet again with a hundred sculptures for my hundredth birthday.'

In the autumn of 1972, he began coughing frequently and caught a heavy cold which developed into bronchitis. An artificial respirator had to be installed beside him. This mobile apparatus accompanied him wherever he went. He even had to stop working for several weeks, though he felt better when Christmas time came.
It was to be his last spring. On 8 April 1973, his body abandoned him and he became immortal. In the end, he had conquered death.

Paloma, Maya, Claude and their father Pablo at the corrida with Jean Cocteau in Vallauris, photographed by Edward Quinn in 1955.
Pablo, his nephew Javier Vilató (on his right) and his son Paul (in the background), June 1952, at the arena of Arles. Pablo continually went to the corridas in the arenas of Arles and Nîmes, which reminded him of his native Spain, on the 'right side' of the Pyrenees, after deciding that he would never go back there once Franco had come to power.

PICASSO AND ETERNITY

'I paint as others write their autobiography.
Posterity will choose which pages it prefers.'[101]
Pablo Picasso

Pablo is dead; Picasso is eternal. He is timeless. Over four decades after his death, no one doubts that his name and his oeuvre will survive for century upon century. He who battled with time to prolong his art to the extreme limit has finally merged into the collective memory, and thus outlived himself.

In the very last years of his life, he confided to his friend, Hélène Parmelin: 'It seems to me that I am getting somewhere ... but I've only just begun.'[102] He needed to gain time, more time, to finish a canvas, and then one more. His world was his canvas.

He has become one with it. Today he is assimilated into this oeuvre to which his fame has given immortality – and which returns the favour. His fame derives above all from his work; from his endless quest. As if he had been entrusted with a mission: to refuse the order of the world, its static organisation, the ordinary arrangement of things.

What order? To Picasso, there was no order. He was obliged to impose his own language to rewrite the world. Some would see a mystical aspect in this quest: the pressing need to reveal a new reality. There was something messianic in him. 'What is required is to identify what is natural ... Painting needs to be so discerning that it becomes the same thing as life.'[103]

The audacity of his work fascinated his contemporaries, those who came after him, and those who will yet come after him. I use the word 'work' because Pablo Picasso never spoke of his art as entertainment or escape. To him, it was work.

When my grandfather died and the estate was examined, the unexposed portion of this work came to light. When all his houses had been explored and inventoried, what was revealed to the world was a treasure: thousands of works of every period, classified in accordance with that higher order that is ordinarily described as disorder. These repositories unfolded the tale of a genius to the world.

Unlike the common run of men who might dream of immortality, Pablo Picasso had never thought about becoming famous. Admittedly, there is a myth which claims that when he was very small the return from Rome to Malaga of one of his father's painter friends, Antonio Muñoz, left a lasting impression on him. Pablo was three and a half years old when Antonio came back from Italy, on the same day that King Alphonse XII visited Malaga. The town was decorated with flags and the jubilant crowd was waiting for the King to pass. Antonio

arrived at the same moment as a procession of court carriages containing functionaries. Pablo thought all this was to celebrate the return of the painter, and was persuaded that a painter could achieve glory in this way.

Se non è vero… No, my grandfather never sought fame. His paramount need was self-fulfilment. This was an irrepressible need, which enabled him to accept living conditions which were wretched or – worse – luxurious.

When he renounced the destiny planned for him by his father in Barcelona – that of a teacher of drawing and a talented portrait painter – he never imagined that the 'art market' as we know it today would make him a celebrity and its prime mover. At the end of the century, there was no such thing as the art market – especially in Spain. In the world of Iberian art from 1880 to 1900, deserving artists were given honorary awards by academies and patrons. Outside the institutions, there was no future. Few artists dared to deviate from the system, and none really expected to grow rich. They were indebted to a few salons and a few patrons.

The Impressionists were the forerunners of a new form of art, a new economy and, obviously, a new form of fame. Courbet, Manet and Renoir became the new standards of reference. The dealer Paul Durand-Ruel was their mentor, with his network of collectors and critics. Money and fame arrived together. At the end of the century, the great galleries ruled. In the twentieth century, the artist would be king. Picasso, or rather Pablo Ruiz Picasso, had sensed that the world was changing. The changeover from the nineteenth to the twentieth century had enlivened minds: something must be happening. And it was in a spirit of adventure that Pablo set off for Paris, the city of greatest promise, and embarked on an artist's life: poor, but rich in as yet ill-defined hope.

He met with his first successes after negotiations with a refusal to give ground which made his reputation on the artistic scene. But he was never known outside a small circle of initiates: painters and dealers. Then came the upheavals of a century characterised by technological progress – the press, radio, television. The show-business society was born. Until 1945, Pablo could stroll through the streets and have a drink at the *Café de Flore*, in Saint-Germain-des-Prés, without anyone recognising him. After the Liberation, those carefree days were gone: he had become Picasso. Certainly, many people knew of his name and his work, as far afield as the United States. But how many of them knew his face?

Overleaf: Luncheon on the Grass, after Manet, *13 July 1961, Mougins, oil paint on canvas, 60×73, Musée national Picasso-Paris.. Picasso always worked within the framework of the history of art, from his years of academic training, until he confronted the great themes of the masters of the past (such as Cézanne, Manet, Delacroix, Velázquez, Ingres or Goya).*

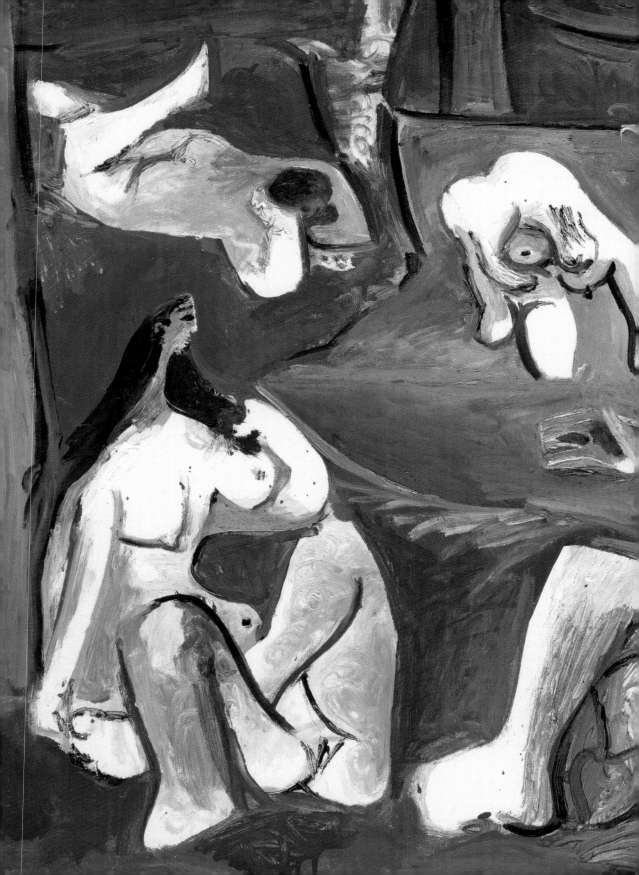

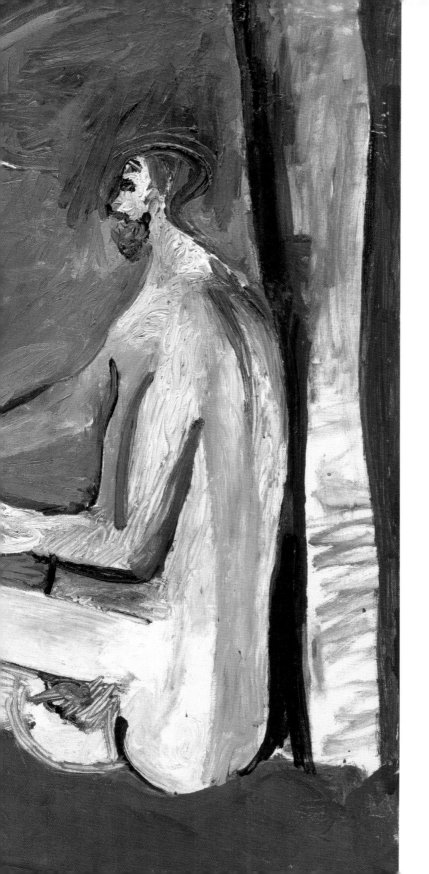

There was no way that Pablo could have abused his fame in any way before he was old (he was sixty-four in 1945!) and in complete control of his situation. He never knew the global glory of a twenty-year-old pop star, or the mindless idolatry offered to reality-TV celebrities of which so many ephemeral examples are seen these days. It was this maturity that enabled my grandfather to reconcile his personality with sudden media celebrity. Picasso never had a press secretary. Nothing was planned. But he knew instinctively how to charm the media. To paraphrase him, he had 'found' – where other more worldly-wise artists had 'sought' – material for self-promotion. He showed the way for the great specialists in media exposure: Dalí, Warhol, Koons, Hirst, and so many others.

How keenly was he aware of his fame? And when did he become aware of it? I have described the visits paid to him by so many American soldiers when Paris was liberated. He was then with my grandmother Marie-Thérèse and their daughter Maya, in their home in the Boulevard Henri-IV, on the Ile Saint-Louis. As soon as the barricades were down and the sharpshooters arrested or killed, the American GIs roamed the streets of Paris with their list of things to do – including paying a visit to Picasso! It is said that Marlon Brando, then a soldier, came to see my grandfather, as many others did. Ernest Hemingway, for example, when he failed to find him at his studio in the Rue des Grands-Augustins, left him a case of hand-grenades as a souvenir.

Thus it was at this pivotal moment that Pablo took his unique place among the global celebrities whose every act was reported by the media. He, who had always taken care to guard his own secret worlds, with their joys and sorrows, could never again be incognito. Pablo's life had all the ingredients for popular success: love, women, children, fame, wealth, originality and, if not good looks in the ordinary sense, undeniable charisma and charm. And, in addition, that one superhuman quality: the power to create, to inspire, to disconcert, to stir the emotions and, at the same time, to transmute any object into gold.

It must not be thought that he abused his status. His work, even when it consisted of no more than four lines drawn in a few seconds, should not be analysed as a source of income, but as a mission. If this were not so, his houses would not have been found to contain nearly half of his output. He only parted with the rest to make his living, support his dependants and be able to go on working. He had to fulfil himself, even if it meant going faster than time to express himself again and ever more fully, even if it was just in a few seconds – until time caught up with him.

But he was also skilled at maintaining his celebrity and popularity.

How was this fame achieved? First, through a familiar name, easily remembered by the media, and before long by the public. Next, by creating shocking work. Lastly, by polishing his image. Picasso was likeable! He led his life to please himself. He set

an example. He represented the colourful alternative in an inescapably grey world. He was politically committed, indeed a revolutionary – but he destroyed nothing except preconceived ideas and conventions. Who could imagine such energy and mischievousness in this man of mature years, who could be seen on the beach with his family after the war? My grandfather, albeit unconsciously, was a great 'communicator'. It was instinctive; he knew how to play the photographers' game and give them what they wanted: a show. With two bread rolls for Robert Doisneau, a gun and a cowboy hat for André Villers, a sunshade for Robert Capa, an 'Olé!' for Lucien Clergue, and a torero's hat and cape, with the addition of a red nose, for Edward Quinn! And the eternal sailor's jersey. Communication, he teaches us, is doing the essential with accessories. What magic moments, what eternity! He did not like the sound of his own voice, and was afraid of making mistakes in French. He had also suffered too often from statements that had been attributed to him, and from words that had been misunderstood. Daix adds: 'He loved jokes, humour and things like that. But it always got peddled around, distorted, repeated, and so on. It always caused trouble, and he hated trouble, in political matters as much as in his private life. There was the fact that he had an accent, which was true, and when he was faced with a microphone, he probably felt in an inferior position.' He did not like his own voice, but he managed to make films – without words, or

practically so. One was with Paul Haesaerts, in 1950, in which he paints on a sheet of glass, though no one really captured his mastery of line. In 1953, for a documentary with Luciano Emmer, Pablo takes an active though silent part, looking impishly at the camera, and paints on the famous vault of the *Temple of Peace* in Vallauris. He also composed a remarkable sculpture from miscellaneous recycled objects which constituted the elements of a puzzle, to which he alone had the key, on the floor of one of the large rooms in the workshops at Le Fournas; I knew it well from playing there as a boy before the property, inherited by my mother, was renovated. Then, when Henri-Georges Clouzot suggested shooting *The Mystery of Picasso* in 1955, intending to reveal the secrets of the artist, Pablo actually takes over the camera, and not only does he reveal nothing, he even, if this is possible, deepens the magic and the secret that enfold his talent, thus immortalising his genius. Clouzot's documentary was awarded the Special Jury Prize at the 1956 Cannes Film Festival, and the gold medal for Best Documentary in Venice in 1959. I believe that if my grandfather had not been so old at the time when television really developed, in the 1960s, he would have 'found' the way to use it. By the way, his one and only television interview for Belgium television in the late sixties took place unexpectedly

Overleaf: Pablo Picasso during the making of the film Le mystère Picasso *(The Mystery of Picasso), photographed by André Villers in 1955.*

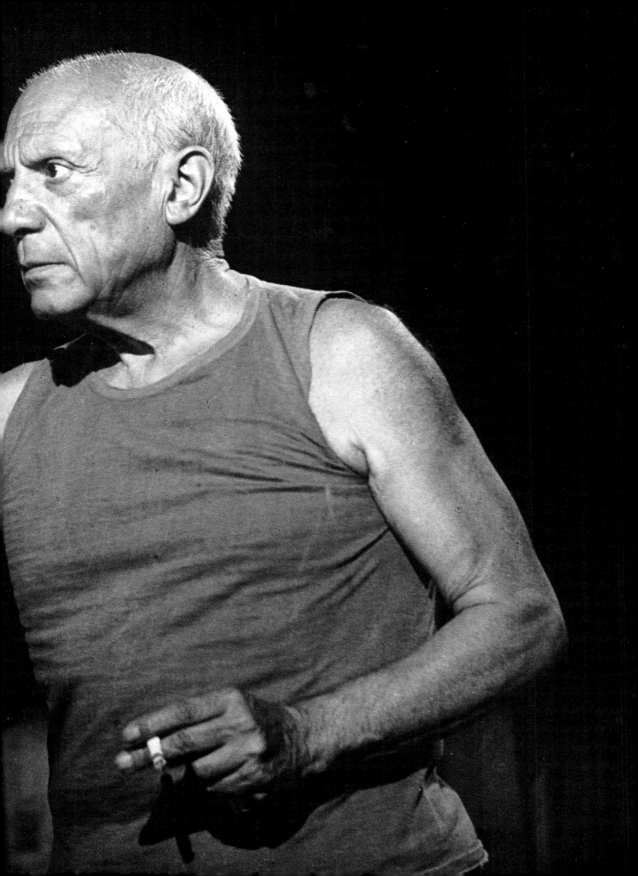

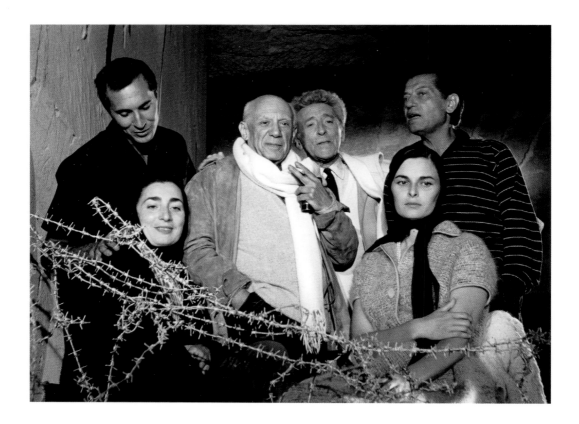

but his few words were so accurate and charming to the point I used it as the opening scene of the documentary film, 'Picasso, the legacy' I wrote with director Hugues Nancy and produced in 2014. And this is without considering the virtual realities of today, which he would have enhanced quite considerably. (Incidentally, an internet search for 'Picasso' yields over a hundred million hits!)

This great talent for communication, in the last analysis, consisted of not communicating. Towards the end of his life, when he began to count years as so much time less to live, Pablo refused visits. It was his decision, but Jacqueline has been held responsible for this isolation. He retained his prestige, while she suffered the resentment. Yet all the people I have spoken to insist that she was innocent – her only fault was

to obey her husband's orders too faithfully. Whatever authority she may have had over him, Pablo's decisions were her orders. He wanted peace, and she made sure he got it. *Enough said.*

Yet he could not ignore the fact that his work benefited from his celebrity status, and even more from his popularity. Admittedly, he had been discovered, showered with praise and vouched for by the art professionals, the collectors, the gallery owners; but he, quite naturally, had allied himself with the public. Just as he declared himself a man of the people *with* the people, so he was a public man, in touch with the public. With this public support, he set himself apart from the 'professionals of the profession' – a rare achievement for an artist. He almost escaped valuation, since each new sale quickly showed itself to be a record.

My mother remembers hearing him say: 'They can speak ill or good, as long as they talk about it!' And it must be understood that he was talking about his work alone. Nothing else. The rest, including politics, was family business.

It is no more than a step from celebrity to scandal and my grandfather trod the line with aplomb, letting slip titbits of information, to all appearances casually. He was aware that it kept the myth alive. He had created *Les Demoiselles d'Avignon* out of an almost physical need. Despite all the sarcastic remarks, some of them even from his friends, he had held fast to the artistic position he had adopted, and he had won. He was the inventor of modern art. And its principal destroyer. The real, primal scandal was shaking up people's minds.

As time ran out, it forced him into other explorations, both scandalous and necessary. At the same time, his aversion to revelations about his private life is well known. There was no place for scandal at his expense. I think that Picasso had another absolutely unique limit in that the life of the man and the life of the artist were inextricably linked and inseparable. In the ordinary way, the separation of the man from the artist makes it possible to admire the artist while disparaging the man. 'Picasso, creator and destroyer' is a biographer's fiction which does not work. In him, there is no dissociation between the life of the artist and the life of the man. Could he have created the sublime portraits of Olga and Marie-Thérèse without feeling gentleness and calm in his very bones? Could he have opposed them without experiencing the anger of the wife and the refuge of the muse? Conversely, Dora Maar inspired an intellectual relationship in him, with her fascinating allure, but also her tormented but stimulating spirit. Surely, the Côte d'Azur and Françoise represent the radiant reality of *The Joy of Life?* Could he have captured childhood without the joy of being the father of Paulo, Maya, Claude and Paloma? He suffered when respect for his right to a private life was infringed.

On the other hand, could he forbid any talk of him by others, who had their own memories of him, seeing that he had been so important in their lives, and that they had been through the same times together? To my mind, it all depends on the duration of their relations, close or non-existent, even if these were no more than financial.

The memoirs of Fernande Olivier,[104] his companion at the Bateau-Lavoir at the beginning of the century, enraged him, and he tried in vain to have the book banned. Looking through it, one can understand that it actually caused little excitement among readers. It consisted of memories that were, all things considered, innocuous, though useful. To my grandfather, however, it was the principle that was unacceptable, despite the fact that Fernande was a free woman and had not lived 'through' him for a very long time.

The publication of Françoise Gilot's book,
Life with Picasso,[105] aroused the same anger.
Against the advice of Roland Dumas, he
persisted in trying to get the French courts
to prohibit the book, which had appeared a
few months earlier in the United States. His
case was dismissed.

In my eyes, this book had really become a
sort of taboo, a forbidden thing. I thought
it would contain some sort of horrible
revelation. When I was grown up, I read it
through, cautiously, but with attention, and
came to the conclusion that there had been
a lot of fuss about nothing and that Pablo,
by over-reacting, had stirred up a row out of
all proportion. Dumas had been right.

The book was an unexpected success at
the time. Pablo, whether despite his efforts
or through his own fault, got the scandal
he had been dreading. Unfortunately, their
children Claude and Paloma suffered the
consequences in their relations with their
father. Much ado about nothing. And much
unnecessary hurt.

At the end of his life, my grandfather's
fame was a burden on him. After 1954, the
Cold War and excessive media coverage
of his political commitment on the side of
the Communists, he gave fewer interviews.
Every year, he received a delegation from
the Communist Party, who came to bring
him his militant's card. He insisted on paying
his subscription and put the card away. He
limited himself to his actions and his trade:
drawing, painting and donating works by
way of support.

This withdrawal coincided with the
dawn of his new life with Jacqueline. The
phenomenon steadily gained ground. After
1965, he hardly ever went out any more: he
was very old and, above all, he had become
the prey of photographers since the scandal
of Françoise's book. Any photo of Picasso
that could be snatched was a godsend
to newspaper editors all over the world.
Sightseers and journalists often hung about
in front of the villa Notre-Dame-de-Vie.
Photographs taken during the last years of
Pablo's life show how his physical appearance
had deteriorated. He still had all his wits about
him, but he had grown thinner, and his face
was furrowed with deep lines; he also had
a large age spot on his left cheek. Many of
Lucien Clergue's photos hint that he is no
longer the same man. When he met people,
he observed more than he participated.
His mind was concentrated now on
essentials: his oeuvre. He was completely
free of all material constraints, and what he
asked of visitors was additional stimulation.
His friends of the last years, such as Hélène
Parmelin, her painter husband Edouard
Pignon, the journalist Georges Tabaraud,
Zette and Michel Leiris, stoked the fire
of argumentative conversation that was
such a stimulus to Pablo's mind. The only
reservation was that they shared the same
opinions, or could feign to do so, having
learnt long ago that Pablo did not enjoy
sterile conversations about boring subjects.
Boredom was death. With these friends,
Pablo fought real intellectual jousts.

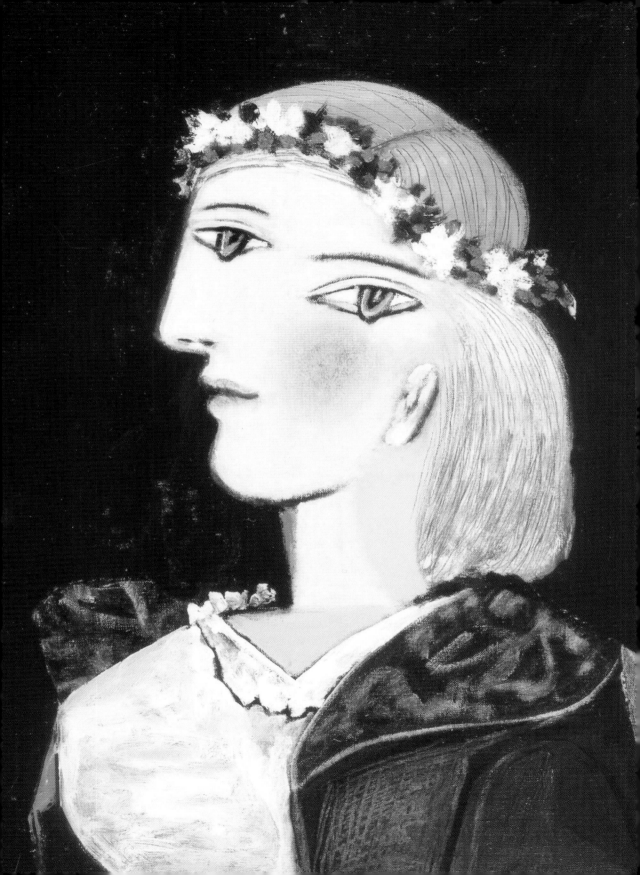

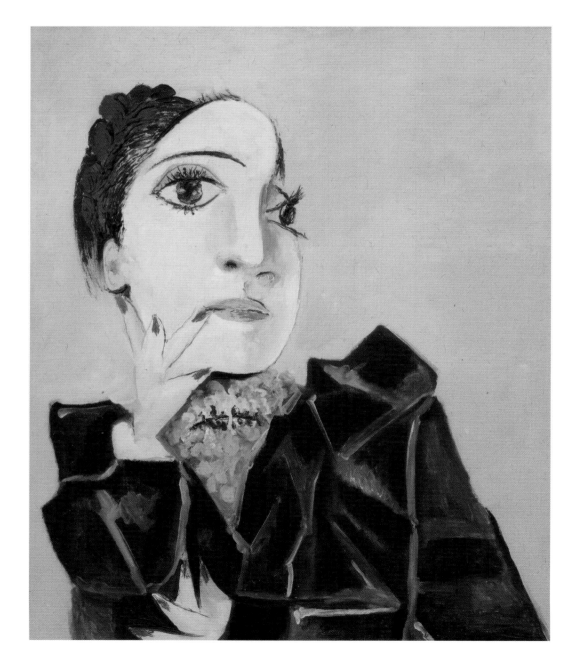

His passing caused a media tidal wave all over the world. The press, with one voice, in special issues, paid tribute to the artist's extraordinary career and lifted the veil on the man. It is true that the filiation proceedings for Maya, Claude and Paloma, necessitated by recent reforms, had only just started, and coincided dramatically with the death of their father. Everything was now in the public domain.

The whole world honoured the demise of 'the painter of the twentieth century' with innumerable admiring testimonies. Even General Franco's Spanish television made a brief announcement of the death of 'the Spanish painter genius, Pablo Ruiz Picasso'. *Pravda* restricted itself to reproducing, on an inside page, the eighteen-word despatch of the Russian TASS news agency, announcing the death of the 'Spanish painter of worldwide repute'. Only Soviet television declared proudly that he was a Communist. The door was open for rumours of every kind, even the most sordid. But the legend of Pablo Picasso had already saved him from them. He remained a shining sun.

In today's world, in which the notorious 'fifteen minutes of fame' predicted by Andy Warhol have become a reality, in this civilisation where image matters more than deeds, an advertising man would say: 'Picasso pulled off his stunt very well.' Except that a 'stunt' does not last. Picasso is a whole oeuvre.

THE NAME

My grandfather decided what name he wanted to bear. By tradition and by law in Spain, a child takes a name made up of part of its father's name and part of its mother's name. In this particular case, the couple's names – Don José Ruiz Blasco and Doña María Picasso López – gave rise to Pablo Ruiz y Picasso, later Pablo Ruiz Picasso.

It is worth noting that the double 'S' in 'Picasso' is rare in Spanish spelling. My grandfather chose to use his mother's name on its own to sign his work. Was this because 'Picasso' was much more original than the very common name of 'Ruiz'? It is certainly quite probable: people very quickly adopted the single name 'Picasso', as often happens with compound names. It sounded good. It was original. In my grandfather's opinion, 'Ruiz' was not very attractive from the phonetic point of view, but 'Picasso' with its double 'S', he said, was 'more uncommon, more musical'. He once commented to Brassaï: 'Have you ever noticed, by the way, all the double "S's" in Matisse, Poussin and Douanier Rousseau?' His friend Sabartés had called him 'Picasso' the first time they met,

Dora Maar with Green Fingernails, *1936, oil paint on canvas, 65×54, Museum Berggruen, Berlin.*
2013 saw the extension of the Museum Berggruen, which already possessed 69 works by Pablo Picasso on its inauguration in 1996. A new wing now houses additional works from the collection of Picasso's dealer, Heinz Berggruen, made over to the federal government and the state of Berlin by his children Nicolas and Olivier for a symbolic sum.

in Spain. Gertrude Stein, too, had thought it was a catchy name. Braque never called his friend anything but Picasso – never Pablo! In spite of Pablo's love for Doña María Picasso, I do not believe that it was because of an Oedipal problem that he decided to suppress the name of his father. Pablo always spoke of him with the same respect; and he reproduced his appearance in many canvases, whenever he needed to portray 'a man, a real man', as he put it. He even wrote to his mother to make sure that his decision to use the single name 'Picasso' would not be misinterpreted by his father, and asked her to assure the latter of his unalterable affection and respect.

As regards the law, he was never in the slightest doubt. There was the law, and there was his life. His official documents were drawn up in the name of Pablo Ruiz Picasso, but his works, when he signed them and they left his studio, even at the very start of his career, were simply signed 'Picasso'. In one respect, he was a forerunner of the reform of the law relating to surnames in France, which was passed in 2001, replacing the French patronymic. From that time on, a child could bear the name of its father or its mother or both, in either order. The law establishes a variety of procedures, also available to a child born prior to the new law.

After the 1972 filiation reform, natural children received the name of the parent who first acknowledged them, either the father or the mother (regardless of whether or not the father or mother was married at the time of their conception or birth). In an irony of history, the natural child now had the unexpected benefit of being able to choose its parents (not to mention subsequent acknowledgements of paternity), whereas the legitimate child, until 2001, could only bear its father's name. My own case is atypical: during my schooldays, I only bore the surname of my father, Widmaier (a name originating from Territoire-de-Belfort), but in 1973, with the beginning of the Succession proceedings, I was spotted at school, where I was labelled 'Picasso's grandson'. This conferred a dual identity on me, though I had no difficulty in accepting it. The law on customary names of 23 December 1985 enabled me to give official validity to my dual association with the past of my mother and also that of my father, as Olivier Widmaier Ruiz Picasso. In everyday affairs, I am sometimes Widmaier, but more often Picasso.

One last episode has occurred relating to the name. At the beginning of 2003, the French Prime Minister, Jean-Pierre Raffarin, decided, in accordance with a proposal by the Minister of Justice, that this 'customary name' should become the definitive surname of my brother Richard, our sister Diana and myself. Today, in France, any child can bear the name of his father or his mother alone, or both names in one order or the other.

However, even before the enactment and development of the recent law, many people

have expressed surprise at this feminine ascendancy in our family. Pablo bore his mother's name; I also bear my mother's name; Gaël and Flore, Marina's children, bear the name of their mother only and not that of their father, Dr Abguillerm.

A 'Picasso' is never anonymous. Such a name possesses such force that deciding to enjoy the advantages it brings means also accepting its burdens, and respecting them. It confers both rights and obligations.

One final word on this matter. In general, once the period of mourning is over, the place of the ancestor fades away and disappears. The inheritance has been passed on. In the case of Picasso, it is still there. Irrespective of the merits or efforts of each of us, Pablo's presence and his image continue to mark our destinies. There is no escape for us. The eternity of the artist is such that the same dilemma faces each succeeding generation. To live with Picasso, to live through Picasso, to live without Picasso.

How can each of us not remain modest, when we ourselves benefit from media interest by the mere fact of being one of his descendants? How can we congratulate ourselves on possessing his works when they are, first and foremost, the heritage of his labours and of his collector's passion?

Pablo Picasso rests in Vauvenargues at the foot of the Mont Sainte-Victoire, facing the Mediterranean sun, in perfect harmony with his southern origins. His works are exhibited throughout the world, especially in the many museums where millions of visitors come to admire them.

Among these, the Musée National Picasso, in Paris, has a very special place. It conserves a complete set of works of all periods, on all subjects and using all techniques, which Pablo had kept all his life, foreseeing that some such destiny awaited such a collection. The building is one of the capital's finest town houses. Its monumental architecture of classical elegance and, especially, its immense spaces, would have been to Pablo's taste. The Hôtel Salé has received Pablo as his true last home. A living Picasso of the twenty-first century and beyond.

'When I work, I leave my body at the door, just as Muslims take off their shoes before entering a mosque. In this state, the body exists in a purely vegetative state, and that's why we painters usually live so long.'

The Young Painter, *14 April 1972, Mougins, oil paint on canvas, 130×162, Musée national Picasso-Paris. Executed a year before his death, this is Pablo's last self-portrait, as a sort of allegory: the dream of lost youth when everything was still possible.*

'MISCHIEVOUS DEVIL!'[106]

As I bring the epic tale of my grandfather's life to a provisional close, I realise that there is one particular point that I have not touched upon, although it is predominant in the image of Picasso: he is alleged to have been manipulative.

Has anything been left unsaid against the womaniser who supposedly manipulated his conquests? Against the artist, said to have manipulated the dealers? And, the ultimate question: did he manipulate the public?

It is a view that takes little account of reality. Let us not forget that he arrived in Paris penniless, and lived for a long time in what today is often termed a precarious state. And that long years went by before the skies began to clear for him.

Did he seduce Fernande and Eva, or marry Olga, because he was rich and famous? Marie-Thérèse, my grandmother, did not even know who Picasso was!

If he kept Fernande in ignorance of Madeleine's existence (and that was before their relationship had become official), or if he kept Olga unaware that he had met Marie-Thérèse, was this in order to profit from his duplicity? No, it was quite the opposite. Trapped with Olga in a marriage to which he could not put an end because of the prohibition of divorce in Spain, his only motive was to protect her, and his son Paulo.

Did he lie to Marie-Thérèse or Dora? He never concealed from them that he was married, and when, in the end, he asked

Marie-Thérèse to marry him, she was the one who was not willing.

Manipulation is by its very nature calculating. The facts prove that Picasso was guided by his heart alone. His greatest concern seems to have been to try not to hurt anyone. Can this be considered skilful manipulation? Similarly, in his relations with the dealers, he showed that he had nerve. But surely he was justified in wanting some control over the destiny of his work? He had known poverty; he devoted himself single-heartedly to his work; was it so unreasonable to demand a decent price for it?

For that matter, how far was Pablo really master of his destiny? His fatalism suggests that he just let things happen. He obeyed his instincts, without too many second thoughts. Through his tenacious pursuit of the ineffable and the impalpable, he had learnt that it was better to leave things up to the hazards of fortune. And fortune would smile on him, sometimes exceptionally so. And what does it matter if, in spite of everything, the man escapes us, seemingly impossible to grasp? Let him remain a mystery! His oeuvre is still there, revealing other worlds to us, teaching us to know ourselves; an oeuvre which belongs to all of us. Blessed with such light, let us accept an element of the unknown.

As my grandmother Marie-Thérèse used to say of Pablo, he was a real 'mischievous devil'. But he was also just 'tremendously wonderful'.[107]

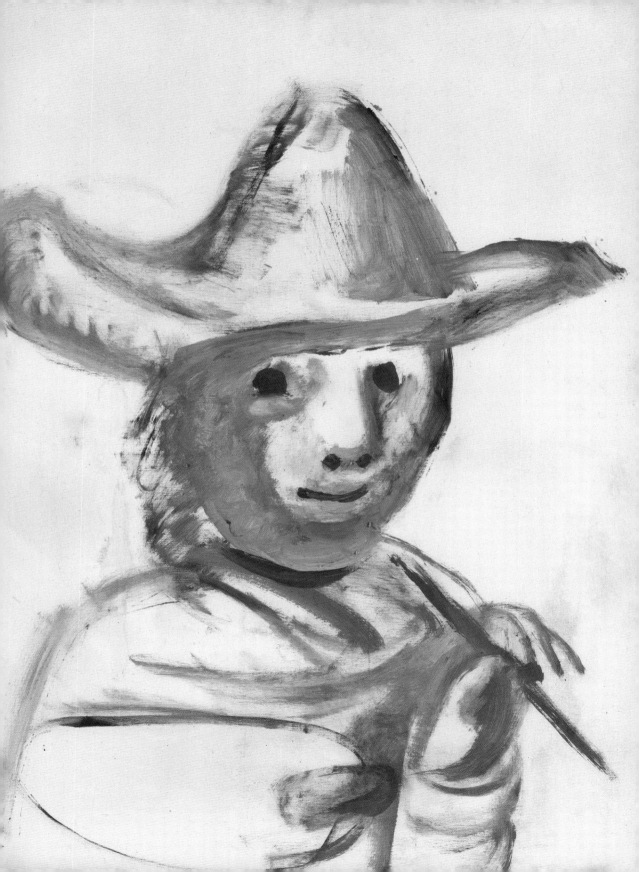

APPENDICES

NOTES

1/ The Picasso joint owners (said 'Indivision' in French) are Maya, Claude and Paloma, the painter's three children, and Marina and Bernard, the children of his eldest son Paul, who died in 1975. See p. 256. 2/ 'Lettre sur l'Art', in *Ogoniok*, Moscow, no. 20, 16 May 1926; trans. from the Russian by C. Motchoulskky, in *Formes*, no. 2, February 1930. 3/ Arianna Stassinopoulos-Huffington, *Picasso créateur et destructeur*, Paris, Stock, 1989. 4/ A dilapidated building full of studios situated in Montmartre (Paris) into which Pablo moved several times. 5/ John Richardson, *Vie de Picasso*, Paris, Le Chêne, 1992. 6/ *Ibid.* 7/ Pierre Daix, *Dictionnaire Picasso*, Paris, Robert Laffont, 1995. 8/ Patrick O'Brian, *Pablo Ruiz Picasso*, Paris, Gallimard, 1979. 9/ Fernande Olivier, *Picasso et ses amis*, Paris, Stock, 1945. 10/ Eugène Soulié, dealer in second-hand goods and pictures, a former fairground wrestler, according to John Richardson. It was through him that Picasso was able to subsist in the early days in Paris, selling him pictures from time to time to buy food, paint, canvases, oil for his lamp and coal for his stove. He was eternally grateful to him. 11/ It is now exhibited at the Picasso Museum in Paris. 12/ Fernande Olivier, *Souvenirs intimes*, Paris, Calmann-Lévy, 1988. 13/ P. Daix, *op. cit.* 14/ *Ibid.* 15/ 'Le néoclassicisme et les portraits d'Olga Khokhlova', in *Picasso et le portrait*, Paris, RMN-Flammarion, 1996. 16/ Pablo would not tell her about his marriage to Olga until a month after the ceremony, by post. 17/ Auction sale catalogue of *Les Picasso de Dora Maar*, estate of Madame Markovitch (aka Dora Maar), 27 and 28 October 1998, in Paris. 18/ On the advice of André Breton at the end of 1921, he had bought the canvas immediately on credit. *Les Demoiselles d'Avignon*, sold by Jacques Doucet's widow to Jacques Seligman, was acquired in 1937 by the Museum of Modern Art in New York, which financed the purchase in part by selling a canvas by Degas, *Le Champ de courses*. 19/ Interview with Marie-Thérèse Walter by Pierre Cabanne, in the radio broadcast 'Présence des Arts' on France-Inter, 13 April 1974. 20/ Thirteen etchings and sixty-seven engraved drawings, freely interpreting the novel by Balzac, under the terms of a contract with the dealer Ambroise Vollard. 21/ Interview with Marie-Thérèse Walter by Pierre Cabanne, 13 April 1974, *op. cit.* 22/ *Ibid.* 23/ *Ibid.* 24/ Owned today, amid great media uproar, by Steve Wynn, Las Vegas casino king. 25/ P. Daix, *op. cit.* 26/ These photographs were destined for the periodical of the surrealists, *Le Minotaure*, in which they appeared the following year. 27/ Interview with Marie-Thérèse Walter by Pierre Cabanne, 13 April 1974, *op. cit.* 28/ *Ibid.* 29/ F. Gilot, *op. cit.* 30/ 'Per Dora Maar tan rebuffon, Les portraits de Dora Maar', in *Picasso et le portrait, op. cit.* 31/ Interview with Marie-Thérèse Walter by Pierre Cabanne, 13 April 1974, *op. cit.* 32/ F. Gilot, *op. cit.* 33/ According to Pierre Daix: 'Like Picasso's poems, the style of this play borders on automatic writing, and it is probably one of the best examples of truly surrealist oneiric theatre.' 34/ Picasso had concluded a ten-year agreement (1927-37) with the dealer Ambroise Vollard by the end of which he was to have supplied a hundred illustrations (engravings and etchings). This collection of 'classical' drawings, powerfully inspired by mythology, constituted the famous *Suite Vollard*. 35/ Bernhard Geiser (1891-1967), a Swiss art historian, had begun, in 1928, the critical catalogue of Picasso's engravings and lithographs which he would continue until 1964. 36/ F. Gilot, *op. cit.* 37/ They became lovers, meeting very sporadically, and saw each other again in 1950, in the absence of Françoise, in Paris, and then in Saint-Tropez at the house of Paul Eluard - who was very embarrassed by the situation. Geneviève Laporte published her memoirs in 1973 and 1989: *Si tard le soir, le soleil brille*, Paris, Plon, 1973; *Un amour secret de Picasso*, Monaco, Éditions du Rocher, 1989. 38/ F. Gilot, *op. cit.* 39/ *Ibid.* 40/ Interview with Marie-Thérèse Walter by Pierre Cabanne, 13 April 1974, *op. cit.* 41/ F. Gilot, *op. cit.* 42/ *The Young Nicolas Poussin*, oil on canvas, 73 x 60 cm, dated 31 July 1971. 43/ Hélène Parmelin, *Voyage en Picasso*, pub. Christian Bourgois, 1994. 44/ F. Gilot, *op. cit.* 45/ Georges Tabaraud, *Mes années Picasso*, Paris, Plon, 2002. 46/ Pablo Picasso quoted in *Picasso à Antibes* by Dor de la Souchère, Paris, Éditions Fernand Hazan, 1960. 47/ Hélène Parmelin, *Voyage en Picasso*, Paris, Christian Bourgois, 1994. 48/ P. O'Brian, *op. cit.* 49/ Raymond Bachollet, 'Picasso à ses débuts', in *Picasso et la presse, un peintre dans l'histoire*, Paris, L'Humanité & Éditions Cercle d'Art, 2000. 50/ Generation of 98, a generation of Spanish intellectuals marked by the defeat of Spain in the war against the United States. 51/ He signed a *Manifeste de la colonie espagnole à Paris* in 1901, in support of the anarchists imprisoned for opposing the 1889 war against the Cubans. 52/ Gérard Gosselin, 'Picasso, la politique et la presse', in *Picasso et la presse, un peintre dans l'histoire, op. cit.* 53/ *13 journées dans la vie de Picasso*, DVD, Paris, Arte Éditions, 2000. 54/ 'Picasso, la politique et la presse', in *Picasso et la presse, un peintre dans l'histoire, op. cit.* 55/ *Ibid.* 56/ Cité in Daniel-Henry Kahnweiler, *Mes galeries et mes peintres*, conversations with Francis Crémieux, Paris, Gallimard, 1961. 57/ P. O'Brian, *op. cit.* 58/ *Picasso and the War Years 1937-1945*, Steven A. Nash with Robert Rosenblum (eds.), London, Thames & Hudson, 1998. 59/ P. Daix, *op. cit.* 60/ André-Louis Dubois, *Sous le signe de l'amitié*, Paris, Plon, 1972. 61/ F. Gilot, *op. cit.* 62/ P. O'Brian, *op. cit.* 63/ *Ibid.* 64/ G. Gosselin, *op. cit.* 65/ A painting which, incidentally, was not very well received at the May Salon because the soldiers depicted were not Americans, as the 'comrades' would have liked, but plain stateless robots. 66/ In 'Picasso at Auschwitz', *Art News, September 1993*. 67/ Relating his meetings and conversations with Picasso, Paris, Gallimard, 1974. 68/ Roland Dumas, *Dans l'œil du Minotaure. Le labyrinthe de mes vies*, Paris, Le Cherche-Midi, 2013, p.92. 69/ In Efstratios Tériade, 'En causant avec Picasso', *L'Intransigeant*, 15 June 1932. 70/ P. O'Brian, *op. cit.* 71/ Brassaï, *Conversations avec Picasso*, Paris, Gallimard, 1997. 72/ F. Gilot, *op. cit.* 73/ *Ibid.* 74/ Brigitte Léal, *Picasso et les enfants*, Paris, Flammarion, 1996. 75/ F. Gilot, *op. cit.* 76/ Picasso made these sculptures out of paper, and his collector friend, Lionel Praejer, reproduced them in metal, which Pablo would paint or not, as he felt inclined. 77/ In B. Léal, *op. cit.* 78/ Including *The Goat* (1951), a *Head of Marie-Thérèse* (1932) and a *Woman* (1943-4). *Pregnant Woman* (1950) was soon added to make more room indoors. 79/ Before being transferred, like *Woman with a Vase and Man with a Lamb*, to Mougins in 1961. 80/ Henri-Georges Clouzot (1907-1977) aimed to show the process by which Pablo created his works. Through an ingenious system of tracing paper stretched over frames and felt pen, then tracings on large frames and paint, the artist created a whirlwind of works before the eyes of the spectator, revealing his doubts and his certainties. This film, which was more than an hour and a half long, was awarded the special prize at the Cannes festival in 1956 and the gold medal for the best documentary at the Venice festival in 1959. 81/ F. Gilot, *op. cit.* 82/ *Nice-Matin*, 19 January 1974. 83/ F. Gilot, *op. cit.* 84/ Marina Picasso, *Grand-père*, Paris, Denoël, 2001. 85/ F. Gilot, *op. cit.* 86/ *Ibid.* 87/ P. O'Brian, *op. cit.* 88/ In Heinz Berggruen, *J'étais mon meilleur client, souvenirs d'un marchand d'art*, Paris, L'Arche, 1997. 89/ G. Tabaraud, *op. cit.* 90/ D.-H. Kahnweiler, *op. cit.* 91/ This last exhibition, prepared in collaboration with Pablo during his lifetime, took place in the Palais des Papes (as with the show of 1970), in May 1973. It was such a success that it was extended. In January 1976, the one hundred and eighteen exhibited canvases were stolen. They were found by the Marseilles CID the following October. 92/ In *Le Point*, no. 251, 11 July 1977. 93/ Hélène Demoriane, *Ibid.* 94/ In A. Malraux, *op. cit.* 95/ *Ibid.* 96/ P. O'Brian, *op. cit.* 97/ A. Malraux, *op. cit.* 98/ Antonina Vallentin, *Picasso*, Paris, Albin Michel, 1957. 99/ F. Gilot, *op. cit.* 100/ *Ibid.* 101/ In F. Gilot, *op. cit.* 102/ H. Parmelin, *op. cit.* 103/ *Ibid.* 104/ F. Olivier, *Picasso et ses amis, op. cit.* 105/ F. Gilot, *op. cit.* 106/ Interview with Marie-Thérèse Walter by Pierre Cabanne, *op. cit.* 107/ *Ibid.*

CHRONOLOGY

1881 Birth of Pablo on 25 October, son of José Ruiz Blasco and María Picasso López, in Malaga (Andalusia).

1884 Birth of his sister Lola.

1887 Birth of his sister Conchita (she dies of diphtheria in 1895).

1891 The family moves to La Coruña (Galicia).

1896 The family settles permanently in Barcelona.

Pablo enters the school of fine arts, La Lonja, after passing the competitive examination. He lodges alone in the Calle de la Plata.

1897 Pablo settles in Madrid, alone.

He takes courses at the Royal Academy of San Fernando, but his attendance is irregular.

Return to Barcelona.

1898 Following an attack of scarlet fever, convalescence lasts several months in Horta de Ebro, at the home of his friend Manuel Pallarés.

Return to Barcelona.

1899 Meeting with Jaime Sabartés.

1900 With his friend Carles Casagemas, moves into a large studio in Barcelona.

First exhibition at the Quatre Gats café.

Departure for Paris, in October, with Casagemas and Pallarés, for the Universal Exhibition.

First meeting with Germaine.

Meeting with Catalan middleman Manyac, who introduces him to the dealer Ambroise Vollard and the gallery owner Berthe Weill; she buys three paintings from him.

Return to Barcelona at Christmas, then departure for Madrid, where he participates in the periodical *Arte Joven*, while Casagemas goes back to Paris.

1901 Exhibition at the Vollard gallery.

Meeting with Max Jacob, critic, poet and writer.

Suicide of Casagemas in Paris.

Return to Paris. Beginning of the 'blue' period.

Return to Barcelona.

1902 Return to Paris with painter Sebastià Junyer-Vidal, in particularly difficult financial circumstances.

1903 Return to Barcelona.

1904 Picasso settles permanently in Montmartre, in a studio in the Bateau-Lavoir, 13 Rue Ravignan.

Meeting with Fernande Olivier.

1905 Joins artistic circles in Paris: he associates with Guillaume Apollinaire, André Salmon, Juan Gris, Marie Laurencin, Leo Stein.

Evenings spent in the Lapin Agile cabaret and the restaurants of Montmartre.

Trip to Holland during the summer.

1906 Brief stay, with Fernande, with his family in Barcelona.

Trip to Gosol, accompanied by Fernande.

Introduced to Matisse by Gertrude Stein.

Starts to represent desire in his work.

Discovers tribal sculpture and art.

Portrait of Gertrude Stein and initial studies for *Les Demoiselles d'Avignon*.

1907 *Les Demoiselles d'Avignon*.

Meeting with Daniel-Henry Kahnweiler.

Cézanne retrospective at the autumn Salon.

1908–9 Work on geometric shapes and discovery of works by Braque during the summer in L'Estaque.

Art critic Louis Vauxcelles talks of 'cubes'.

Adoption of Raymonde, a girl of about thirteen. Fernande takes the child back to the orphanage in the Rue Caulaincourt after a few days.

1910 Move to 11, Boulevard de Clichy.

Trip with Fernande to Cadaqués in Spain.

Return to Paris in September.

1912 Break-up with Fernande.

Meeting with Eva Gouel (real name Marcelle Humbert).

Move to Montparnasse, Rue Schoelcher.

1913 New trip to Céret with Eva.

Death of Don José Ruiz Blasco, Pablo's father.

Funeral in Barcelona.

1914 Summer in Avignon with Eva and his friends.

Declaration of war between France and Germany. Pablo, a Spanish national, and therefore neutral, remains in Paris.

1915 Baptism of Max Jacob. Pablo is his godfather.

Meeting with Jean Cocteau.

Meeting with Eugenia Errazuriz. Initiation to society life.

Eva dies of cancer in December.

1916 Move to Montrouge in October.

1917 Short stay with his family in Barcelona, in January.

Participates in the stage set and costumes of Jean Cocteau's ballet *Parade*.

Trip to Rome with Cocteau to join Sergei Diaghilev with his Ballets Russes and Igor Stravinsky.

Meeting with Olga Khokhlova, a dancer in the company.

Visit to Naples and Pompeii.

Return to Paris, end of April.

Parade opens at Le Châtelet on 18 May; it causes a scandal.

Departure in May for Madrid and then Barcelona, with the Ballets Russes.

Olga introduced to his mother, Doña María.

Return to Paris, and move to Montrouge in November with Olga.

1918 'Neoclassical' period.

Marriage to Olga on 12 July. The witnesses are Guillaume Apollinaire, Jean Cocteau and Max Jacob.

Honeymoon in Biarritz, in the house of Eugenia Errazuriz, who introduces him to dealer Paul Rosenberg.

Death of Apollinaire on 9 November.

Move in late November to 23, Rue La Boétie in Paris, on two floors: there is a studio above the opulent flat.

1919 Stays in London with Olga for three months to work on Diaghilev's *The Three-Cornered Hat*.

Holiday in Saint-Raphaël with Olga in August.

Exhibition at Paul Rosenberg's gallery.

1921 Birth of Paul, 4 February.

First monograph.

Pablo, Olga and their son Paulo installed in Fontainebleau in July.

1923 High-society circles in Cap d'Antibes with Olga and Paulo, and on the Côte d'Azur. Olga is portrayed as 'pensive'.

Meeting with Sara Murphy.

1924 Friendly relations with the surrealists, who publish a tribute to Picasso in *Paris-Journal*.

Family holiday in Juan-les-Pins in June.

Pablo purchases a car and engages a chauffeur.

1925 Departure for Monte Carlo with Olga and Paul in the spring, for the season of the Ballets Russes.

Move to Juan-les-Pins for the summer.

Participation in the first surrealist exhibition in November.

1926 Exhibition at the Paul Rosenberg gallery during the months of June and July.

Meeting with Christian Zervos.

Trip to Juan-les-Pins and Antibes during the summer, then to Barcelona in October, with Olga and Paulo.

1927 Meets Marie-Thérèse Walter, 8 January, in Paris.

1928 Summer holidays in Dinard with Olga and Paulo. Secret presence of Marie-Thérèse. Return to sculpture, with sculptor Julio González.

1929 Family stay in Dinard. Marie-Thérèse in the neighbourhood in secret.

Meeting with Dalí.

1930 Purchase of the Château de Boisgeloup, in the Eure, in June.

Summer holiday in Juan-les-Pins with Olga and Paulo, as well as Marie-Thérèse.

In the autumn, Marie-Thérèse is installed at 40, Rue La Boétie.

1931 Periodical stays in Boisgeloup with Marie-Thérèse.

1932 Family summer holiday in Boisgeloup. Olga and Paulo depart for holidays in Juan-les-Pins in August.

Retrospective exhibition at the Georges Petit gallery, with untitled portraits of Marie-Thérèse and sculptures shown for the first time.

Publication in October of the first volume of the catalogue raisonné by Christian Zervos, devoted to the period 1895–1906.

Legalisation of divorce enacted in Spain (now a Republic).

1933 Publication of Fernande Olivier's book, *Picasso and his Friends*, which Pablo, under pressure from Olga, tries in vain to prevent.

Meeting with lawyer Maître Henri Robert to consider divorce.

1934 Trip to Madrid, Toledo and Saragossa with Olga and Paulo during the summer.

Stay in Barcelona with Marie-Thérèse.

Announcement of Marie-Thérèse's pregnancy on 25 December.

1935 Petition for divorce.

Non-conciliation hearing in the spring.

Non-conciliation judgement on 29 June.

Olga leaves 23, Rue La Boétie with Paulo, and moves into the Hôtel California, Rue de Berri.

Birth of Maya, 5 September.

Beginning of friendship with Paul Eluard.

First meeting with Dora Maar.

1936 Departure in March for Juan-les-Pins with Marie-Thérèse and their daughter Maya.

Creation of backdrop for *14th July* by Romain Rolland.

July: beginning of the Spanish Civil War.

Departure for Mougins in August, to join Paul and Nusch Eluard.

Another meeting, in Saint-Tropez, with Dora Maar, whom Eluard had introduced to him the previous spring in Paris.

Discovery of Vallauris, a historic village of potters.

In the autumn, Boisgeloup, now the official residence of Olga – who will never go there – is abandoned.

Move to Le Tremblay-sur-Mauldre with Marie-Thérèse and Maya, into a house with a studio lent by Vollard.

1937 Move in January into a new studio at 7, Rue des Grands-Augustins, in Paris.

In February and March, regular stays in Le Tremblay-sur-Mauldre. Execution of a series of portraits of Marie-Thérèse.

In April, request from the Spanish Republican government, which wants a mural painted for the Spanish pavilion at the Universal Exhibition in Paris in July.

From 26 April, bombing of the Basque town of Guernica.

Execution of the fresco *Guernica*, between 1 May and 4 June.

12 July: inauguration of the Spanish pavilion at the Universal Exhibition.

Request for an enquiry in the proceedings for the divorce from Olga.

1938 Stay with Dora Maar in Mougins during the summer.

Return to Paris end of September.

1939 In January, death of Doña María, Pablo's mother, in Barcelona.

Franco's troops enter Barcelona.

Grand retrospective, including *Guernica*, first at the Museum of Modern Art in New York, then in ten other cities in the United States, on the initiative of Alfred Barr.

Death of Ambroise Vollard in July.

Repeal of divorce in Spain. Petition for official separation from Olga.

Declaration of war between France and Nazi Germany in September.

Departure for Royan to join Marie-Thérèse and Maya. Dora accompanies him in secret.

1940 Judicial separation order against Olga in February. Olga appeals.

Armistice signed. Vichy government.

Shuttling between Paris and Royan.

Final departure in the autumn from the flat in the Rue La Boétie – though he will keep it on – for the rest of the war, and move into the studio and the small flat in the Rue des Grands-Augustins.

1941 A play, *Desire Caught by the Tail*, published by Gallimard.

Marie-Thérèse and Maya return to Paris and move to the Boulevard Henri-IV.

Appeal court judgement confirms separation from Olga.

1943 Meets Françoise Gilot in May.

Olga's appeal rejected.

1944 Liberation of Paris.

Joins the Communist Party.

Participation in the autumn Salon.

1945 First lithographs with Fernand Mourlot.

1946 Trip with Françoise to the Côte d'Azur and Provence in March.

Moves in with Françoise in April.

Work at the Antibes museum, lent by Jules Dor de La Souchère.

New retrospective at Museum of Modern Art in New York.

Françoise's pregnancy announced.

1947 Birth of Claude, 15 May.

Move to Golfe-Juan with Françoise and their son in June.

Beginning of intense pottery activity with Suzanne and Georges Ramié in Vallauris.

Winter stay on the Côte d'Azur.

1948 Move to a villa in Vallauris, La Galloise.

The *Dove of Peace* created for the Congress of Intellectuals for Peace in April, at the Salle Pleyel in Paris.

Trip with Eluard to Wroclaw (Poland) in August, for the Congress of Intellectuals for Peace.

Visits to Cracow and Auschwitz.

Return to Vallauris in September.

Françoise's second pregnancy announced in October.

1949 Birth of Paloma, 19 April.

Acquisition of the workshops of Le Fournas, in Vallauris.

1950 Second Peace Conference in England, in October.

Awarded the Lenin Peace Prize in November.

1951 Departure from the flat in the Rue La Boétie in Paris, and purchase of two flats in the Rue Gay-Lussac.

1952 Execution of the fresco *War and Peace* in a deconsecrated fourteenth-century chapel near the market square in Vallauris.

1953 *Le Cubism 1907–1914* exhibition at the Musée National d'Art Moderne in Paris; it includes *Les Demoiselles d'Avignon*.
Death of Stalin and the affair of the portrait – scandal in the Communist Party over a portrait of Stalin requested from Pablo and published in *Les Lettres françaises*.
Françoise departs for Paris with their children. They settle in the Rue Gay-Lussac.

1954 Retrospective in Rome and Milan (Italy). Meets with Jacqueline Roque at the Madoura gallery in June.

1955 Death of Olga.
Pablo appointed second guardian of Claude and Paloma.
Retrospective in Paris at the Museum of Decorative Arts.
Purchase of a villa in Cannes, La Californie. Pablo moves in with Jacqueline and Maya, then with Claude and Paloma for the school holidays.
Making of Henri-Georges Clouzot's film, *The Mystery of Picasso*, in July and August.

1958 Purchase of the Château de Vauvenargues (Provence).

1959 Pablo applies to the Minister of Justice to give his name to his children Maya, Claude and Paloma, with the agreement of Paul.

1961 Marriage to Jacqueline in Vallauris, 2 March.
Purchase of a *mas* in Mougins, Notre-Dame-de-Vie.
Celebration of his 80th birthday in Vallauris.

1962 Award of his second Lenin Peace Prize.

1963 Opening of the Picasso Museum in Barcelona (donation by Jaime Sabartés).
Collaboration with the Crommelynck brothers, who install their copperplate engraving workshop in Mougins.

1964 Publication of Brassaï's book, *Conversations with Picasso*.
Publication in the United States of the book *Life with Picasso*, by Françoise Gilot.

1965 Publication in France of Françoise Gilot's book, *Vivre avec Picasso*. Proceedings to prohibit it fail.
Retrospectives in Canada and Japan.

1966 Celebration of his 85th birthday.

Retrospectives at the Grand Palais and the Petit Palais, with numerous sculptures never previously shown, in November.

1967 Expulsion from the studio and the flat in the Rue des Grands-Augustins (law regarding unoccupied accommodation).
Refuses the Légion d'Honneur.

1968 Death of Sabartés.

1970 Donation of early works to the Museu Picasso in Barcelona.
Exhibition of latest works at the Palais des Papes in Avignon.
The Bateau-Lavoir is destroyed by fire.

1971 Celebration of his 90th birthday.
Exhibition of eight canvases in the Grande Galerie of the Louvre museum in Paris.

1972 Reform of filiation law in January, followed by promulgation in August.
Legal application for recognition of filiation of Maya, in December.

1973 Legal application for recognition of filiation of Claude and Paloma, in February.
Pablo dies on 8 April at Notre-Dame-de-Vie in Mougins. Buried at the Château de Vauvenargues.
Exhibition at the Palais des Papes in Avignon, in May.
Picasso Donation to the State of the personal collection of works by other artists: Cézanne, Matisse, Rousseau, Balthus and others.
Beginning of the Succession proceedings.

1974 Definitive court decisions officially acknowledging Maya, Claude and Paloma as natural children of Pablo Picasso.
Nomination of a legal administrator, Maître Pierre Zécri, and an expert, Maître Maurice Rheims.
Start of the inventory.

1975 Death of Paulo (June). He leaves three heirs: his widow Christine and their son Bernard (born in 1959), and his elder daughter Marina (born in 1950).
Beginning of the Succession proceedings on Paulo's estate.

1976 Signature of succession agreements (in March, then in December for the 'preferential choices').

1977 Completion of the inventory and simultaneous declarations of the successions of Pablo and Paulo.
Suicide of Marie-Thérèse in October.

1978 Official submission of the Donation proposal (in settlement of death duties, cumulative for the successions of Pablo and Paulo).

1979 Official handover of the works for the Donation (exhibited in part in the Grand Palais in the autumn).
Beginning of sharing operations among the heirs.

1980 Exhibition *Pablo Picasso: A Retrospective* at the Museum of Modern Art in New York.

1985 Opening of the Musée national Picasso-Paris.

1986 Suicide of Jacqueline in October.

1996 Exhibition 'Picasso and Portraiture' at the Museum of Modern Art in New York and Grand Palais in Paris.

1999 Retrospective *Picasso – Sculpteur* at the Musée national d'Art moderne-Centre Pompidou in Paris.

2002 Exhibition *Matisse – Picasso* at Tate Modern in London, Grand Palais in Paris and Museum of Modern Art in New York.

2003 Opening in Malaga of the Museo Picasso Malaga, at the initiative of Bernard, his mother Christine and his wife Almine Rech, with the Region of Andalusia.

2014 Reopening of the Musée national Picasso-Paris after five years of renovation and rebuilding.

2015 Exhibition *Picasso.Mania* at the Grand Palais in Paris.

2017 *Picasso-Méditerranée 2017–2019* program (42 exhibitions in over sixty international institutions) by the Musée national Picasso-Paris.
Exhibition *Olga Picasso* at the Musée national Picasso-Paris.
Exhibition *Picasso 1932. Année érotique*, at the Musée national Picasso-Paris.

2018 Exhibition *The EY Exhibition: Picasso 1932 – Love Fame Tragedy* at Tate Modern in London.

BIBLIOGRAPHY

ANDRAL Jean-Louis, exhibition catalogue for *La Joie de Vivre 1945–1948* at the Palazzo Grassi/Musée Picasso, Antibes, Skira/Palazzo Grassi, October 2006.

ANDRAL Jean-Louis, exhibition catalogue for *Picasso 1945–1949, l'ère du renouveau* at the Musée Picasso, Antibes, Snoeck Éditions, October 2009.

ASSOULINE Pierre, *L'Homme de l'art: Daniel-Henry Kahnweiler, 1884–1979*, Paris, Balland, 1988.

AVRIL Nicole, *Moi, Dora Maar*, Paris, Plon, 2001.

BALDASSARI Anne, *Le Miroir noir, Picasso sources photographiques 1900–1928*, Paris, RMN, 1997.

BALDASSARI Anne, *Picasso photographe*, Paris, RMN, 1995.

BALDASSARI Anne, *Picasso, papiers journaux* (exhibition catalogue), Paris, Tallandier, 2003.

BALDASSARI Anne and BERNADAC Marie-Laure, exhibition catalogue for *Picasso et les maîtres* at the Grand Palais, Paris, RMN, September 2008.

BALDASSARI Anne and LEHNI Nadine, *Picasso/Berggruen : une collection particulière*, Paris, Flammarion/RMN, 2006.

BARR Alfred H. Jr., *Matisse: His Art and his Public*, New York, Museum of Modern Art, 1951.

BARR Alfred H. Jr., *Picasso: Fifty Years of his Art*, New York, Museum of Modern Art, 1946.

BARR Alfred H. Jr., *Picasso: Forty Years of his Art*, New York, Museum of Modern Art, 1939.

BARTHES Roland, *Mythologies*, Paris, Le Seuil, 1957.

BERGGRUEN Heinz, *J'étais mon meilleur client, Souvenirs d'un marchand d'art*, trans. from the German *Hauptweg und Nebenwege* by Laurent Mulhleisen, Paris, L'Arche, 1997.

BERNADAC Marie-Laure and ANDROULA Michael, *Picasso, propos sur l'art*, Paris, Gallimard, 1998.

BERNADAC Marie-Laure and DU BOUCHET Paule, *Picasso, le sage et le fou*, Paris, Gallimard, 'Découvertes' series, 1986.

BERNADAC Marie-Laure and PIOT Christine, *Picasso, écrits : Picasso et la pratique de l'écriture*, Paris, Gallimard-RMN, 1989.

BERNADAC Marie-Laure, MARCEILLAC Laurence, RICHET Michèle and SECKEL Hélène, Musée Picasso. *Catalogue sommaire des collections*, Paris, Ministry for Culture-RMN, 1985.

BERNADAC Marie-Laure, MONOD-FONTAINE Isabelle and SYLVESTER David, *Le Dernier*

Picasso, 17 February–16 May 1988, Paris, Centre Georges Pompidou, 2000.

BERTRAND DORLÉAC Laurence and MUNCK Jacqueline, exhibition catalogue for *L'Art en Guerre, France 1938–1947*, Musée d'Art Moderne de la Ville de Paris, Paris-Musées, 2012.

BRASSAÏ, *Conversations avec Picasso*, Paris, Gallimard, 1964.

CABANNE Pierre, *Le Siècle de Picasso*, Paris, Denoël, 1975; repub. Gallimard, 'Folio' series, 4 vols, 1992.

COOPER Douglas, *Picasso-Théâtre*, Paris, Le Cercle d'Art, 1967.

COOPER Douglas, *The Cubist Epoch*, Oxford, Phaidon, 1971.

DAIX Pierre, *Dictionnaire Picasso*, Paris, Robert Laffont, 'Bouquins' series, 1995.

DAIX Pierre, *La Vie de peintre de Pablo Picasso*, Paris, Le Seuil, 1977.

DAIX Pierre, *Picasso*, Paris, Somogy, 1964.

DAIX Pierre, *Picasso créateur*, Paris, Le Seuil, 1987.

DAIX Pierre, 'Picasso et l'art nègre', in *Art nègre et civilisation de l'universel*, Dakar-Abidjan, Les Nouvelles Éditions africaines, 1975.

DAIX Pierre, *Picasso, la Provence et Jacqueline*, Arles, Actes Sud, 1991.

DAIX Pierre, *Picasso: Life and Art*, New York, Harper and Row, 1993.

DAIX Pierre, *Tout mon temps*, Mémoires, Paris, Fayard, 2001.

DAIX Pierre and BOUDAILLE Georges, *Catalogue raisonné des périodes bleue et rose, 1900–1906*, Neuchâtel, Ides et Calendes, 1966; revised in 1989.

DAIX Pierre and ROSSELET Joan, *Catalogue raisonné du cubisme de Picasso, 1907–1916*, Neuchâtel, Ides et Calendes, 1979.

DE LA SOUCHERE Dor Jules, *Picasso à Antibes*, Paris, Fernand Hazan, 1960.

DOMENECH Silvia, *50 Years of the Museum Picasso in Barcelona: Origins*, Museu Picasso, Barcelona, 2013.

DUMAS Roland, *Dans l'œil du Minotaure, le labyrinthe de mes vies*, Paris, Cherche-Midi, April 2013.

DUMAS Roland, *Le Fil et la Pelote, Mémoires*, Paris, Plon, 1996.

DUNCAN David Douglas, *Les Picasso de Picasso*, Lausanne, Édita, 1961.

DUNCAN David Douglas, *Picasso à l'œuvre – Dans l'objectif de David Douglas Duncan*, Gallimard, February 2012.

DUNCAN David Douglas, *Picasso and Lump: une histoire d'amour*, Paris, Éditions du Chêne, 2007.

DUNCAN David Douglas, *Picasso et Jacqueline*, Geneva, Albert Skira, 1988.

ELUARD Paul, *À Pablo Picasso*, Geneva, Trois Collines, 1944.

ÉLY Bruno, exhibition catalogue for *Picasso-Cézanne* at the Musée Granet, Paris, RMN, May 2009.

FITZGERALD Michael C., *Making Modernism: Picasso and the Creation of the Market for the Twentieth Century*, Berkeley-Los Angeles-London, University of California Press, 1995.

FRY Edward, *Le Cubisme*, Geneva, Éditions de la Connaissance, 1966.

GAUDICHON Bruno, exhibition catalogue for *Picasso à l'œuvre, dans l'objectif de David Douglas Duncan* at the Piscine de Roubaix, Paris, Gallimard, 2012.

GAUDICHON Bruno, *Picasso et la céramique*, Paris, Gallimard, March 2013.

GAUTIER Pierre-Yves, *Propriété littéraire et artistique*, Paris, PUF, 'Droit Fondamental/Droit Civil' series, 1991.

GIDEL Henry, *Picasso*, Paris, Flammarion, 2002.

GILOT Françoise and LAKE Carlton, *Life with Picasso*, New York, Virago Press, 2001; first edition in the United States published by McGraw-Hill Inc. in 1964.

GILOT Françoise and LAKE Carlton, *Vivre avec Picasso*, Paris, Calmann-Lévy, 1965.

GIMENEZ Carmen, exhibition catalogue for *Picasso, Black & White* at the Guggenheim Museum, New York, Delmonico Books/ Prestel, 2012.

GOMBRICH Ernst H., *Histoire de l'art*, Oxford, Phaidon, 2001.

GOMBRICH ERNST H., *Réflexions sur l'histoire de l'art*, Nîmes, Jacqueline Chambon, 1992.

GOSSELIN Gérard and JOUFFROY Jean-Pierre (eds), *Picasso et la presse, Un peintre dans l'histoire*, L'Humanité/Cercle d'Art, 2000. And in this work, the following articles:
– Bachollet Raymond, 'Picasso à ses débuts';
– Daix Pierre, 'L'art dans la presse';
– Gosselin Gérard, 'Picasso, la politique et la presse';

– Jouffroy Jean-Pierre, 'Un fondateur de la deuxième renaissance';
– Tabaraud Georges, 'Picasso et *Le Patriote*'.
JACOB Max, *Souvenirs sur Picasso contés par Max Jacob*, Paris, Les Cahiers d'Art, 1927.
JOBERT Véronique and DE MEAUX Lorraine, exhibition catalogue for *Intelligentsia, entre France et Russie, archives inédites du XX^e siècle*, Beaux-Arts de Paris and Institut français, 2012.
JOUFFROY Jean-Pierre and RUIZ Édouard, *Picasso, de l'image à la lettre*, Paris, Messidor, 1981.
KAHNWEILER Daniel-Henry, *Entretiens avec Francis Crémieux, Mes galeries et mes peintres*, Paris, Gallimard, 1961.
L'Art dans la pub, Musée de la publicité, Paris, Union centrale des Arts décoratifs, 2000.
LAPORTE Geneviève, *Si tard le soir, le soleil brille*, Paris, Plon, 1973; revised and enlarged, *Un amour secret de Picasso*, Monaco, Le Rocher, 1989.
LÉAL Brigitte, *Picasso et les enfants*, Paris, Flammarion, 1996.
LEBRERO STALS José, exhibition catalogue for *Pablo Picasso Family Album*, Museo Picasso de Malaga, 2013.
Les Picasso de Dora Maar, catalogue of the auction sales of 27 and 28 October 1998, organised by the consultants Pisa and Maître Mathias, succession of Mme Markovitch (aka Dora Maar) at the Maison de la Chimie, Paris.
LEYMARIE Jean, *Picasso, Métamorphoses et unité*, Geneva, Albert Skira, 1971.
MALRAUX André, *La Tête d'obsidienne*, Paris, Gallimard, 1974.
McCULLY Marilyn, *A Picasso Anthology*, London, Arts Council of Great Britain, 1981.
McCULLY Marilyn, *Els Quatre Gats: Art in Barcelona around 1900*, Princeton, The Art Gallery, 1978.
McCULLY Marilyn, 'Picasso und Casagemas. Eine Frage von Leben und Tod', in *Der junge Picasso*, Bern, Kunstmuseum, 1984.
McCULLY Marilyn and RAEBURN Michael, *Picasso Ceramics: Jacqueline's Gift to Barcelona*, Museu Picasso, Barcelona, 2012.
McCULLY Marilyn, RAEBURN Michael and ANDRAL Jean-Louis, exhibition catalogue for *Picasso Côte d'Azur*, Hazan, 2013.

McKNIGHT GERALD, *Bitter Legacy: Picasso's Disputed Millions*, London, Bantam Press, 1987.
MENNOUR Kamel, exhibition catalogue for *Objectif Picasso*, Paris, Éditions Mennour, 2001.
MIGUEL MONTAÑES Mariano, *Les Dernières Années*, Paris, Assouline, 2004.
MOURLOT Fernand, *Picasso lithographe*, Monaco, Sauret, 1970.
NASH Steven A. and ROSENBLUM Robert (eds), *Picasso and the War Years 1937–1945*, London, Thames & Hudson, 1999. And in this work, the following articles:
– Nash Steven A., 'Picasso, War and Art';
– Nash Steven A., 'Chronology';
– Rosenblum Robert, 'Picasso's Disasters of War: The Art of Blasphemy';
– Gertje R. Utley, 'From Guernica to the Charnel House: The Political Radicalization of the Artist';
– Fitzgerald Michael C., 'Reports from the Home Fronts, some Skirmishes over Picasso's Reputation'.
O'BRIAN Patrick, *Pablo Ruiz Picasso*, trans. from the English by Henri Morisset in 1976, Paris, Gallimard, 1979.
OLIVIER Fernande, *Picasso et ses amis*, Paris, Stock, 1933; repub. Pygmalion, 2001.
OLIVIER Fernande, *Souvenirs intimes*, ed. Gilbert Krill, Paris, Calmann-Lévy, 1988.
PALAUI FABRE Josep, *Academic and Anti-academic (1895–1900)*, New York, catalogue of the exhibition at the Yoshii gallery, 1996.
PALAUI FABRE Josep, *Picasso vivo (1881–1907)*, Barcelona, Poli´grafa, 1980; trans. English, *Life and Work of the Early Years 1881–1907*, Oxford, Phaidon, 1981.
PAPIES Hans Jürgen, *The Berggruen Collection* (Museum Guide), Berlin, Prestel Verlag, 2003.
PARMELIN Hélène, *Picasso dit...*, Paris, Gonthier, 1966.
PARMELIN Hélène, *Picasso sur la place*, Paris, Julliard, 1959.
PARMELIN Hélène, *Voyage en Picasso*, Paris, Christian Bourgois, 1994.
PENROSE Roland, *Picasso*, Paris, Flammarion, 1982.
PENROSE Roland, *Picasso: His Life and Work*, London, Gollancz, 1958.
PENROSE Roland (text) and QUINN EDWARD (photos), *Picasso à l'œuvre*, Zurich, Manesse-Verlag, 1965.

Picasso and Braque: A Symposium, organised by William Rubin, chaired by Kirk Varnedoe, edited by Lynn Zelevansky, New York, Museum of Modern Art, 1993.

Picasso, documents iconographiques, preface and notes by Jaime Sabartés, Geneva, Pierre Cailler, 1954.

Picasso et le portrait, exhibition at the Grand Palais, Paris, Flammarion-RMN, 1996. And in this work, the following articles:

– Léal Brigitte, 'Per Dora Maar tan rebufon/Les portraits de Dora Maar';

– Fitzgerald Michael C., 'L'art, la politique et la famille durant les années d'après-guerre avec Françoise Gilot', 'Le néoclassicisme et les portraits d'Olga Khokhlova';

– Rubin William, 'Réflexions sur Picasso et le portrait'.

PICASSO Marina, *Les Enfants du bout du monde*, Paris, Ramsay, 1995.

PICASSO Marina and VALLENTIN Louis, *Grand-Père*, Paris, Denoël, 2001.

Picasso, œuvres des musées de Leningrad et de Moscou, introduction by Vercors, followed by an interview between Daniel-Henry Kahnweiler and Hélène Parmelin, Paris, Le Cercle d'Art, 1955.

RAMIÉ Georges, *Céramique de Picasso*, Paris, Le Cercle d'Art, 1974.

RICHARDSON John, *Picasso, aquarelles et gouaches*, Basle, Phœbus, 1984.

RICHARDSON John, *Vie de Picasso*, vol. I, 1881–1906, Paris, Le Chêne, 1992.

RICHARDSON John and GILOT Françoise, exhibition catalogue for *Picasso and Françoise, Paris-Vallauris 1943–1953*, New York, Gagosian Gallery, 2012.

RICHARDSON John and WIDMAIER PICASSO Diana, exhibition catalogue for *Picasso and Marie-Thérèse: l'amour fou*, New York, Gagosian Gallery, 2011.

RUBIN William, exhibition catalogue for *Pablo Picasso, A Retrospective*, New York, Museum of Modern Art, 1980.

RUBIN William, 'La Genèse des *Demoiselles d'Avignon*', in *Les Demoiselles d'Avignon*, 2 vols. Paris, RMN, 1988.

RUBIN William, *Picasso in Primitivism in Twentieth-Century Art*, New York, Museum of Modern Art, 1984.

RUBIN William, *Picasso in the Collection of the Museum of Modern Art*, New York, Museum of Modern Art, 1972.

SALVAYRE Lydie, *Et que les vers mangent le bœuf mort*, Paris, Verticales, 2002.

SECKEL Hélène, *Max Jacob et Picasso*, Paris, RMN, 1994.

SINCLAIR Anne, *21, rue La Boétie*, Paris, Le Livre de poche, April 2013.

SPIES Werner, *Welt der Kinder / Picasso et les enfants*, introduction by Maya Picasso, Stuttgart, Prestel, 1995.

SPIES Werner and DUPUIS-LABBÉ Dominique, *Picasso sculpteur*, Paris, Centre Georges Pompidou, 2000.

SPIES Werner and PIOT Christine, *Picasso, Das Plastische Werk*, Stuttgart, Gerd Hatje Verlag, 1984.

STASSINOPOULOS-HUFFINGTON Arianna, *Picasso, créateur et destructeur*, Paris, Stock, 1989; trans. from the English, *Picasso, Creator and Destroyer*, by Jean Rosenthal, New York, Simon and Schuster, 1988.

TABARAUD Georges, *Mes années Picasso*, Paris, Plon, 2002.

VALLENTIN Antonina, *Picasso*, Paris, Albin Michel, 1957.

VALLES Eduard and CENDOYA Isabel, exhibition catalogue for *Yo Picasso. Self-Portraits*, Museu Picasso, Barcelona, 2013.

WEILL Berthe, *Pan ! Dans l'œil, Ou trente ans dans les coulisses de la peinture contemporaine 1900–1930*, Paris, Librairie Lipschutz, 1933.

WIDMAIER PICASSO Diana, exhibition catalogue for *'L'art ne peut être qu'érotique'*, Paris, Assouline, April 2004.

WIDMAIER PICASSO Diana, exhibition catalogue for *The Sculptures of Pablo Picasso*, New York, Gagosian Gallery, 2003.

WIDMAIER PICASSO Diana, 'La rencontre de Picasso et Marie-Thérèse. Réflexions sur un revirement historiographique', in *Picasso et les femmes*, Chemnitz, catalogue of the Kunstsammlung exhibition, 2002.

WIDMAIER PICASSO Olivier, *Picasso-l'ultime demeure*, Paris, Archibooks, 2016.

WIDMAIER PICASSO Olivier and NANCY Hugues, *Picasso, the legacy (l'inventaire d'une vie)*, Dvd, Arte/Gedeon Programmes/Welcome/RMN-Grand Palais, 2014.

COPYRIGHT

ACKNOWLEDGEMENTS

I wish to express my thanks to all those whose words helped to bring my grandfather back to life for me in our conversations between 2000 and today. They have given me valuable information, and some of them have shed useful light on the description of his estate, which is first and foremost the expression of his oeuvre.

Jean-Louis Andral, Maître Armand Antébi (†), François Bellet, Heinz Berggruen (†), Ernst Beyeler (†), Lucien Clergue (†), Pierre Daix (†), David Douglas Duncan, Maître Roland Dumas, Bruno Ély, Luc Fournol (†), Françoise Gilot, Carmen Gimenez, Maître Paul Hini, Jean Leymarie (†), Maître Paul Lombard (†), Glenn Lowry, Adrien Maeght, Alberto Miguel Montanés, Markus Müller, Lucette Pellegrino (†), Alain Ramié, Maître Maurice Rheims (†), Mstislav Rostropovich (†), Francis Roux, Gérard Sassier, Inès Sassier (†), Werner Spies, André Villers (†), Maître Pierre Zécri (†) and especially my mother, Maya, who added the sincerity of her heart to the accuracy of her knowledge.

Also, for their help:
Dr René Abguillerm (†); Doris Ammann; Anne Baldassari, Nicolas Berggruen; Manuel Borja-Villel, Museo de la Reina Sofia; Guillaume Cerutti, Christie's; Jean-Paul Claverie, LVMH; Anne Davy; Olivia de Fayet, Christie's; Ursula and Wolfgang Frei, Edward Quinn Archive Ltd; Larry Gagosian; Sylvie Gonzalez, Musée d'Art et d'Histoire, Saint-Denis; Odile d'Harcourt, RMN; Bernardo Laniado-Romero, Museo Picasso, Malaga; José Lebrero Stals, Museu Picasso, Barcelona; Anne-Marie Levaux; Solange and Daniel Mossé; Christine Pinault, Picasso Administration; Noëlle Prejger; Diana Pulling, MoMA; Bernard Ruiz-Picasso, FABA; Christine Ruiz-Picasso; Javier Vilató; Diana Widmaier Picasso, my sister; and last but not least the archives department of the Conseil Général des Alpes-Maritimes, and the Musée national Picasso-Paris.

Thanks, too, to Isabelle Pailler (Arte) and Nicolas de Cointet (Albin Michel), in charge of editorial, Elisabeth Marx, responsible for documentary and artistic research, and all the authors, historians and recognised biographers, whose writings have been crucial in enabling me to supplement family memories, archives and research.

THE PRINCIPAL PICASSO MUSEUMS

Musée national Picasso-Paris (France)
www.musee-picasso.fr

Museu Picasso, Barcelona (Spain)
www.museupicasso.bcn.cat

Musée Picasso, Antibes (France)
www.antibes-juanlespins.com/les-musees/picasso

Museo Picasso, Malaga (Spain)
www.museopicassomalaga.org

Kunstmuseum Picasso, Münster (Germany)
www.kunstmuseum-picasso-muenster.de